WORD *of* MOUTH
NASHVILLE CONVERSATIONS

by LILY CLAYTON HANSEN

PHOTOGRAPHY *by*

Danielle Atkins

Andrea Behrends

Brett Warren

Joshua Black Wilkins

SPRING HOUSE PRESS

THE CONVERSATIONS

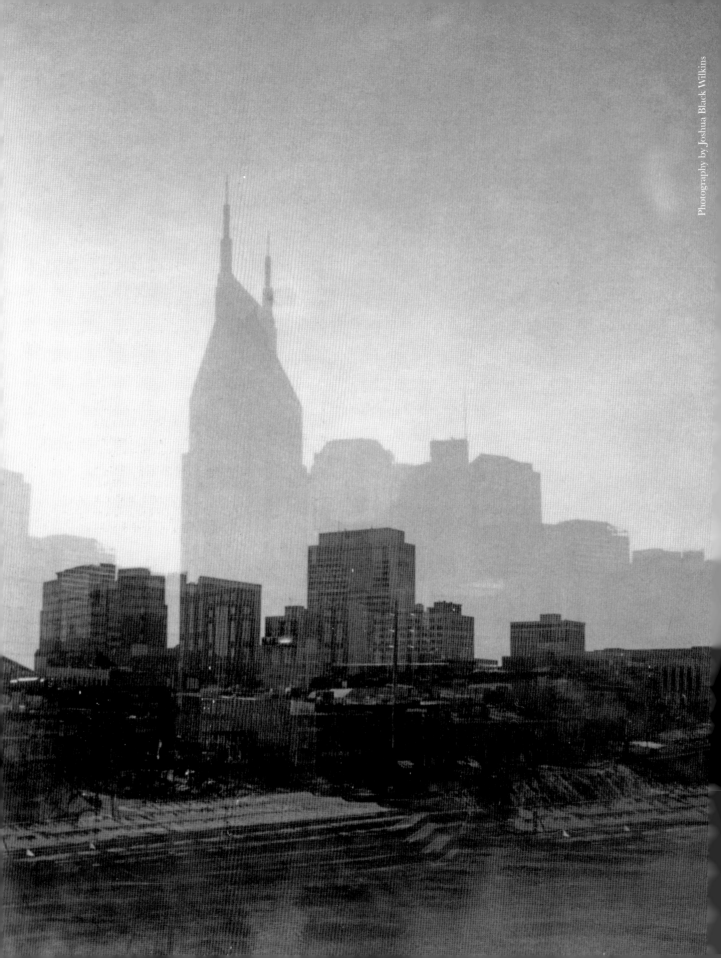

Photography by Joshua Black Wilkins

INTRODUCTION

It felt like a conversation between two friends.

"Life is too long to not do what you want," declared Rowdy Yates, a brilliant wordsmith and songwriter. We were sitting on a friend's rooftop when he nonchalantly offered that phrase, which seemed to dance to the beat of the live blues music in Printers Alley. It was with this same fluidity that the forces aligned to help these pages come to fruition.

Late winter is a season notoriously barren of freelance work. I was a burgeoning 25-year old writer with too few creative outlets. The majority of my writing experience lies in magazine journalism, an industry anchored in timely material with a minute shelf life. I had a notebook full of pitches for which I had no channel, and after tailoring my voice to various publications, I felt I had lost my own style. I felt stagnant and drained of the joy I used to derive from writing. One morning I snapped out of my daily meditation with an idea. Why not conquer this slump by seeking out conversations with a spectrum of inspired people? I spontaneously whipped this plan into action.

This book celebrates the passion and pursuit of what we love most in life. This collection of stories is meant to serve as a guidebook for others looking to orchestrate their own paths. The anecdotes, quotes, and particles of wisdom affirm the satisfaction that comes from following one's heart—despite the sleepless nights and other sacrifices when doing so.

Dreamers and doers seem to congregate here in Nashville, Tennessee, to coax each other into bringing ideas into action. We hang onto our roots, regardless of where we hail from, yet we aren't afraid to reinvent ourselves. Camaraderie and creativity spark an electric energy that has formed a renaissance of sorts in Music City. My goal was to archive this inspiring moment in time.

I interviewed fifty up-and-comers whom I admired in the arts, culinary, and music industries. Eventually I had to add a "wild cards" section for interviewees who eclipsed any category. My title, *Word of Mouth*, refers to the organic, tried-and-true method through which all of my subjects have attracted their fan base and support network. Many of my subjects are friends, collaborators, and champions of one another's work, a testament to Nashville's zest for collaboration and nonexistent social hierarchy.

We met at coffee shops, homes, studios, and offices—anyplace of significance to the subject where he or she felt most relaxed. I rebelled against typical journalistic rules of interview etiquette. I interjected myself into the conversation and I asked plenty of off-the-cuff questions. I approached each interview without a formula, agenda, or plan, although each dialogue inevitably circled back to one serendipitous situation. It cemented the idea that when you put your dreams into motion, the universe aligns.

Plain and simple, this book means everything to me. The black and white portraits of my photographers Danielle Atkins, Andrea Behrends, Brett Warren, and Joshua Black Wilkins elicit an emotional response every time I look at them. Shot in digital, film, and Polaroid formats, they are gritty, classical, and soulful. They captured the courage and charisma I saw in each of my subjects. To make it in any industry, you have to hone the art of believing in yourself and be rebellious in the most endearing sense of the word. This project impacted my psyche and creative ambitions, reinforcing my own goals to pursue a career as a writer. Life is subjective, and we must tune out the naysayers, especially when the loudest voice is our own. I hope this book proves to my readers that anything is possible, and that no gamble is too great if it brings you joy in the moment. Let us be driven by passion, rather than fear.

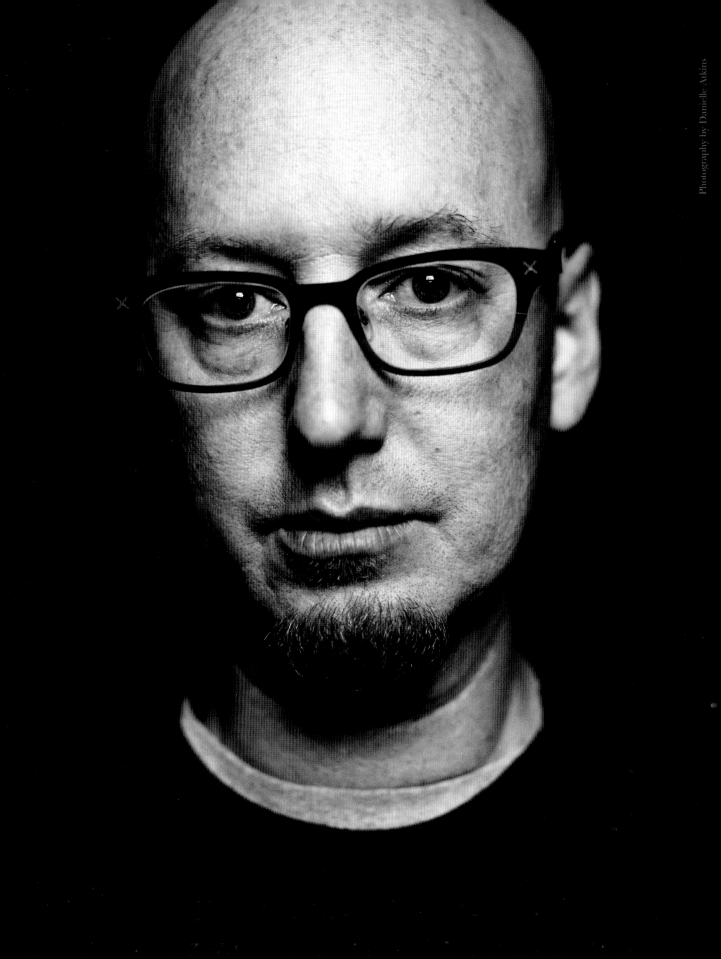
Photography by Danielle Atkins

MARK MONTGOMERY

{*Founder,* FLO Thinkery & echomusic}

There are world-famous, visionaries, and those you've never heard of. Much like his abnormally aligned left and right brains, Mark Montgomery falls into both categories. In 1990, a fast-talking and walking northern storm from Green Bay, Wisconsin, swept through Nashville. The city has ceased to be the same ever since—Montgomery has continuously challenged the status quo and powers that be. The founder of marketing firm, FLO Thinkery, has the unique ability to identify with CEOs and "unicorn-esque" artistic geniuses. He is a serial entrepreneur who in 1999 co-founded digital marketing and distribution company echomusic—one of the first companies to implement B2B and direct communication between artists and their fan-base. When Ticketmaster purchased a majority interest in the company in 2007, it left Montgomery a multimillionaire before age 40 and free agent to pursue other passions. In the interim, he has started a spirits company, brought Google to Nashville, and the made the Entrepreneur Center a small business epicenter. Helping put the "It City" on the map has earned him praise as "the other mayor of Nashville." However accomplished the city's music and tech entrepreneur, there is always a mile-long to-do list that Montgomery has yet to materialize. Nothing in life is guaranteed, which is why he is always willing to gamble for the sake of progress. The mildly crazy, local contrarian is determined to accomplish the unattainable. By refusing to hold his tongue when it comes to polarizing points of view, he has said and done what everyone else is thinking.

You're known as the brilliant troublemaker whose extracurricular activity is to ruffle feathers.
On the surface, the South is a much gentler culture versus the North, which is very direct. I finally say, "Enough of that!" in regards to blanket statements in very complex discussions. Things are not often as black and white as people would like them to believe.

You're the grey area expert.
I'm also the guy who gets told "that's impossible" and does it anyway. Google is a great example of that. When I started engaging Google, which predates this firm, I believed having a company of that caliber garner interest in the city would be invaluable to us—especially, from an all boats rising perspective. However, people thought it couldn't be done. So I just went ahead and did it myself.

When you look at yourself, and Nashville as a city as well, what do you think of the direction you've both gone in since then?
When I moved here with $800 to play guitar my own life vision was much smaller. That being said, I'm a big believer in living into a vision, which means addressing where we aspire to be in the future. Putting that idea into the universe is a critical component of manifestation. We can always do better and accomplish more.

The world is rapidly changing and power is up for grabs. I make the argument that one of the potential market advantages is when you're underestimated. When people count you out, then it's really the time to make a lot of noise. What do those Nashville hillbillies know? A lot.

What are the key attributes that have made the city so successful?

If I had to pick one thing that is, far and away, a market advantage, it's the community itself. We're fairly unique in the way that we function by cooperating with one another, rather than straight competition. Nashville has a strong taproot combined with a substantial geographic advantage in the sense of we're within 60 percent of the US population on a one-day's drive and 80 percent within a 2-days drive. That's a huge market advantage because even digital companies have physical attributes.

Then you take into account the size of the creative class and their relationship historically to entrepreneurship. All of that stuff is in the city's DNA, and then you sprinkle on the fairy dust of our burgeoning food scene, Google's Fiber project, and the entrepreneurial community. That's why it feels like the city is about to explode. If you're already entrenched in the market, it's a good time to be here.

You moved to Nashville to become a music star, so when and how did you make the transition into the business world?

My mindset comes from this weird hybrid of a very artsy-fartsy mother and practical, driven entrepreneur father. Throw in the fact that I'm a Gemini and you get this weird soup where I can play either side. I have some weird amalgamation of skills to deal with either side of the brain, whether it's a creative or analytic mindset.

When I got here it wasn't too long before I realized I was a very small fish in a very big pond. I remember working as a second engineer in a recording studio and thinking, time to form a Plan B, after hearing the other session guitarists.

I've always had a penchant for finding opportunity. Most of the rooms that I found my way into, I didn't belong in. I found a way to stick my foot in the door through sheer persistence. While timing, luck and expertise are factors, at the end of the day, I just don't give up.

How do you know if you're out of your skill set?

Right now I'm running a spirits company, which I've never done before, but 80 percent of any business is the same. The last 20 percent is domain expertise. I understand at my core what I'm great at and attract the people who have skills that I don't.

What are your areas of expertise?

I'm a design thinker and a people magnet. I can see around corners and sell an ice cube to an Eskimo. Lastly, I'm a cliff jumper. Tell me I can't do something and I'm likely to do it just to spite you. I'm very risk tolerant because I trust that when I jump, the net will appear.

When was the first time you realized that you were really good at something?

I'm pretty good at building culture, which I realized because my old employees still congregate regularly even eight years after my company went out of existence. Lifting people up, instilling confidence, and watching them achieve is the most important thing. I also love teaching and being able to tell kids the truth, and inspiring them to do something they've never been encouraged to do. To be able to tell a kid in a very formative place "fuck them, why can't you do that?" is something they need to hear.

How do you know what you want to pursue?

If I get up every morning willing to do it for nothing—that's how I know I want to pursue it. I've been lucky because I've always had passions, stayed the course, and known what I wanted to do.

What's the best piece of advice you've given?

Do work that's inspiring and makes a difference in people's lives. Follow your passion because that's when the money shows up. I don't think it happens in reverse.

What is your biggest accomplishment so far?

Figuring out what my real priorities are, which is my wife and child, and keeping my commitment that they come first. I also like that I refuse to be put in a box, which I probably pay a political price for but don't really care. Lastly, to be able to serve this prolific music community in some way, shape, or form has been hugely satisfying for me. However, while we're really good at patting ourselves on the back and throwing a party, the work is never done. We can always be better, push the market harder, and aspire to more as it relates to becoming a leader.

Why are you so passionate about Nashville?

Nashville has been really good to me. When I got here, half the people who gave me a leg up had no reason or business to do it. It's just how this place functions. After I sold echo in '07, the conventional wisdom was to pack my stuff and go to the Valley because that is the next, big pond. However, I wanted to see this city live into its potential. Are we there yet? No. Are we moving in the right direction? Yes. Are we going to get there? If I have anything to say about it we will.

My grandpa used to say, "Watch people's feet not their mouth." People have called me the ill-dressed, big-mouthed, self-made guy who swears too much. While that's all true, I show up with my work boots on and my checkbook in my pocket. The public may not agree with my tactics, but they like my results. I want people to say, 'god what a motherfucking idiot' or "*that's* the guy I want to be in business with." I'm just fine with one half loving and the other half hating me.

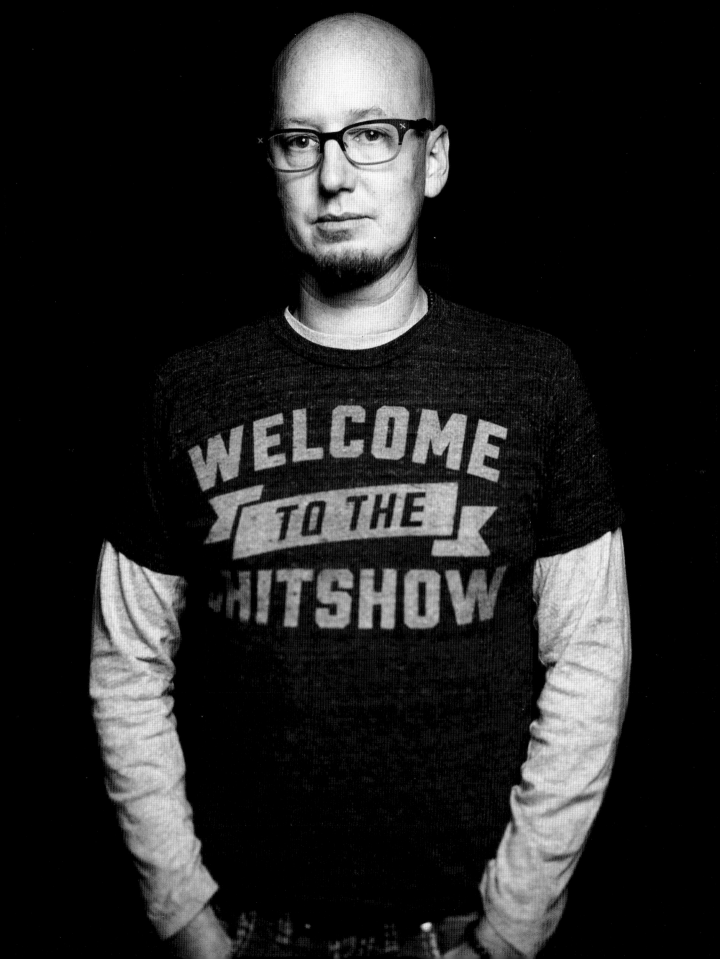

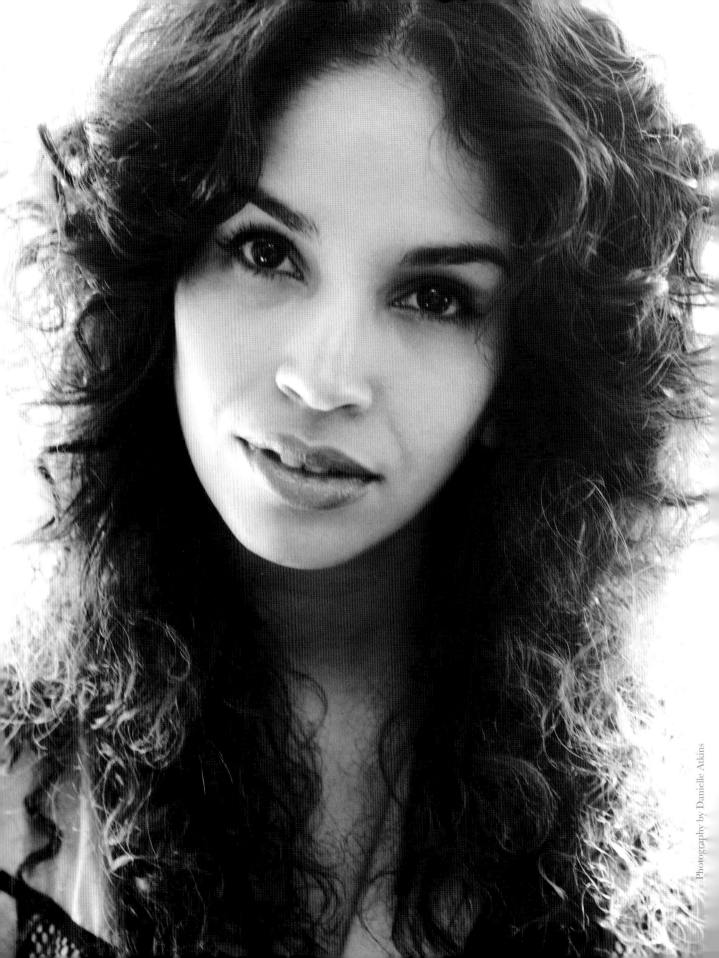

PONI SILVER

{*Fashion Designer & Drummer*, The Ettes}

Maria "Poni" Silver may gravitate towards decadence, but she wants women to wear her clothing on a daily basis. In the designer and drummer's world, fashion and music intersect one another. Her brand Black by Maria Silver is expressive of Silver's rock star style, marked by opulence, exoticism, and the avant-garde. She is a Queens, New York, native who studied women's wear at the Fashion Institute of Technology. Afterwards, Silver honed her tailoring skills while designing costumes for Broadway. Her atelier and showroom, Black by Maria Silver, is housed inside of East Nashville's Fond Object—a record store, arts collective, and resident hangout spot she opened with her band, The Ettes. After a decade of couch surfing and touring the globe, she has finally been able to actualize her sartorial dreams. Amongst the rolling racks, fabric stacks, and sketchbooks at her studio, she fabricates unique, universally flattering pieces. Her ready-to-wear collections and commissioned tour wardrobes are meant to make women feel beautiful about their bodies. As one of the forefathers of Nashville's fashion industry, Silver is exhilarated by the opportunity to define a city's trends. In her own fluid, enterprising way, the tastemaker is setting the bar for future fashion plates.

I find your career very interesting because you sort of did things backwards, downsizing from a metropolitan city to a small one—especially considering the fashion industry in Nashville is still very up-and-coming.

In a good way, because it's new and we're growing together it's very refreshing. Whereas in New York, L.A., or Paris, it's been established long before and it will be there afterwards. It's so much more exciting to be a part of this budding community. Everyone is helping each other out instead of being competitive because there's room for it, and the industry is being welcomed. Girls want more interesting clothing because to find that medium-price range of really cool, unique things is so far and few between. There is a budding fashion community here, but the fashion industry is even smaller. The resources are limited, but I've heard people talking about stuff, so how exciting is that? I feel like everything has been done before and already exists, so to be part of the beginning of it all is rare and exciting.

I'm really interested in your costume design background because when I was a kid I was always really into musicals.

I studied Women's Wear in college at FIT and would end up designing all of these elaborate costumes for no apparent reason. My college ended up giving me an award because the designs didn't fit into a specific category. After graduation, I worked for a costume design house on a ton of amazing shows like Jesus Christ Superstar and Sebastian Bach. Everything in that industry is couture, hand-sewn, and immaculate; even if it's a white but-

ton-down shirt they make it from scratch. Initially I was in the millinery department and I also sourced the fabric swatches. I would travel all over the garment district for eight hours a day and visit twenty floors of dealers. There would be a guy where all he sold was religious brocades for priests or a particular kind of button. I definitely have to tone down my designs even now from what I originally sketch because I have to think about whom I'm selling to.

I noticed your virtual inspiration board was filled with images of 1970s African American icons. You're clearly inspired by strong, ethnic women.

Absolutely. I have a dream one day I'm going to get a bunch of photos of these women and put them all on one wall. My parents are both Dominican, but my mom was very white with straight hair, and my dad is darker with curly hair because Dominicans are such a mish-mash of difference cultures, so you get this smorgasbord of people. I used to look at my mom and wish my hair was straighter and my lips were smaller and I was lighter skinned, and it took such a long time to grow into my own. So I fall in love with these strong, ethnic women.

And your look books also feature predominantly androgynous models.

I was raised by drag queens. As soon as I left high school, I was in the gay scene hanging with all these drag queens, and they taught me how to do my makeup and play dress-up. When we had a night to go out, it was a week of preparation, and we'd always have a theme for our outfits. It was this elaborate process of making your garments before you go out.

That sounds so fun! Your life is so theatrical. The fashion industry in Nashville is very much like the city: cutting-edge in a rock 'n' roll kind of way, yet also laidback and down-to-earth. Does the music scene inspire your collections?

When I see an editorial photograph of some gorgeous dress, it always emulates some kind of song. You can kind of hear the song that would be playing if the magazine had speakers attached to it.

I don't know if you can say one particular thing inspires a collection. Music is always involved but a book about Art Deco illustration inspired my last collection. It was published in the seventies and was a take on the twenties, so they were constantly comparing the two eras. The seventies have always been the basis of how I've dressed and designed, so this was *Great Gatsby* meets Studio 54. A painting inspired the previous collection, so it's anything that makes a light bulb go off in your head. I try to combine music and fashion in that I fabric source on tour to make it more economical.

Tell me the story of how you launched Fond Object.

After touring so much and dealing with the whole industry, The Ettes all needed a break and to do something for ourselves. We always wanted to do something like this where we housed all of our projects under one roof. We call this our tiny department store. And it was always an idea we had, but it was kind of in the back of our brains. Coco and I would play Sims when we were on the road all the time, which is virtual life simulation. This is what you do when you spend twelve hours a day in a van, and then you play a show. In our world, it was called the Stone Owl and the only difference was it had a café. It was very successful in Sims Land. It's like *The Secret*, where you think about things and you want them to happen and then they do. We would sit drinking at the Village Pub staring at a little For Rent sign. The space was formerly a dog groomer, so after a lot of painting and cleaning we opened it. Blood, sweat, and tears are in this place.

Considering you already had a following because of The Ettes, what has been the general consensus of your clothing line?

I think women are finally getting what I'm trying to do. Essentially this is a showroom and the samples are one size. If you like something, I take your measurements and make it custom to fit you. There are no numbers because it's size you and it's going to fit your body perfectly, better than anything you've ever bought. The girls that come in here are so excited because it makes them feel special to have a custom piece tailored to their body. Like in *Mad Men*, the clothes fit them incredibly because they only had a few pieces, but you had them tailored. You look the bomb every time!

And your clothes are only slightly more expensive than most fast fashion lines.

If I'm paying thousands of dollars in rent, then I have to up-charge you. I had friends in town from New York last week, and one said he expected my coats to be $1,200 and couldn't believe it was $350. If I don't have to charge that much, then I'm not going to because I don't believe in gouging people just for the sake of gouging people.

Studio 54, femme fatales, drag queens . . . what else inspires your designs?

I love this little neighborhood and the kids who come in to buy records. The inspiring stuff is what people are wearing on the street and put together themselves. Especially when you're in a town where we don't have access to every retail store in the world. And when you're selling to artists without a ton of money, you have to be more creative! I'm also really obsessed with Marrakesh.

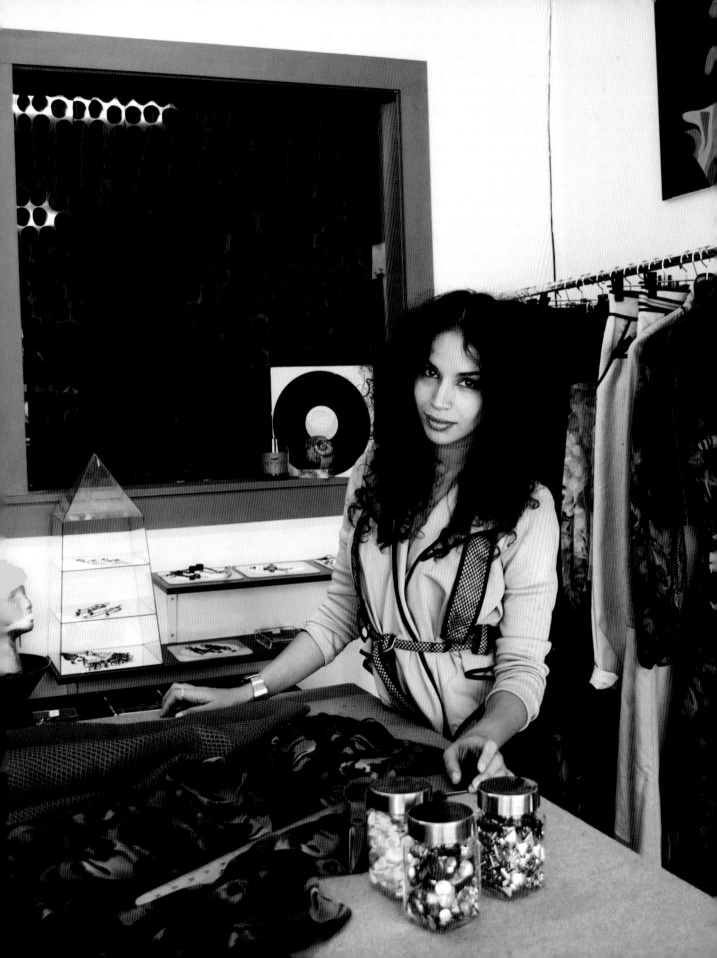

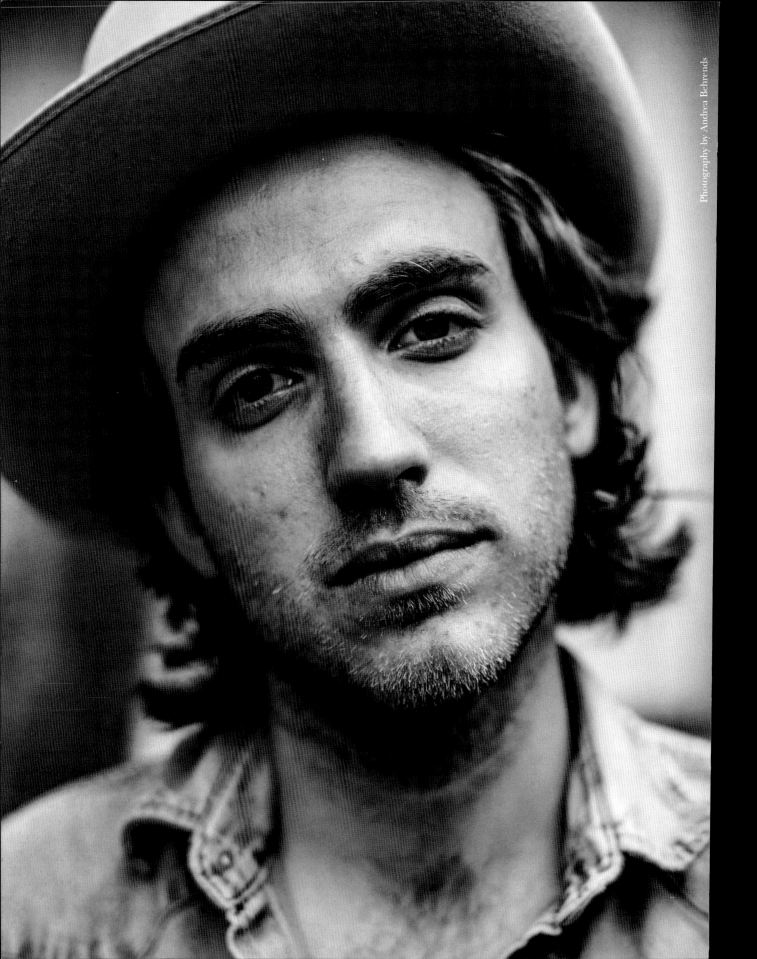
Photography by Andrea Behrends

ANDREW COMBS

{Musician/Songwriter}

S ongwriter and musician Andrew Combs lives for those moments when inspiration strikes hard and fast. More succinct on paper than in conversation, Combs saves words for his rendition of soul swag-style music. The Dallas, Texas, native first became interested in songwriting after hearing Guy Clark's "Let Him Roll." Rich vocals, sinister plots, and black humor characterized his fusion of classic country and blues. He looked towards the lives of others to weave tall tales with personal narratives. It is a method that suits his curious nature to this day, and provides Combs with a constant source of material. A publishing house-signed staff writer, Combs finds balance between penning pop and country tunes for others, and focusing on his own creative endeavors. He is a classic introvert who often holes up at home for days-long writing sessions, and his focus has earned him slots touring alongside major Americana acts. By staying true to his roots and working relentlessly at his craft, Combs has developed a lyrical prowess that would make his idols proud.

How did you end up in Nashville?

I figured if my heroes like Guy Clark, Townes Van Zandt, and Willie Nelson lived here, I should give it a whirl.

Is there a difference between writing lyrics for yourself and other singers?

I always write for myself, and if someone happens to like it, then that's great. I've been doing a lot more co-writing as of late, which I really like. Sometimes when you have someone else in the room, it becomes a different song than what you would write on your own.

What are your career goals as a musician?

My goals as an artist are different than my goals as a writer, yet the two also coincide. I absolutely love writing songs, which is why I did the publishing deal. I'm learning to love performing, and while I'd like to keep moving up in terms of artistry, I'd love to have others record my songs.

Songwriting seems like a lonely, emotionally taxing profession all for the sake of art.

It can be, although it's super-liberating to get it off of my chest. If I'm not writing, well, I'm probably not that pleasurable to be around because I'm just down and disappointed in myself. The publishing company keeps me in a writing rhythm, and I have to write a lot to produce something that's good. I write ten, fifteen songs a month and maybe one or two is good. Maybe.

Are you a perfectionist?

I wouldn't call myself a perfectionist. It's funny because those two songs that I think are the best have elements of all those other songs thrown in. It all kind of makes sense in the end; although, it's painful writing the shitty stuff. Free writing everyday helps me, as well. I'll sit down at my computer or write on a notepad, and sometimes it turns into poetry or a short story. All these ideas start to form when you're free writing, and don't even know it.

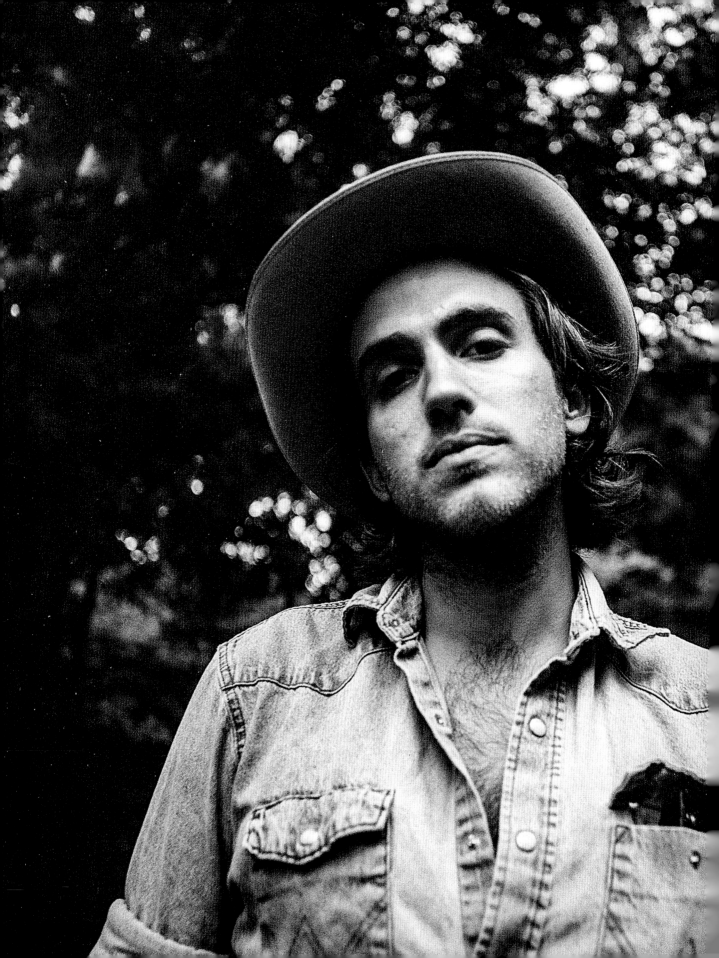

WORDS ALWAYS MATTERED TO ME, AND WERE ALWAYS FIRST IN MY MIND.

Where do your ideas come from?

Not really film, but literature and fiction in particular, and stories that people tell. I'm a white, middle class kid. Nothing in my childhood was fucked up. I had great parents, went to school, and was fed. I don't have a poor, blues background, but you can draw off all these other things and make something that's real and great material. I try and absorb other people's stuff, and a lot of what goes into my songs is drawn from other things and other people.

How do you think living in Nashville has affected your music career?

In Nashville there's this huge creative scene, yet there's also structure, healthy competition, and a lot of collaboration. Everyone is super supportive because we all want to do well, so you try and help out where you can. Plus, it's just really charming and affordable for a creative urban environment.

Do you think having a business degree has provided leverage?

I think schooling can help a little bit, but I think when it comes to the entertainment business, it's all about who you know and word of mouth. The music business is so much about networking that it can wear you out. I always say to anyone that's trying to get a gig that seventy-five percent of it is the hang. Granted, you have to be talented, but if you're a cool person, nice, and easy to get along with, then things will probably go in your favor.

What would you tell other aspiring musicians in the industry?

Be patient, but pro-active.

Any life lessons you've learned along the way?

Although it's very hard at times, stop caring about what others think.

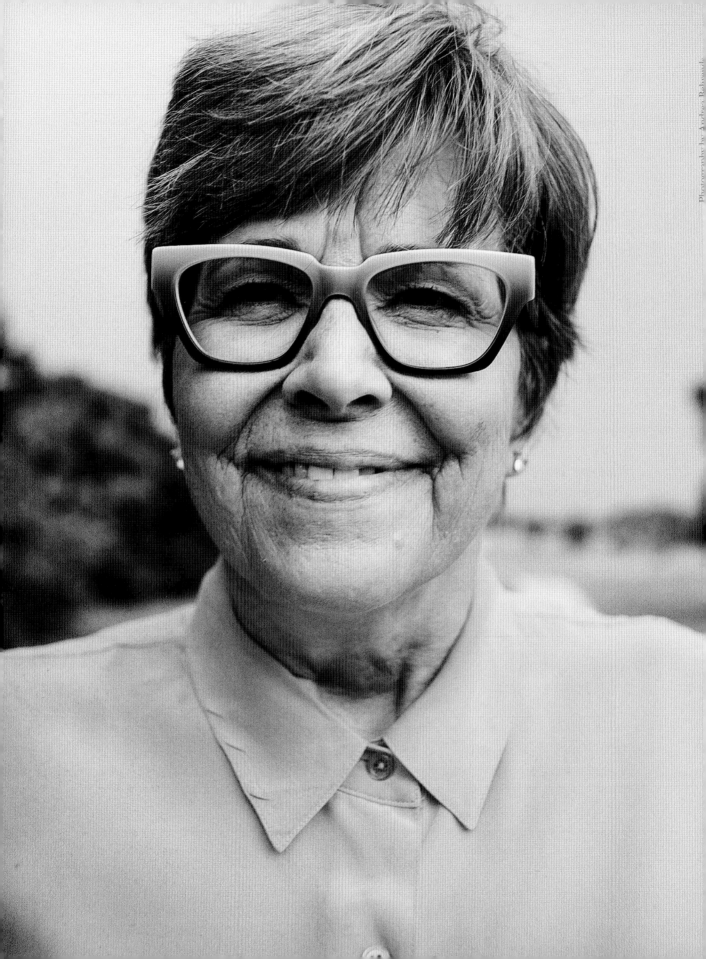

Photography by Andrea Behrends

VAN TUCKER

{*Founder*, Avenue Bank & The Nashville Fashion Alliance}

Van Tucker views her career in terms of legacy. Throughout a 35-year tenure, the Bank of America pioneer and Avenue Bank co-founder used her sixth sense to catalyze change within the industry. Seeing the big picture, as well as the small details, has always allowed Tucker to plan three steps ahead. Since starting as a teller in her native Franklin, Tennessee, Tucker realized that she "wasn't like the other kids." She used this outlier status and real world experience to achieve upward mobility in her field. Tucker's mentors capitalized on her strengths, and encouraged the budding entrepreneur to act fearlessly on her passions. She created new divisions, products, and programs during her 20-plus years at Bank of America. After leading their national entertainment industry team, she developed and directed a similar group at the financial institution that is now known as Regions Trust. Next, Tucker assisted in the record-breaking $75 million capital raise to co-found Avenue Bank, where she remained as Chief Creative Officer until 2008. The lifelong learner is always looking to add new tools to her kit, and recently switched gears to reinvigorate her passion for business. As of late, the consulting strategist has partnered with artists, makers, and entrepreneurs to build a sustainable business around their creativity. She also spearheads the Fashion Alliance, which she hopes will add infrastructure to the disjointed industry. Above all, Tucker encourages her clients to follow what makes their heart beat faster.

What was the first job you ever had?

Fall school shopping was a big deal when I was a kid except if you were at the mercy of a mom who wanted you to wear plaid dresses and tights. Money equaling freedom prompted me to ask my aunt and uncle for a job at age 14. I worked in their jewelry store doing the engraving and gift-wrapping so I could wear overalls.

How did you initially get into banking?

I was a teenage hellion, and our next-door neighbor, who was a bank president, gave me a job as a teller at Williamson County Bank in Franklin. As an extrovert, I fell in love with the customer service aspect of the industry immediately.

When was a time that you felt successful in your industry?

I was working as an assistant to a man named Fred James at Commerce Union Bank, which eventually became Bank of America. He saw that I loved to learn and taught me how to be myself, which helped me flourish from that point on.

What were qualities that helped you excel in the business and finance world?

I've always had a very strong work ethic, but it's truly my willingness and ability to learn that has been the secret to any success I've had. I've never been shy about asking for new opportunities and being humble enough

I FLUNKED 7TH GRADE ALGEBRA. THERE'S NOTHING ABOUT ME THAT SAID I WOULD EXCEL AT BANKING OR BUSINESS.

to admit that I don't know something. Then it's my responsibility to go and understand it.

You're very much like a detective.

I was that child who was always asking "why?" I'm very curious by nature, which is a huge driver for me.

What was your career's biggest learning curve?

Learning how to be a better communicator, which is essential in all areas of life. The best communication skill is listening, which I've made a priority to get better at. Things that are tactile are easy for me but unfortunately you can't YouTube parenting skills or "how to be a better communicator."

You've been in a lot of leadership roles throughout your career. How does one learn how to lead?

I've never set out or consciously said, "I'm going to be a leader," but rather learned through practice and seeing the lessons in my own failures. Leaders inspire people to adopt their way of thinking, act on their courage, and follow their beliefs.

Why the recent leap to work predominantly with creative people?

They are the group I've had a great love affair with for taking the road less traveled. They courageously act from their heart, instead of their head, in a society where logic is considered most valuable.

What was a time when someone tried to discourage you?

While I had been very successful at Bank of America, the president felt that I needed formal education on my resumé to have a national presence. I had never been to college and he offered to recommend me to Vanderbilt where I could earn my MBA. One of my co-workers was vehemently opposed to the idea because he felt that I didn't need a degree to be successful. It wasn't the piece of paper I was exposed to, but rather, this whole new world. At that point, I'd been in this microcosm of the bank for a decade and craved a framework outside of that. It was absolutely the best thing I've ever done.

Experiencing the real world before traditional education is a radical approach.

I'm a big advocate of people taking time off before embarking onto secondary education to get some real world perspective of what they want to do. Sometimes you have to figure out what you don't want to do to find what you really love.

What was it about the finance world that initially hooked you?

I got the most amazing education as a banker because I was exposed to tons of different businesses, industries, and perspectives. Throughout my career I got a really broad perspective as a teller, assistant, financial analyst, product developer, and marketer. Following one career path for 50 years would have robbed my inspiration.

What's the most gratifying thing about what you do?

I love contradictions because that's where life always is. My favorite thing in the entire world is watching people stand on the edge of a bridge and realize they're going to fly. Even if they're fearful and excited at the same time, they know death is on the other side. They have to find the courage otherwise they'll be stuck to a life of mediocrity. There's no other choice.

What do you think is your strongest attribute?

I bring continuity and infrastructure to other companies and organizations. In other words, I help people get their shit together. Business is business. While there are little nuances that may be slightly different, the fundamentals are always the same.

Truthfully, I think we're all creative. While I don't paint, write, or take photographs I consider myself a business artist. A guy I once worked with told me that my greatest attribute was, "To see the vision and execute it every step of the way." If that is my legacy, then I'll die happy.

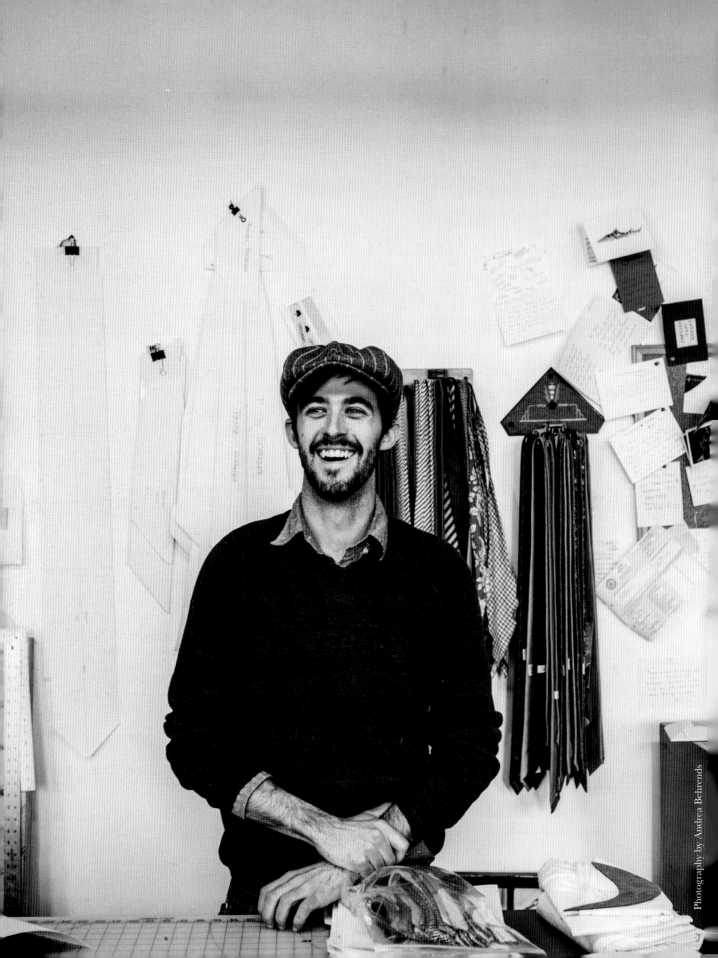

Photography by Andrea Behrends

OTIS JAMES

{Fashion Designer/Tie & Hat Maker}

Although the artistry and quality of his work has made him a forerunner in the industry, Otis James could care less about fashion. The designer's bare feet, blue jeans, and sleepy grin strike a contrast to the dapper ties, caps, and accessories that line his shelves. James is hard on himself and everything that he does. However, if he can establish a connection to his customers then his mission is complete. A collector of caps and vintage ties, James gained retail experience selling suits in college. Post graduation, he rode his bike around the country looking for his place in society. He stumbled across sewing as a survival skill and self-imposed form of independence. Making his own apparel intrigued James, who strived to escape modern society's proclivity to disposability. After settling in Nashville, he began producing custom tie commissions out of his backyard workshop. Next came shelf space at jeans and lifestyle retailer Imogene + Willie, and eventually his own Marathon Village atelier and boutique. Style, quality, and materials compel James to create. Once he got serious about craftsmanship, he looked inside and realized this passion had always been there.

I feel like I'm very much a realist. It's who I am, and it helps me a lot just because I don't generally try and force things. If I had said from the beginning, "This is exactly what I want the company to be, and this is how it's going to go," I'd still be in my backyard trying to make it. I didn't want to do ties until I had the realization that it was a really fantastic opportunity. For whatever reason, the stuff I'm making is in demand, and if I just keep going with that, it's going to present the opportunity to build something bigger.

One of the first things I noticed right away about Nashville is there is a really strong community aspect to the city. People are very supportive. I think that they were hungry for something new and interesting, and I just happened to move here at the right time. The local movement had just started, and the desire to have the experience of talking to the person while they're making the item. Whether it's restaurant owners, painters, and entrepreneurs, it's really fun to be a part of it all. When I went on my cross-country bike trip several years ago, I made as much as I could for it. We have zero connection to many of the things we use in our daily lives. Who designed it, made it, and the concept behind it is irrelevant. If something breaks, you buy a new one. There are so many levels of removal in between source and destination, and it's numbing to me. To have this retail space is really interesting because it's what I always wanted, but I never even realized it: to allow customers a glimpse at the people who produce their ties. At least for one small aspect of life they can see where their product came from, and that's a satisfaction that you can't put a price on.

I wanted to do custom because the whole process was for someone and everything was driven by an ultimate purpose. As I was constructing a tie, I was thinking about the person that I was making it for: the conversa-

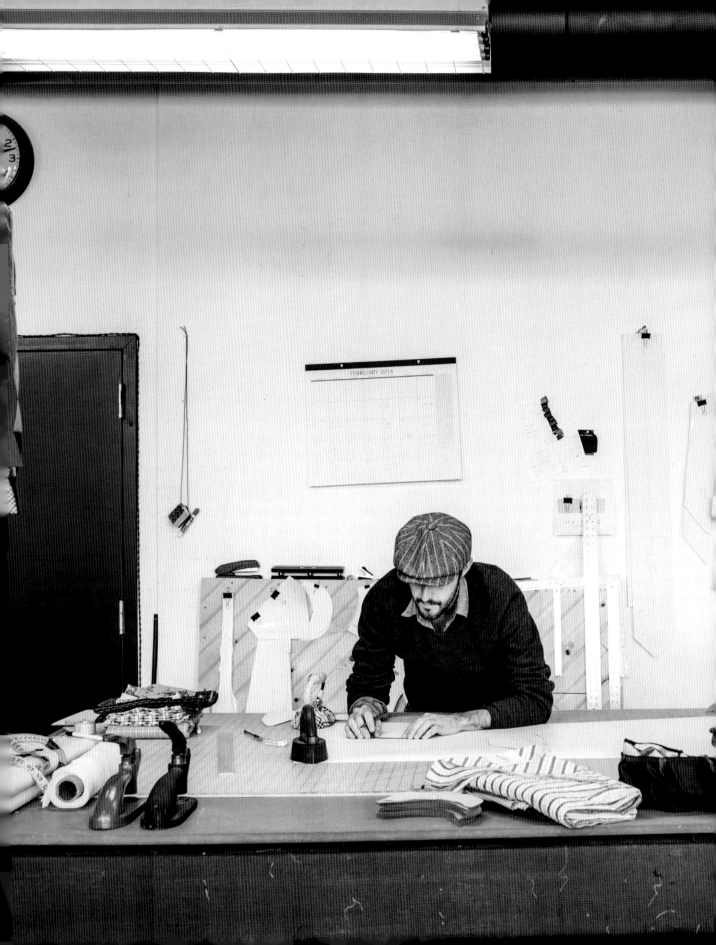

FEBRUARY 2014

I'M VERY MUCH A REALIST AND GENERALLY DON'T TRY AND FORCE THINGS. FROM THE BEGINNING I'VE DONE EVERYHTHING THE WAY I WANT TO.

tions we had and their style. That became lost when we started getting too busy with online orders, and I actually started to resent my business. It took me a long time to embrace this as a legitimate business because I didn't want to charge anybody for anything. For me, it's about the process, meeting people, and having the opportunity to make interesting products.

I undersold myself for a while until one day there was a turning point. I realized this is how I support myself, my employees who rely on me for a paycheck, my overhead, and rent. There's always going to be that creative side, but I don't just sit around and come up with new ideas and look for fabric. It actually made me a lot happier when I embraced this for what it actually is. I think a lot of artists have a hard time associating their craft with money. At the end of the day, we're not trying to get rich, but we need to get by.

Ties are strictly a fashion accessory and have no functional value. I struggled with this for a long time and fought it saying, "This is the last project I'm going to take on." But projects that excited me would come in, and the business would never let me quit. In 2010, I embraced my business and decided if I was going to do it, I was going to make the ties I wanted to make.

Photography by Brett Warren

SARAH BARLOW+ STEPHEN SCHOFIELD

{*Photographer & Art Director*}

Photographer Sarah Barlow and her creative director Stephen Schofield believe in constant reinvention. Since merging forces in 2011, the visionaries have had youth and innovation on their side. Their business and creative partnership is charged by a cohesive energy and entrepreneurial spirit. Barlow is from Chicago and received her first camera at age thirteen. She learned postproduction, lighting, and technique from various internships and online study. It was through experimentation, research, and outside input that she achieved her signature style. Schofield, a skater kid, musician and model, lived both the freewheeling artist and Fortune 300 lifestyles before he arrived in Nashville. The New Orleans native met Barlow through mutual friends and became enamored with her ability to capture raw human emotion. In turn, Barlow credits Schofield with reenergizing her spirit and spinning the wheels of her imagination. Working together, they quickly acquired career mile markers such as cover art for superstars like Pharrell Williams and Taylor Swift. The extroverted artists complement and challenge one another to consistently arrive at a new conclusion. The unique and distinct aesthetic has even inspired its own hashtag: the #lowfield work flow.

Did you two know from the get-go that your collaborative efforts were going to click?

Sarah: We would have ice cream socials and talk business. Stephen would spit out ideas constantly, and we both realized how passionate we were about entrepreneurship. I was burned out on doing it all by myself, and Stephen literally walked in at the exact right moment. The way we think is *so* different that we often have to reshape and compromise to come up with something entirely new. It's always keeping me on my toes and challenging me.

Stephen: I'd write songs by myself in my dorm room, but when it got to a professional level, I realized I wanted to share my ideas and be vulnerable. Music is usually a collaborative effort, so why should photography be any other way? Two minds are better than one if you can find complementary values in both. You keep influencing and inspiring one another. It's cool, organic, and magical once you start the process of actually shooting.

IF YOU'RE A DECENT HUMAN BEING, THEN YOU GET PAST THESE ORBITING SOCIAL RINGS AND GET INTO THE CORE OF PEOPLE WHO ARE DOING WHAT THEY LOVE.

You two definitely have a signature style that's instantaneously recognizable: The soft focus, super-tight crop, and landscape layout. How did that come about?

Sarah: Photography is so intimate because you have to tear down a lot of walls between you and the subject. I believe more so in amazing emotion than in composition. If someone is showing a part of their true self in their photo, even if it's their smile in the corner of the picture, then we've done our job correctly. I love it when people are able to express who they are and feel comfortable with themselves.

Stephen: We're trying to replicate that film vibe and fool people into thinking that it is. There's no real direction other than trying to mimic our influences, and eventually it evolves a style of your own. When it comes to interacting with our subjects, we break down all these sterile, rigid environments. From my own modeling experience, I know fashion and how to move and flow. Sarah's composition is made up of whatever she's seeing in the moment, and the subject's energy and expressions. Our process is loose, spontaneous, and freestyle.

Sarah: Displaying confidence can instantly melt a person's walls. Shooting your friends is comfortable because you know everything about them. So how can you make strangers feel like your friends? The goal is to see something beautiful about them and being able to document that.

I have to bring up your big break job: shooting Taylor Swift's "Red" album cover.

Sarah: She's been a friend, and after I shot her birthday party, she approached me one day and said, "I want you to shoot my album in three weeks. No fans in my hair, just you and I hanging out." She wanted something anti-commercial and that people would connect with. I had previously done music photography and *hated it*. I literally said that if I did it again, it would define the way I shot, which is very raw and candid. The shoot was three days, and after one and a half years, it was the biggest shoot Stephen and I had done to date. While I was slightly intimidated, when you're presented with that sort of opportunity, you recognize how crazy, magical, and meant to be it is.

Stephen: You're not going to progress unless you put on your little confidence outfit. You have to rise to the occasion, be super professional, and convince everyone else that you're more than capable of pulling it off. The main thing we gained from that project is the level of trust people have in us. It generally allows us to do our thing and have total creative freedom.

What is the most rewarding part of your photography career?

Sarah: We take every opportunity as an adventure. There was one week where we were on tour with a band and shot models and a music video back-to-back. It opened my mind and made me think that if I could do this my entire life, it would be so perfect. Being constantly inspired is the most amazing part of it all.

What is it about Nashville that you feel has helped to catapult your career?

Stephen: Nashville is this incubator and tightly knit creative network. If you're a decent human, you get past these orbiting social rings and get into the core of people who are doing what they love. We've gotten to where we are right now through word of mouth and following our passion. What makes this city so unique is there's cross-pollination between different people and industries. It's the layover between New York City and Los Angeles, and people like us fall in love with it. You get to choose where you live, and we've chosen wisely, and enjoyed every minute of it.

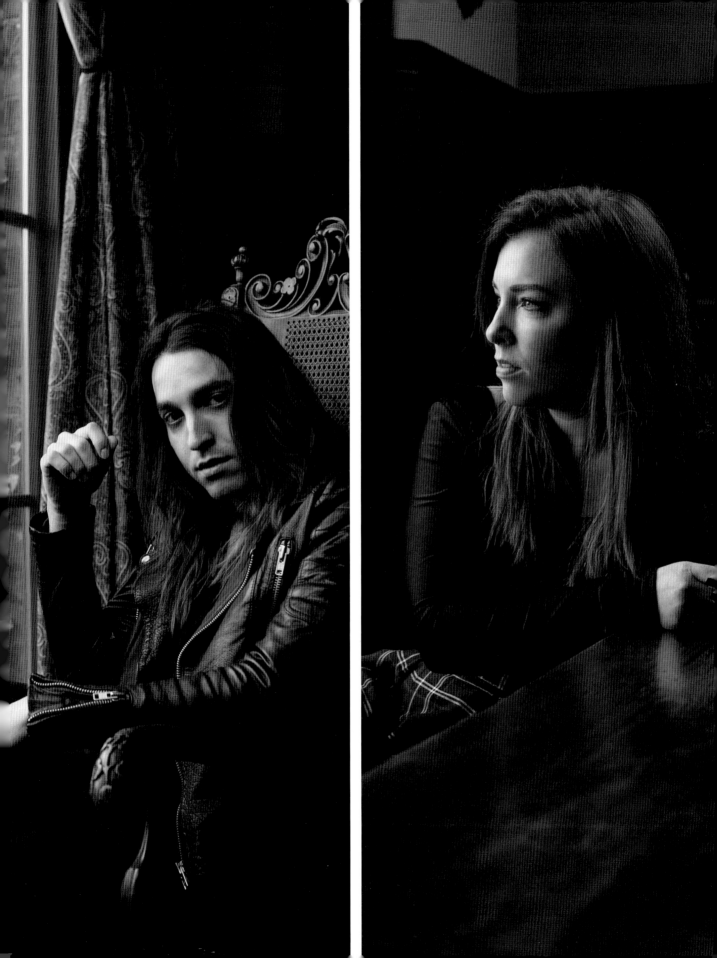

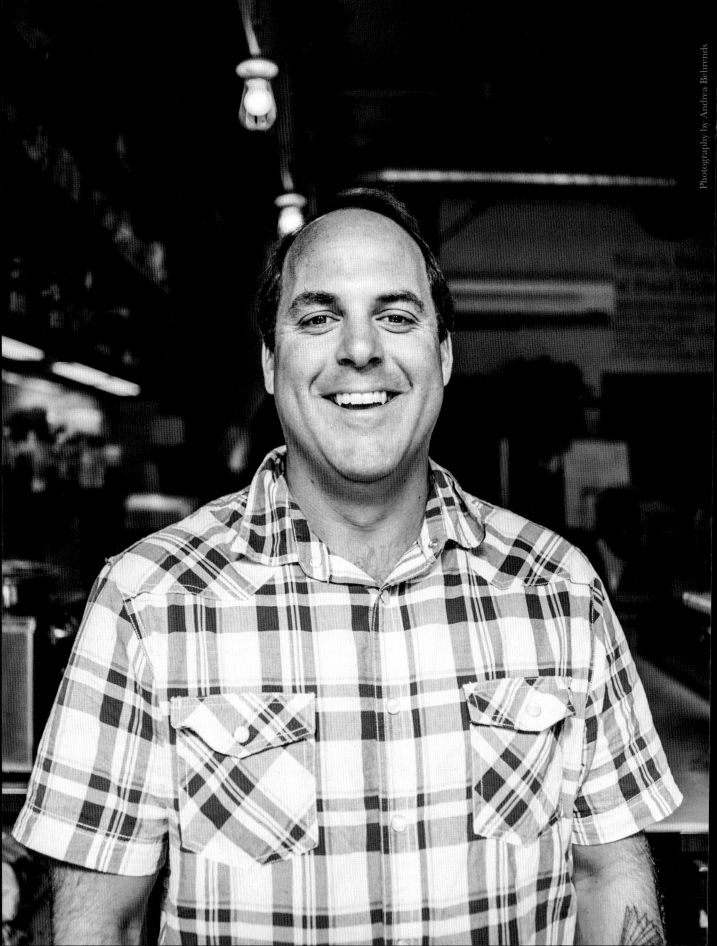

Photography by Andrea Behrends

JEREMY BARLOW

{Chef/Author/Restaurateur, Sloco & Tayst*}*

Food for thought: Healthy cuisine is too expensive, unavailable, and doesn't fit into most people's schedules. By opening his sandwich chain, Sloco, Jeremy Barlow is making it easy for consumers to make the right choice. The slow food activist knows firsthand how hard it is to choose smart when busy life tempts us with a gas-station diet of donuts and Diet Coke. While still operating Tayst Restaurant & Wine Bar, Nashville's first green-certified restaurant, Barlow experienced his own, radical transformation. He was overweight, unhealthy, and a product of the night-owl lifestyle. He reversed the damage by adopting an "everything in moderation" motto and making dining an experience once again. The Sustainable Food Leader of the Year and Culinary Institute of America graduate then became determined to revamp the food system one sammie at a time. When he opened Sloco in 2011, he gave up fine dining to cater to the masses. He began building a blueprint he hopes will scale up to the institutions, schools, and cities. From the dollar to the dinner table, Barlow is determined to get the big guns to change their ways. The author of *Chefs Can Save the World* wants to combat the fast food culture through the building blocks of organic, sustainable, and local. If a Redneck Reuben is the way to make nutrition accessible and affordable, then Barlow is happy to prepare one.

How did you get into cooking?
I was a diehard fast food junkie and addict. Even to this day if I'm hungry and smell it, that bodily response still kicks in, and all of my receptors go off.

If you were on a road trip and desperate for food would you ever indulge?
Yes! This summer my buddy and I drove all the way to Nantucket with three kids, and we ate fast food because there wasn't time to stop for an hour-and-a-half, sit-down dinner. That sector of food is never going away, so it's our responsibility to remain educated and eat as little as we can of it. If we try to stop and start any aspect of the food system, we're going to alienate every-body and create an automatic rebellion. The American way is: give us the information and make it easy and convenient to make the right choice.

Sloco will never ship avocados or mangoes from three continents away. What made carrying seasonal, local products a clear choice?
From the day we opened Tayst, I was always into local food. As I built relationships with my farmers I connected the dots, and realized everything circles back to food. The fact that we keep destroying the land is setting us up for significant failure down the road. If we can't feed our burgeoning population, then we're going to starve from the inside out.

I worked in restaurants for years, and was horrified by how mindlessly wasteful the industry is. We eliminated 95% of our waste at Tayst and don't have that much here because the only items you really have to throw away are plastic wrap and aluminum foil.

When Tayst became entirely green did your pricing margins go up?
Nope, it was exactly the same. After making the decision to go green, it took about a year of research to find an association and learn how to do it. At that time, there were about 30 restaurants in the U.S. that were certified green.

Did it become an obsession for you?
It was just hypocritical to run a restaurant any other way. The food system change needs to combine local and global to force the big farms to grow sustainably.

What was the local reaction like when Tayst went green?
Overwhelmingly positive. We didn't shove information down people's throats like I do at Sloco. Here, I have no problem explaining why our $7 sandwich is better than the processed, antibiotic-filled crap at Quizno's.

One of the demographics you're extremely passionate about is local schools and their lunch programs.
We've been working with Metro for over five years. It all started when my own kids were entering school. In this country we look at food as if it should be broken down into a single pill when it should be approached holistically in terms of how we're growing it. As long as we feed our kids food that is healthy, unprocessed, and not genetically modified or sprayed with a bunch of fertilizers, then that's a healthy meal. Obviously, that's not the case because four of the top six diseases are diet-related and we spend over $300 billion a year on health care. Spending money in the school system to give the students real food from local communities and farmers would fix this issue. We would be healthier, the farmers would make money, and we could support communities in dilapidated rural areas, which really suffer the most.

What is your strategy for expediting this change?
I do a lot of policy work because until you change the dollar and the big companies lose money, or are threatened, you're not going to see significant food system changes. The movement needs to be led by chefs because, whether it's a sandwich shop, fine dining, Tiger

WE HAVE TO BRING BACK THE IMPORTANCE OF FOOD AND EATING AS AN EXPERIENCE.

Mart, or a cafeteria, we control more dollars in the food system than anyone else. Our country eats predominantly outside of the home. The hearth has moved from around a fire where you learned about history, family, and culture to the car, restaurant, and drive-through window. We have to bring back the importance of food and eating as an experience—even if it's in your car on the way to soccer practice. This false cheapness of food has not only affected our waistlines, but the respect that we as a culture have for food on the table.

What keeps you wanting to jump out of bed in the morning and tackle such an uphill battle?
There's no other way to do food. Many of Nashville's restaurants are farm-to-table, however most serve $20 entrées. The biggest issue across the board is affordability, rather than awareness, because almost everybody knows that organic, sustainable, and local are better for you.

Last question: Why did you choose to pursue your passion in Nashville?
Because I was here. I wake up everyday thinking, "I'm crazy" because if I switched to generic brands, I would be rolling in the dough and loving life. But, I also know if I can make Sloco work I can expand in Nashville up to institutions, schools, and cities. At times, my business is brutal in terms of making it cost-effective, but I am in it for the right reasons. I know the work will pay off.

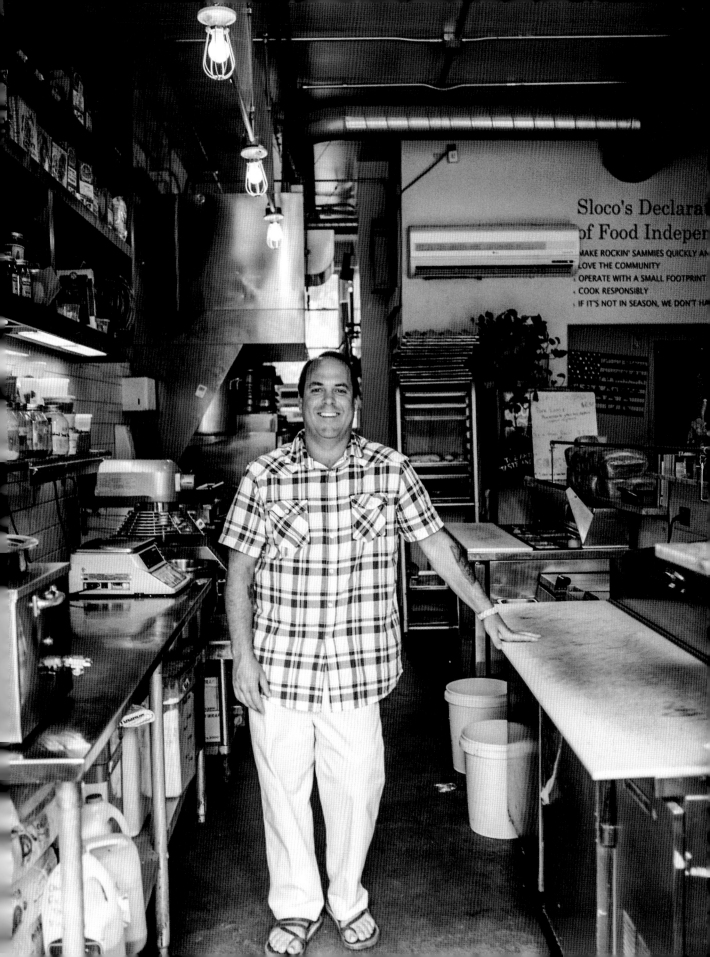

Sloco's Declarat
of Food Indepen

MAKE ROCKIN' SAMMIES QUICKLY AN
LOVE THE COMMUNITY
OPERATE WITH A SMALL FOOTPRINT
COOK RESPONSIBLY
IF IT'S NOT IN SEASON, WE DON'T HA

Photography by Andrea Behrends

SUSAN SHERRICK

{*Curator/Owner*, Sherrick and Paul}

Susan Sherrick demystifies any pretentiousness surrounding the art world. She is co-owner and director of Sherrick & Paul, a contemporary art gallery in the Wedgewood-Houston neighborhood. After honing her eye in the international art market, Sherrick became determined to fill a void in Nashville's art community. The Lancaster, Pennsylvania, native always knew she was a Southerner at heart. The people, heritage brands, and culture were requisites that swayed her relocation to Nashville. In 2013, the independent curator launched sensorial feast, Joint, with media consultant Libby Callaway. The quarterly art, food, and fashion pop-up was Sherrick's way of gauging public interest in the art she wants to present—past themes included fashion photography, vintage motorcycles, and iconic women from the 1970s. In 2014, she partnered with businessman and collector Paul Gilbert to open a fine art gallery focused on mid-career and established artists. While Sherrick's exhibits will elevate the caliber of Nashville's fine art scene, the curator ensures they will be a confluence of inspiration, education, and accessibility.

After working at world-class galleries in New York City and San Francisco how did you establish yourself in Nashville's art community?

When I first relocated here, I was curating a show for the Howard Greenberg Gallery in New York City. The subject was "images made in the South" and it piqued my interest to start reaching out to local photographers. I quickly met Caroline Allison, Joshua Black Wilkins, and Heidi Ross, amongst others, and kept thinking how great it would be to incorporate local and emerging artisans into one gallery exhibition. Around that time, I met Libby Callaway, who shared my common interest of hosting quarterly pop-up events focused on art and fashion. We were both passionate, former New Yorkers, and unique in what we envisioned bringing to the table. We knew it was a must to make it work. In 2013, we found a space, shipped the artwork and launched the first Joint event.

What was it about Nashville that particularly intrigued you?

I knew I would be able to run two businesses, own a house, travel, and have a good quality of life. In New York or LA, I would have had to sacrifice at least one of those things.

Most recently, you opened your own gallery, Sherrick & Paul, in the Wedgewood/Houston neighborhood.

Yes! The gallery will be the first of its kind, in Nashville, in that we aren't showcasing any local artists. When I really started thinking about what kind of artist programming I wanted to bring here, it was evident that my past experience was a huge asset. I'm really excited to be doing something completely new and compliment the area's existing galleries and artists.

WHEN YOU TRULY LOVE SOMETHING, THAT NEVER LEAVES YOU — EVEN IF YOU TAKE A STEP BACK FROM IT FOR A WHILE.

Timing is everything. Why this particular moment to open your own space?

In order to see the type of artwork that I love I was constantly having to travel. One day I was voicing my frustrations to Paul Gilbert and said to him, "I think the timing is right for me to open my own gallery." That's when he offered to back me.

It's amazing that your visions matched so well, and there was no fear of creative compromise.

As the director, I have complete creative control however, Paul and I discuss all of the artists and artwork together. His personal collection is a mixture of established, emerging, and local artists. He truly lives with what he loves, which is awesome and a philosophy similar to my own.

Will the shows alternate between different mediums? Also, what demographic are you targeting?

We're going to alternate between painters and photographers every six to eight weeks. My audience is the collectors and people I've met here who have already bought work from me, and the collectors I've worked with all over the world. All the while, I very much had Nashville in mind when thinking about the artists we would show.

What makes you want to select an artist for your gallery shows?

For the Joint pop-ups, it was about the theme and being able to work with new, old, established, and emerging artists whose work I admire. At Sherrick and Paul, it's much the same but I am also bringing attention to mid-career artists whose work I've followed for quite some time.

Despite the tough market that is the art world, your passion never went away.

I think when you truly love something that never leaves you even if you take a step back from it for a while. The feedback from the Joint pop-ups was overwhelmingly positive, and all of the pieces to open my own gallery fell into place.

Through test-driving the idea you got a feel for what the community craved.

If anything, the pop-ups gave me the hunger for a permanent space.

You also design your own handbag line. How do balance multiple careers?

I'm passionate about both careers, and living in Nashville makes it very possible to do both. I love making bags, and working with my hands is a way for me to relax. Art has always been something that inspires me, and so I feel very lucky to work with artists who I love and admire.

If a recent college graduate went to you for advice on how to become an art curator where would you guide them?

You can live anywhere in the world these days and make a career in the arts industry work. However, if you want to pursue a career in the international art gallery world or auction houses I would recommend going to New York, LA, San Francisco, or Chicago to get top-notch experience.

After fourteen years of working in the art world, what keeps you so passionate about it?

Aside from working with the artists and collectors, the fact that my exhibitions have made a lot of people happy means the world to me. The positive feedback makes everything totally worth it.

Why do you believe you've flourished since moving to Nashville?

I've never lived anywhere where I've found so many good-hearted people. Some of the nicest people I've ever met in my life live in this very town. In the same vein, I want every guest who comes into my gallery to feel welcome. We're inclusive, rather than exclusive. People are oftentimes afraid of art. All I want to do is encourage them to ask.

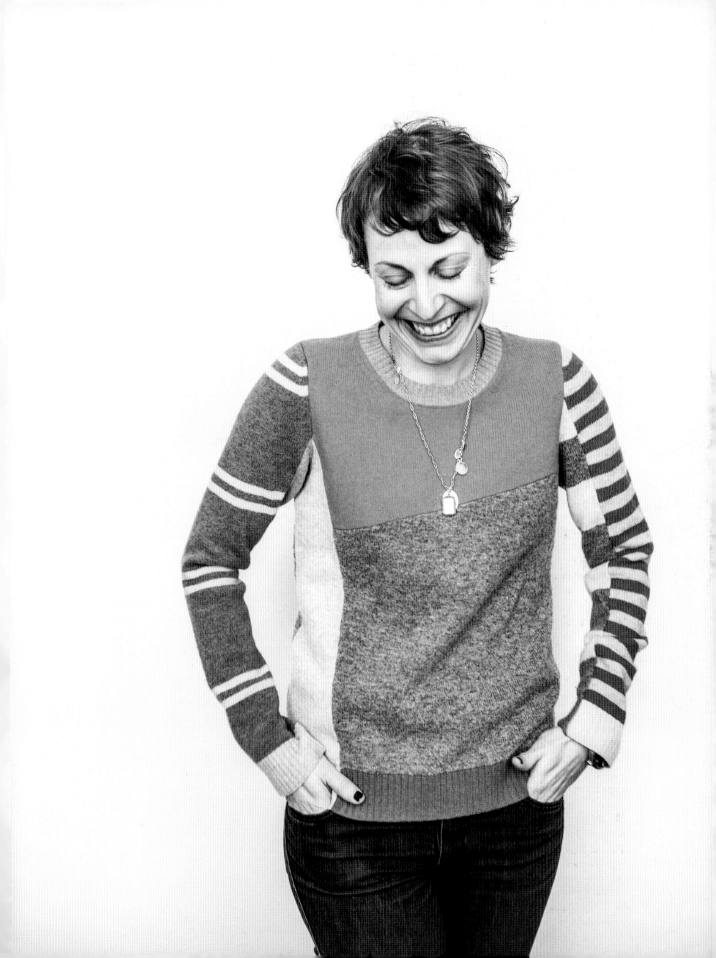

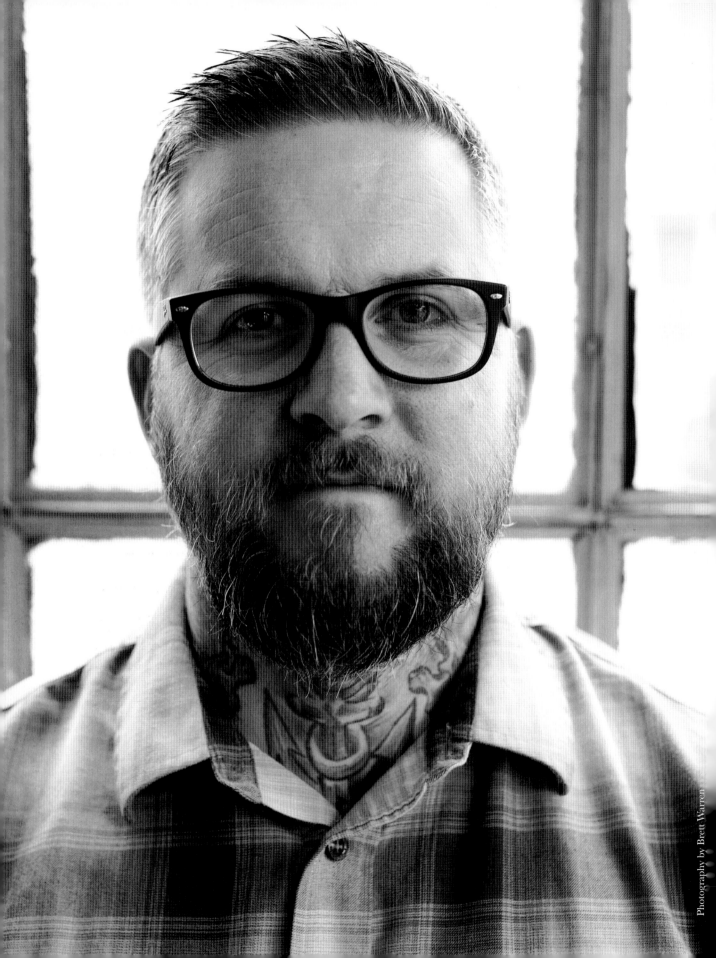

IAN WHITE

{*Tattoo Artist/Owner,* Safe House Tattoo}

Ian White's Safe House Tattoo is the contemporary version of the ice cream social. In the Edgehill Village shop, clients mingle with the artists who sketch and stencil their designs. It is this camaraderie that reminds White why he has chosen this certain path and the human body as his canvas. The art form first piqued White's interest when he was still a child as he tested different designs on his own skin, using pens and markers. Finally, when he turned eighteen, he took the plunge and got his first real tattoo. After serving in the Air Force, he began an apprenticeship with a tattoo artist in Dayton, Ohio. Learning the trade reinvigorated his love for visual art. It was a spiritual rebirth that redirected his unruly lifestyle, and launched his career. Until he landed in Nashville in 2009, White honed his skills as a touring tattoo artist and traveled with established punk rock acts. Three years later, he opened the doors to Safe House Tattoo. Creating within a community nurtured his extroverted personality. It was the answer to the solitary artist's syndrome he had struggled with in the past. Safe House Tattoo became a refuge, and White's clients and artists his second family.

When you give someone a tattoo, is it also a bonding experience?

It can be if you let it. A lot of tattoo artists punch the clock, and while they're extremely talented, there is never a connection.

What makes you stand out from the mass of tattoo artists in Nashville?

For me, tattooing isn't the most important thing in my life whereas years ago it was. Getting my priorities in line has made me a better artist. I love what I do, but it isn't who I am. For me, it's God, family, friends, and tattooing. It just so happens I get to tattoo with all of those. I do feel it's a gift I've been given, not just artistically but connection-wise through conversations and community. If there's not a thing I can learn from you or my next client, then I'm not looking. By permanently marking someone's body, there's a part of me physically, spiritually, and emotionally engrained.

How have you built such a loyal fan-base in only a few years?

It's almost all word of mouth. People almost forget about the tattoo because it's more about the experience. The tattoo is a souvenir. One customer came to me for a piece on his arm, and now we're great friends and on our way to giving him a full bodysuit.

Is there a tattoo that stands out in your memory as truly meaningful? Or a client?

I was tattooing a bridge on this client's arm and after he told me the story behind the design he blurted out, "Man this place is like a safe house or something." We were leaning towards that name anyways and I was like, well it's official. It makes me feel honored when clients share personal stories with me. There have been situations where I haven't looked forward to tattooing someone, yet I was moved and needed something from them. Those are some of my favorite clients now.

GETTING MY PRIORITIES IN LINE HAS MADE ME A BETTER ARTIST. I LOVE WHAT I DO BUT IT ISN'T WHO I AM.

What art style are you known for with your tattoos?

I took a seminar from a painter I love called "Implied Realism." That's my favorite: realism where I create the setting. I also love skulls, because they're a celebration of life, mocking death. And birds.

Do you feel like Safe House would have received the same support in any other city?

I sit in these walls all day and think we could do this somewhere else, but it would be more difficult. In Nashville, I bring what I bring, and people can smell ya from miles away. They know it's there and tell their friends. It's a social city that thrives on connection—much like my studio.

Community should be Nashville's other motto. It's a city of transplants and immigrants, so everybody owns Nashville. People are willing to try your business and be supportive of what's going on. If they have a good experience, they want to sing it from the rooftops.

What do your clients say makes this shop particularly unique?

There are other great tattoo shops in Nashville, but I've had people switch to Safe House because of the feeling they got when they came here. If I had a nickel for every time I heard that, I'd have a lot of nickels and a huge smile on my face. We get recommendations from people who don't even have tattoos because they connect with something we're doing here. A friend said to me recently, "Safe House is more than a tattoo shop," and it's because of everyone in this studio. I'm learning how to lead this place, because I literally feel called to do it. People connect with why you do something, more than what you do. This is exactly where I'm supposed to be.

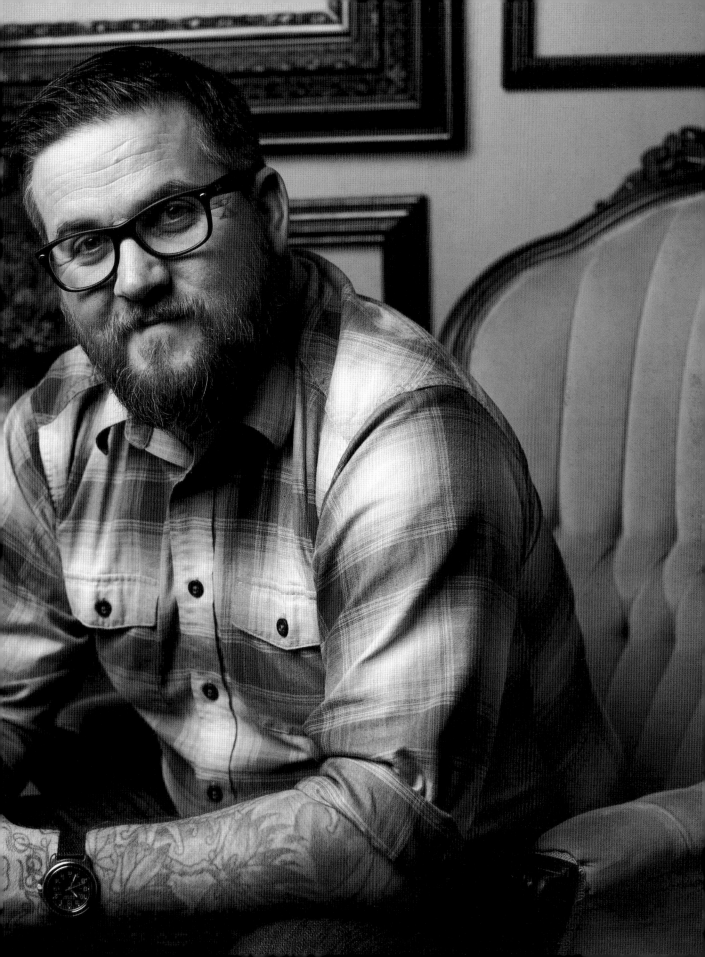

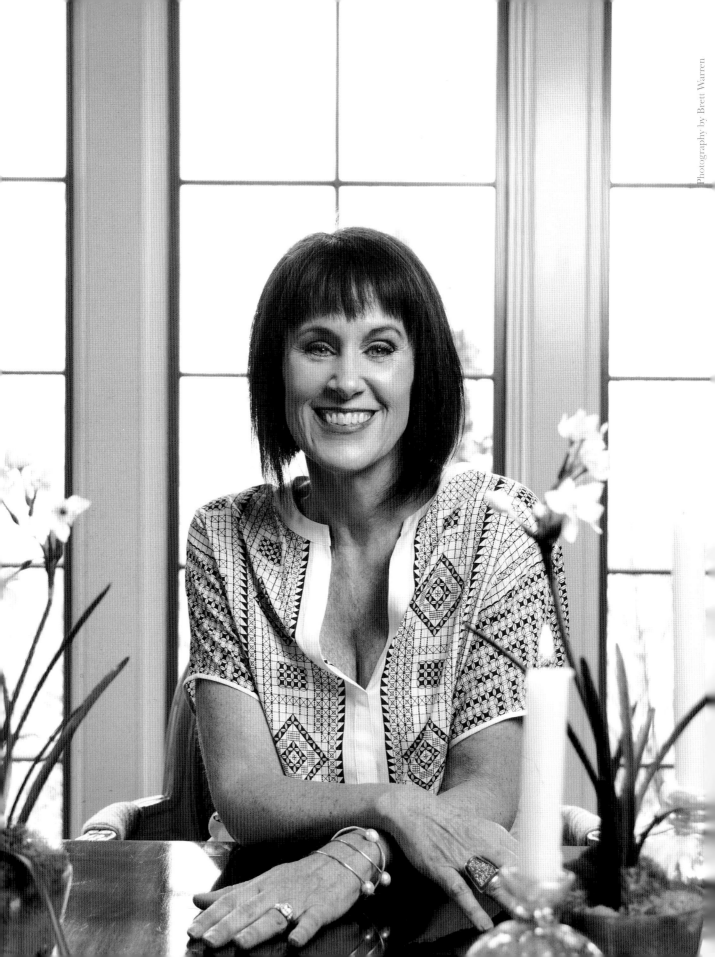

Photography by Brett Warren

CONNIE RICHARDSON

{*Founder,* Nashville Fashion Week}

When Connie Richardson isn't working as a stylist and creative director, she is bringing the festivities of Nashville Fashion Week to fruition. Richardson is most comfortable peeking out from behind the curtain. From pushing models onto the runway from behind the scenes to championing the city's creative talent, Richardson has provided a platform for Middle Tennessee's emerging creative talent. The Brentwood native was one of the original fixtures, it has been said, "to give a damn about fashion in this town." Along with her fellow crusaders Marcia Masula, Robert Campbell, and Mike Smith, she co-founded Nashville Fashion Week in 2010. Richardson believed in an industry long before there was even a community. Her career move was a product of an existential crisis in which she wondered what she wanted to be now that she was all grown up. After serving as partner at Image Design advertising agency for sixteen years, she willingly traded the corporate lifestyle for one steeped in creativity. Her personal decision had a domino effect on the regional community by creating opportunities where there were none. Richardson is a connector by nature and wired to care about other's potential. By mentoring young creative types, she has merged the city's isolated artistic pockets and elevated them as a legitimate and lucrative asset to the community. While entertainment and style have always intersected, it was she who stirred the first whisperings of a sustainable industry. The self-appointed mama of the bunch relentlessly acts as cheerleader for her "kids." She wants them to have the ability to spread their sartorial wings without having to relocate to the coasts. Far more than glitz and glamour it is the people who energize Richardson, as she steers them onto their road to success.

In 1994, my two partners and I started an ad agency called Image Design where I worked for 16 years. I could do the work in my sleep and it paid for private schools where I was president of the parents association. I was on autopilot doing the mama thing and had a total meltdown at age 45. I had spent 20 years thinking about everyone else and wondered, 'what do I want to be when I grow up?' That's when I walked blindly into the fashion industry.

It's just an innate thing, and I think you have it or you don't. I can't draw a straight line with a ruler, but I'm a very visual person. I'll get an idea in my head and make it work. The trick is to surround yourself with people who are better and make you look good. I collect people and push them to do what they love, which drives me. That job title probably needs to be on my business card underneath my nickname "Mama Connie."

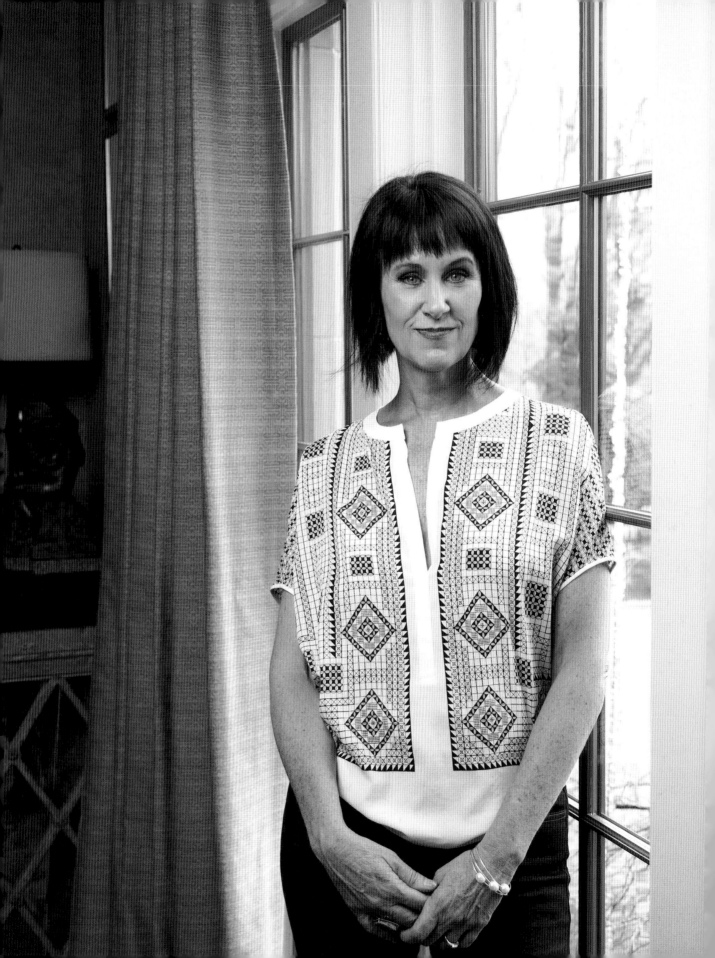

IF YOU DON'T PUT YOURSELF OUT THERE THEN YOU'LL NEVER GET WHATEVER IT IS THAT YOU'RE SEEKING.

My vision for Nashville Fashion Week has always been tattooed East Nashvillians sitting by Miss Blue-hair from Belle Meade. When I look out and see that I know we're doing this the right way.

Nashville Fashion Week isn't for buyers or to compete with New York City, but rather, to create a level of interest in our burgeoning industry. I'm naturally a connector. I see my role as going in between the lily pads and connecting these people who are bouncing around in their own separate spheres.

I want to make this fashion industry a force to be reckoned with by providing infrastructure and a support system. Right now, the reality is, designers have to be in New York City to thrive because we don't have the fabric sourcing and production facilities here. However, I predict there will be a handful of people who pool resources and change the game for everyone else. I'm starting to focus on facilitating this in a way that I haven't been able to in the past. I view my role as Team Mom—this non-threatening force that can connect the dots and encourage the designers to support one another.

I don't care if you live on a farm in Timbuktu—what girl doesn't love picking up a fashion magazine at the beauty shop? I want to show off fashion as an artistry and expose people to things they haven't seen before. Maybe then we'll realize how similar we all are to one another.

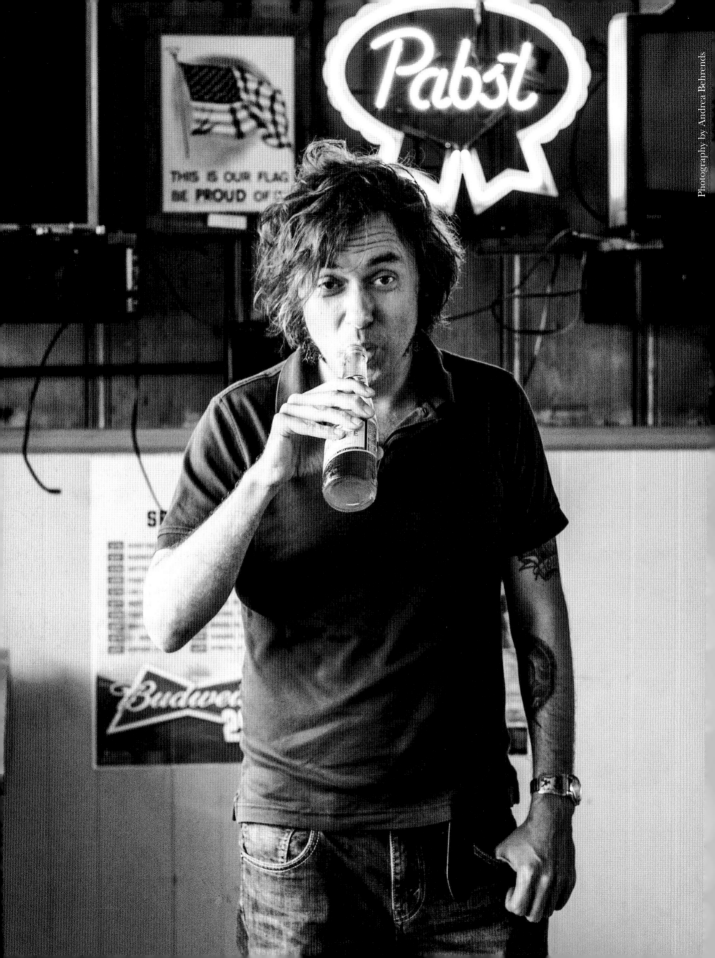

CHET WEISE

{*Founder,* Poetry Sucks!/*Author,* Language Lessons Vol. 1}

Chet Weise, founder of literary series Poetry Sucks!, will do anything to save the art form from extinction. The poet, musician, and college professor is a master of reinvention. From touring the world to teaching at a university level, Weise doesn't play by the rules of specialization. Most recently, he is at the helm of Third Man Records' first imprint, Third Man Books, and editor of the poetry and prose compilation *Language Lessons: Volume One*. Inspired by the cult following of Poetry Sucks!, it bears work from Pulitzer Prize finalists to budding linguists. Like most success stories, Weise's stemmed from selfish tendencies. To create great art, one must be around it and in 2010, he set out to facilitate a contemporary literary community. Slowly but surely, Weise began recruiting novice and nationally recognized poets for monthly readings at beloved dive bar, Dino's. The event, which merged language and live music against an unassuming backdrop, hit a nerve at a perfect time and place. Locals have credited Weise with preserving poetry's oral tradition and providing a sanctuary for self-expression. Through rhythm, emotion, and theatrics his events have helped free verse come alive off the page.

"Poetry has always been a transcendental experience for me. I would compare participating in a Poetry Sucks! reading to talking with a stranger in a bar. Sometimes people have a tendency to share more with someone they don't know. Maybe there's less fear that they'll be judged.

In high school I was first exposed to William Blake and William Butler Yates. They wrote about real stuff, but the fact that it was from the 1700s gave it more gravity. Also, hearing about the power of poetry behind the Soviet Iron Curtain curtain during the Cold War. Those poets would bring out 60,000 people because they were speaking about change, revolution, human rights, and love. They had to speak about taboo subjects in metaphors so poetry became akin to a code language. Learning about how poetry spoke across the centuries, and demonstrated real power and affection, attuned me to the music of language.

Why does it seem contemporary America does not share

that affection? I think the disconnect lies in having our only exposure to poetry be a formal school presentation. It's too often seen as a puzzle to figure out. Teachers do the best they can with what they've got, but many aren't into poetry. When someone listens to their favorite pop song it's meaningful because of the writer's intentions and the listener's interpretation. Music and self-interpretation are the beauty of poetry, just like why a song becomes important to an individual for more reasons than Bob Dylan or David Lee Roth could have anticipated.

I started my event so people could experience poetry differently. I wanted them to witness the bond and communion between a writer and audience, like those stadiums behind the Iron Curtain, except in a dive bar.

A different dynamic happens when you go live from tweaking lines on the fly to how a poet's delivery is affected by the mood of the crowd. The folks I like best write

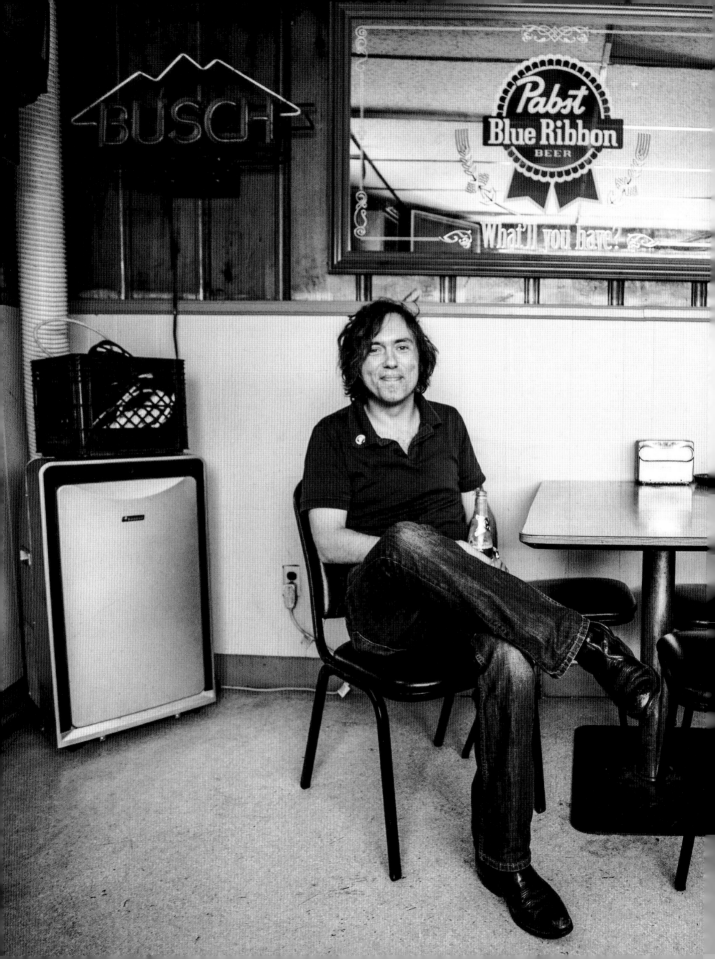

WHEN PEOPLE ARE PROACTIVELY PURSUING THEIR PASSION, THEIR AUDIENCE CAN SENSE IT.

very personal stories that live on the page, yet work well in a public setting. I absolutely love seeing the art form develop during a performance.

When I decided to quit music for a couple of years, I went full sail into writing and discovered the best poetry that's ever been written is right now. I believed in the power of the word and knew I could at least fill up a couple of bar stools at Dino's. A lot of the foundation of the Poetry Sucks! community is folks that I met on the road while touring with bands like the Immortal Lee County Killers. Whether it's human nature or social mores I think everybody struggles with going after what they truly want to do. Case in point: I sat on this event for two years because it was so hard to take that first step. I waited until I was comfortable reading my own poetry in front of an audience. When I first started 30 was the average attendance and now it's a couple hundred. Credit to humanity! People do want to talk to each other after all.

I've never documented the event because there's something magical that happens when people tell one another about how a poet got heckled while reading, and came back with a great one-liner. That story ends up becoming more and more elaborate whereas if you saw it on a video it wouldn't have nearly the same impact. In today's world, I find it very comforting that word of mouth is still the most powerful form of communication. The old-school posters I plaster around town have become as much a part of the night as anything else. In a nostalgic sense, they remind me of the days where I would photocopy punk rock flyers at Kinko's.

Folks have said that it was a very surreal, psychedelic experience to stand in a crowded room and listen to someone's voice. People have thanked me because the poets I bring to town touch them. While I appreciate it, I'm in this game for the beauty, period. It's that element of connection that makes the poets, attendees, and myself happy and is how we're going to keep this world from blowing up.

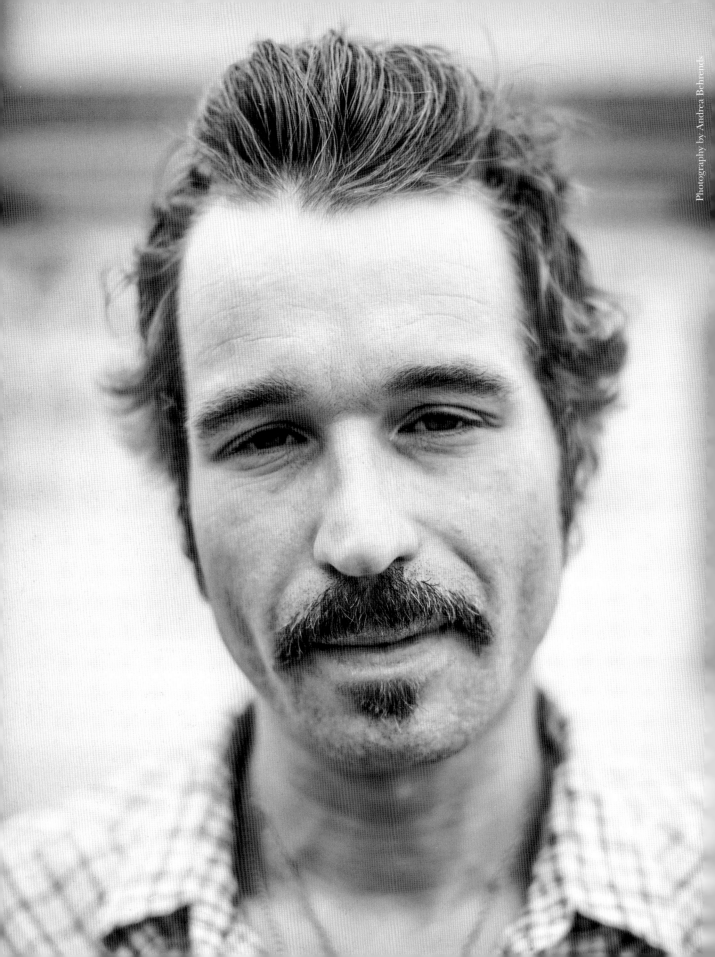
Photography by Andrea Behrends

JOE FLETCHER

{*Musician/Curator*}

While Americana is a handy term to describe Joe Fletcher's music there is a common thread that links his cross-pollination of country, blues, and early rock 'n' roll. Notable storytelling capabilities have earned the frontman of Joe Fletcher & the Wrong Reasons comparisons to Bob Dylan and Leonard Cohen. However, he affirms there was a time when he couldn't book a gig down South to save his life. This was prior to the Providence, Rhode Island, native becoming a full-time road warrior. The troubadour is most fulfilled when on tour the majority of the year. Even when he held a day job, Fletcher would forgo vacations to play rock clubs around the country. He credits the haunting narratives at the helm of his songs to his former careers as a newspaper reporter and a high school English teacher. Once the free spirit decided to transition his hobby into livelihood, he went after the music industry full throttle. However he humbly credits his musical proficiency to having a lot handed to him at once. It was evident to the guitarist that he had to get better or bow out. Fortitude accelerated his skill set and earned him gigs like curating showcases at the legendary Newport Folk Festival. "Newport to Nashville," which debuted in 2013, was his tribute to the craftsmanship, camaraderie, and spontaneity of Music City.

When did you decide to pursue music as a full-time career?

I used to want to be a shortstop for the St. Louis Cardinals. As soon as I gave up on that, being in a band took over. Music has always been my desired profession, and any job I had in the meantime was always secondary to pursuing it. Until a couple of years ago, it wasn't financially feasible to make a reality.

You were a high school English teacher for a decade, and now you tour seventy-five percent of the year. In your opinion, is that the only way to make your career work?

Traveling is something that I really like to do, so the touring side is easy for me. Nobody at my level is getting rich selling CDs or records. If you hear of any other reliable ways to make money—through these interviews—please pass them along.

You played guitar for several reputable bands, including The Worried and Deterrents, before having absolute artistic freedom.

The music I make is reflective of the music I listen to. A lot of times I'll write the lyrics first and think about what sort of music would suit that within my personal palate. The only criteria are my songs have to sound equally good with a band as they do solo. I love playing with my band, strangers, and alone.

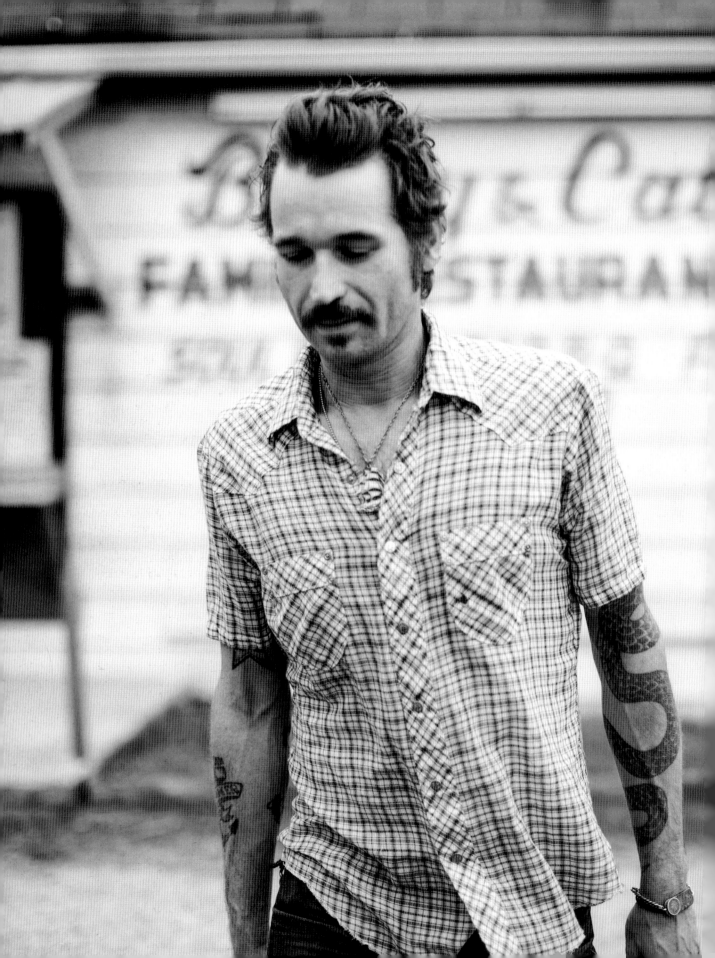

Even when you were a Providence, Rhode Island, resident you were still a strong fiber in Nashville's artistic cloak. How did you become so connected to the scene?

While I was teaching, I always toured during school vacations and started hitting Nashville as often as possible. I started meeting really good people who helped me book shows and sink my teeth into the city. The level of musicianship here is just totally insane, and it feels like home. I always say, "We speak the same language." Because I can't just sit down with anyone and discuss my favorite Rolling Stones records. This was always the town I would stay in a day longer because I didn't want to leave, and that was a sign it'd be a good place to live.

You made a big splash at the Newport Folk Festival this year. Where did the Nashville to Newport showcase idea stemmed from?

The festival approached me to see if I had an idea for the Museum Stage, and gave me a lot of power to bring in whoever I wanted. The idea sprang from me thinking, "who are my favorite musicians without regards to where they live?" It turned out the majority of them happened to be Nashville residents, and with this city being a popular story it seemed like a foolproof plan. I started calling the artists and asking if they'd like to come up and play for fifteen minutes, and everyone said, "Yes."

How did you select the lineup with so many talented musicians in this town?

I didn't pick anyone I hadn't actually seen play live. One thing about the show was you would not confuse any person's music with one another. Everybody knew one another, and it was like a huge group of friends playing together on a stage, except in a different state. It was important that Nashville's atmosphere translated as far as people sitting in and spontaneously playing with other musicians. No one is monogamous here; meaning one drummer may play with three separate bands. The musicians don't need to rehearse songs, because they can jump in and do anything. There was a line out the door the whole time, and a lot of people would pop in to see one act and still be standing there four hours later.

Why do you love playing music?

People comment on how hard I work, but, aside from booking and songwriting, I don't feel like it. I'm really happy with how things are now. I don't live to a point for that record deal to make me happy or for any particular career milestone. It's nice that good things keep happening, and it definitely feels like there's an upward trajectory to my music right now, but it's important that I really enjoy what I'm doing each day. As long as things don't start going backwards, everything is great.

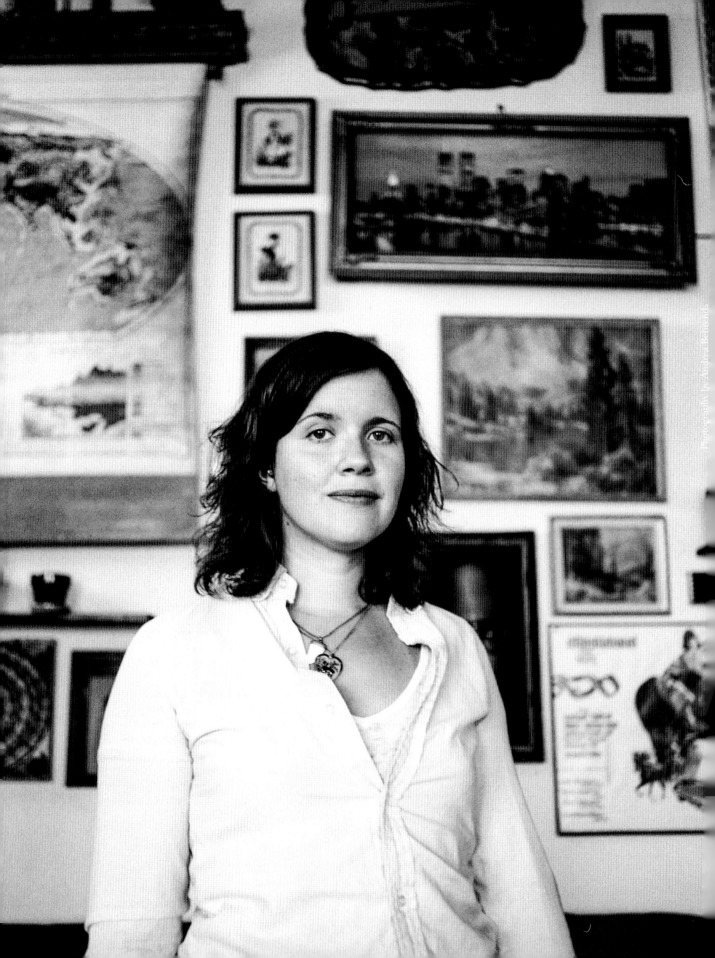

ELISE TYLER

{*Owner,* The Stone Fox}

Elise Tyler aspires to set a new standard for her generation. She is co-owner of the Stone Fox, along with her brother, best friend and musician William Tyler. The native Nashvillians are longtime fixtures of the city's cultural scene. The Stone Fox, established in 2012, is Elise's second stab at small business ownership. She previously dabbled in journalism and event planning before co-founding her first community-oriented business, Halcyon Bike Shop on 12th Avenue South. Her intention with the Stone Fox was to open a communal space that had a focus on positivity, progression, and empowerment. She and William stumbled upon the century-old house in "The Nations" neighborhood, once a blue-collar, industrial district notorious for crime and car lots. The dilapidated dwelling had served as a dive bar in the past and also a karaoke joint, so transforming it into a new watering hole wasn't a stretch. Nine months later the Stone Fox opened its doors as a collective music club, bar, and restaurant reminiscent of a 1980s house party. Locals view the venue as the catalyst for a long overdue regional renaissance. Soon after its opening, real estate skyrocketed, and other businesses rushed in. To Elise, it is a creative playground that lacks any pretext or context. On her own dime, sweat, and teardrops she's grateful to have total freedom to do what she wants—offer four walls where world peace can be found on a microscopic level.

What made you want to open up a restaurant/bar/music venue?

William and I are definitely fans of the culinary arts. He had worked in a few restaurant kitchens, and I had bartended. Our initial plan was to open a food truck-style kitchen where we did one thing really well because we thought this was primarily going to be a venue and bar. The most fun thing about owning a business is realizing you can do whatever you want with it. We have very high standards for ourselves and want to make sure every part of the business is special.

What are some of the most important lessons you've learned?

I think there are two types of entrepreneurs: ones who are disciplined, calculated, and corporate; and another type, whose businesses feel like an act of love or a family affair. This is definitely the latter, and; therefore, you go into things somewhat blind, because if you really knew the amount of work that was in store most people wouldn't do it. I think our business has a lot of character and heart, and we've just had to adapt to the different demands and facets.

Is it hard catering to the many varieties of clientele that walk through the door?

You have to listen to what people are saying, although trying to please everyone can sometimes be a downfall for us. However, we really want to be a neighborhood spot and have everyone feel welcome here.

You took a gamble on an up-and-coming neighborhood, and clearly you were right on the money because West Nashville is now desirable.

I feel kinship with the renegade East Nashville businesses because when they opened up people said, "You're crazy and going to lose money." It takes patience, fellow businesses opening, and real estate transactions to get a neighborhood established. There's a delicate balance because, while I'm a romantic, I also believe in progress.

Nashville is unique because it takes young entrepreneurs, like yourself and William, seriously.

Definitely. It's always been such a creative city, and the music industry constantly attracts this influx of young people. I think the established people in town realize it's the younger ones who keep everything moving. We've gotten so much support and couldn't have done this in another place. We want to keep making Nashville a cooler place and knew if we didn't do it now, we were going to kick ourselves later on.

Many of the Stone Fox's nightly activities are focused on the community, and I know you're passionate about civic activism.

I don't want to get too deep or cryptic, but I am a very sensitive person who cultivates a deep inner life. The world is in a really interesting place right now, and our generation needs to set the standard of what we want our future to look like. I've always felt driven to create alternatives to mainstream options. My driving force is to have a place where people can come together and be happy, creative, and commune. It's important to follow what your inner voice is telling you to do. For me, it was as simple as being my own boss. My mother gave us a great piece of advice: If something makes you feel excited then do it. I followed that energy, and it led me here.

What's are the hardest lessons you've learned?

There are a lot of things I wish I'd done when I was younger if I wasn't so afraid of rejection. There was always some reason or excuse I made up not to pursue my passions. As a woman, I felt pressure to have kids rather than focus on my career. Today, I encourage the young women I mentor to create their place in the world. I tell them, it's possible to be strong and vocalize your opinions while still being feminine. If women ran the world it would be so much cooler. (Laughs)

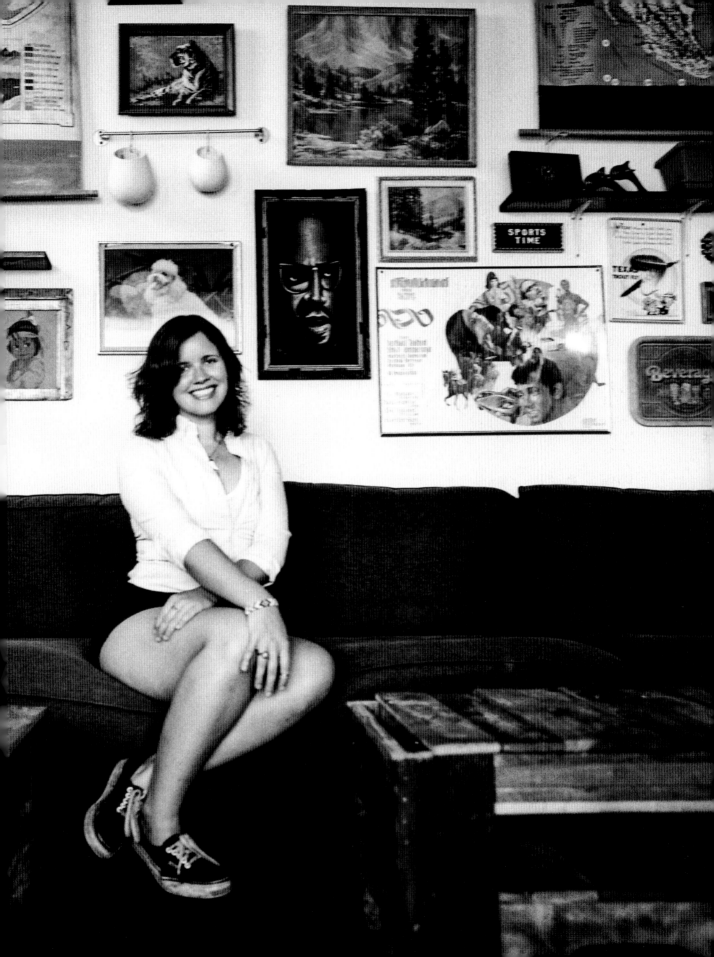

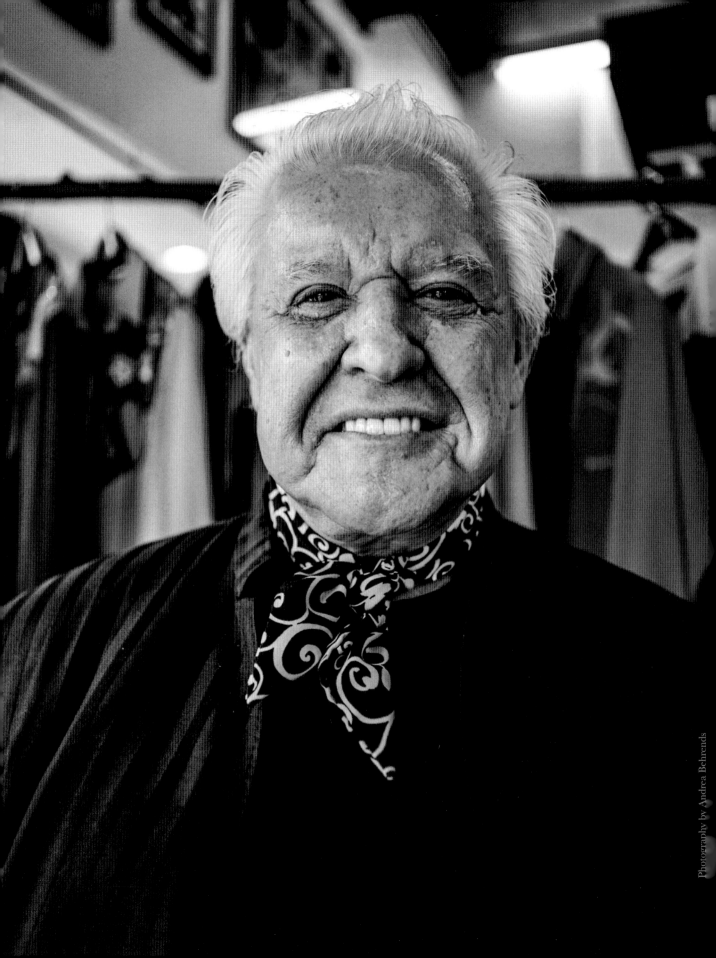

MANUEL CUEVAS

{Fashion Designer}

When stars aren't in the sky and on the red carpet, they are milling about the atelier of Manuel Cuevas. The fashion designer is as legitimate as they come, as he has worn nothing but his own creations for 60-plus years. The Rat Pack, Johnny Cash, and Elvis Presley's gold lamé suit are some of the looks he has designed for the icons of the 20th century. However, Manuel, as he is known, started out with modest beginnings as one of twelve children in Coalcomán, Mexico. In attempts to find his place in the world, the aspiring costumer began learning how to sew underneath his seamster brother. He studied tailoring as a member of a local theater troupe, and honed his lightening fast sewing skills making prom dresses for the locals. Around that time, he became enamored with the art of individuality, and ability to fabricate characters for his clients. This passion for imagery drove him to Los Angeles where he worked for legendary Hollywood tailors, and famed western wear boutique proprietor Nudie Cohn. In 1989, the designer relocated to Nashville where his gold lamé, sequins, and embroidery have since become staples within the entertainment industry. The city has been good to the Rhinestone Rembrandt whose days are a whirlwind of celebrities, galas, and decadent couture. Manuel always knew that fashion was his calling and by following his heart he created an unparalleled career.

Who first taught you how to sew?

My brother was playing tailor one day and said to me, "Stop looking pretty and help me sew some pants!" Since that day, the sewing machine and I have never parted ways. When I was 12, I started a business making custom prom dresses, which I could charge diamonds for because they were completely unique. The first year I had 77 dress orders!

How did you become so entrepreneurial when most kids are still playing hide-and-seek?

My dad was a merchant who could have sold condoms to the pope. At eight years old, he inspired me to start a shoe shining business, which brought in more money than the local banker's weekly salary. As a child, I also did woodworking and sold popcorn machines. Business is business, no matter what, and I became a multi-millionaire at age 16.

Why the decision to start over in Los Angeles when you were 21?

Because of clothing! I worked for Nudie Cohn as a cutter and designer, which is where I met Edith Head. She's the best designer I've ever met in my life and we first worked together on the film *Giant* in 1954 starring James Dean and Elizabeth Taylor. We chose cowboy as our look, which set the trend for Americans to wear jeans on the street. Later on, I made bell-bottoms for

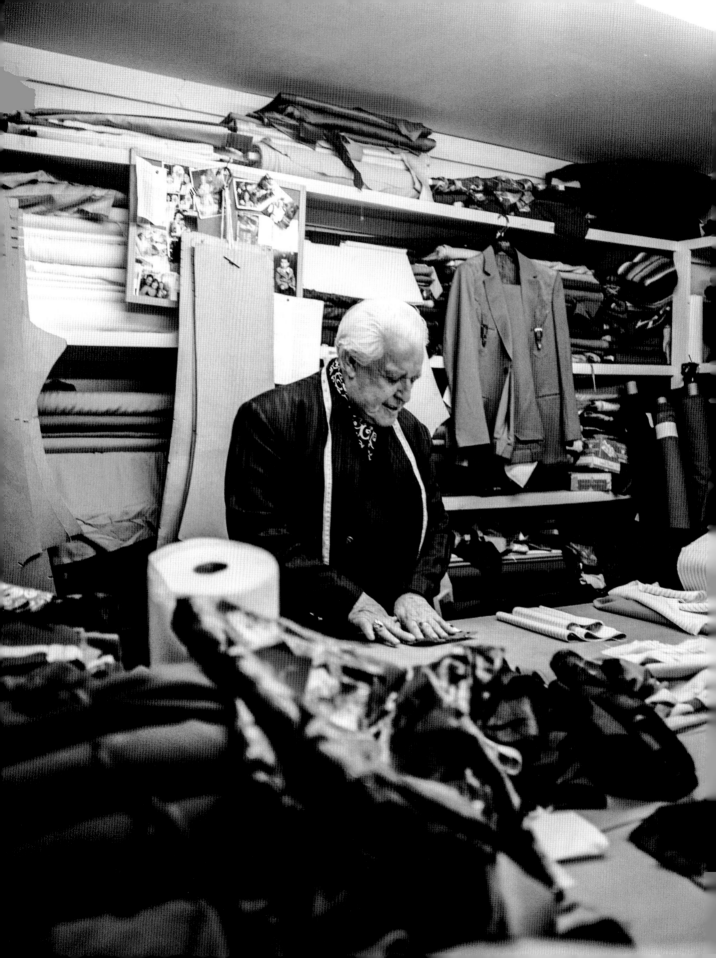

TO ME RETIRED MEANS TO PUT ON NEW TIRES. EVEN IN MY 80S I CAN STILL KICK ASS.

Sonny & Cher, and then created the "Hillbilly Deluxe" look for John Travolta. I shot bullets through his jeans to make holes and rips. There was also the Rat Pack, Frank Sinatra, Sammy Davis Jr., Dean Martin, Bob Hope, and the Lone Ranger—who I absolutely loved. Coming from someone who has designed for presidents, kings, queens, he's my favorite client of all time.

How did glitz, embroidery, glamour, and rhinestones become your signature?

That comes from Nudie [Cohn], who I was with for 14 years. At his store I met Salvador Dali, the Kennedys, and John Travolta. When I first met John he said, "Sir you are my hero" to which I responded, "Yeah, and my name is Santa Claus." He went on, "When I was a little boy my mother brought me into Nudie's, and you asked if I was a cowboy. When I said, yes you put a rhinestone tie around my neck, and it's still hanging from my bed board."

How do you create an image for someone as distinctive as Johnny Cash?

He was himself, which is a very unique person. We were great friends when he started ordering custom garments from me back in 1957. At first he wasn't sure about the all-black attire but eventually said, "The color is no longer debatable. I want you to make me a closet full of black suits, jackets, and dusters." Laughing I said, "I knew I was right."

Is it easier to design for someone that you have a personal relationship with?

I'm quite good at cultivationg friendships with my clients. It's necessary to do it that way, and sometime it ends up being a collaborative process. Like with Bob Dylan, I always made grungy clothes for his daily attire and then something fancier if he was going to meet the Pope.

How do you develop that trust factor with someone?

Blindly! There is a fear when you go and buy a new car because you want a guarantee on your money. I tell my clients that if they're not crazy about something to be honest with me. I want my clients to tell me how they *feel* in my clothes! Price is not an object. I simply want to make clothing that is perfect and to their liking.

Have you ever had a dissatisfied client whose opinion you valued?

I have been so lucky. However, I don't believe in telling someone how great an outfit looks. I don't sell because my clothes are for buying only.

What is the best compliment a client has ever given you?

"I feel confident because I don't have to think about my wardrobe." It was a pleasure to graciously receive that remark.

What's been your own personal definition of success?

When you open a business and sell more than one. If you repeat riches, then you eventually become a millionaire.

What do you love most about your job?

I really love and respect the clothes. I've had the chance to teach many kids that want to be designers. From the bottom of my heart, my goal is to create an international American designer.

After all of your success, accolades, and illustrious clientele what still keeps your heart in the game?

To me retired means to put on new tires. Even in my 80s, I can still kick ass with *the best* and sew faster than any of the kids I work with for 12 hours a day.

What do you think makes a legitimate designer?

From your pillow to your brassiere, hat, and rings it's important to have the designer thing going on. You know what I mean?

What's your personal take on style versus fashion?

Fashion is hanging on every rack, boutique and second-hand store. An image is what you show to the world. It's the real you coming out, and is everything that you always wanted to be.

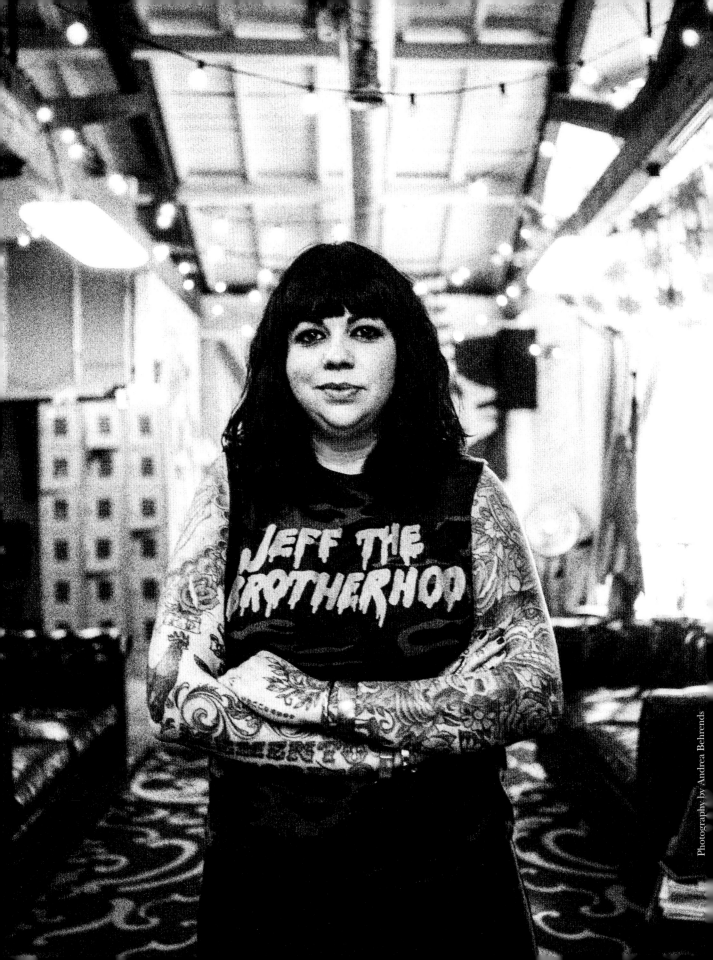

CALI DEVANEY

{*Hair Stylist/Owner,* Parlour & Juke}

Taxidermy, punk rock posters, and tintype portraits plaster the walls of Cali DeVaney's barbershop and salon, Parlour & Juke. Intuitive, charismatic, and scissor savvy, the chief hairstylist has a devotedly loyal fan following. Her clientele runs the gamut from anonymous Janes and Joes to luminaries, yet DeVaney approaches everyone's image with equal dedication. DeVaney's rock-n-roll style—she's covered in tattoos and concert tees—stands in juxtaposition to her specialty, au natural hair. An innate aptitude and emotional investment in her clients' self-worth initially earned her eminence in the beauty industry. It prompted the visionary to open Parlour & Juke on her own dime in 2010. The shop provides a place where misfits and social butterflies rendezvous together underneath one roof. The salon's name alludes to this all-inclusive concept: an amalgamation of the French gathering space and the quintessentially raucous, Southern juke joints. To enthusiasts, it's an oasis where one may crack a beer and bond over the universal birthright to see beauty in our reflections.

You are a true Southern belle born in Florence, Alabama. What initiated your passion for hair, and why did you pursue it as a career?

All I can say is that I've always been curious about it. When I was growing up, I would fix my grandmother's hair and makeup, and my mom would cut and perm my hair. I love the instant gratification you get from quickly changing someone's appearance. I worked at a salon in high school and eventually dropped out to enroll in hair school. I've always loved the social atmosphere of salons because if you get it right, the atmosphere should feel like a bar.

What were your first jobs as a hairdresser?

My first was at Castner Knott, which is now Dillard's, and after two years I moved to a reputable, independently owned salon. In hindsight, it's where a lot of my inspiration comes from because it was the first job where I was able to be myself. I held onto that sentimen-

tally over the years because how cool is it that they let a nineteen year old work there and do her shit?

The confidence you gained there has done you well in Nashville.

Some say Nashville is a place where dreams are crushed, but out of that struggle comes awesome stuff. I thrive off that and was completely fearless when I opened my business. I would say, "It's going to work." And it was because of the supportiveness of this environment and the people.

Did you always know you would be extremely successful?

For years I would say that I never wanted to own my own business. Here's the truth: It got to a point where there was nowhere for me to work in which I felt comfortable and inspired. Hearing other people say the same thing made me realize if somebody

WHEN I GOT THIS SPACE EVERYONE ASKED WHAT THE HELL I WAS THINKING BECAUSE WE DIDN'T HAVE A STOREFRONT AND IT WAS IMPOSSIBLE TO FIND. I LOVED IT!

opened a place like this, they would be successful, simply because it didn't exist. The salon world can be pretentious and intimidating. I wanted to own a welcoming, laid-back spot, where you wouldn't feel awful about yourself the second you walked in the door.

Everyone is trying to do something unique. It's like that line in the film, American Beauty: "There's nothing worse than being ordinary."

Instead of feeling like I did something really special it makes me wonder, why don't you do it, too? I'm a really passionate person and also fearless in the sense that if it doesn't work, I'll move on. At Parlour & Juke, I really streamlined my focus to do one thing really, really well.

Why do you think you've developed such a cult following?

Because I'm genuine and no bullshit, and it either works for the person or doesn't. Money has never been an object for me because I love what I do. I sit down with every client and point out what's good about them—instead of how much better I can make you look. My style is hyper natural: you look just like yourself, except better. We draw people who are similar to us, which is why I'm really happy with my clientele.

Describe the pressure you experience when recreating someone's look.

My work truly affects me because, as pretentious as it sounds, it is an art form. You're expressing yourself; it just so happens to be on another person. I feel like I could write a book on psychology because you have to read body language, read between the lines, and be really aware of someone's personality. Half my job is proving myself, and it took me sixteen years to realize I can't please everyone. This sounds so cliché, but in hindsight, the severe bullying I experienced when I was younger has made me who I am. I wouldn't trade it for the world. And thirty, for me, was some magical age where I truly gained my confidence. I just had to be me, whether people liked it or not. That comes with life experience.

You've created this bizarre, idiosyncratic Southern Gothic world and ironically, all walks of life find it relatable.

That makes me feel great because my dream was to open a place where everyone felt accepted. Growing up a misunderstood teenager, it's reassuring to feel like people get me now, and that's where most of the confidence comes from.

Hair salons are this interesting juxtaposition where on one end you're making people feel good about themselves, yet notoriously, there is a lot of cattiness behind closed doors.

All of us very much respect each other. Everyone who works for me is insanely talented. We're all inspired by one another, and it's just perfect. It's the best environment I've ever worked in, and the bonus is that I helped to create it.

Parlour & Juke is symbolic of the anti-hair salon culture.

That's exactly right.

You said you're open to transformation. Do you always see yourself styling hair?

It's instinctual, my art medium and one of the ways I express myself. Whether it's in my kitchen or a salon, I will always have my hand in cutting hair. But, there are other things I am interested in, so we'll see!

Nashville is this magical place where we throw a dart, and our dreams finally come true.

I actually feel the same way. There's a really good, honest support for creative people and local businesses. Lower Broadway is a metaphor for the city because musicians play for peanuts, and people flood down there night after night to support them. This city is just incredibly supportive. Somebody should write a book about that.

Maybe I will.

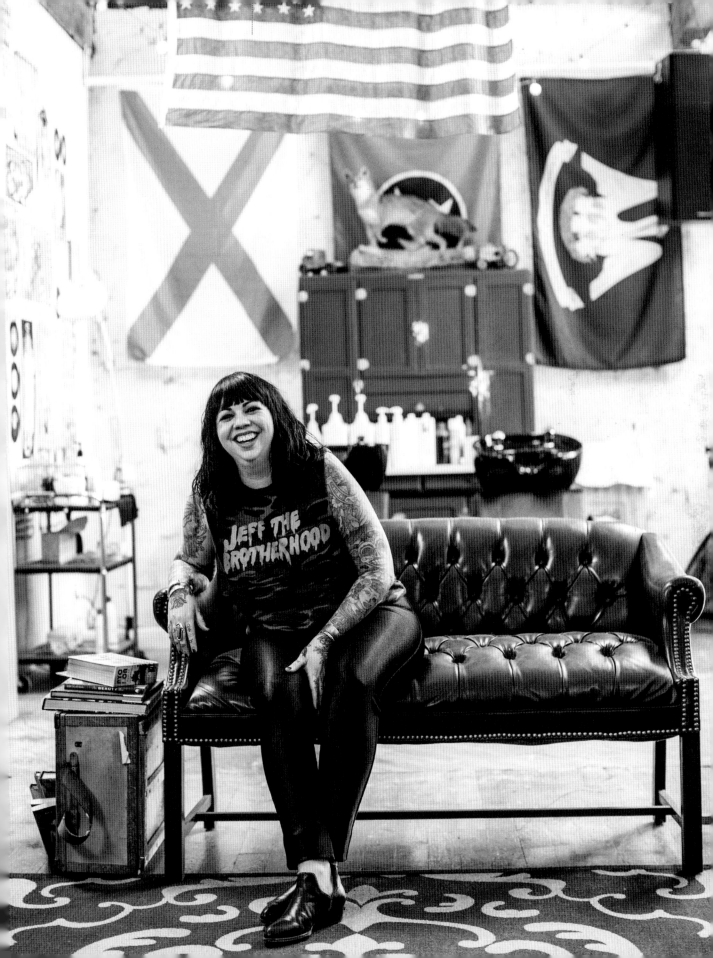

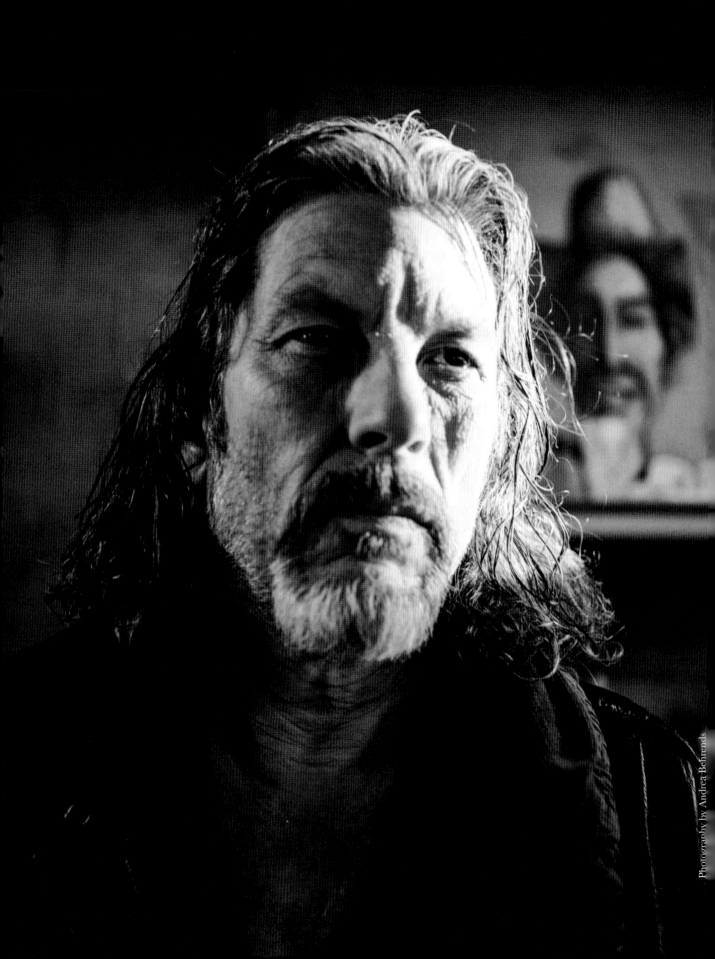

Photography by Andrea Behrends

BUDDY JACKSON

{Sculptor/Photographer/Visual Artist}

Buddy Jackson remains an open vessel and allows the ideas to flow in. He is best known for his female figurine Adelicia and public art piece *Emergence*, in commemoration of the 2010 flood. However, mediums are mutable in Jackson's world as he frequently alternates between disciplines of sculpture, photography and drawing based on his mood or gallery show. The "foothills, mountain kid" hails from South Knoxville, part of a lineage of sign makers, portrait photographers and painters. Since his days as owner of Jackson Design, the advertising executive has always used art to encapsulate human emotion. After accumulating enough awards to adorn every mantle piece in town he spontaneously sold his business after 25 years. The rebellious art school kid in him realized his spirit had been slaughtered. He needed to relinquish the viable lifestyle in order to reinvent himself as a Renaissance man. Once the freewheeling artist embodied his new lifestyle, muses began knocking at his doorstep in unexpected forms. Jackson remains fearless of a challenge and continues to script his own rules.

When I was 30, I borrowed $300 to start my company and bought a T-square, a drawing table, light, and maybe a stool. I went over to Music Row and rented a little office so I could access their equipment. We hardly did any marketing, and it was very much word of mouth. The next thing I knew, I had a company without one drop of business training or beating on doors. I just never worried about it too much.

My clients were always people who were on their way up or down. Rarely did I work with A-listers. Probably eighty-percent of the creative people who ever worked for me were women because they were underappreciated, and I also liked hiring kids because they were untainted.

I got to this point where I felt like the biggest phony on the planet because I was playing a role. Even though I was good at it! After twenty-five years, I ended the company with about eighteen thousand completed jobs and a dumpster that I filled up with awards.

After that I started scrapping around for money like I've always done. At some point in my life I realized change was a permanent part. You can either let it happen or try to control it. Nothing sits still.

When I left my agency, I was finally presented with the opportunity to do what I wanted fulltime, and I probably didn't go into the sculpture studio for two years. I was just kind of lost, and then at some point I woke back up. It became an escape, and I didn't give a shit if things sold or not.

There are certain decisions you get to make, and I knew if I put off my art until I retired I'd be making a big mistake. I started doing sculpture purely as a hobby, working with coat hangers, pantyhose—crap, anything you could find. I took a class with Allen McGuire, and he taught me processes just by watching him work.

AT SOME POINT IN LIFE I REALIZED CHANGE IS A PERMANENT PART. YOU CAN EITHER LET IT HAPPEN OR TRY TO CONTROL IT. NOTHING SITS STILL.

At my second show, I noticed this woman crying in the hallway. I went over to her and asked if she was all right and she said, "I'm fine, the piece just moves me so much." It was this male figure that I didn't really like all that much yet it connected with her on this weird level. It made me realize the depth and impact of the artwork was so much bigger than I realized.

A lot of people from outside of this town tend to think my work has a very Southern feel to it. I don't see it; although I did a show on snake handling once. Primarily my work is about people and trying to show something in the portrait that evokes a feeling. I have this theory that if a guy is playing a guitar solo and transfers emotion into it, then you'll hear that. Art is the same as music: it makes you feel something.

I tend to work in surges. I'm always thinking, drawing, working or executing something. But every once in a while, I'll go into the studio and not come out for six months. I'm really fast when I start working, and a lot of times it's connected to a show of some sort. I used to feel guilty when I wasn't working, and at some point I realized there's some process. I've read a lot about creative minds, and there are very few Picassos. He got up in the morning and went to the damn studio every day. There are some, but I'm far from that guy.

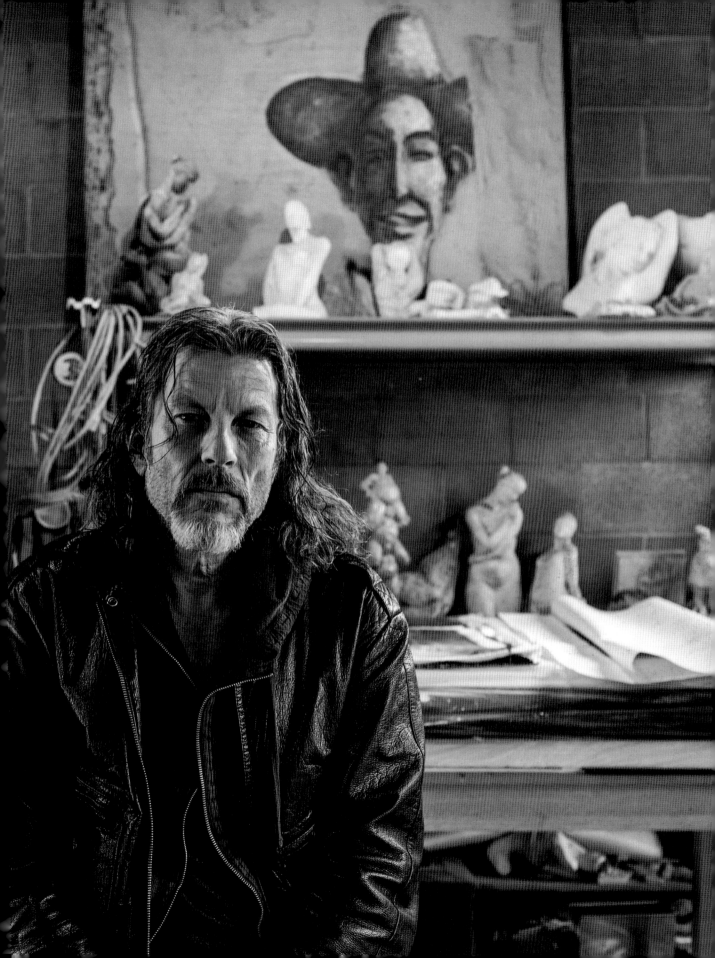

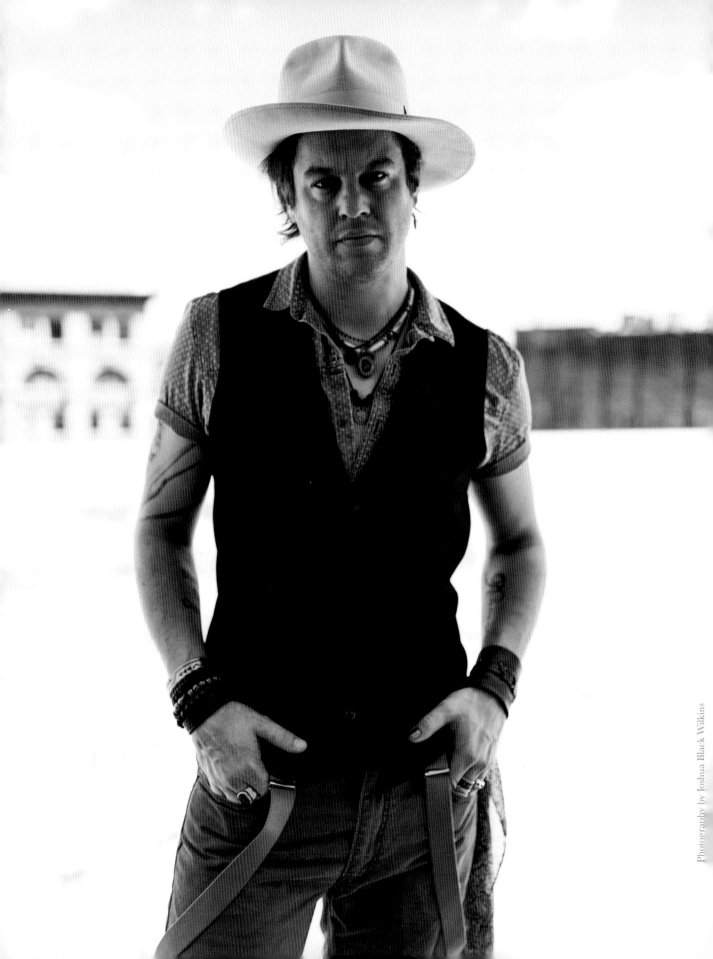

CORY BASIL

{Painter/Animator/Author/Musician}

From now until eternity, Cory Basil will never lack for an idea. While his imagination is forever four-years old, the artist often gravitates towards the more twisted side of life. Art was Basil's form of survival as a child in a strict, religious society of Phoenix, Arizona. As an adult, he walked away from his former life as a husband, pastor, and community member. The slate was wiped clean to start anew in Nashville. In 2007, he adopted a Renaissance man identity and began creating at a warp speed. There was nothing to lose, and Basil compulsively projected music, poetry, paintings, and animation into the creative hemisphere. In 2011, the self-coined polymath publicly debuted his artwork for the first time. Ever since, his audience has been fascinated by the one-man juggling act, which constantly adds new credentials to his plate. There is never a moment when the artist's head isn't brewing, and a fear of mortality keeps him working at a frenetic pace. From children's books to stop-motion animations, Basil lives vicariously through the lives of his characters. Like him, they are continuously discovering who they truly are.

What causes you to feel most inspired?

I think daydreaming is one of the most important and underrated activities; those times when you're sitting and staring but it's truly helping an idea to birth into something bigger. Although I am very hermetic I know being around people is what refuels me. Sitting at a coffee shop and watching people's quirks and ticks like a fly-on-the-wall is what helps me keep spitting out art. As much as I'd like to say I could just live in a cave forever, I know the circle of life is what fuels my creativity.

How did you develop your own style?

I would definitely say Tim Burton is my number one influence. I saw *Edward Scissorhands* at a friend's house, and it was the first time that I felt like there was somebody out there like me. I was always experimenting and trying to find an outlet. Today, I believe that because I was repressed for so long I never lack for an idea. My head is constantly ready for me to grab something and put it on paper.

Is it hard attaching a price tag to your art?

No, because all I've ever wanted was to be at a place where I can create all of the time. The hardest thing was going public with my art because it was so insanely vulnerable. When I perform music it's a persona and the stage is separating you from the audience. When I first had to stand in front of my work at an art show I had to adjust to the idea that people will say the most uninhibited things to you. "Why are you so depressed? Are you suicidal? Do you need help?"

Since you work with so many mediums I'm curious what is one of your favorites.

I love watercolor because it's very risky. I could be three hours away from finishing a painting and spill over the

white, and there's no saving it. It's the way I deal with a lot of things: either I'm all in or all out.

It seems like in all of your art forms you're trying to bridge the gap in humanity. You're slightly a performance artist and yet not entirely comfortable putting yourself out there.

Once something has happened and sat with me awhile it's okay to make it public. I see everything as a challenge, and that's what keeps me alive and going. Human beings are so amazing in that we have the ability to evolve, grow, and really dissect ourselves. You really can be and do whatever you want. You just have to put the frog on the cutting board and see what it's made of.

You're known for creating in very short bursts. Is it difficult to be creative everyday or be self-disciplined?

When I started writing the first *Fishboy* novel it was very heavy because I'd go days and days of writing without any creative pay-off. It was the first time I'd written a novel at about 40,000 words where I really felt that I made a major breakthrough. I was on a nothing-can-touch-me cruise control and every day I wrote 2,000-4,000 words and it just kept coming and coming. Yet, to be creative everyday was a struggle and took a lot of discipline to dial in a focus.

When you're writing or painting do you look towards references or let it flow totally from your own imagination?

I just let it come. With the novels I've written I didn't have time to do much research. My only preconceptions of children's literature were Shel Silverstein and Dr. Suess. Yet, I knew the *Fishboy* character could provide so much more to culture. Before I started the writing process I decided to go to this monastery in Kentucky to shut it all off, and find my center. I was there three or four days and finally had a personal epiphany in my thought process. I woke up the next morning and started writing. One major breakthrough and five thousand words later, I thought "okay, this is what he's supposed to be." I wrote the entire book in 45 days.

Are you proud of the finished product?

Yes, it's everything that it's supposed to be. I'm such a perfectionist to a fault and beat the crap out of myself until I feel that it's close to whatever idea I've created in my head.

AS AN ARTIST I AM PRIVILEGED TO REMAIN CHILDLIKE AND LIVE IN MY IMAGINARY WORLD WITH MY IMAGINARY FRIENDS.

Is it difficult to write about a character that hits so close to home?

I was a late bloomer, big time, at 4'11" when I was a freshman in high school and the target for every bully. It was difficult to write the angsty sections but the cool thing about my perspective is I know what I've evolved into. I wanted to tell the character, "You're going to make it, I promise."

Let's talk about your *Whimsy* series for a minute because after separating that from your fine art it seems to be what truly connects to people.

The whimsy stuff is my therapy and represents my own character development. The characters, with their big heads, sad eyes, smiles, and striped shirts represent emotion in various ways. I remember I would bawl my eyes out as a child because I didn't want to grow up. As an artist I am privileged to remain childlike and live in my imaginary world with my imaginary friends. It's easier to laugh at the tragedies of life through a childlike character rather than some brooding adult on the corner with his heart in his hand.

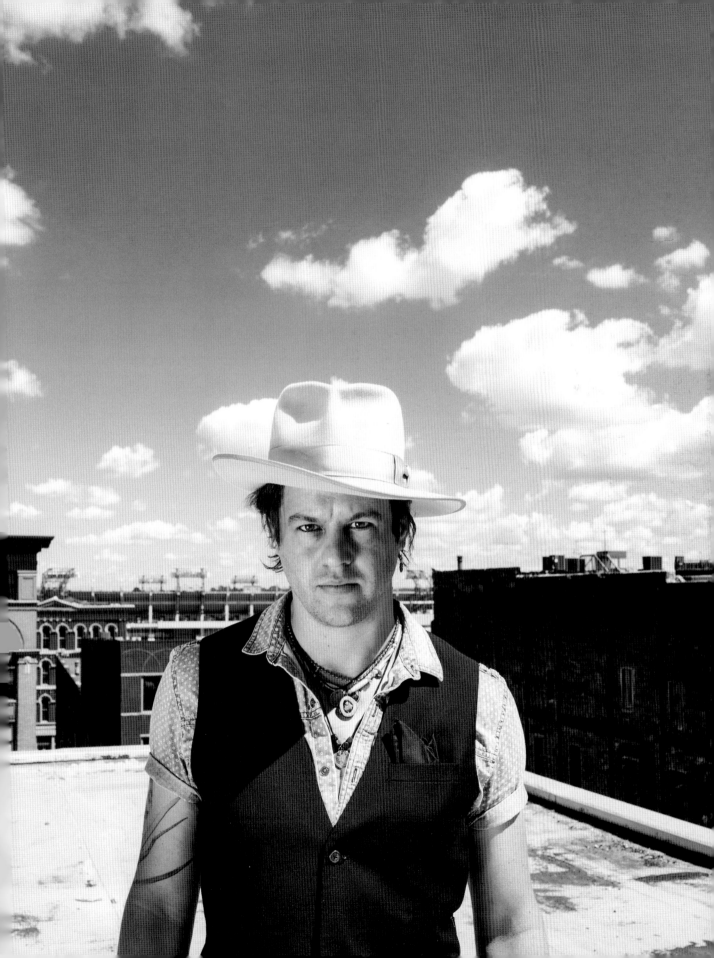

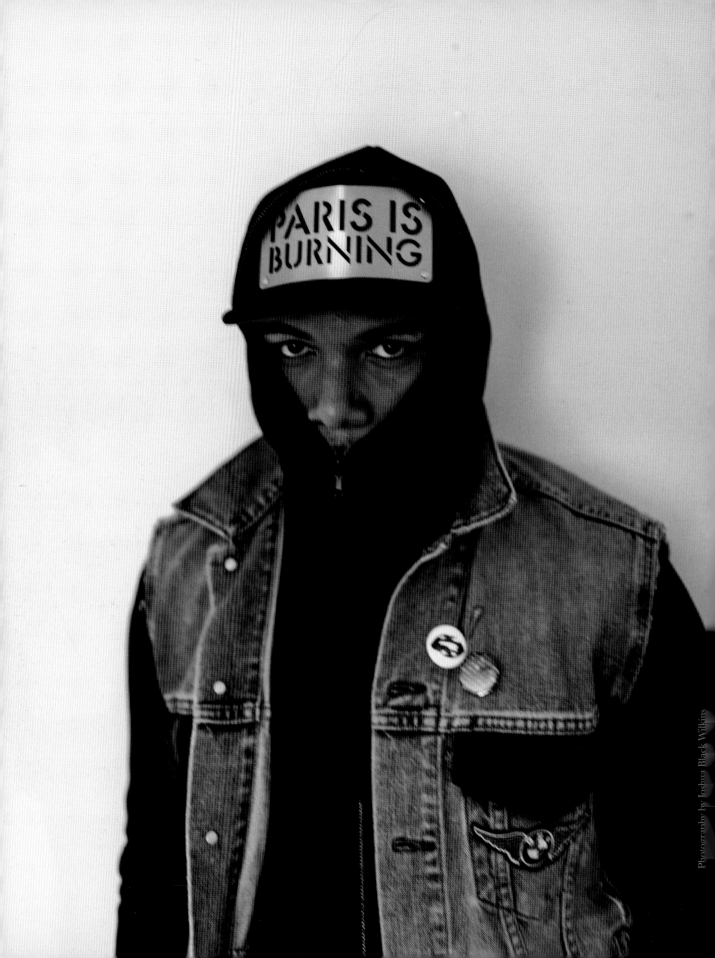

CHANCELLOR WARHOL

{Rapper & Hip Hop Artist}

Chancellor Warhol is a rapper with a rock star presence—a rarity in the city built upon country music. With each new album, the hip-hop artist aspires to spark conversation and showcase the man he is at that moment. The native Nashvillian first started spinning rhymes alongside poets at open-mic nights penetrating the underground hip-hop scene with the collective, NOBOTS, (No Other Band Offers This Sound). Like their West Coast-based hip-hop predecessors, they merged rap, alternative, and skateboarding culture. As a solo artist he continues to explore this genre-defying medley. Under his adopted moniker, the artist releases film score-inspired compositions driven by emotional sagas and thundering beats. His cinematic performances strive to engage all five senses and often collaborates with unusual venues like the Sudekum Planetarium and Schermerhorn Symphony Center. It is his refusal to be pigeonholed that has accelerated his evolution as an artist. Similar to his inspiration, iconic pop artist Andy Warhol, he lives by the art of reinvention.

Why the obsession with Andy Warhol?

When I was younger, I was really artistic and always painting. One of the first books I ever discovered was about Andy Warhol, and I was really drawn to it. He isn't the greatest artist, but he was a genius and total reflection of his art. My fascination with art is more so about my connection to the artist, the intriguing stories behind their artwork. Art sparks so many questions, and there's never a right answer. One teacher always told me, "It's your interpretation because you see it differently than the person sitting next to you."

As a musician, you create this sensorial, full-bodied sonic experience, which makes sense because you are a film buff.

I get a lot of my inspiration from film and cinematography and watch a lot of movies on mute right before we record in the studio. You keep a beat playing in the background and write the words to paint an audio picture for the visual. I'm inspired by artists who are visual and detail-oriented, which is why I had my listening party at the planetarium. How full-bodied can

something appear, sound, and feel? It's about making something that's bigger than me because those are the artists whose music outlives them.

What's more important, the lyrical content or beats?

It's about playing with words and painting a visual picture. I'm fascinated by pop culture, and as an artist, I have the freedom to reference *Third Rock from the Sun*, *Sleepless in Seattle*, and *No Sleep Till Brooklyn* in one sentence. Words are a palate, which is why I'm conscious not to use cussing as a crutch. They say the darkest secrets make the brightest art. That's what I try for.

In terms of themes you run the spectrum from lighthearted, party anthems to incredibly dark sagas. Do you extract subject matter from your own life or fictionalize your stories?

I definitely mix in both because there's so much material to write about in the world and be inspired by. I was a daydreamer growing up and believe my mind is an extremely creative world somewhere in between

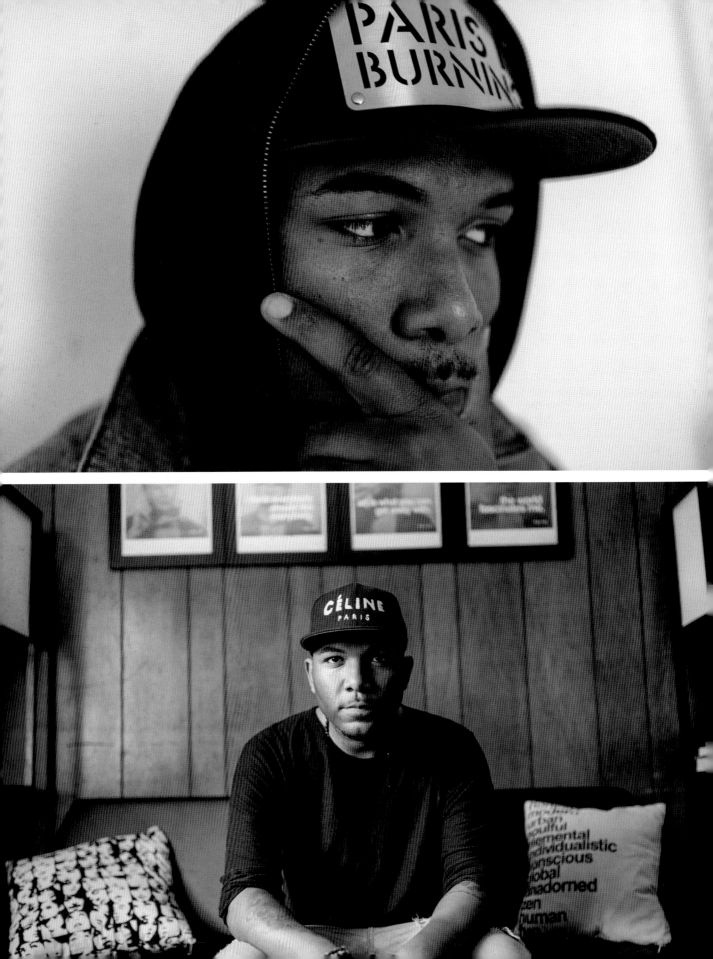

The Neverending Story and an animé film. Part of being creative is not confining yourself to one lane, but rather pulling in all of these different elements. I want to intrigue people to find out what happens next.

What does it feel like to produce something you're truly proud of?

There's no better rush to know the end result is the best that you've done, and is something new and fresh. I get a really big high when that happens.

Creative people are generally able to make magic with most mediums, but you're especially fearless in that way.

My grandfather told me, "Lazy people who don't give their all die twice." You want to die once, in the physical form, and if you work hard you'll leave your impression. In the art world, you'll last forever. I try to pursue stuff that feels natural and speaks to me, and will maybe inspire someone from another generation or time.

The first time I heard your music, I breathed a sigh of relief. My ears yearned for something locally-grown other than country and rock. What have been the most exciting moments so far?

Thank you. I took one and a half years off from music to try and find myself. I didn't know if it was going to be substantial and real until I made my first record and the response came. That's when I really found my voice and all of these people connected to it, and it was named "Best Rap Album of the Year." Playing Austin City Limits and seeing eight thousand people come to my stage when all these other big bands are playing at the same time was really humbling, like I have a voice.

You mentioned you're naturally shy and introverted, so is it cathartic for you to perform on stage and be a completely different person?

Yes, because it's an extension of the art. There are people whose records I love that I've seen live, and it's disappointing. I never want to be that artist. I always give one hundred percent to every show. I constantly watch music documentaries because the best live artists always present themselves like rock stars. If you're not feeling the music you're writing, then what are you doing? You've got to bring it *every time*.

You have such a diverse fan base. What has your experience been like blending together your own alternative and hip hop background?

At the end of the day you have to please yourself. I grew up in the projects when I was younger and feel like now more than ever, I get respect from the hip hop community because they see my success and hard

MY MOM ALWAYS LIKED NEW BEGINNINGS AND WOULD TELL ME, NO MATTER WHAT, YOU CAN ALWAYS RECREATE YOURSELF. THAT REALLY STUCK WITH ME AND IS WHAT I TRY TO DO WITH EVERY PROJECT.

work. In Nashville, the hip hop scene is *so* underground that there are always people at my shows who I never thought would be into my music. We all learn from one another, so it's cool.

You seem very spiritual, like someone who is always looking inside of himself to better understand his role as a person and artist.

I am. I've visited temples, studied Buddhism for two years, and spent time on a Native American reservation. There's a lot of chaos and flash that goes into being an artist, so sometimes you have to break away and find yourself. I'm introverted but I live an extrovert's life. For me to understand myself, stay sane, and motivated, I have to find that balance.

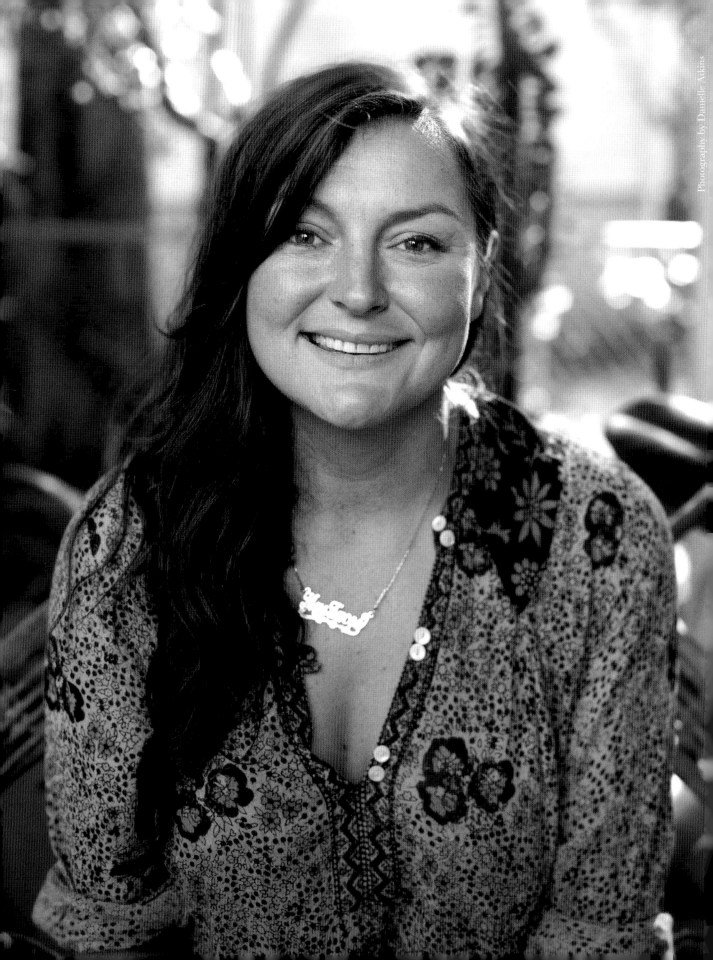

TERESA MASON

{Chef/Owner, Mas Tacos}

A Southern belle with no culinary background makes the most authentic Mexican street food in town. That statement is still beyond Teresa Mason's wildest dreams. Since the launch of her food truck-turned-brick-and-mortar Mas Tacos, Mason has become something of a national sensation. She is someone who lives for knowledge, and there has been no greater learning curve than teaching herself how to cook. Mason found her niche in New York City when she unexpectedly fell in love with the hospitality industry. For the first time, she was introduced to flavors and food beyond her Southern palate. This revelation inspired her to eat, research, and travel her way through Mexico and Central and South America. Mexico's cuisine most resonated with her palate and she became determined to recreate the traditional dishes in her hometown. While Mason had once viewed restaurants as place to figure out your future career, she began daydreaming about running her own establishment. In 2008, she bought a 1970s Winnebago, whose popularity would forever revolutionize Nashville's mobile food scene. The city became addicted to Mason's personality and straightforward Mexican street food. It proved her theory that great food doesn't have to be complicated. Once you find your product, do it the best that you can.

After studying photography and journalism in school, I moved to New York City in 2000. While I initially moved there for photography, I applied for a bartending job right away because I wanted to say hello to someone every once in awhile. Slowly but surely, I found myself at the restaurant more than the studio.

Around that time, I started taking trips to Mexico, Central and South America. Those have always felt like my countries because I am in love with the food there. In Mexico, I would dine at these roadside stands with folding tables and outdoor fryers. Then I would fly back to New York City and witness how these big production restaurants came together. Having that juxtaposition gave me the gumption to pursue my own business because I realized it didn't have to be a huge operation. Every time I visited Mexico, I would go to a different region. I began to realize how different salsa and tacos are in the north as compared to the south. By taking portraits of the locals and putting into practice the Spanish I had studied in college I was able to really dig into my surroundings.

I left New York in 2008 because it was the right time for a change and, ultimately, I wanted to work for myself. I bought myself a one-way ticket to Mexico and thought *I'm going to just travel* for a little while and figure things out.

There was one woman in particular who sold fish tacos every morning. While she had three competitors, *her* stand always had a line and knocked the others out of the ballpark. Her staff was a rotating cast of friends and family, and she was only open until the moment she sold out. I thought, "That woman has it all figured out!"

So after returning to Nashville, I decided to emulate her with a taco truck. Even if it failed, I knew I had still succeeded in test-driving a new business plan. Plus, it was less permanent that opening a brick-and-mortar restaurant. Then it occurred to me, I don't know how to cook! But, I'd already committed to the idea in my mind. If I didn't follow through with this what was I going to do with my life? Fortunately, my last restaurant position was in management, so I had an idea of how a kitchen ran. However, getting the food up to standard in that wild, fast-paced environment was certainly a huge learning curve.

I gravitated towards traditional and simple recipes, which could get me from point A to B. I was completely obsessed and driven to cook all day, everyday until the menu was perfect.

In August of 2008, I opened the truck with a fish, chicken, and quinoa taco. I knew I could intrigue customers because what I was doing was kitschy, but I really wanted to create something that you couldn't find anywhere else. That first summer I would park in the Five Points area of East Nashville because there weren't a lot of late night food options. I worked until the end of the year, and then closed shop to travel until the following spring. When I returned people asked, "Where's that taco truck? Come back!" so I opened back up in the spring of 2009. Immediately, I had to bring in my girlfriends and mom to help because we were so busy. In retrospect, it was an incredible marketing plan, which opened up my business to a whole new audience.

When people compliment our food I always say, "It's just a taco, but it's the best that we can do." I'm not trying to change my customer's lives, but I want them to have the same experience every time because that sense of security creates loyalty.

My passion for food comes from the feeling I get when it's an incredible experience. Even if chicken and rice is cooked properly, you can eat an entire bowl and feel happy. Simple food that is done well is fine by me because again, I'm not a professional cook.

My accountant told me once that I could write off my publicist as a tax deduction and I just stood there and laughed. My entire success is based upon the people of Nashville simply sharing their experience at Mas Tacos with others. I *love* Nashville and feel so blessed and lucky to live in this city. After living in a bigger city, I've realized that I move a little slower. Deep down I know that being somewhere smaller gave me the time to figure out what I wanted to do with my life.

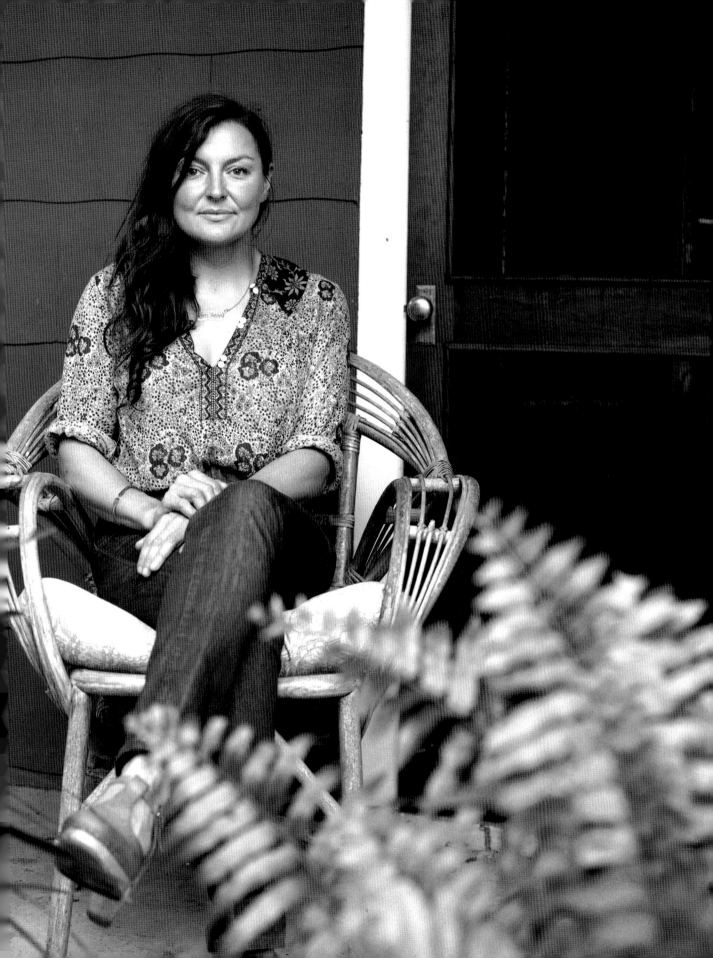

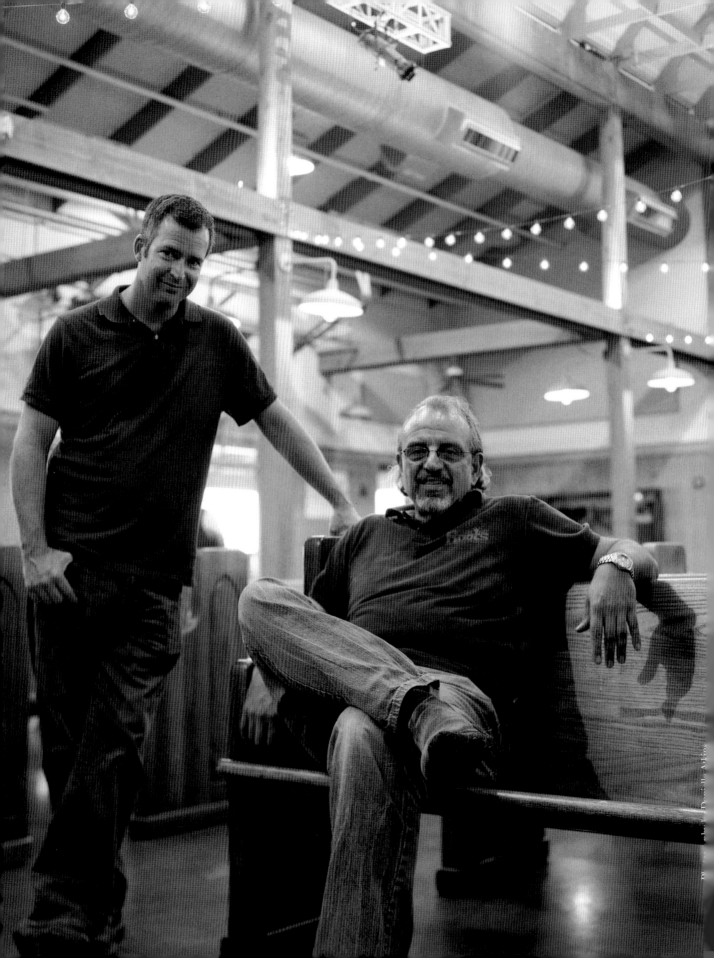

TODD MAYO + JOHN WALKER

{*Founders*, Music City Roots & Bluegrass Underground}

John Walker and Todd Mayo are so creatively in sync that the co-producers' conversations could be a "greatest hits" album. They view live music as a magical moment between audience and performer. As the producers of *Bluegrass Underground* and *Music City Roots,* they want to define the soundtrack for Nashville's twenty-first-century zeitgeist. Mayo and Walker are masters of the modern variety show: stripped-down performances that let the world-class musicians shine. Whether in a barn or cave, it is about uniting mankind in a disconnected world. They redefine what is roots music today by paying homage to the past through modern channels of technology. Ultimately, it is the spontaneity and camaraderie of the Grand Ole Opry that they want to recreate—prior to the commercial saturation of the entertainment industry. Mayo and Walker are two extraordinary men who met in the most ordinary of ways: over water cooler chitchat in the corporate world. They were marketing savvy with an affinity for music and the mom-and-pop radio shows of the past. By merging 'bands, brands, and fans' they were able to once again marry content and sponsorship. This proclivity is still evident in their sound bite speak and gift for coining taglines on the fly. It is their vocabulary and reasoning for their unusually high peanut butter-and-chocolate moments. At the heart of their dynamic is how mellow musician Walker balances the mile-a-minute art fanatic Mayo. They experience art on a visceral level and own it as their spirituality—hence Music City Roots' slogan, "a music revival on the edge of Music City." It is their goal to provide a platform for discovery and diversity, and encourage people to come together in ecstasy over music. In the greater scheme of things they want to set a societal paradigm: it is not only a tangible possibility but a human right to do what you love.

Todd: Life comes in four-year cycles: presidents, high school, and college, so this is a good time to reflect. We're fixin' to graduate! It's our senior year for what we don't know.

John: Not a week goes by that I'm not totally moved by someone who should be a household name. At the end of the day, we provide a platform for discovering art at a time when there's an overwhelming amount of it.

Todd: Art is subjective, and we're not here to say what is and what isn't, but I think it's fair to say that there's a lot of art that's commercialized. The artists that reach our stage do it for the sake of the art and stay true to who they are. It's such a blessing that four years later, I'm having a deeper experience than when we started, because there are so many ways to export these artists.

John: Todd coined a really great phrase, which I use all the time now, which is, "We're nurturing the emerging musical middle class." It's no longer about the record deal or top-40 song that results in financial freedom. The artists we are most moved by consider success being able to go out, share their music, and make a living. Doesn't

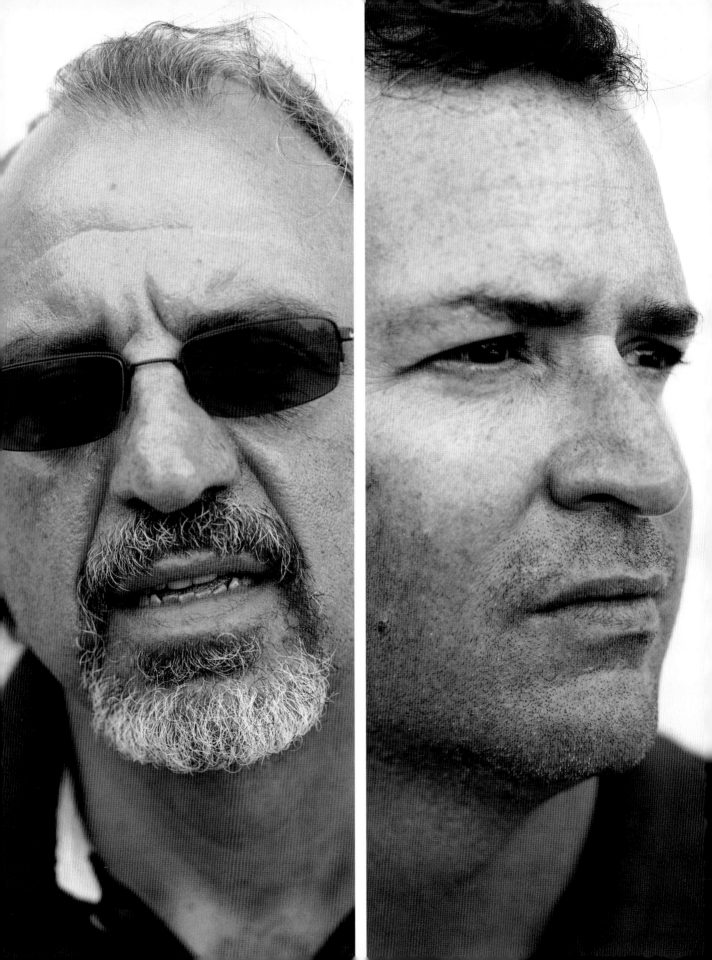

that deserve to be supported by the world because they make it a better place to live?

Todd: I believe qualitatively and quantitatively, there is more good music now than there ever has been. That's saying a lot when you look at the history of music. We see it every week, and for everybody who plays Music City Roots, there's another ten artists we have to say no to. It's mind blowing, and I truly believe it's the golden age!

John: Part of our mission is the eradication of genres and categories. Our corporate radio background wanted to put everybody in a box. There's such a freedom of expression now. Thank god the era is dying where everyone had to have the right haircut to get the record deal. We're also trying to erode age limitations. Our favorite shows cross-pollinate the legends with up-and-coming musicians. There is a mutual respect between generations, which is completely counterintuitive to the old industry model. Fostering moments like a twenty-six-year-old kid being able to play with a musician whose music he knows so intimately is going to make music even better.

Todd: I believe anybody that's born tomorrow is brought into a better musical world than somebody today. At some point most people become musically closed-minded because they stop living in the present and get stuck in the past. A lot of people I know say, "Things suck these days. Shit, music was great back then!" but the fact is, we get everything up to right now and all of the future. Part of what we're trying to do is open people's minds to new music. Our metaphor is, "Roots, branches, and offshoots."

John: I find myself using the buffet analogy because you're more apt to try something new a little at a time. Our best shows are eclectic, which enhances the overall musical experience. If you don't like one act, get a beer and twenty minutes later we'll give you something else.

Todd: I compare things to my own personal beer consumption. When I was younger, I drank shitty beer, and now I consume better beer, but less of it. People are on the lookout for the same quality in music, and I believe we experience it in a sixth sense way. Not that you can't have a life-changing experience because of a biscuit, but music brings that on a larger level. We're trying to shine light on reality to change the perception of Music City. Of course, on the edge of the city there should be a barn that flows with fried chicken, biscuits, moonshine, and an old time radio show. It's ideal and reality at the same time.

John: There's a story being told. We've treated this like a point in history from the very beginning and archived every moment. We want people to look back and say,

we cared enough about music to navigate the industry's changes and find a solution. That's what I want inscribed on my tombstone: *We were part of the solution, and kept art alive when the industry was in shambles.* It's a symbiotic relationship between bands, fans and brands because one hand washes the other.

Todd: I believe if you're open to things, take small steps forward every single day, refuse to be stagnant or go backwards, and have a vision that you work towards to execute, you will see serendipitous situations, synchronicities, coincidences, providence, fate. Things like that happen all the time. While nothing we're doing is religious, it is spiritual because it touches you. For some people, the language of music is as close as they might come to God.

John: Music has taken me all over the world, and I truly believe there's a tangible creative and spiritual energy in this city. I believe we're in a similar historical period as when Nashville became Music City.

Todd: When a creative class of people come together, the sum becomes greater than its parts.

John: It's coupled with the friendly nature of the South. It's a welcoming community that encourages everyone to come and create for the sake of the art. Don't worry about what's going to happen from a commercial standpoint—let that take care of itself. We are trying to nurture a world where a person doesn't have to use the last ten percent of their energy after working a sixty-hour week to create. It doesn't have to be a decadent lifestyle, but you should be able to do what you love for a living instead of as a hobby. That's the emerging middle class I'd like to see happen.

Todd: I never booked a bar mitzvah or grade school dance before I got into this. I had no idea about the music business before I walked down into that Cave and was just making it up as I went along. To me, music is magic and makes life worth living. The fact that two people can take the same recipe and yet one transcends the other—I don't think that mystery can be solved.

John: Music transcends language, and it has the ability to go to a place you can't put into words. Race, religion, and politics divide. Music has the ability to unite because everyone feels something different, yet is moved in some way.

Todd: Think of us as fiddlers on the Titanic. If the world is going down, we're bringing joy and comfort and peace to people as it does. I have a feeling a thousand years from now there will still be people making beautiful music. Maybe they'll be on the moon.

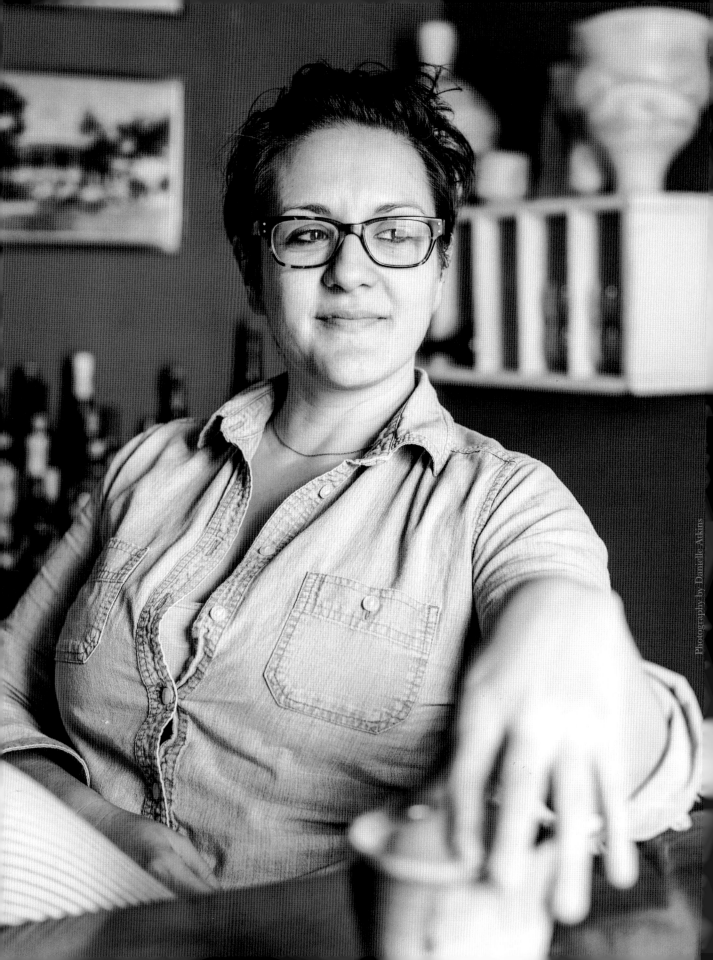

LISA DONOVAN

{*Pastry Chef,* Husk, City House, Margot}

There are moments in life so pleasurable they inspire you to recreate them. Pastry chef Lisa Donovan knows firsthand the joy of eating for fulfillment, versus to fill a void. It was a dark chocolate, hazelnut cherry truffle that changed the trajectory of her life. While growing up in Germany, Donovan had her first transcendental tasting experiences. She identified with the European families who paid homage to their ancestry through recipes. This pairing of pleasure, history, and creativity inspired Donovan to adopt bread baking as a hobby in her early 20s. As a young mother, Donovan realized the importance of quality food. Her interest in the culinary arts deepened when she began to wait tables to make ends meet. Margot Café & Bar's kitchen served as her entryway to an epicurean career. Donovan became enamored by the intellectual and physical properties of cooking. It allowed the budding pastry chef to work with her hands in a significant way. The studious server read obsessively and learned under the wings of her mentors. Hard work, imagination, and gumption led to her role as Head Pastry Chef at City House. After a few years, she hosted the first Buttermilk Road Sunday Supper Club. The event became a ritual where friends, neighbors, and strangers broke bread together on a spiritual day. After leaving her position as Pastry Chef at Husk, Donovan still experiences an absolute euphoria when it comes to baking her famous buttermilk chess pies. It is butter and flour, better known as "growin' food," that lends an intense feeling of pleasure that has never gone away.

How did you become so passionate about pastries?

My dad was in the army, and as a child we would spend three or four years in Germany and then a year for his training in South Georgia. My first memorable food experience was in Vienna when this GI brought me a truffle while I was standing in the town square. Although I didn't know it at the time, I had this feeling that something really important had just happened. I thought about the layers of flavors for days and just couldn't enjoy junk food after that.

Having grown up in the North, I find it so interesting how passionate Southerners are about their pies. Women describe baking as meditative and therapeutic, and I'm wondering what your personal connection is to it.

It all started because of my son. I was an art student and single mom, and became interested in cooking because I had another life to sustain. I really missed the basic bread I dined on while growing up in Germany and wanted him to have that same experience. Their bread is artisanal in the deepest sense of the word. The recipes have been handed down generationally, and you

THE THING YOU'RE ALWAYS GOING TO GET WITH SOUTHERN PEOPLE IS A DEEP SINCERITY I HAVE THESE DEEP, RIDICULOUS MOMENTS OF HOMAGE-PAYING EUPHORIA WHEN I'M BAKING PIE.

can taste the cultural importance of it. I dove headlong into bread baking as a hobby and eventually started selling it on a freelance basis. After I started waiting tables at Margot's, everything changed. It made me realize I wanted to work with my hands on a bigger level.

I loved that line in your bio in which you say, "As most writers do we all end up in the restaurant industry." I myself can relate to that.

As a child, I painted, danced, wrote, and lived in my head. Then all of a sudden, I started waiting tables at Margot and it was the first time it occurred to me that there was no difference between art and food. First and foremost, I was so excited to discover a culture where the people were all impassioned about food. Through working there I became a student to learn as much as I could. I wanted to wrap my head around this entire universe.

It seems as though you had an advantage by forgoing formal education.

Completely and utterly. There is an advantage to being fearless, passionate, and not having this rote education of culinary school. Although there have been many, many, many moments of fear up until I took this job at Husk where I wondered, "am I a total fraud?" I was fortunate to not only have the audacity to call myself a pastry chef but work for Tandy [Wilson, Owner of City

House] who gave me a kitchen, guidelines, and how to think, cook, and write a menu like a chef.

What prompted you to start the Buttermilk Road Sunday Supper Club?

I wanted to have complete control over the environment in which I was cooking. I was going to graduate school for my MFA at the time and thought, 'I need to quiet the part of my brain that wants to feed people because it is *loud*.' I started researching different region's Sunday suppers and thought it was a beautiful concept.

It's a spiritual day to eat, relax, and socialize.

I wanted to create a supper that anyone could come to, meet people in their community, and share a great meal and wine like a family. The first meal had 42 guests at this little manor in East Nashville. We pushed four tables together together, ate, drank wine, and listened to great music. People passed butter beans, and left as friends. It became the model, which is having dinner with strangers.

What is something that continuously inspires you about Southern culture?

The thing you're always going to get with Southern people is a deep sincerity. There is a truth about where we come from, who are people are, and what we've been through. I think sometimes that's misinterpreted as rebel pride. I have these deep, ridiculous moments of homage-paying euphoria when I'm making pie.

I find it interesting you've lived in both Europe and the South. There is a cultural similarity where you get time to breathe, explore, and play.

Society today is very go, work, go, and there needs to be a moment where we're all looking at each other and even better, over wine and really good food. The reason I loved those German bread recipes was to have the experience of making something that's been perfected over 250 years. It's how the family that created each recipe has made their place in the world, and that is beautiful.

The service industry requires thick skin. Being sensitive and creative, is this ever an obstacle?

Yes! There is a harshness, which you just nailed. If someone storms through the kitchen it affects me like a punch in the nose. On a daily basis I struggle with compartmentalizing my emotions and not becoming some jagged, cussy, spitty chef. When I left City House I said to Tandy, "I love the work, but I hate the hard living, rock 'n roll lifestyle."

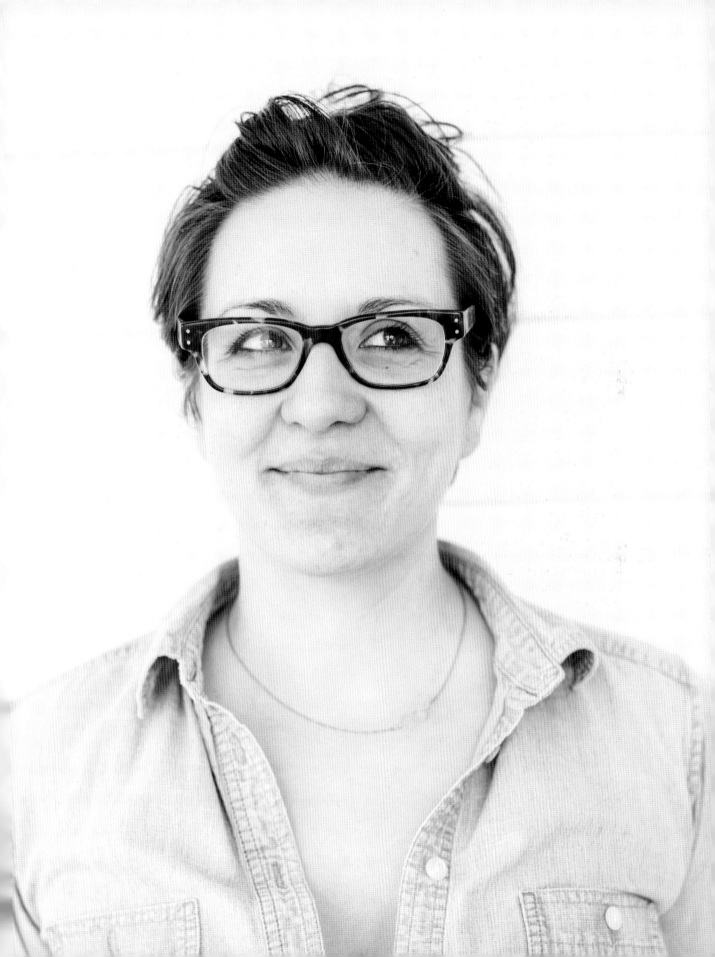

BRYCE MCCLOUD

{*Artist/Printmaker/Founder,* Isle of Printing}

Artist and peacemaker Bryce McCloud wants to make the world a better place. Printmaking first piqued his interest after he inherited his historian uncle's apparatuses and handwritten notes, To earn his stripes, McCloud schlepped and swept at the original Hatch Show Print. Finally, the legendary shop offered him a paid position where he understudied print master Jim Sheridan for a decade. McCloud eventually embarked on his own to establish Isle of Printing in 1997. He met his first printmaking clients in Lower Broadway's honkytonks and eventually, progressed to installations, album artwork, and industrial design. He has since been commissioned to render custom pieces by some of the city's biggest entrepreneurs, musicians, and restaurateurs. Although his work is of fine art caliber, McCloud eschews the conventional gallery world. He prefers to create for the masses via pixilated murals or community-oriented art projects. Whether in a public or private setting, McCloud believes art brings people together and inspires more harmonious behavior.

I would make the contention that everybody is artistic, but there's something about our society that squelches it. Some of us win the lottery and don't have to stop. I've always just liked making things. If you took away all my letterpress stuff, I think I'd be content embroidering, making signs, or drawing in the dirt.

My decision tree in college was to pick things that I'd never again have access to. I wanted to learn processes, and although I loved printmaking, chose to major in sculpture. Ultimately, I really liked the idea of public art. Printmaking is a democratic art because it allows you to make multiple originals. It literally allowed democracy to happen because it disseminated knowledge to the masses. Suddenly Abraham Lincoln was reading in a log cabin by candlelight, and later on became the President.

When I got out of school, I didn't have a sculpture studio or tools, so I started waiting tables. I didn't know how to turn my desire to make art into a living. I was into the idea of street art: the direct interaction between audience and artist without any filters. By a twist of fortune, my uncle left me all of his letterpress equipment. Back then it was a blue-collar trade and something you did for nine hours of the day before you got drunk. What we're doing here is really artsy, but I want to honor the tradition of it being a way to reproduce things. I always tell people who intern here, 'Turn around now because this is your last chance. Once you're in, you can't ever leave it.'

I remember when 9/11 happened, and there was so much hate in the world. Everyone wanted to kick someone else's ass, so I sent prints I had made to a friend in New York. They were of people shaking hands instead of punching each other out. There is a lot of dark shit in

WE CREATE THE WORLD WE LIVE IN. I CHOOSE THIS ONE.

the world, and it's incumbent on us to create something that will have a positive influence. The reason I stayed in Nashville was because I felt it was small enough that I could have an impact on the city.

I worked at Hatch Show Print officially for three years, but for about ten I was there almost every day doing something. Jim and I are great friends, and I always credit him for helping me get started by throwing me the jobs they didn't want. For a year, I set up my own shop next to Third Man Records, and by the time I left Hatch, I was already taking on work. The great thing about posters is your name goes on the bottom of them and literally nobody else was doing it. I danced every night on Lower Broadway and met Old Crow Medicine Show, The Shack Shakers, The Dirt Daubers. They'd say, 'Hey, you make posters?' It was totally word of mouth, half-assed, and exciting.

Sometimes people come in with a specific idea, but most of the stuff you see here is something I conceptualized. When I waited tables, it always made me sad because at the end of the night, if you've done your job correctly, the place looked exactly like it did when you came in. With this, you get a giant stack of stuff that makes you feel like you really worked hard. I think the most interesting thing about the people who are making stuff now is there's more of a social consciousness about it. For me, there are a lot easier ways I could make money, but the goal is to improve the place that I live in. And hopefully not starve to death.

We're only as good as the people around us, both as a business and a world. We have to take care of each other because we're all in it together. Figure out a way to all go forward and hopefully upward. If we're actively working on trying to be better people, then maybe we will be a little bit. I think living in an aesthetically pleasing world indicates a place where people treat one another with respect. Our environment affects us, and if you live in a place that has honest beauty to it, it affects how you interact with other people. An artist will say, 'if you make the road prettier, people will be kinder.' If things are unattractive it's kind of hard to get jazzed about life.

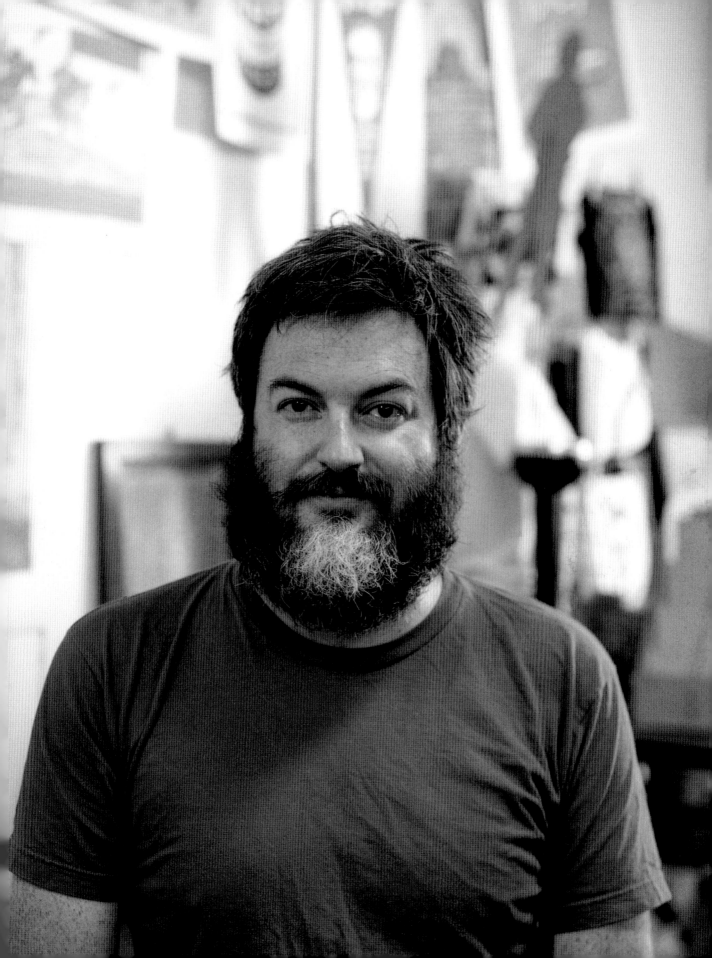

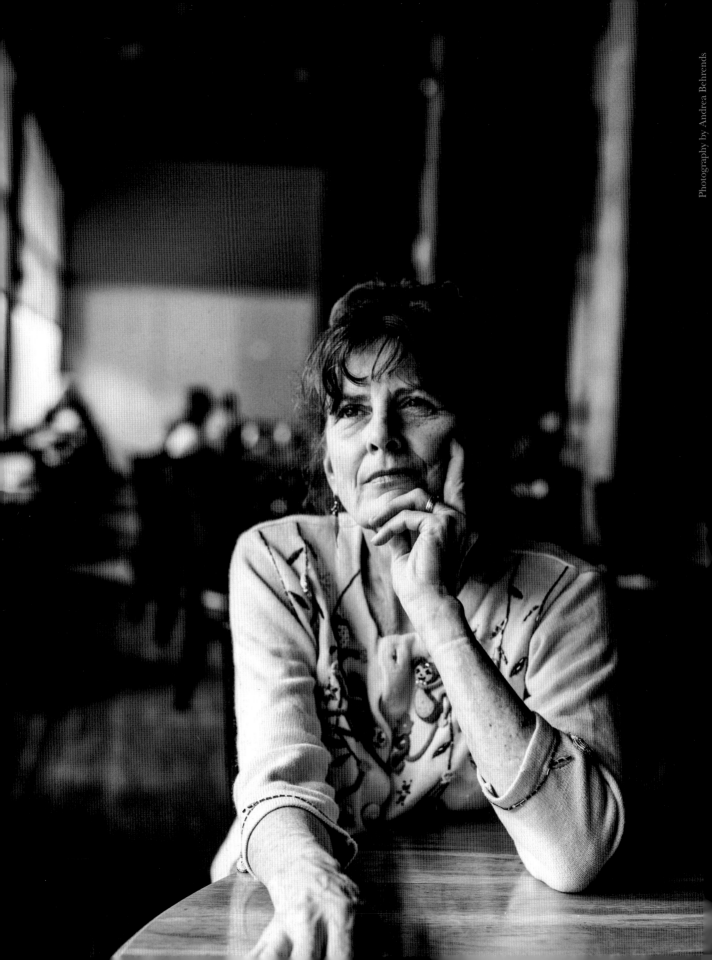

DEB PAQUETTE

{*Chef,* Etch}

Deb Paquette is over-the-top in every possible way. The chef hails from South Florida, and made Nashville her home in 1982. It is where she became the first woman certified as Executive Chef in Tennessee, and brought other restaurateurs success through her consultation work. However, it is the hallmarks of her cuisine—big, bold flavors gleaned from cultures around the globe—that trademark this madcap personality. As chef and owner of Zola she achieved her first national notoriety. Critics applauded Zola as one of the best restaurants in America, and were crushed when Paquette closed the doors in 2010. She felt compelled to travel the world with her husband Ernie, and eventually returned to Nashville to spearhead fine dining concept Etch in 2012. It was a decision perfectly timed with the city finding itself on the map as a serious foodie destination. The adventurous chef felt more liberty than ever to play with exotic dishes. Through introducing the region to Indian, Moroccan, and Turkish recipes, Paquette has pushed southern diners beyond their meat-n-three comfort zones. It is her fierce flavors, painstaking attention to detail, and artful approach to cuisine that sets her fare apart from the rest of the pack.

What is it about cooking that you so enjoy?

I'm one of the lucky people who found something that I really like and am good at. I practiced the craft, and here I am thirty-five years later. I love the instant gratification of creating a dish and making it taste really cool. I always had a creative knack, and it was an avenue that just fell in my lap. I didn't grow up in the business and got a late start compared to other people, but I always went above the call of duty. I have an incredible work ethic and show that I am a worthwhile employee. Maybe it's a guilt complex or simply that I'm a true Virgo, and that's our nature.

You seem very methodical and organized.

Yes, at least in my work. At home I just shove my underwear in the drawer.

A musician friend of mine once said that until your restaurant Zola opened in Nashville, he couldn't wait to get back out on the road so he could get a decent meal.

I would always say, "When will Nashville be treated as a place where you can eat?" and really, it took until a couple of years ago. I came along at a really good time because we didn't have a lot of restaurants, and I wasn't afraid. I'm glad I get to be a part of the elevated Southern cuisine trend, even though I've been doing it for a long time and wish this had happened in my forties.

You've lived here since 1982. What kept you motivated to establish Nashville's culinary scene?

Patience, and I can't think of any other place I'd like to live. The people here are kind and generous, there's still growth, and I make a decent living. Everything has just gotten a lot more fun because people are just so

FOOD SHOULD BE ARTWORK BECAUSE PEOPLE EAT WITH THEIR EYES.

creative! It's not just technology that's growing but the creativity of the individual has been allowed to come out. It's okay to do crazy, different food because people are willing to try it. Sometimes I am so overwhelmed by people's overabundance of kindness and that they truly like my food. I'm hopefully going to stay on these feet for another ten years and am determined to watch the city grow, have fun, and discover new foods. I want to make fun and flavorful food and make people happy.

Your cult following is known as "Deb Heads." Does the pressure ever get to you to keep them interested after thirty years?
It seems so silly and strange. My style of food is big, bold flavors on one plate, and a lot of people are intrigued by that. I keep trying to interest my customers in new ways while keeping my head above water. It's hard. Challenging. It is kind of scary and takes a lot of energy.

You've been named Chef and Restaurateur of the Year by the Middle Tennessee Chef's Association, and your restaurants have been cited as some of the best in the nation. How do you constantly find innovative, new ways to combine ingredients and techniques?
I order a lot of cookbooks because food photography sends the sparks flying. When you've looked at enough photos and sit back, it starts all coming together. I'm very methodical and picky, so it takes me forever to write a menu. I almost went into social work because I really like making people feel special. Food should be artwork because people eat with their eyes. I won't ever be someone who puts three peas on a plate. I like for food to be lively and to feed people. People love their basics, so I mix those with a little fun and try to have a good time with it.

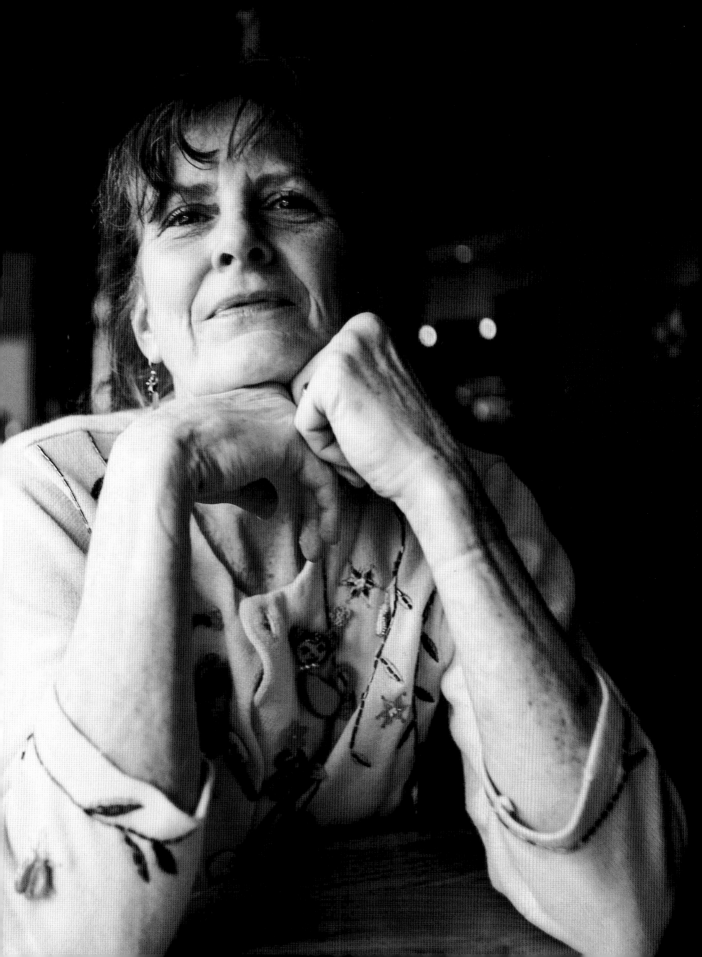

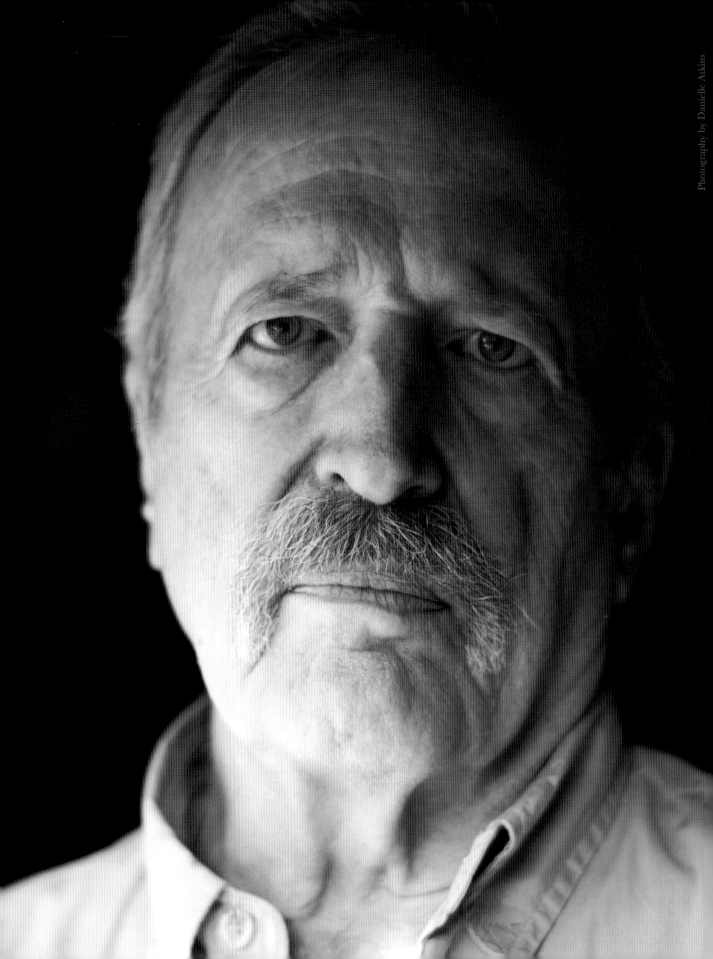

PAUL HARMON

{*Painter*}

As the rest of the world sleeps, painter Paul Harmon works briskly in his Brentwood studio. Once the clock hand hits ten, a fireplace burns, music hums, and a dog snores at his feet. The artist has received international praise for adding his own flavor to the fundamentals of art history. Masters like Cezanne, Picasso, and Manet are evident in his work, yet are filtered through the artist's own life experience. The Tennessee native began painting as a child alongside his artist grandmother in her studio. In college, he studied English literature, which, along with poetry and philosophy, still stimulates his imagination. Harmon is a firm believer in the art of total immersion. During an 11-year sojourn he spent the majority of his time in Paris, France. Overseas, he abandoned his Southern comfort zone by completely submerging himself in the culture. By "stealing" from the styles of his predecessors, the painter developed his own signatures: stencils, bold graphic lines, and symbolism. His universally recognized imagery condenses complex ideas onto a flat plane. They are loose enough for audiences to add multiple layers with their own minds, imagination, and memories. After sixty-plus years as a practicing artist, Harmon is more in love with the process than ever.

How was your time in Paris spent?
My gallery and studio were on Rue St. Paul in the Marais. I lived there for seven months out of the year because that's where all of my heroes grew up. I knew it would be good for my art if I lived somewhere that had different sounds, smells, and sights than Brentwood, Tennessee. I spun the globe and decided upon Paris even though the art market wasn't strong there at the time.

Yet it was calling you?
I made the decision with my heart, rather than my head, and it ended up being extremely good to me. Within the first year I had gallery representation and midway through the second, three galleries showing my work in Paris, Mount Pellier, and Cannes.

Did the move have the effect on your work that you were hoping for?
After I had been painting there for a little over a year, I came back to show my assistant some slides of my work. Even though I was still using the same concepts and ideas as before, the move had skewed my style in a more mature direction. The change was completely unconscious.

What was the most striking difference between Paris and Tennessee?
Everyone in Paris has an opinion about art regardless of his or her education. My Portuguese concierge, who spoke broken French and no English, would come into my studio to see what I was working on. She was confident in delivering her thoughts whereas Americans

would invariably visit the gallery and hedge when it came to giving criticism or praise. Europeans are always around art so there is no insecurity when it comes to taking about it.

Did you feel more inspired to create while living in Paris?

Oddly, I felt almost at home there immediately. It definitely felt as if I had lived there in a past life, and somehow surpassed feeling like a foreigner. Regardless of my surroundings, I am driven to create anywhere. Yet being a leisurely walk from the Louvre and Notre Dame was certainly inspiring.

Do you paint from memory or reference?

All of the above. I'm not shy about picking out a figure from a Gauguin painting and adding my own spin to it. That process makes me feel connected to the artists whose shoulders I'm standing on.

No one's style is completely original unless they've been living in a box their entire life.

A pet peeve of mine has always been artists who create work solely for the market place. Successful or not, you're always going to be stuck with an uninspiring subject matter. At the very least if you paint honestly, you'll end up with work that is valuable. When I veer away from that path my radar sensor starts beeping until I get back on it. It's my biggest form of self-discovery.

What was the painting that really established your own style?

In 1961, I worked on this particular painting forever and ironically, it kept getting simpler as time went on. Finally I gave it the title, "Moment of Realization," with the idea that we all have lots of moments where we understand ourselves on the planet. That was the day I stopped trying so hard and let it come naturally.

What is the biggest influence on your work?

Poetry. The distillation is very similar to the way that I paint using symbols, similes, and suggestions. Art history has also been hugely influential and something to which I am greatly indebted.

What did it feel like to finally find your own style?

A French critic once said, "A thousand meters from a speeding car you can recognize Paul Harmon's work." I've always been wary of having to paint poppy fields for the rest of my life. So I've taken a clue from Picasso and David Hockney where they can paint a reclining odalisque and still make it theirs.

YOU KNOW EVERY ARTIST IS INSECURE, WHETHER WE ARE WELL-KNOWN OR NOT.

Where did the idea for your famous stencils come from?

I was on a writing assignment once down in New Orleans. The photographer and I were walking through these mile-long warehouses with packing crates all around us. They had these universally recognizable symbols on them, and the beauty of that really struck me. Suddenly people weren't questioning, "Who is she?" in regards to the women in my paintings because they became a symbol for every woman.

Have you always kept the same night owl schedule?

Yes. My world does not exist beyond my desk lamp, background music, and studio during those hours. I read about a writer once who pasted craft paper over his windows so he couldn't see the outside world. While I'm not that extreme, to stay in the flow I have to turn off the side of my brain that deals with reality. With no distractions, I'm very much a kill artist who moves at a fast, steady rhythm.

Is working incessantly what keeps you so motivated?

Absolutely. I love the idea that my art and life are seamless. I never have the urge to go on vacation because I can't think of anything more fun than creating. While it's a roller coaster, I've been able to relax a great deal. The work has taken me so many interesting places, and kept me on the right track. *Happy* has a frivolous, small-minded subtext but *contentment*, to me, means that all is right with the world. When you know who you are, then you can really enjoy being on the planet.

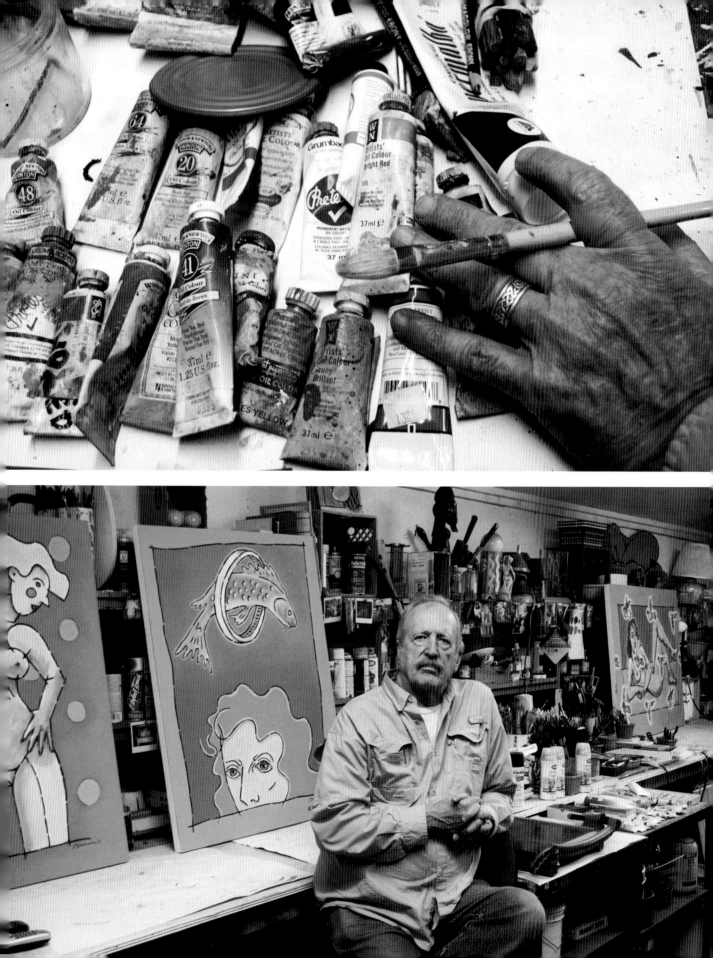

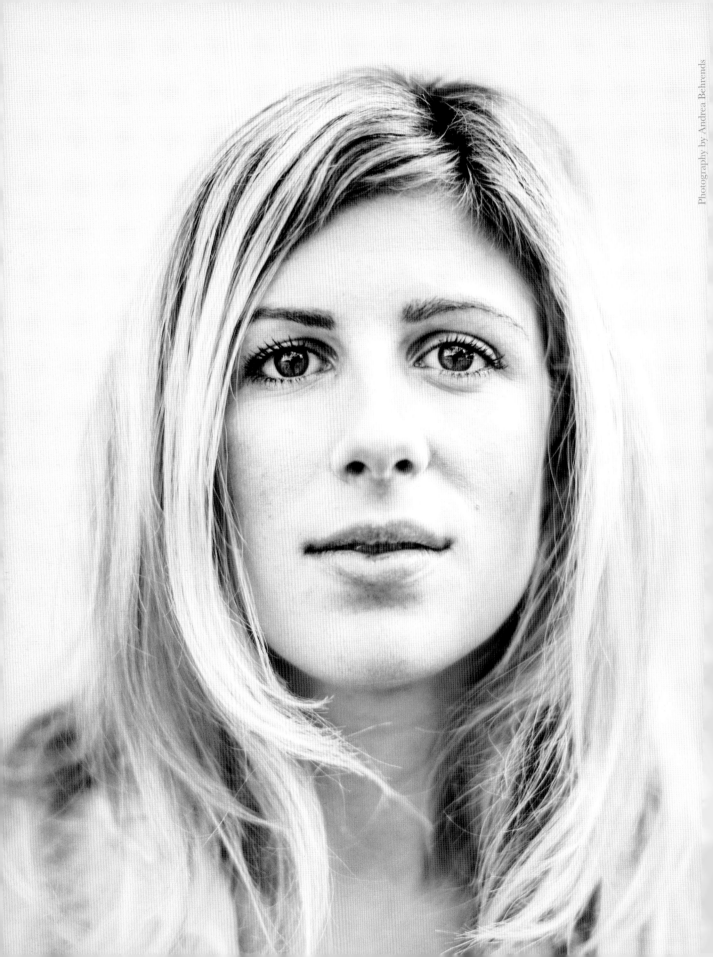

JESSIE BAYLIN

{ *Singer/Songwriter* }

Jessie Baylin views songwriting as total freedom of the human spirit. The artist's romantic crooning cuts right to the bone, and envelops the listener with wisdom and warmth. She is a songwriter in spirit, and often pulls lyrics from journal entries. A full orchestra backs her classic pop and jazz vocals. Baylin became a buzz-worthy name during her six-year stint in Los Angeles, where she performed at legendary clubs like The Mint. After writing her first song at age nineteen she was fortunate to receive a publishing deal shortly thereafter. She eventually settled in Nashville with her musician husband Nathan Followill, a member of rock act Kings of Leon. With her last album, the independently released *Little Spark*, Baylin was resolute to take back her creative control. It felt unsafe to create art in the major label world, and so she financed and distributed it as she desired. The choice resonated and resulted in a feeling of weightlessness, similar to reflecting in the rear view mirror. Her songwriting process is equally cathartic as Baylin sonically captures experiences during intense creative periods. Her latest challenge is learning how to balance being a musician and mother, though she affirms that both roles complement each other. As an artist, Baylin strives to capture the stories that sporadically come through her and write music with no expiration date.

You attended the Professional Children's School for acting and singing. When did you know being a singer-songwriter fit the bill?
When I wrote my first song at nineteen, I've never felt more alive. I'd been going on acting auditions and wasn't a fan of having to say someone else's words. Being an actor didn't complete me in any way, and my first song was about things in life that don't quite fit. Acting felt uncomfortable and unnatural in every way.

Yet you pursued a career that involves performing.
I've always loved singing. I feel like I am transported to a place greater than anywhere else. My parents owned a bar, and I would talk about records with their custom-ers. They'd recommend certain albums, and I'd play the records until they burned. I don't ever recall a time when music wasn't everywhere.

You write in your journal daily. How does this freestyle form help you with your songwriting?
I will write some poetry, a journal entry, and then find myself pulling some of those lines into a song. I always have a song or lyric idea while showering or blow drying my hair. I hear a song, grab my journal, and start writing again. It's very unexpected, and I feel pulled to capture some story that's coming through me.

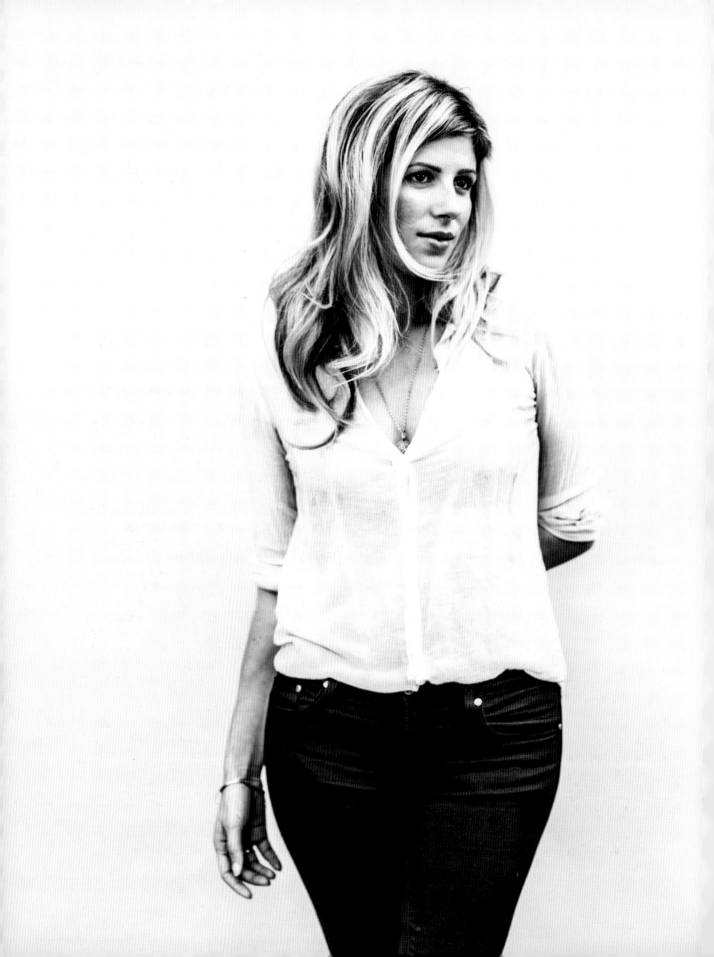

You took more than a year to write your last record, *Little Spark*. What was your process?

The way I've written since day one is to live and then dig into it intensely for one or two weeks. *Little Spark* took one and a half years, yet I would write seven songs in two weeks, nothing for five months, and then suddenly another six songs. I live life and capture it later.

Do you find it difficult to dig back into old memories that have maybe been dormant in your subconscious?

Yes, but even the best relationships have plenty of heartbreak. You can shine a light on one moment and make it sound like the saddest thing in the whole world. Still, it's not the easiest.

You are an artist who truly lives by her heart. Do you ever battle with wanting to share your struggles, yet not wanting to overexpose yourself?

You should always put the truth out there because nothing speaks louder. If it's true for you, then everyone will believe it. I'm finally writing for myself and, for a minute when I wasn't, it became the most depressing, broken time. When I shifted into doing it for me, the music grooved, and everything felt right. If it feels right in my body then it all connects.

I started listening to your music while going through a breakup. I was so touched because it's apparent you came full circle and were willing to risk it all for love again.

That means so much to me. My family is proof that heartache heals, and love is bigger and better the next time around. If not that one, hopefully the next.

Is it cathartic for you to release an album that is so personal and precious?

There's a sense of peace and lightness because the weight is gone. Like it's in my rearview mirror. I'm excited to have captured those experiences if only for my daughter. I imagine her listening to my album one day while she's going through affairs of the heart. Somehow my music might move and speak to her because I know she won't listen to me.

My dad is a musician, and I never appreciated it until I was older. Do you think your daughter will want to try her hand at music?

You want to do well for your kids, and I'm so happy to share that part of me with her one day. She's already musical, and you can sense it in her soul since forever. She sings, and sometimes it becomes this little melody. It's the sweetest thing. A piece of advice someone gave me is to encourage your child to express themselves.

I LIKE TO LIVE AND THEN CAPTURE IT LATER. THAT'S HOW MY SONGWRITING WORKS.

However they need to do it, let that part of them come out. That's what my parents did for me, and that's how I want her to be.

How has having a child affected your music career?

I don't know who I am anymore. In some ways, on a deeper level, I'm getting to know this new version of me who's a mother because there's more of me now. I had to get my last record out before I started a family because I couldn't go on the road with a baby.

I know some musicians who love living out of a suitcase, but you seem like a homebody.

I like recording the most. I love live shows but have a lot of stage fright, and that anxiety kicks into high gear when I'm on the road. I just want to be good, so my expectations are really high, and I beat myself up a lot if I wasn't doing it right. It's tough going into a new market and having to prove yourself to a bunch of strangers. I was the opening act for a lot of different people over the years, and that is hands down the hardest gig. Although I wasn't always set up with the right acts, when I am, it's magic and so fulfilling. Iron & Wine was perfection.

I'm wondering what music means to you.

It's like complete freedom of the spirit that I don't have anywhere else in my life. I felt disconnected for a while until I realized my daughter needs both an artist and a mom. So I started singing and exploring again, and felt the same way I did when I first started: every cell in my body connected for the first time.

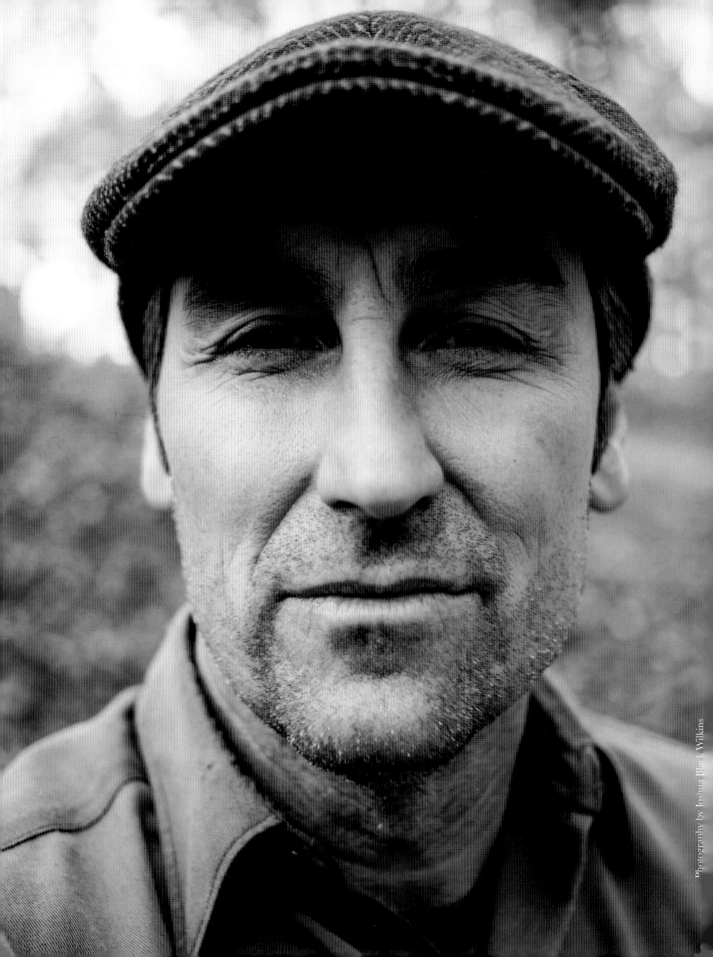

MIKE WOLFE

{*Creator/Star* American Pickers *& Entrepreneur*}

The chameleon feeds off other people's passions, and validates their affinity for collecting mini time machines. In 2010, Mike Wolfe debuted as creator, director and star of *American Pickers*, The History Channel reality television show. He presents a slice-of-life, niche industry with a cinematic flair through snapshots, sound bites and stories. Even prior to television stardom, Wolfe always dealt solely in cash and dug through the garbage everywhere he went. He developed his wheeler-and-dealer skills in rural Iowa as a means of coping with unfavorable financial circumstances. Discarded objects became his toy collection, and he learned to make a buck through the art of bartering. Sales pitches and street smarts became the driving forces for his businesses, bike shops and real estate ventures. However, when he began pitching his television show Wolfe heard the word *no* repeatedly over a four-and-a-half year period. His persistence led to rewriting the American dream, proving success doesn't necessarily stem from a scholarly background. The chameleon feeds off other people's passions, and validates their passion for collecting mini time machines. He attributes his own success to a lack of specialization—no matter the collectible Wolfe lives for the "whom, what, and why" and the thrill of foraging and flipping goods. His Midas touch, power of persuasion, and childlike enthusiasm has generally caused life to unfold in his favor.

How did you know that your career would make for a compelling television series?

I believe there are moments in your life that change and inspire you to pursue certain things. I had very emotional, vulnerable, passionate experiences while picking, and wanted to show the world that these places and people exist. I didn't really know about how to do it, and so I bought a camera and tripod and started talking into it. Frank and I would come down here and set up at the flea market, and that was how I met Kristin Barlowe, who has directed a block of our show. When I said, "Hey, I'm trying to do a television show," everybody in my three thousand person town laughed.

They thought I was friggin' nuts, but she helped me understand what a treatment was, what to film and what to lose. Even the smallest words she gave me were huge in the respect of just making me believe in myself.

When did your interest in history, antique objects, and dusty old things start?

When I was little, I had a stick and some dirt, so a lot of the things that I found became my toys: an old bicycle, cigar box, or I'd go to the junkyard and dig through old cars. I wanted to know who owned it, how it landed there, and what was the history. I would walk

the alleys everywhere in my town because you could see what no one else saw. I'd get stuff out of the garbage, from behind people's garages, or if their garage doors were open… I was always very curious, and guess I was born with it. I don't ever remember being young. Even when I was four years old, I had one of those crazy cars and would ride along the shoulder of the gravel road. Imagine seeing a four-year-old doing that now, you'd be like, "What the hell is that?"

Would you ever encourage one of them to do what you do for a living?

Oh, completely. Anybody can do what I do for a living because it's all smartphones and Paypal now. Twenty-five years ago when I was doing this, you had to shoot from the hip and educate yourself constantly on what you were buying. Sometimes people school me. You're always paying for your education.

Let's talk about passion, because obviously you have plenty.

I've been fortunate because I've made a living off my passion my whole life. I graduated from high school with straight Ds because I was bored, and my mind had ten different things going through it constantly. I didn't give a shit if it was an A or D because I just wanted to go to the next grade. I've been self-employed twenty-six years, way before the show. I wanted to own a bike shop, a property company, and a television show, so I started them. Every single step in my life has been driven by passion, because I'm not the smartest guy in the world. I'm just not.

What made you so determined to translate what you do for a living to television?

Because I felt it was so important! I was so driven by story, constantly wanting to tell or learn one! When we get to people's properties, I always tell them, I'm here to tell your story. That's what drove me so hard to do this. I wasn't trying to be an actor. And to be honest, we didn't have a format for the show. It just unfolded as we started filming. I talked for frickin' thirty minutes the first time anybody ever asked me a question because no one had ever done that before. When a director engaged me, it was like a cork popped and everything spilled out. Passion for me is a godsend, not a choice, because I'm not qualified for anything else. Am I going to get a job at a bank or restaurant? I don't know how to wait tables or run a cash register. If I didn't make a living from my passions, I'd probably be a garbage man.

In niche professions such as your own, you have to make your dreams happen. Your survival skills kick in.

Exactly. The reason I waited so long to marry and have a child was because I always felt it was so incredibly difficult to take care of myself. How could I ever take care of anyone else? Growing up with a single mom that had three kids and struggled her whole life, I understood the importance of working hard. We didn't have anything, so I realized I had to be really assertive when it came to my passions. They put me on the cover of *Entrepreneur* magazine a couple of years ago, and I don't even know how to spell *entrepreneur*. Five-page spread they did on me about how my show created a new television category: artifact transactional television. I always thought the show would do well, and that's why I stuck with it, but not to the magnitude it has. It's a format that can be used around the world because it's a show about all of us.

Has picking become any less magical now that you've broken it down to a science?

Completely, and I fight with that all of the time. That's why the kids' letters saved me. All of a sudden, boom, you're thrown into this mix, and I get six thousand emails the day after the show airs, and two hundred

people asking for my picture and autograph. Don't get me wrong, because I know I'm blessed, but would you ever think in your whole life that someone would want your autograph and picture all day long? You're dealing with that, and trying to make a show on a constant basis, and not trying to say the same thing over and over again. How many times can I buy a motorcycle and talk differently about it? I realized right away how people hang on every single word and thing that I buy. We make thirty-two, one-hour shows a year, and in those I have to sum up what I appreciated about the person and the item I bought, and make it into an attractive sound bite that makes you continue watching the show. So yeah, your passion gets drained because all of a sudden it's not working for what you love, it's working.

As a native Iowan, who spent a good deal of time in Nashville before moving here, what is it about the South that intrigues you?

The folklore, romance, mystery, and dark side of it all. You've got your own language, food, and music. It's like another planet down here. History is so important here. I can't tell you how many old houses I've tried to buy out here. People will let them fall to the ground and rot before they will sell their family's history.

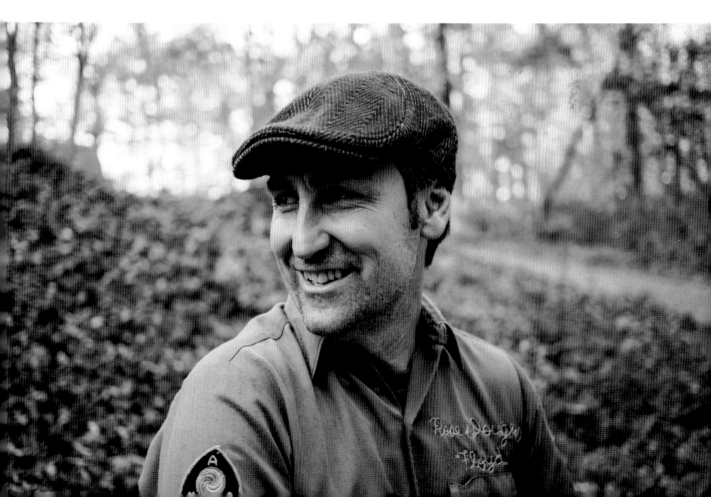

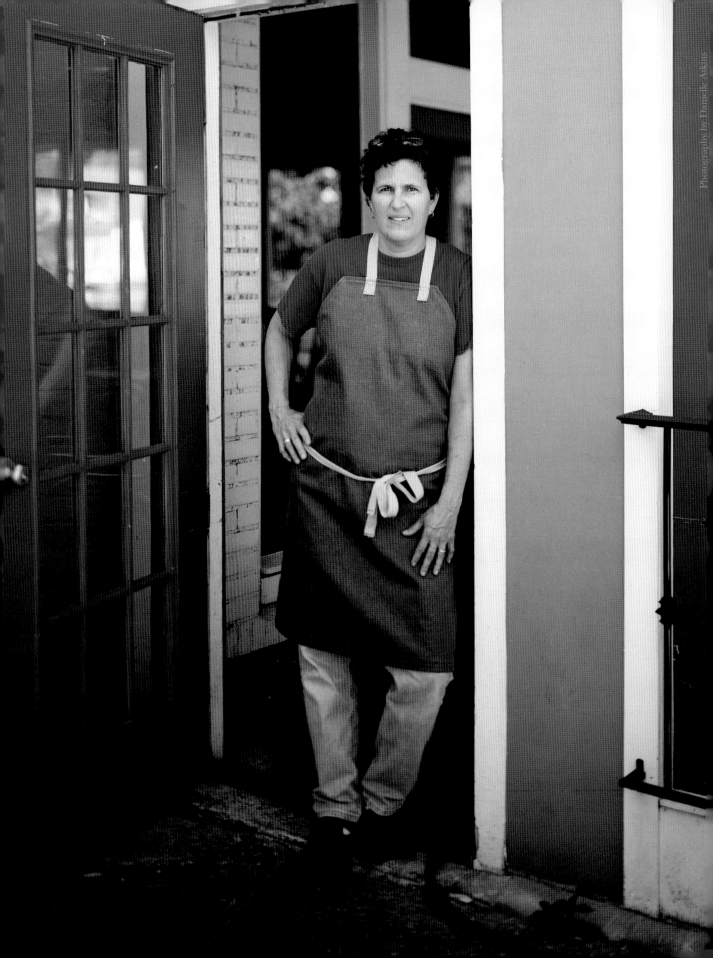

MARGOT MCCORMACK

{*Chef/Restaurateur,* Margot & Marché}

Margot McCormack is mentor and matriarch of her city's culinary scene. The chef-run Margot Café & Bar has elevated the local dining barometer and served as a training ground for the next generation in gastronomy. A culinary career has always made sense in the grand scheme of McCormack's life, and circles back to the food that she and her mother made. She first cut her teeth at a corporate chain restaurant where the art of cooking was broken down to a science. Next she moved to New York to attend the Culinary Institute of America. There, she received formal education in the way that she's always loved to eat: fresh, creative, and seasonal favored over clichéd plates. She was particularly influenced by a small, East Village European café where she learned to draft a daily menu without second-guessing herself. At age 30, she returned to Nashville to work as executive chef at F. Scott's for five years. Margot opened in 2001 followed by bistro, market, and "best brunch spot in town," Marché Artisan Foods. At both of her restaurants the chef remains steadfastly loyal to the source of her success. Rustic French and Italian recipes, regional farmers, and her restaurant family have made the "Southern Alice Waters" who she is. McCormack is intense, focused, and knows what she wants from each product. She runs a tight ship where expectations are high, egos banned, and even the roughest parts of the job add up to a rich process.

What was it about the culinary world that initially fascinated you?
Everyone who is successful in this business is a little bit OCD, which really appealed to me. Restaurant life has always fascinated me because of the employees and customers who are always coming and going.

How did you learn to hone your own style?
I worked for Jody Faison who was the big man on campus back in the day. The restaurant was independently owned, had lots of personality, and resembled the way my mom and I cooked together. He took a real shine to me and facilitated the right connections so I could attend the CIA.

How did your time in New York help you grow in your industry?
I worked at this tiny European café, which was where I was first introduced to French peasant food and rustic Tuscan Italian cuisine. We didn't have a cooler, so what went in had to go out. The owner went to the green market, cheese shop, and bakery every morning. Young New Yorkers don't entertain in their homes and just want a home cooked, simple, honest meal. The food we served spoke to them, which became the inspiration for this. Putting together a menu today comes from years of experience. I don't just throw stuff together and hope that it will taste good.

Why the return to Nashville?
While I eventually came to love New York, it got to the point where I didn't need it anymore. Nashville is pretty much it's own city and smarter than people give it credit for. The locals demand respect for their tastes.

F. Scott's was a test to see if I could stay in Nashville. People will say that all you need is a Chardonnay, filet, and salmon on your menu to make money, but that kind of cooking is soulless. I believe if you put yourself into

the work then your employees and customers will keep coming back. People trust me and accept what I put on the menu. It's a pretty awesome feat.

Many successful chefs have earned their stripes in your kitchen. What is your advice to aspiring chefs?

It's a lot of hard work and dedication. People don't normally understand what the job requires, so I give them the worst possible description first. "The kitchen is hot and loud, you don't make a ton of money and have to work really fast." Working in a kitchen is all about what is happening in the moment. My staff makes contributions, rather than punch the clock, because that level of interest comes through in the food.

What specifically keeps you excited about the business?

In a nutshell, I opened this restaurant so I have a place to go everyday where I can do what I love. The people that I choose to work with are smart enough to read a recipe and don't mind spending eight hours a day with. I don't give a shit about where you've been or what someone else says about you because we all click with different people. While I may come across as tough, I really care about my employees. I want to watch their lives happen before me. They're my legacy after all. I'm all about the old and wonder why everyone is so obsessed with the new. Do you have any idea how hard it is to go in everyday for 13 years and do what we do at the same caliber or better?

WHILE I MAY COME ACROSS AS TOUGH, I REALLY CARE ABOUT MY EMPLOYEES. I WANT TO WATCH THEIR LIVES HAPPEN BEFORE ME. THEY'RE MY LEGACY AFTER ALL.

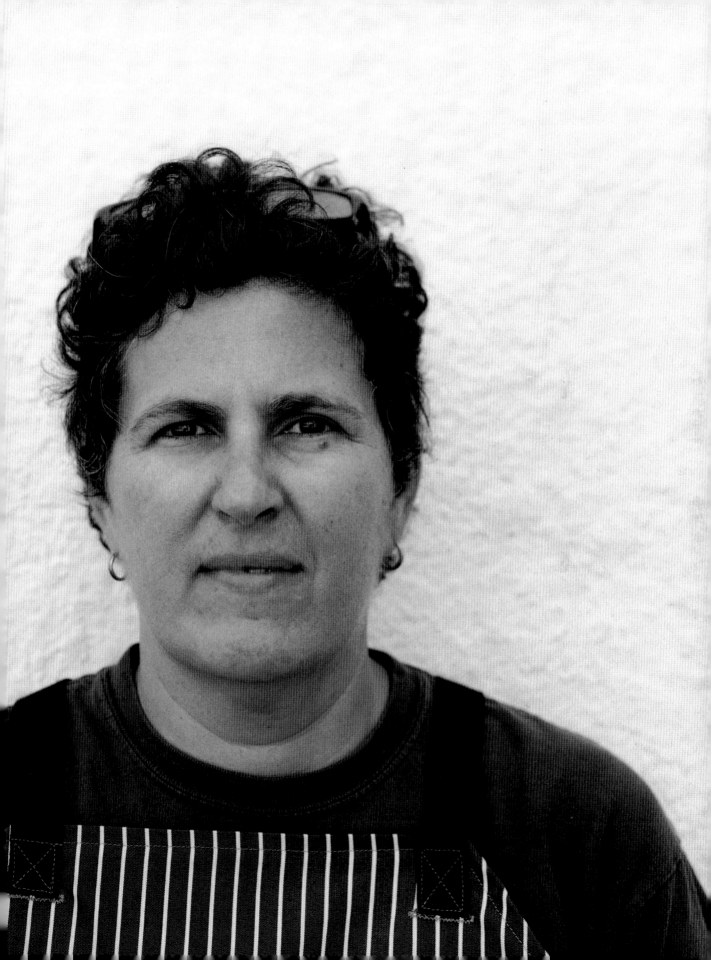

gangster-ish

TROY DUFF

{*Graffiti Artist*}

Troy Duff has always been ahead of the curve. Since the mid-1980s, the graffiti artist has spray-painted every surface in sight. It is the imperfection of the art form and out-of-the-box interpretation that speaks to him. Graffiti is his contribution to the community, one that bridges its past and progression. Prior to commission work and corporate events, the artist relocated to the West Coast where street art was culturally accepted. There he enmeshed himself in the skateboarding, punk rock, and tagging scene. On Venice Beach's boardwalks, surfboards and designer clothing, Duff honed his flavor. The various mediums led to his unique style: intricate angles, fades, and lettering intended to be visually assembled like a puzzle. After pursuing acting, modeling and fashion design careers, Duff left Los Angeles to focus on his fine art. Ironically, it was the moment Music City changed its tune about street art. The artist had always aspired to paint his childhood stomping grounds and was at last able to do so with residential, retail, and public art projects. His career is one that combines a love for painting, penmanship, and performance art. Duff wishes for his murals to intellectually stimulate and spark conversations. It is about making beauty universally accessible. By feeling and freehand, he creates his own font.

How did you get started in graffiti art?
A friend introduced me to graffiti art at age 16, and I remember right off the bat being excited that I could translate my drawings with a spray can. We all chose our individual tagging names and started bombing the city together, tagging on any and everything. Of course the neighbors were upset and asking, "Who are these punk kids that keep spraying on everything?"

How does one transition from tagging to producing full-scale pieces?
I was a doodler and loved to see if I could draw something in a photorealism style. Graffiti-style lettering appealed to me, and I spent time copying subway and spray can art in books and trying to develop my own style. It takes time to develop a letter style and learn scaling, 3-D, drop shadows, and the blending of colors. I remember friends describing the feeling of exhilaration. Just like jumping out of a plane because it's a race against time before someone catches you.

I've always thought graffiti was such an interesting artistic hybrid. It's a code language focused on lettering and then on the other hand, it's homage to the lost art of penmanship. People associate words, letters, and the alphabet with graffiti so what makes you want to constantly add your own spin to that and plaster the city?
Even when I was in art school at Nossi, studying commercial art and graphic design, I knew I was too hands-on to sit behind a computer everyday. Graffiti goes back

to typography, calligraphy, the art of lettering, cursive writing. It's about making penmanship your own by creating an original style.

Do you like this wild style where nobody aside from you can ever figure out what it says, throw-ups, or really structured pieces with 3-D and 2-D bubbles letters?

There has always been a debate in Nashville about graffiti as art versus vandalism. We're making progress slowly, but surely. I feel very honored to be the guy who's painting murals in my old stomping grounds. Graffiti isn't all about perfectionism. I'm doing this all freehand without stencils so every line isn't going to look like it's done by a machine. It's a visual art that makes you step outside of the box. You may not be able to read it right off the bat, but give it some time. It's like a puzzle or maze that you put together with its own interpretation. Graffiti comes from the soul because an artist has given a piece of himself to the community. It's not black and white, clean cut, or for everybody.

Your fine art incorporates graffiti, which is fairly unique.

I incorporate airbrushing, acrylic, spray paint, grease pencils and occasionally mixed media. I grab some canvases and see what comes out. Much of my abstract fine art incorporates angles, fades, hard lines, and geometric shapes. I call them "Fractional Pieces." It's street meets 60s Pop Art.

When did you realize Nashville was truly ready to support graffiti as an art form?

My corporate jobs have really taken off over the last few years. I wasn't out there posting Craigslist ads but rather people came to me. The very first one that shocked me was spray painting inside of the Cool Springs Galleria for the Calvin Klein fragrance *Shock*. The second one was painting the wrestling room at David Lipscomb High School where my crew and I did a bunch of graffiti back in the day. Calvin Klein, Converse, Marc Jacobs, DISH Network, and Journeys. The jobs, to my surprise, keep on coming.

Why does graffiti resonate so strongly with you?

It's where I find my comfort zone, and once I get into a piece it's like total ecstasy. I love the art form, and that people watch to see how it's all coming together. It's the challenge of walking up to a wall or canvas and not knowing what I'm going to do. It will never matter how old I am because it will always make me feel alive.

RIGHT FROM THE BEGINNING I THOUGHT, GRAFFITI IN 12 SOUTH? I KNOW SOME PEOPLE ARE GOING TO BE PISSED OFF ABOUT THAT.

It must be rewarding to be living out your fantasy career.

It's been a rough road at times although I don't regret it. Even though sometimes I don't know when my next paycheck is coming, you keep doing it and things always seem to work out.

No matter what game you're in it takes a good ten years of being in your field before you really start seeing some success.

I feel very honored to be the guy who's doing it in this city and the neighborhood in which I grew up. While some people aren't going to like it I've learned you can't please everybody. Still, I'm putting my heart and soul into it and hope that people will look at my pieces and maybe, their topic of conversation will change. That's the beauty of graffiti: it encourages you to discern the image that you see.

Like vitamins, it's good for your brain.

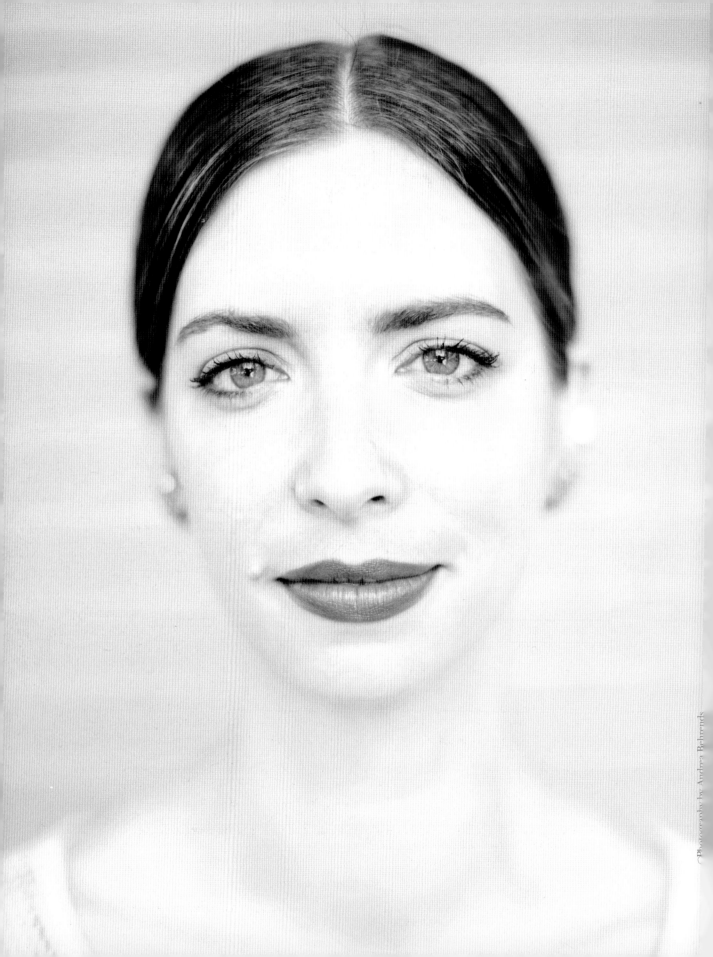

AMANDA VALENTINE

{*Fashion Designer*/ Project Runway}

America may have fallen in love with Amanda Valentine on *Project Runway,* but Nashville has watched this feminist and fashion plate work her couture magic for some time as a commercial, film, and television stylist. That's how she made ends meet before launching her brand Valentine Valentine, which caters to men and women with eclectic and daring styles. The headstrong designer has always had one goal in mind: to morph her one-woman operation into an international phenomenon. Fashion has been her creative outlet since childhood when she used it as a way to shine in a family of five siblings. Imbued with Midwestern hustle and a strong work ethic, the Nebraska native learned to scavenge thrift stores and sew at an early age. After college, she headed out west to be near her musician brother and began assisting the city's top stylists in Los Angeles. However, she found it impossible to curb the desire to work on her own designs. She craved a slower pace of life and more creative freedom, instinctively moving to Nashville where her sartorial ambitions took flight. Finally, after her first season on *Project Runway,* Valentine began taking the necessary steps to build a team and business model. At the forefront of her goals is empowering the female workforce and reverting production back to American soil. In her designs she pays homage to traditional feminine arts, like quilting, sewing, and crocheting employing masterful seamstresses whenever possible. She is cognizant of the impact the fashion industry has on the world and strives to ground beautiful garments in social awareness.

What is the strangest job you've ever had?
While attending the University of Nebraska, I worked full time as a janitor and managed a make-up counter. I've done every weird job you can think of. If you've cleaned toilets you can get by. Now I don't cook or clean, and am a horrible housewife.

Why Nashville?
I became tired of L.A. and had the excuse to move here because of a relationship. I knew nothing about the South and had horrible misconceptions. I visited a couple of times and completely fell in love with the vibe and people. I realized there are thousands of girls just like me that are in L.A. and New York City, and I liked the idea of coming to Nashville and being a part of starting the fashion industry. Being the big fish in a small pond was personally more exhilarating than part of a machine that was already in place. Nebraska was too small, L.A. too big, and *Nashville is just right.*

What are the benefits and biggest hindrances about starting a fashion brand in a city with no industry?

It's terrifying to create a business where there's no framework, factories, or investors behind you. But it's also completely liberating because I get to make it all up and do things completely on my terms. I can throw a fashion show at my friend's bar if that's how I want to do it. It's exciting to think completely outside of the box and build my business in a comfortable, organic way.

What is a major lesson you've learned while launching your fashion design career?

I'm starting to bring a team around me now. I'm so used to doing everything myself from marketing to fabric sourcing, so it's been nice to have people step in and ask, 'What do you want to do?' It's made me realize that I'm totally a flighty designer who just wants to sit, sketch, and dream up concepts. It's made me realize why there's a huge team behind each designer, because it's really hard to be prolific when you're doing it all yourself. My creative mind never stops spinning, and I get frustrated because I don't have time to design every item that I would like to.

How do you go about designing a collection?

I have a gut reaction when it comes to fabric sourcing. Something will just hit me, and then it becomes a collection. I was always afraid to say I designed for myself because that just seemed narcissistic. Then one day my husband, Will, who many of my good ideas come from said, 'You are your girl and that's okay.' So now I design one hundred percent for myself, and my work has, as a result, become significantly better. The biggest challenge for any artist is being confident enough to trust that your point of view is valid. I needed a really good ass kicking and to lose a reality television show to kick it up a notch.

Because of the city's lack of resources you've had to think outside of the box. What is your strategy for growing exponentially?

There are these pockets of skilled workers who I would love to employ on a freelance basis to sew my collections. I spoke to the Nashville chapter of the American Sewing Guild in 2013 about my dream of employing sewers part time, so they can have the freedom to make their own schedules. I organized a meeting to discuss setting up production, and twenty sewers showed up ready to work. Many of them had been laid off from factories because everything is being made overseas. Fashion is such a flighty industry, and I want to ground it in social awareness.

It's also a bit of a feminist statement.

Everyone around me, including my consultant, interns, and these sewers are all women. I'm just obsessed with having this army of skilled female workers and taking back American production. It's exciting. I know that we're all just trying to make a living, but we can kind of be aware of the world we live in and try to make it better.

How do you deal with being an independent designer in a big brand world?

It's just a shame that we're all addicted to fast fashion. I love the traditionally feminine arts of quilting and sewing, and try to incorporate those into my designs. I have such respect for these retired women who have been sewing for fifty years. Their work is just insane and beautiful.

What is it about Nashville's culture that inspires you?

Nashville is that perfectly sized city where you can really pursue your artistic profession be it music, art, or fashion and get by. In L.A. I worked so much. There was very little time to experiment, play, grow, study, and research. Here it's expected to give yourself creative space to grow. And the energy is incredible. My husband and I—our favorite thing to do is sit and talk about his next music video and my new T-shirt design. I love that everyone's crafts crossover and it's not about making money or getting all this press. We just want to make beautiful things happen and it's rad.

What was your experience like on round two of Project Runway?

I hated that I was "on my best behavior" on Season 11. I fell into the background and didn't rock the boat. The second time around, I decided I wanted to enjoy the ride, relax, and make exactly what I wanted. By taking control of the situation it turned out almost exactly like I imagined: Simply by being myself I received artistic validation. People truly understood my vibe, and I was remembered this time around.

Since you were a little girl you have never given up on fashion. Why?

One of the last things I said to the judges on Season 13 was, "Besides my husband, of course, fashion is the great love of my life." And you do anything for your great love, right?

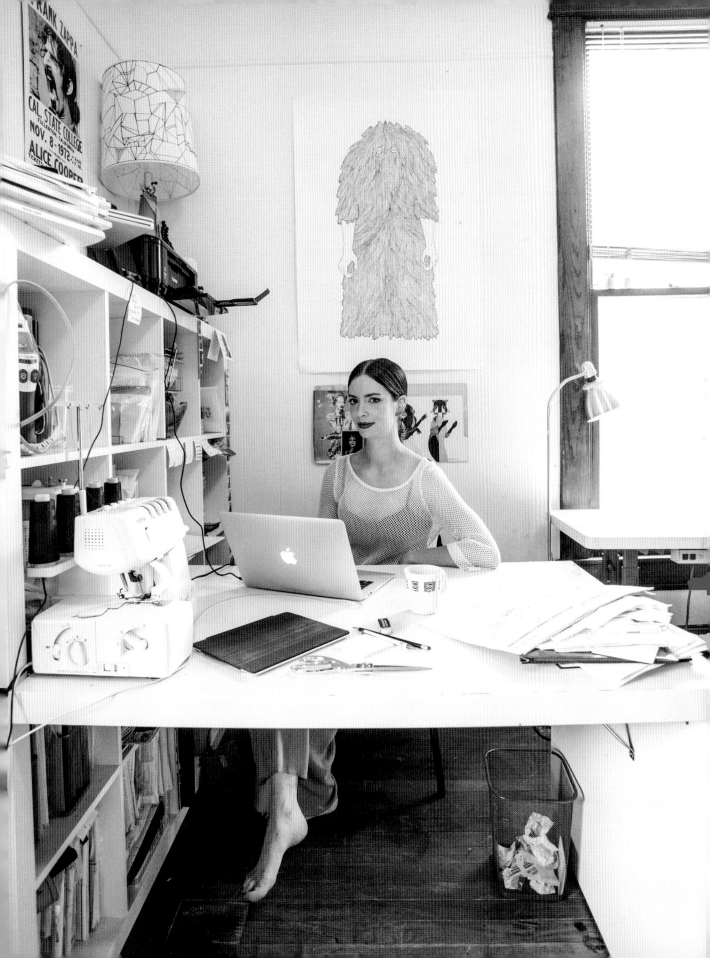

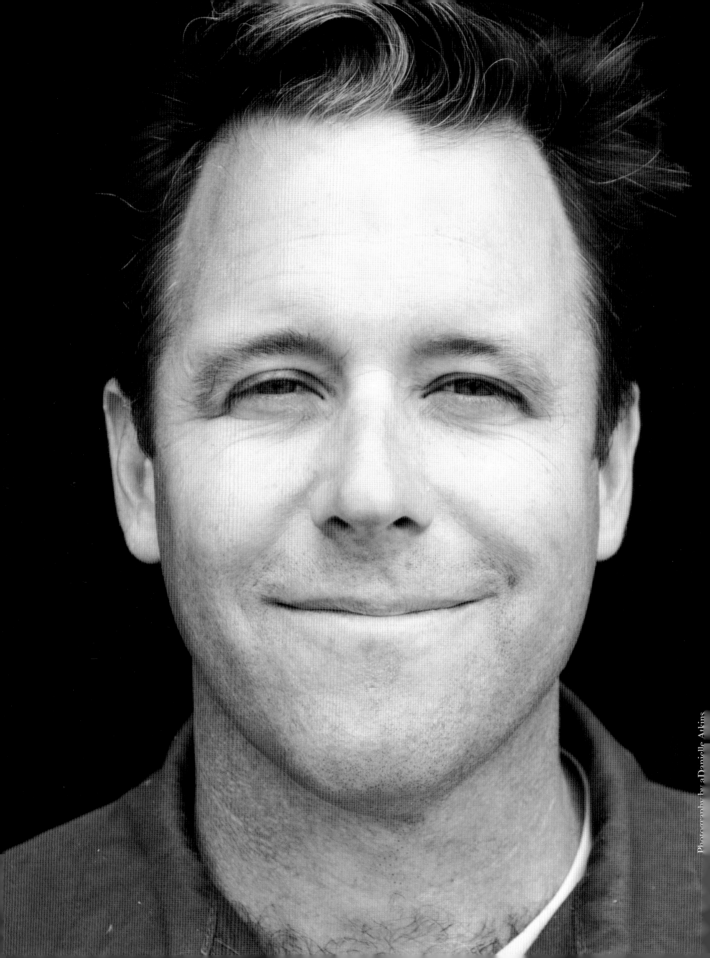

LINUS HALL

{*Founder,* Yazoo Brewery}

Once a seed is planted in Linus Hall's head, he has a hard time letting it go. As the founder of Yazoo Brewing Company, Hall has been credited with introducing local imbibers to a world beyond watered-down domestics. However, until college, the brew master himself didn't realize that beer had a purpose beyond intoxication. After moving from his native Mississippi to small-town Virginia, he and a buddy ordered a homebrew kit out of the back pages of *Rolling Stone*. With the nearest liquor store twenty miles away, they began making kegs for weekend house parties. Years of experimentation later, Hall would take home a gold medal at the 2004 Great American Beer Festival. In 1996, Hall settled in Nashville only to discover that craft beer was lagging behind the city's culinary scene. After fantasizing about brewing techniques and bottle labels, Hall realized his engineering background and creativity were the perfect combination to run a brewery. By playing his cards correctly, he got the entire community excited that great beer was being made right down the street. The entrepreneur covered his bases through an official certification, apprenticeship at Brooklyn Brewing Company, and MBA from Vanderbilt University. Styles like Yazoo Sue, Tennessee's first legal high-gravity beer, have since been credited with pioneering the city's craft beer phenomenon. Having been in business now for more than a decade, Hall attributes his success to fate, partnership, and the communion between brewers and beer fanatics. If a product is tasty and its manufacturers pleasant, then why wouldn't it be a marketplace shoe-in?

While craft beer is a given now, when you were starting out it was an entirely new ballgame.

The craft beer scene in the South has always lagged behind the rest of the country, even though we have an extremely diverse, creative food culture. When I was starting out, there were two fairly good brewpubs in town, Boscos and Blackstone, but there just wasn't a lot of competition. I was lucky to be at the right place at the right time. People were excited to support local beer and a small business they believed in.

How did you initially get the word out about Yazoo?

Word-of-mouth. Nashville is like a lot of small towns jammed into one. By showing up with a growler of beer at a restaurant and saying, "Taste this before I start talking about it," I was able to connect with a lot of chefs and restaurateurs. In our restaurant community everyone knows what everyone else is doing. If someone is successful you'll see other people picking that same idea up quickly.

Where do you do your experimenting?

I still use my little 15-gallon home brewing system to create new flavors to this day. For any new style we brew a small batch and keep tweaking it until we get it right, and then scale that up to our big system.

What is the most trying element of owning a brewery?

As we've grown, it's making sure that in adding different balls to your juggling act you don't drop one. The initial flavors have skyrocketed, and while that's incredible, a small production facility makes it harder to add additional ones. Also, Tennessee has some of the highest beer taxes in the country, which means I have to be really lean with employees. Everyone chips in with brewing, packaging, filtering, making deliveries and pouring drafts at our weekend promotional events. By necessity you have to wear a lot of hats around here.

What is most meaningful about your days at Yazoo?

I love the creative aspect because it's a blend of art and science. You can make a technically perfect beer, but if it lacks creativity, then it's lifeless. Yet, you also have to be able to recreate those recipes time after time. I would say the physical component is most satisfying. Pouring a pint and being able to drink something that you made never gets old. Besides, I didn't open a brewery so I could sit behind a desk and count my money. That wouldn't take very long anyways.

What's been the most rewarding thing about owning your business?

Lila and I had kids around the same time we started the brewery. Yazoo seems like another family member that has grown up because it's taken on such a life of its own. I also love getting to know other beer lovers and brewers. On a small scale, it's a very collaborative industry. We all know one another and share information and experience.

Why do you think your business has thrived so greatly in Nashville?

The microbreweries here don't compete against one another but rather, collectively convert people to our style of beer. Our team mission is to take away business from the huge breweries that have completely dominated in the past. Maybe 20 years down the road we'll get a little sharp elbowed, but for now there's still a lot of growing room for everyone in the Southeast.

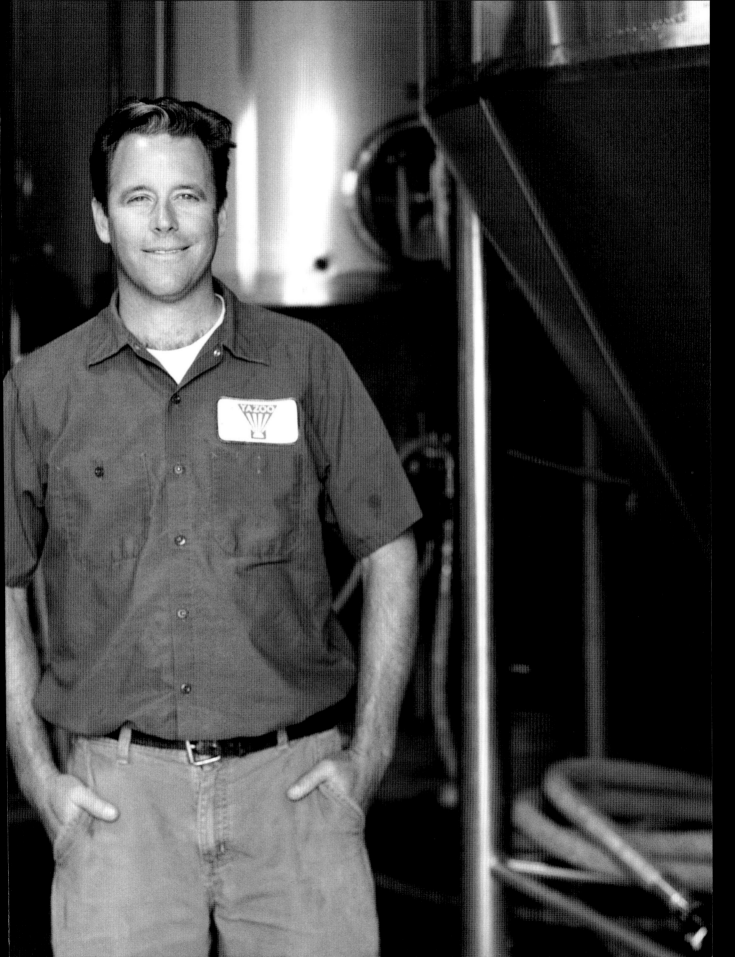

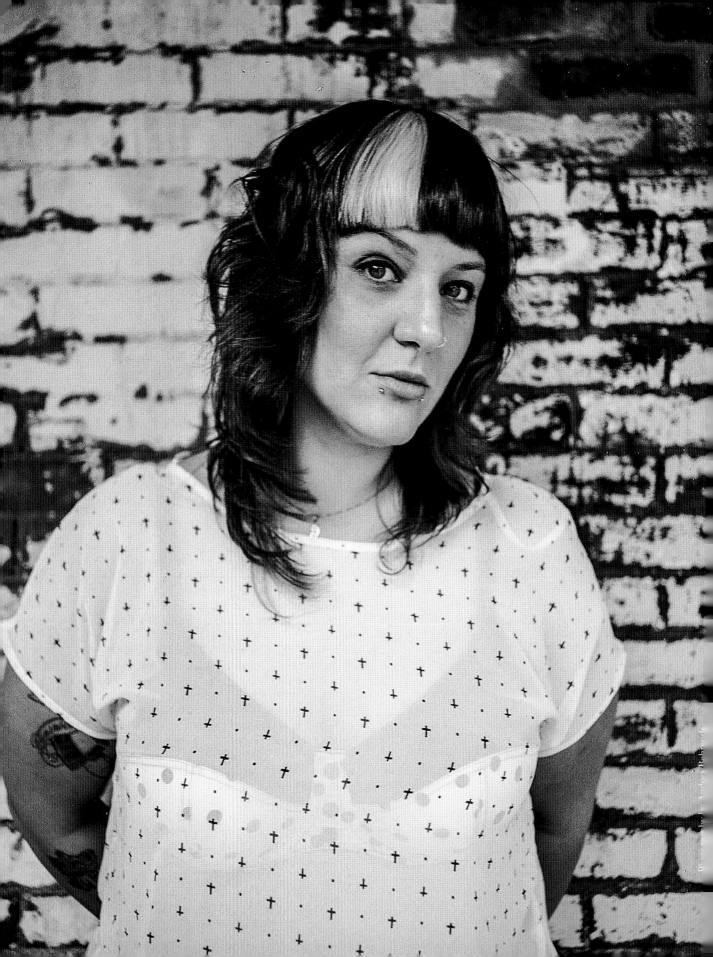

ALANNA QUINN-BROADUS

{*Entertainer & Front Woman*, Alanna Royale}

Act like a rock star and be perceived as one. No matter the size of the show, front woman Alanna Quinn-Broadus lends the illusion of a big-time situation. The namesake of local sensation, Alanna Royale, possesses an intangible allure that cannot be taught. Together Broadus and her fiancé, Royale guitarist Jared Colby, hustled their way to the crown of the local music circuit. After meeting at Berklee College of Music in Boston, the couple moved to Nashville with aspirations of stardom. They knew there wasn't a second chance for first impressions, and vowed to knock it out of the ballpark from the very beginning. After abandoning their former punk rock catalogue, the pair formed a band around four, du-wop ditties. Their brief, yet memorable sets quickly dismissed any skepticism surrounding overnight success. Shortly after introducing their soul and funk set in 2012, the sextet earned slots at Record Store Day, *Austin City Limits*, and Bonnaroo. Rather than reinvent the wheel, they simply injected a classic, Motown sound with a punk rock attitude. Broadus' party girl stage presence filled the gap between sexpot and songstress. Yet it is the pipes of the in-your-face front woman that have eclipsed the expectations of the industry's most respected players.

What was your first impression of Nashville?
My original friends are a solid group of people and players in the East Nashville community. While I was skeptical at first because everyone's trying to do his or her thing, there isn't a step-on-you to get to the top of the pile mentality. Ironically, people like to achieve success together here.

What were your plans when you initially move down here?
When we moved down here I thought I was going to work in publishing and Jared had hopes for working in a big studio. I quickly changed my mind because I don't like sitting down for long periods of time or looking at a computer for hours. I would much rather wait tables than work an 8-4.

How did you and your fiancé Jared begin playing music together?
Jared has been recording bands since he was a teenager. When we started dating we were in separate bands and never discussed playing music together. When both of our projects dissipated we started writing songs together, which is a difficult process because our brains are completely different. I hear, sing, and do whereas Jared is much more methodical. Our bandmates balance us out.

How did you form the sound for Alanna Royale?
We had written a bunch of grunge rock band songs, which we played for our current drummer before he declined joining us. So we played him our slower, du-wop songs and he said, "This I will do! No one else is playing music like this here." Ironically, I felt less confident about those songs but sure enough, it worked.

You "wouldn't play locally until the performance was perfect." Why?
You never know who is going to be on the other side of the stage or when your next opportunity will come. Also, when 90 percent of the audience is other talented musicians it can be slightly intimidating. I waited until I knew the band was up for the challenge.

There have been several bigwigs in Nashville who've been particular champions of your band.
I waited on Mike Grimes one day and he said, "Boston girl, come play at my venue!" We practiced for two months, which felt like an eternity, before we played at the Basement's New Faces night. They invited us to come back and headline the next month. Our second show was $2 Tuesday where our friend hustled the tip jar around and made us almost $200. Now he's our merch guy because he'll walk around with CDs hanging out of his pants and t-shirts over his shoulders like he's selling gold-plated toothbrushes on the corner of Chinatown.

What is your intention when you walk on the stage?
The audience should always be on the same emotional page as us. If we're playing a dance song and throwing it down, then we want the crowd shaking their ass. It's the same intention, different sentiment, if we're playing a heavy, sad song. I am always pushing to be bigger and better. Never will we play the same show twice.

How did you learn to own an audience as a front woman?
I should have been on the Mickey Mouse Club circuit as a kid because I always wanted to be the center of attention, although I didn't know to what capacity. While growing up in upstate New York, I was really into punk rock although I knew I would never play in a hardcore band. I sang in my high school's jazz band and continued with that genre at Berklee, Then again, I've always loved R&B music and wrote Mariah Carey-reminiscent, 90s summer jams while growing up. I was looking for my place because you can't sing jazz music and break bottles over people's head.

What are your particular responsibilities in running the band?
I'm the combined publicist and manager and handle seven different people's schedules. We work constantly because I don't have a Plan B. At the risk of sounding cheesy, if you have one then you never really wanted to accomplish your dream in the first place. That's what Will Smith said anyways.

What has been the biggest challenge?
I had no idea how much work it would be. Sometimes you want to cry or throw in the towel when someone says you're a flash in the pan or only good live. Still, the coverage we got after having only released four songs gave us so much ammo.

JUST BECAUSE I HAD A BAND DIDN'T MEAN THAT I WAS READY TO PLAY SHOWS. IT WAS IMPORTANT TO ME TO WAIT UNTIL I KNEW WE WERE REALLY, REALLY GOOD.

How did you get to be so confident and comfortable in your own skin?
If not me, then who else? I fully believe in my band and that we are creating something people should listen to. As the person with the microphone I get to speak up for us all.

What is the best advice you could give an aspiring musician?
Value your time because otherwise no one else will. People will try to get artists for as cheap as possible and drain their life force, and there's no guarantee at the end of the day.

What has been your secret to making such a splash in Nashville?
I hit the ground running upon arrival. I am an extremely competitive person and have no problems asking people for their contacts. My band lets me do my thing because I'm the Tasmanian devil of publicity. The bottom line was I didn't move 850 miles away from my friends and family to sit on my ass. You have to be excited about what you're doing to get other people to care! I hypnotize my audience into a trance to make them a fan. Sometimes people like what scares them.

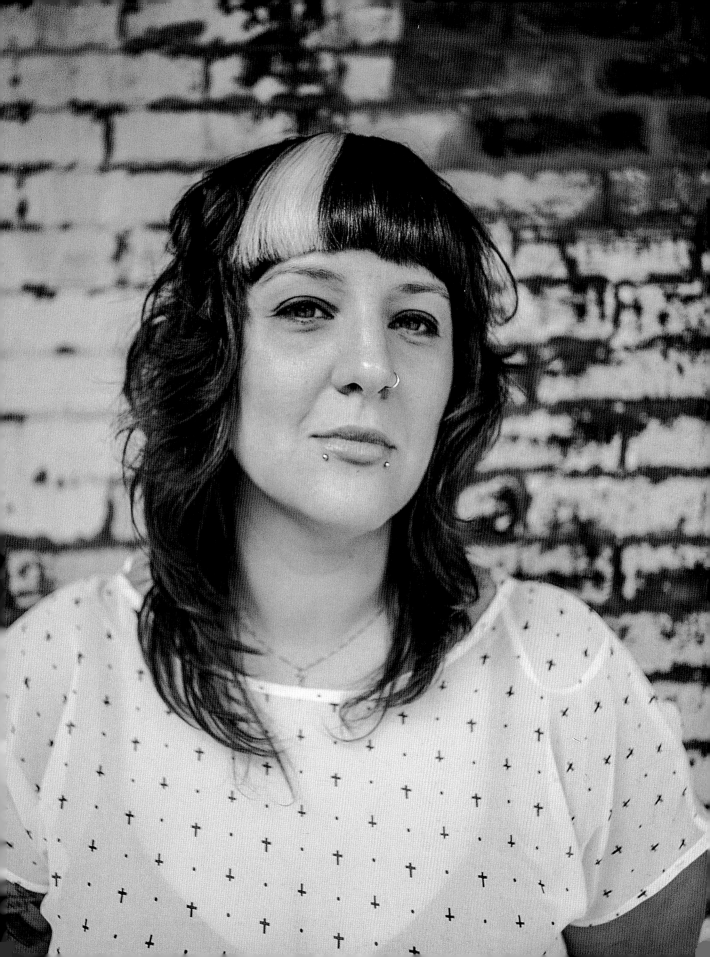

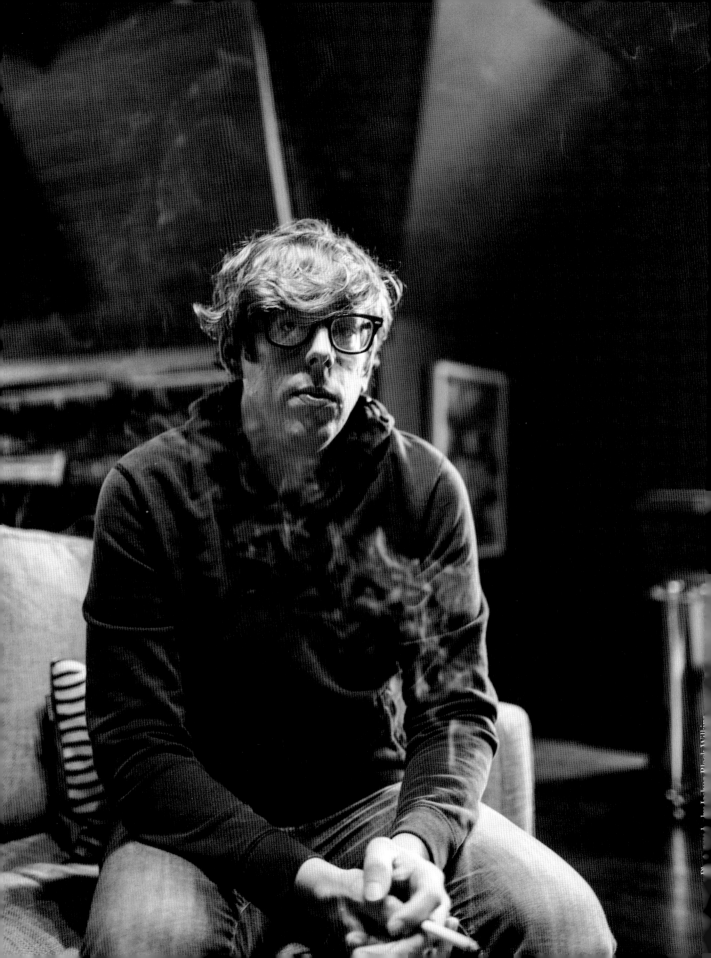

PATRICK CARNEY

{*Musician*, The Black Keys *& Producer*}

Patrick Carney initially wanted to be a producer—someone who brought out the best in a band without letting them stray too far from their origin. He is known for his role as drummer in Grammy-winning duo The Black Keys. Yet, orchestrating the sounds of others most nourishes his passion for music. The Black Keys' decade-long evolution has provided Carney with a self-taught trajectory. He understands the unique producer-artist relationship and the trust that must exist between the two. Carney prefers to work with bands who are willing to explore unfamiliar territory, escape their comfort zones, and get a little out of control. As a third party, he filters and fine-tunes an album, while avoiding any set formulas. He thrives in the unknown territory that is the recording process. His most accomplished work is spontaneous, in the same vein as a live performance. By adding his stamp of approval to various artists, Carney hopes to highlight the underdogs, and pass forward the success he has achieved.

When did you first become interested in producing?

That's what initially I wanted to do. When Dan [Auerbach, The Black Keys lead guitarist and singer] and I were in high school, he had a cover band that wanted to make a demo. I had just bought this digital recorder, which was a big deal in Akron because I made $5 an hour. Dan came over, and his band never showed. So he, my friend Gabe and I recorded a demo together, which turned into a record deal. The whole reason all of this happened was because I wanted to record bands. Making albums always really interested me.

You started off producing The Black Keys and eventually moved onto working with bands like The Royal Bangs, Tennis, and The Sheepdogs, whose album won the equivalent of a Canadian Grammy. Does it bother you that a lot of your production work goes unnoticed?

It bothers me sometimes, but I expect that to happen because most of the stuff I listen to has gone completely under the radar. I've been producing three records a

year for the last three years, and when I lived in Ohio, I recorded bands constantly. They would usually sell one hundred copies. It's weird for me to experience what bands have to go through, because even with a good record with my name attached, they still run into trouble with their labels. There's something about making an album you're proud of and watching the band's frustration. It reminds me of when Dan and I first became a band, because even though we had a label, the only way we could make things work was by touring a lot. That and tons and tons of luck, you know?

How do you choose the musicians you work with?

I just work with bands that I really, really like and who agree to work with me. Most of the time it tends to be small bands. It keeps me in check and motivated to stay in touch with what it's like in the real world of making albums when no one gives a shit. Every week I hear a record that's really fucking good, and not enough people pay attention to it. And maybe once a year I hear a record that's really good and everyone pays attention. Most

good music is ignored. I still get freaked out if something I've worked on is played on the radio. I get such a kick out of it because it's just so rare for that to happen.

Is it more pressure to produce someone else's music than your own?

My production style is completely collaborative. I like when a band puts me in an uncomfortable position, and I do the same. Everybody compromises and walks that line where you come up with something that's bigger than the sum of its parts. There's always pressure when you're making a record, because if you're doing it right, in my mind, you don't know what's going to happen. There's an uncertainty and that's the exciting thing about art in general. If you know going into it knowing exactly what's going to happen, then that's more of a science. That's why pop music becomes so boring, because it's written to a formula. It's rare to hear something in the pop world that's not directly borrowing from something else.

How do you earn a band's trust to help shape their sound and add your touch?

You never work with a band that you don't love or see a way you could help expand their sound. There are a lot of bands I love and would never want to work with because it'd be hard to touch anything they've done in the past. I like working with new bands that are still figuring their shit out. Every band has its own chemistry and combinations of people, and it's about trying to negotiate that. The main thing I relate to completely, and why I build trust with certain artists, is that for a long time, Dan and I were scared to work with or let anyone else in. It wasn't until we found Brian Burton [aka Danger Mouse] and worked with him a couple of times that we got really comfortable with the process. One way I build trust is I can relate to the fear that someone might come in and water down the sound or make it something other than what they originally intended. Dan and I have made really cool albums on our own, but we do have a hard time producing ourselves lately. I think at a certain point, when you're really trying to push things forward, you need outside influence to do it.

Does producing other bands have a positive affect on your own music?

Absolutely. One thing I regret a little is that Dan and I didn't try to work with other people earlier. And if we hadn't bent and worked with Brian, our music would have gotten really stale. If you're trying to start a career and tour, it definitely helps to take your ideas and filter them through another person. Early on, Dan and I worked well together because we bounced ideas off one another, and at this point, can predict what the other one is going to like or not. It's always good to have a deal breaker in the room. We don't know which person they're going to side with, but in the end, everyone has to agree on it. The only downside is we used to be able to make a record in a day, and now it takes us a month or longer.

It's hard to find that balance, to create something people will like but that you also want to play over and over again yourself. You just want to create something good, but not necessarily everything that's good people are going to like. When we made *Brothers*, it was a big departure from our previous record, and we didn't know whether or not anybody was going to like it, and it sold a lot of copies. Then we went into the studio to make *El Camino*. We had worked a decade to make a record that was cool and not give a fuck about it. It was kind of a risky proposition to change our sound completely at the peak of what we've been working towards, but that's why music is fun. You're trying to do something different on every record. And most of the bands that I love—like The Clash, Beatles or Sonic Youth—never made the same record twice.

What has always been the end goal for you as a musician?

It's always been just to have people at our shows. We spent a lot of time playing shows to very few people and then three hundred or five hundred people, which, at the time, we thought was tons. When we got to one thousand seats and then our first arena, it was kind of bizarre because we've never been trying to get to the next spot. It's just kind of happened. I like being on a major label and not having to fight with them because you know you're making them money.

When you were playing as a no-name band at small rock clubs, what made you know it was all going to be worth it in the end?

We didn't, and I still don't know if anybody's going to like our new album. You never know. And in a way, it's easier when you're first starting out because you can make records without thinking twice about it. Now we make a record and realize this is something we only get to do every two years. You want to make sure it's the best and start second-guessing yourself, but that's all part of the process. What it comes down to is Dan and I like to make music. We recorded almost thirty-five songs for this new record, and we're trying to figure out now which eleven we want to hear over and over again for the next two years. For me, music is like a life force or special power, and I can deplete it. Putting it aside is what keeps it special, like summer break for kids. The last day you can't wait to get the fuck out of school, but everyone always wants to go back and see their friends.

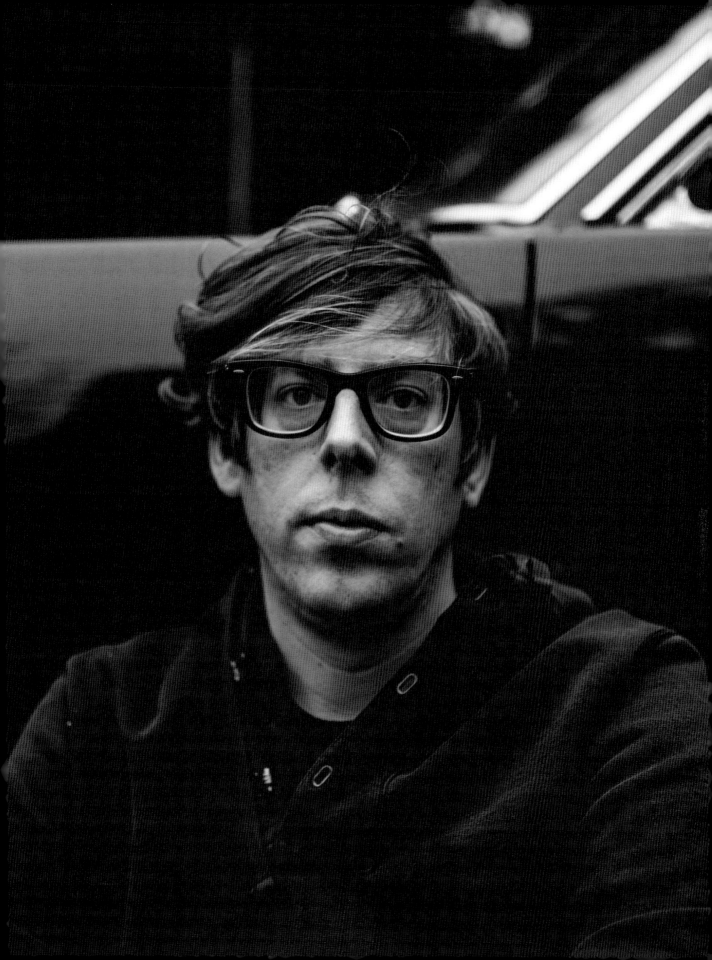

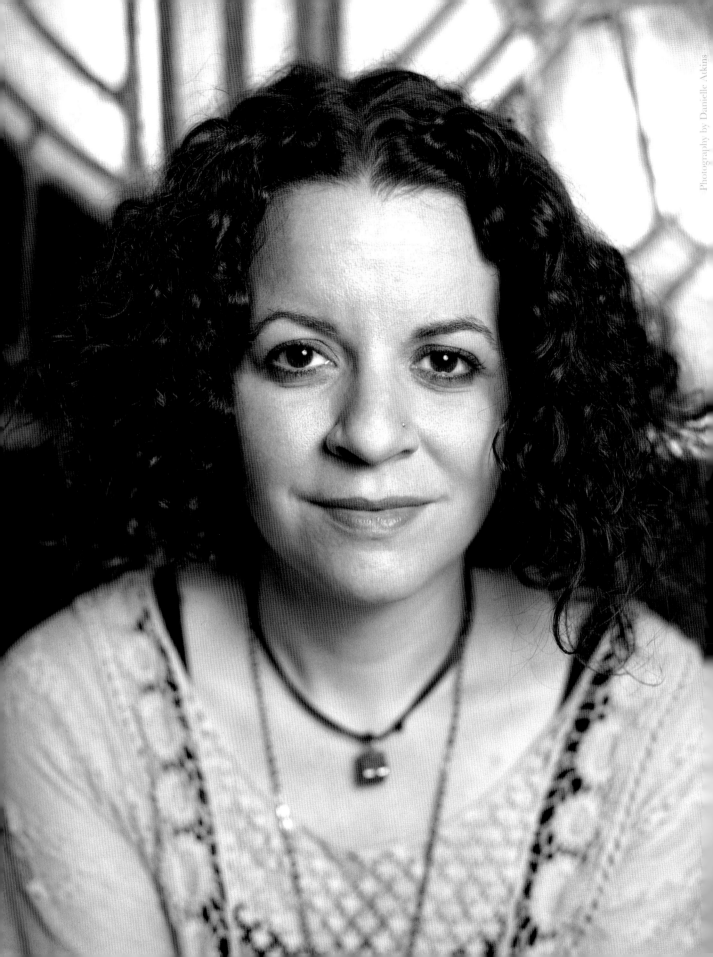

TASHA FRENCH LEMLEY

{*Founder*, The Contributor}

Tasha French Lemley's jobs have always involved saving the day. However, *The Contributor* founder commends a gentleman named Don for changing the course of her life. On her way to work one morning, she met a fellow kindred spirit who sang and drummed for his supper on a downtown corner. There a simple hello was exchanged and a friendship forged, which would become the blueprint for Nashville's first street newspaper. The photojournalist began documenting Nashville's homeless society whose humor, intellect, and demeanor she related to. She has always loved learning through people who've had different experiences than her own, and quickly became infatuated with the city's street culture. In 2007, she and cofounder Tom Wills inaugurated the first issue of *The Contributor*. The mission was to educate readers on issues surrounding poverty and provide a source of revenue to the jobless. Most importantly, since its inception lives have been changed on both sides of the fence. By allowing an opportunity for vendors and customers to dialogue, Lemley inadvertently recreated her original experience.

How did you meet the man who inspired you to found *The Contributor*?

I would pass by Don everyday on the way to work although we never addressed one another. One day it hit me that if he were my "equal" we would have introduced ourselves a long time ago. One day on my way to work, I parked the car, walked up to him, stuck out my hand and said, "Hi I'm Tasha." Everyday after that I would think of something to ask him because I figured that he knew something I didn't.

How did meeting Don impact you?

I became completely fascinated with the homeless culture, which re-inspired my photography. As someone who was forced to live his private life in the public eye, he would do the most beautiful things. One day I caught him shaving with a disposable razor by looking at the reflection in his watch face. That simple act said so much about him and humanity.

Did you capture those moments?

No, but they inspired me to eventually photograph him. One day I asked if I could and he became really excited about it. He had this kind of Frank Sinatra vibe and I photographed him with my 35mm film Nikon on a drizzly day. One day a MDHA Homeless Outreach worker named Lee saw my photos and asked if I'd like to do more. I started following him around Riverfront Park, making portraits and hanging out with strange men in alleys at night. It was everything that a 5'1", middle class white girl isn't supposed to do.

I THINK PEOPLE WERE HUNGRY TO GIVE TO THE PERSON DIRECTLY IN FRONT OF THEM RATHER THAN THE COLLECTION PLATE.

How did the idea of founding a street newspaper cross your radar?

I was familiar with them through my travels although I had never actually bought one before. When I first became interested in homelessness I heard a commentary on NPR by a man named Lee Stringer who authored the book, *Grand Central Winter*. He was a homeless addict on the streets of New York City for about a dozen years and ended up becoming the editor of *Street News*. I just fell in love with his story and ended up befriending Lee, which really planted the seed. I couldn't get hired by any publication in Nashville or have any of my photos published so I thought, I'll just start my own damn paper.

I know as a writer I always want to relate to my subjects so I'm wondering if it's difficult at times to forge a connection with the vendors?

I can't relate at all to what my homeless friends have gone through. While you can duplicate the physical discomfort through urban plunges, where you sleep on the street for a couple of days, I can't ever know the mental anguish and emotional trauma. I'll never know what it's like to have exhausted all of my resources and have nowhere to go. Something I learned very quickly is to be respectful of the fact that you are entering their home, even if it's public property or a bench.

There are some people who believe homeless people should seek "a real job." Have you faced that adversity in the past?

If we were selling apples to someone for .25 cents, and they were in turn selling them for $1 that would be considered a real job. It was important to me from day one that our quality of content continues to increase, and we spend a lot of time and money reporting on the issues surrounding homelessness and poverty. Why is that any different than selling produce?

Do you ever worry about gentrification negatively impact what you're doing?

No. We serve a small, yet significant portion of people who have experienced homelessness. As long as we can remain within the bus line we'll be fine.

Is the issue itself ever overwhelming?

The issue of homelessness isn't so much to me, because I feel really optimistic that we're seeing lives changed, but the nuts and bolts of the organization have become incredibly frustrating at times.

What is it that keeps you going during times like the summer of 2013 where *The Contributor* literally ran out of money to print a newspaper?

That's a tough question. A few years ago, after a speaking engagement, a girl came up to me and said, "You recreated your original experience with Don." Hearing that made it worthwhile and helps me realize this project is changing lives on both sides of the socioeconomic divide. We're still by far the highest circulating street newspaper per capita in the world and numbers-wise are the highest circulating in any city North American city. The community supports us and we need to be here.

What is it about Nashville as a community that is so philanthropic?

I think people were hungry to give to the person directly in front of them rather than the collection plate. I think people were dying for that interaction, and we didn't know that was something we were tapping into initially. People are in love with their vendors, and the vendors are in love with their customers and that's where our success stems from.

While Nashville is becoming increasingly congested and fast paced, people still take the time to smile and say "hello" to you on the street. In bigger cities people are more in self-protection mode of their safety and schedule.

Nashville is relaxed and engaging, and the newspaper gave people an excuse to do that. It's easy to look at the 50-something, white male sleeping on the bench and say, "*that's* what homelessness is." We get criticized because some of our vendors look too homeless and others don't look "homeless enough." Homeless people look all kinds of ways. The loud, aggressive panhandler has stereotyped all of their brothers and sisters simply because they're the loudest of the bunch.

Note: Lemley left the paper to embark on other ventures in 2014.

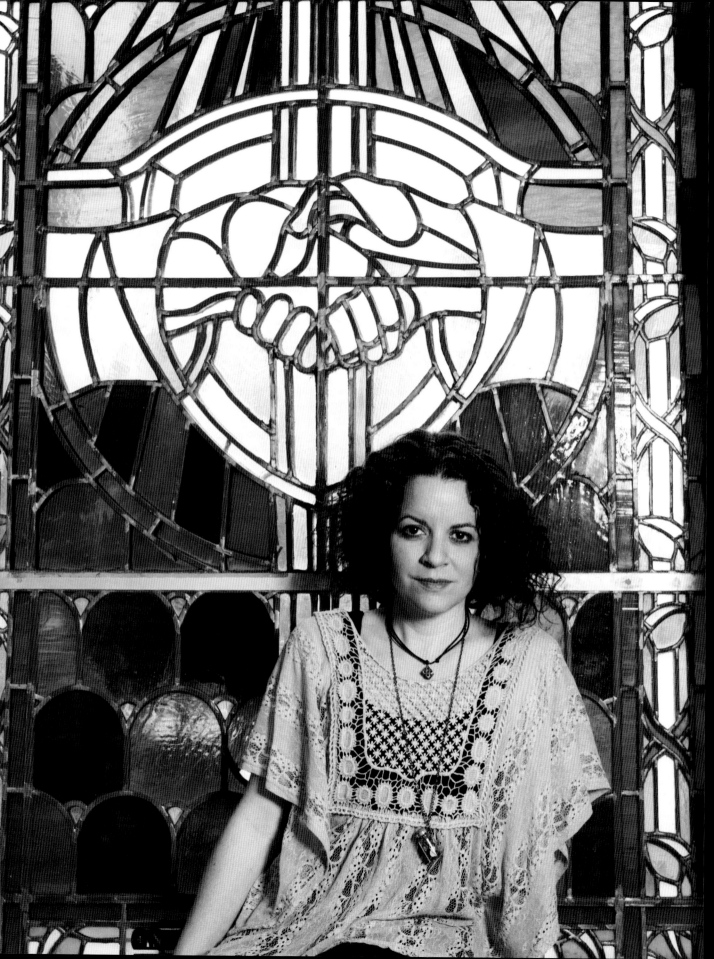

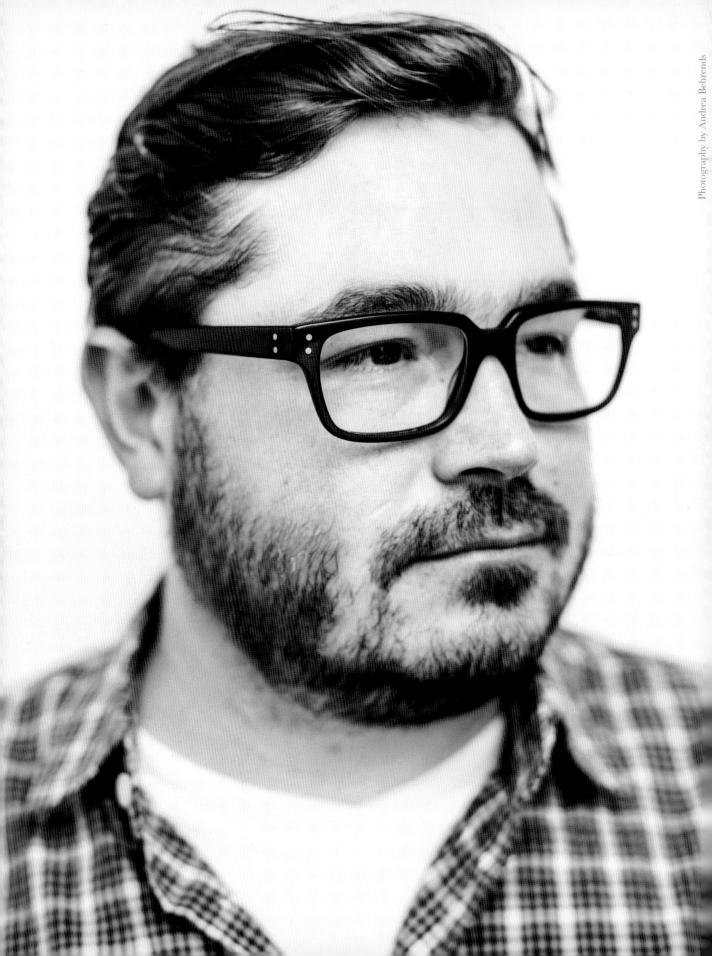

Photography by Andrea Behrends

SEAN BROCK

{*Chef/Restaurateur,* Husk *& Author,* Heritage}

The ability to cook what is at an arm's length makes for a great chef in Sean Brock's mind. In his opinion, it is the only way to truly taste the South. The James Beard award-winner behind Charleston, South Carolina spinoff Husk Nashville isn't satisfied unless he is pushing himself to the extreme. However, Brock's greatest inspiration comes from a rather relaxed, rural Virginia upbringing. After years of searching high and low for inspiration, he realized it was right underneath his nose. Like most families in their hometown, Brock's family grew and harvested everything they ate. Snapping peas, shredding cabbage, and cracking walnuts were simply a part of daily life. As exemplified by the heirloom vegetables tattooed on his arms, they later on, instilled in the chef an unwavering appreciation for food. After beginning his career in Charleston, and later on Nashville, the chef became impassioned about resuscitating traditional Southern cuisine. Taking an anthropological and historical approach, he began incorporating 19th century recipes, philosophies, and plant life on the plate. Seed preservation, antebellum crops, and heritage breeds of livestock have since become part of his crusade. They go along with Brock's adrenaline junkie theory that scarcity results in heightened creativity. The hillbilly kid from the coalfields and trailer parks still had a hard time believing how far he's come.

"Growing up that far back in the mountains is a very secluded lifestyle because we never traveled outside of the South. I just assumed that was the way the rest of the world lived until I was 13 and moved to a more urban environment in West Virginia. Until I was 15, I had never been to a restaurant that wasn't a cafeteria or a Sizzler chain steakhouse. To think that my grandmother would ever go to a grocery store would blow my mind. We grew everything during the harvesting months and in the wintertime, ate preserved food. It inspired the concept behind my restaurant, which is only serving food that I know the farmers behind.

It wasn't until age 16 when I started cooking in professional kitchens that I realized most of what restaurants serve is crap. I could tell by the flavor, character, texture, smell, and aroma of the vegetables. After a childhood where I cut my own lettuce in the field, to see a cardboard box with a plastic bag full of mixed mescaline greens was depressing.

Everyone I grew up with loved to eat, so they were selfish about growing what they personally liked. I started gardening myself because I was tired of what produce companies offered. However, when I took on the responsibility of a garden in 2007, I realized how difficult it was. It gave me the incentive to go home and get as much agricultural knowledge as I could from my grandmother, mother,

IF YOU'RE GIVEN A TALENT AND LOVE FOR SOMETHING IT'S IMPORTANT TO REALIZE HOW SPECIAL THAT IS.

and step-grandpa. My entire family is master gardeners whose techniques come from generations before them. My grandmother had saved a seed collection every single year. After her funeral, I grabbed her vinegar mother and seeds that she stored in pill bottles. We grew them all summer long at Husk. My own seed collection has 150 varieties of beans, and each is named after a family, person or area. While each is slightly different in flavor and appearance most importantly, there's a story behind it, which is passed down over the years.

Making my grandmother's handwritten recipes word-for-word is a different kind of enjoyment and emotional experience. It connects me to my family, which is an incredible source of inspiration. I don't care what anybody says because that care and passion comes across on the plate.

I believe cuisines are formed because of a combination of cultural influences, plants, and livestock that thrive in a particular area. At Husk, we limit ourselves to food produced, raised, and harvested in the South because it also allows products to really speak for themselves. It allows customers to truly taste the region, and has accelerated my own learning by putting new situations in front of me.

Ordering produce from Mexico is against our rules, and that forces you to create new techniques. When you have 60 ingredients from all over the world, a head of cabbage doesn't have the same level of excitement. A carrot could be sweeter or bitter the next day depending on the weather and rainfall therefore, you're cooking differently one day from the next. My cooks are learning on a different level, rather than robots that clock in and make the same meals everyday.

Some days this job is painful, but it's what I choose and want to do. Most cooks that have worked for me think I'm out of my mind, which I tell them in the interview process: "This is going to be the most difficult job you've ever had, but you'll learn more than you ever could have

dreamt." Some folks quit before they even step foot into the kitchen. One of my employees had a heart attack on the job. My guys come in at 9 a.m., cook for 170 people at lunch, prep, another 170 at dinner, and walk out of here at 1 a.m. It's insane, nuts. Who would want to do that? That being said, if you've been given a great love for something it should motivate you to have a stellar ethic. Once you express your gratitude for that gift, then you have to work hard to pay back that debt.

When I was 24 years old I took over as executive chef at the newly renovated Hermitage Hotel. The second night we were open, we did three times as many covers as that restaurant has ever done since. We also got the worst review I've ever read the next day. That was February, and I slept in the kitchen until the middle of December when we got reviewed again. That's just the way I am. However, from my experience if you work hard, keep your head down, and share your gifts good things do happen.

If I stand at the stove for the rest of my life, I'll break in half or be dead at 50. I want to do TV and write. *The Mind of a Chef,* the eight-episode show I did with Anthony Bourdain, was amazing. Chefs love to share and create experiences, but that platform is only so big. With television you can share your passions, discoveries and experiences on a global level. Lately, I'm most interested in Southern artisans and makers who add something to the quilt of a certain area.

Writing is something I really love, and I've decided to always be working on a book. Once I was profiled in *The New Yorker* and, while that process was grueling, I realized how therapeutic it was to unload. Sometimes after I've had a few cocktails it's really entertaining, and my warped sense of humor certainly comes through in the storytelling. I always keep notebooks handy for free writing and would eventually love to go back to school for it one day. It's great exercise for your mind that keeps me alert, aware, and focused.

My goal is to inspire people to be proud of where they're from, period. As an adult, my pride in the South has changed my perspective on what it means to be a human being. America is just now coming into our own and people are realizing that the South is a huge part of that evolution. In my opinion, it's quite possibly the most special place in our country.

At the end of the day, I want to encourage as many people as possible to explore, ask questions, and dig into their family and region's history. It's all about understanding where you come from. Does that make sense?

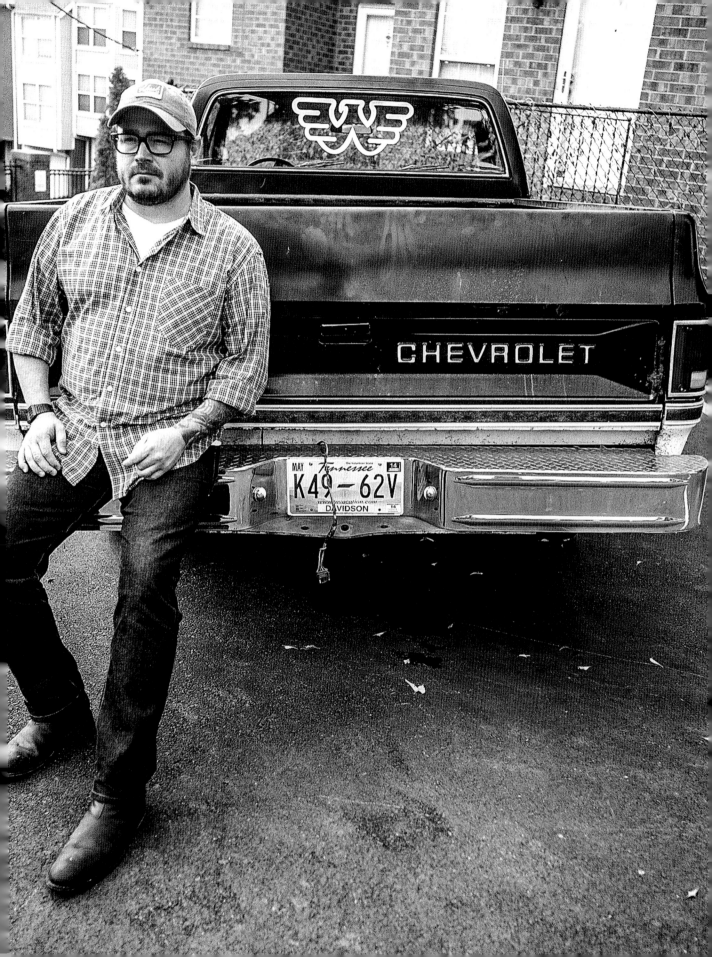

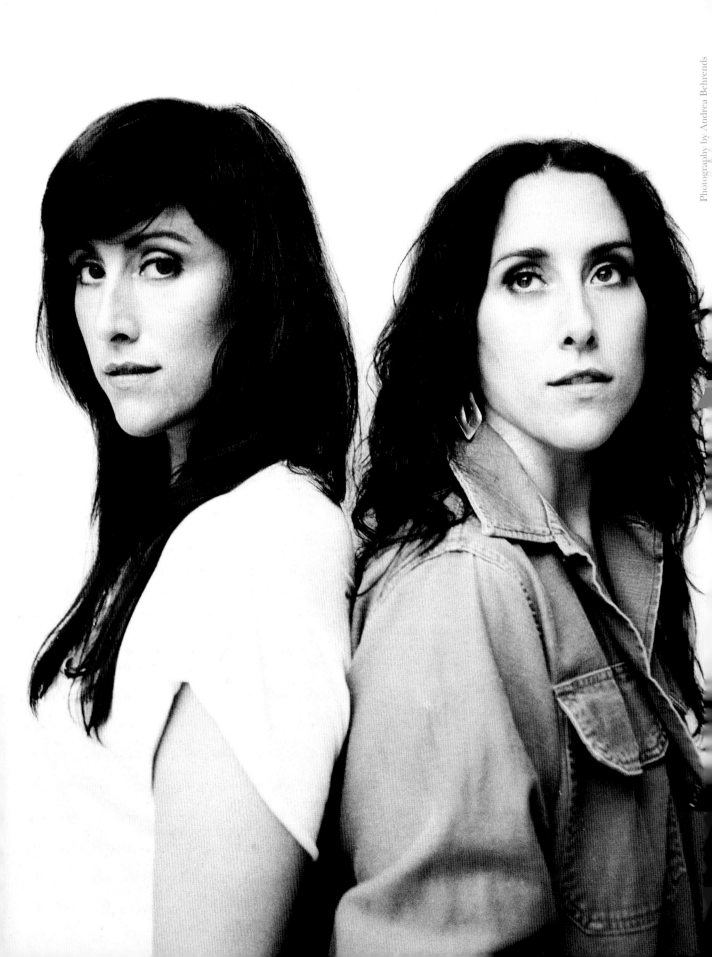

WATSON TWINS

{*Singer/Songwriters, Co-founders of* The Cordelle}

Together, Chandra and Leigh Watson are the truest form of themselves. As backup vocalists, The Watson Twins strive to complement the artist's vision. Their Rutledge Hill event space, The Cordelle, has a similar goal in mind: to find that sweet spot where they and the city blend together. The Cordelle has given Chandra and Leigh much-craved stability after fifteen-years in the music industry. However, singing will always be the sister's first love. In their hometown of Louisville, Kentucky, they got a head start while in the womb. When performing in the church choir Chandra and Leigh realized singing was their means of spiritual connection. Shortly after college, they relocated to musical hotbed Silverlake, Los Angeles where the artists hit the ground running by supporting larger acts such as Jenny Lewis, The Shins, and Death Cab for Cutie. Several years ago, other ambitions began nagging, and the sisters decided it was time to start a new chapter in their lives. Chandra and Leigh chose Nashville as the place to reinvent their identities and explore new territory as businesswomen. The Cordelle has become the center of the sister's world and allowed their passion for southern hospitality to take precedence. The venue is a perennial reminder to push their creative comfort zones and always stick to their guns. By doing "the Watson Twins thing" Chandra and Leigh make every endeavor wholly their own.

This is my first time interviewing twins. What is that dynamic like in terms of creating?

Leigh: She'll never admit it, but I taught her everything she knows.

Chandra: We're very truthful and don't have a problem saying, "That chorus sucks, back to the drawing board."

Leigh: That partner in crime mentality has pushed us to move forward if one of us ever wanted to throw in the towel. There were moments where one of us felt like it wasn't worth it and the other one did. We knew we'd worked too hard to bail on one another. Then, suddenly, we'd get a record deal.

Chandra: Although we always joke, "You're fired from the band. I'm going solo as The Watson Twin!"

Aside from each other, what kept you going during those times when you wanted to give up?

Chandra: Every time we'd talk about going on hiatus, something big would happen.

Leigh: That's where spirituality, faith, and belief in what you're doing become the momentum. It's about the trust of letting go. When you put that out into the universe, those things come back to you.

Chandra: Having the death grip on your career is the worst thing you can do to yourself. You have to let things organically evolve, nurture them, and support yourself and the people around you. That's the environment where things flourish. If you're being a curmudgeon who wants to be around that?

Leigh: I'm too old for that shit.

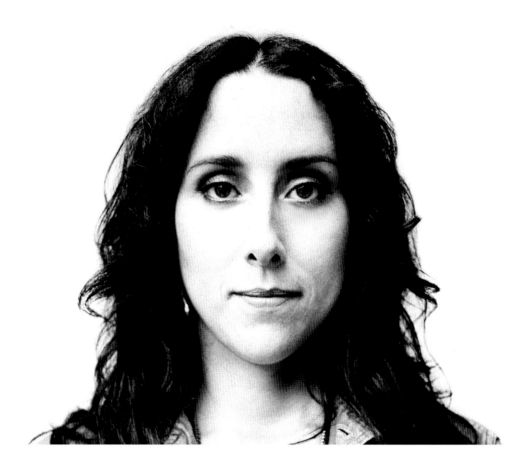

How did the idea of The Cordelle come about?

Leigh: My mom suggested it. I was planning my wedding at the time and wanted an event space that felt urban and contemporary. My husband and I really wanted our wedding to be downtown and our guests to have a true Nashville experience. The Cordelle was founded upon the idea of adding something creative and complementary to the city.

Chandra: When we really started to dig into Nashville it started to become a lot more than just the music hotbed that we always knew it was. Even though an event space was out of our wheelhouse, we're all creatives and knew it would be an adventure. We had been managing our music business for a long time, and through that, know you figure things out and don't allow obstacles to set you back. Everything organically came together from the construction process to deciding who would be the CFO, marketing, and salesperson between Leigh, myself and our partner Neely.

Leigh: There is always a sense of diplomacy in how we do everything. If all three people didn't agree upon an idea, then it didn't happen. That kept our vision really pure and also allowed us to work as a team. Even at the hardest moments, there was the desire to make everybody happy. Our reception has been so warm and welcoming in Nashville. If you have a good idea, shoot from the hip, strike from the heart, and your vision is pure, people will support it. Even other event space owners were like, "The water's great; come on in!"

What's been the most rewarding thing about starting this company so far?

Chandra: We've loved working with the local vendors and artisans. Not only are they people we respect and admire, but they made our vision extremely unique and community-driven. Hosting a mixture of corporate, music industry, art world, and wedding events keeps thing interesting and us inspired. Even if it's crazy and stressful, we're part of the fabric in the history of these people's lives now. What we created is where they're sharing these important dates, and that is extremely touching.

What's been most challenging about embarking on this new adventure?

Chandra: Art, as you know, is always changing and

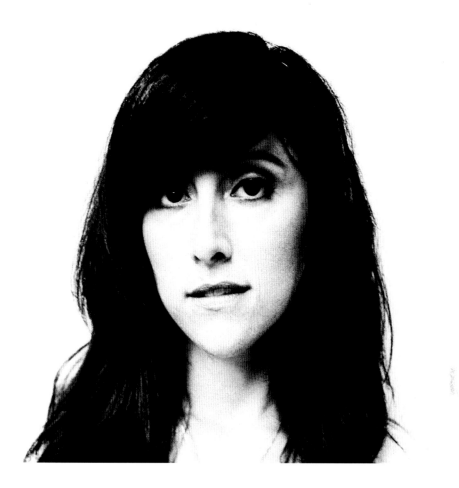

moving. It's been refreshing to have this brick-and-mortar place, which is totally solid. This is the heart and soul. It's the center of the universe, and we rotate like satellites around The Cordelle to grow and maintain what happens here.

Leigh: We've all thrown a lot of parties and knew—from lighting to having music play throughout the space—what makes a good party happen. We want our clients' events to be his or her own and create a space that functions really well stress-free. We love people, entertaining, and being around others. That energy trickles down from the top of the pyramid, as well.

How do you know if a certain art form or project resonates with you?

Leigh: We love creating in general, and music was just something we were good at, gravitated towards, and could do together. Harmony is something we were born with, but it's also about having supreme dedication and working hard on your craft. Our mission as musicians has never been to become stars. We always joke that we are 'famous adjacent' and have been fortunate to sing with a lot of talented, and amazing people.

Chandra: If you would have told me when I was in college that I'd be onstage with "fill in the blank," I would have said, "You're crazy. How would that ever happen?"

Leigh: I think success is all about timing, passion, and luck.

Chandra: I always say the stars have to align. When we were coming up in the L.A. music scene, Silverlake was a zygote of what it is now. Then all of a sudden Beck and Elliott Smith were in the neighborhood, and you started seeing articles in *Rolling Stone* about how it was a musical hub. We wanted to live there because of all the indie rock clubs, and within weeks started meeting other musicians who were excited and wanted to collaborate. We surrounded ourselves with others who were working towards the same goal.

Chandra: Our goal has always been to pay our bills, stay out of debt, and have food to eat. There's an intoxication and misunderstanding of what fame is, and when we saw firsthand the struggles celebrities have I was like, "You know I'm cool with being right here on the sidelines."

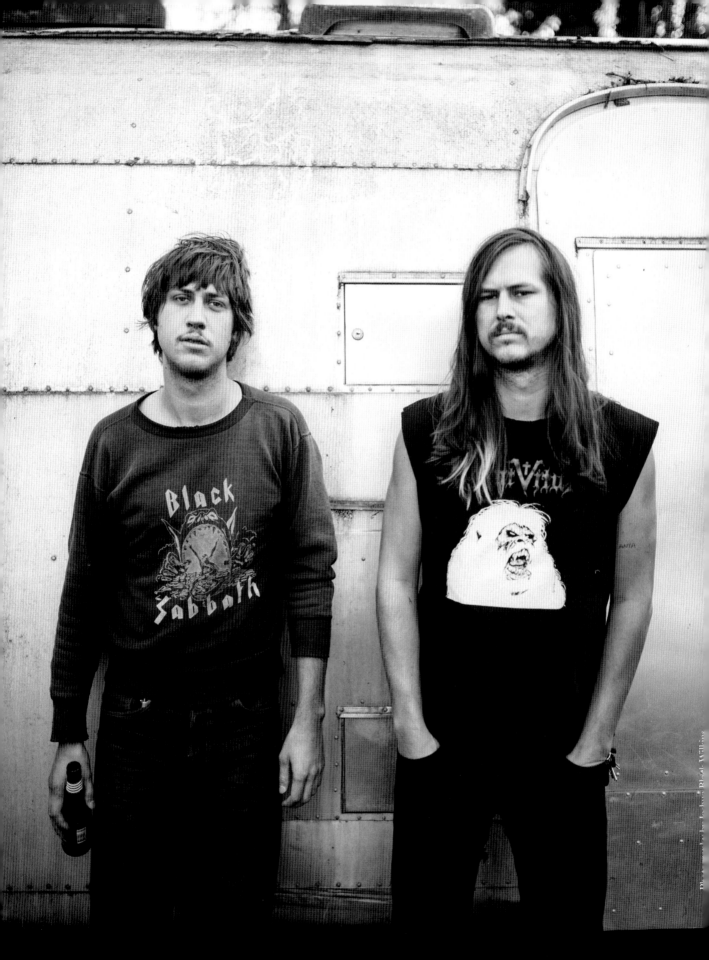

JEFF THE BROTHERHOOD

{*Musicians*}

Total dedication and no distractions is the only way to have a lasting career in the music industry. That's how Nashville natives Jamin and Jake Orrall see it anyways. They are respectively, the drummer and guitarist of garage rock duo JEFF the Brotherhood and co-founders of independent label Infinity Cat Recordings, along with their singer-songwriter and producer father Robert Ellis Orrall. The family established their label to provide an alternative for musicians outside of the country music market. While Jamin is no longer actively involved, Jake works as a producer and recording engineer on the rare occasions that JEFF is in town. Rock 'n' roll is all the siblings have ever known, as they have played together, and separately, since childhood. The musicians made their first foray into the industry with their high school band, The Sex, which has since been reincarnated into JEFF the Brotherhood. Even when the brothers were signed to Warner Bros. Records, a level head kept their egos in check. They find equal enjoyment playing a riotous house party as headlining sold-out concert halls. In the midst of writing an album, they get atypically serious about the ups, downs, and all-around truths of life as professional musicians. Creative freedom is more crucial than financial stability, which is why their latest album will be released through Infinity Cat.

When and why did you decide to pursue JEFF the Brotherhood and being in a band fulltime?
Jamin: Like as a job?
Jake: In 2009. The album we made at the time was way better than anything we'd ever done.
Jamin: I'd just left Chicago where I was going to school for animation. We decided to try it for two years to see if we could make a living off of it. We moved out of our houses and quit our jobs.
Jake: We lived in our van and had our stuff in a storage space for a year and a half.

Did your parents think you had lost your minds?
Jake: No. We have really cool parents.
Jamin: As long as we're happy, they're happy.

How did you develop JEFF's sound?
Jamin: We started out playing punk music because it's the easiest.
Jake: When we were ten and twelve we started beat-ing on the guitar and drums. We were like, "Whoa! We don't have to be good at our instruments!"
Jamin: We started playing our first all-ages shows when I was thirteen and he was fifteen at Guido's Pizzeria in 2001.
Jake: There was literally one other band at my high school, and they were our rival band. At first it was hyper competitive, and then we became a community.

Why do you two still like playing together so much after all these years?
Jamin: It's just convenient for us at this point.
Jake: We never intended to be a two-piece band, but we grew up in the country. If there had been another kid in our town who played bass, we probably would have brought him on to jam with us.
Jamin: Recently we brought on two new band members because it had been eleven years of just the two of us. It totally revitalized our excitement about the band.

What keeps you excited about playing music?

Jake: Outside influences.

Jamin: Sometimes we get each other excited. But if we hadn't gotten to the point where it's our source of income now, I don't know if we'd still be doing it.

Jake: We've both been in countless bands, but this is the one that stuck. We're still trying to make a go at it because we live off of it.

Jamin: This one was the most financially successful because we put in the most work.

Would you recommend Nashville as a place for other aspiring musicians to live?

Jamin: Yes, because there's no point in living in an expensive city when you're trying to make music.

Jake: Agreed. A band should be playing everywhere but their hometown. And if anything important happens in L.A. or NYC, you go there as needed.

Some bands get a big ego and think they're better than playing at dive bars or a small club, but you guys enjoy playing wherever.

Jamin: We just play wherever seems like it's going to be fun.

How many dates do you play a year?

Jake: Usually two hundred forty to two hundred sixty. This is the first year we've been off for over a month since 2009.

When you play two hundred forty shows a year, how do you get hyped up every night?

Jake: You don't. You get burned out, and most of the shows are boring.

Jamin: It's not a good idea to play longer than you have to.

But you always deliver.

Jake: Absolutely, because it's a performance. You're not going onstage to be yourself. You take what the audience gives you and if it's nothing, then you act.

Jamin: And then you receive a bad review saying, "The band looked disinterested."

Golden question. Why do you love doing what you do?

Jake: Getting to do music fulltime is like winning the lottery. No one "gets" to do it, it's that most people don't try to do it because it's so hard to make money.

Jamin: I think it's fun.

Jake: It's fun, and we actually happen to make money doing it.

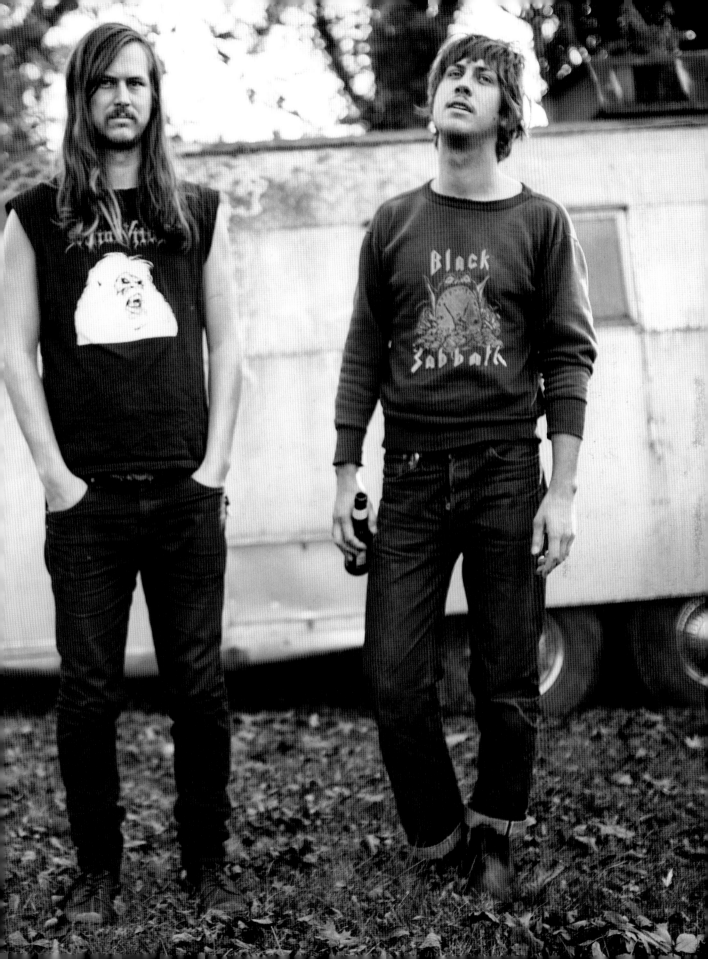

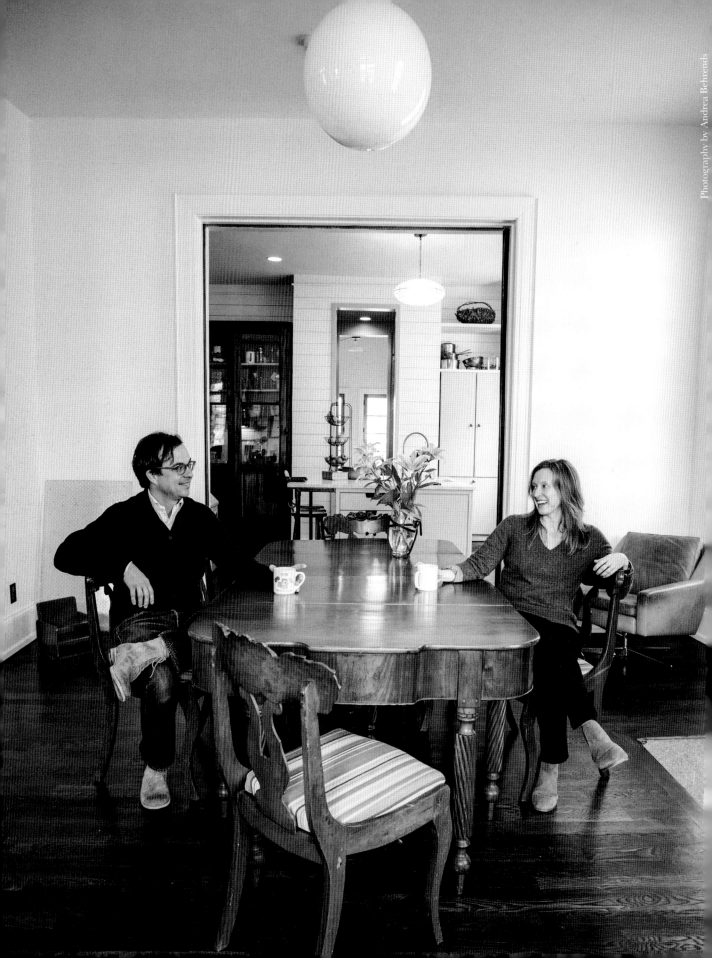

Photography by Andrea Behrends

NICK DRYDEN + CAROLINE ALLISON

{*Photographer & Architect/Owner* DAAD}

In their respective industries Nick Dryden and Caroline "Lina" Allison take relics and repurpose them. The married couple is fascinated by Nashville's history and incorporates it when possible into their projects. Dryden is co-founder and lead designer of architecture firm DAAD Group and Allison, a fine art and editorial photographer. Even prior to meeting the couple's stimuli was strangely similar: interior spaces, stories, and Southern mythology have always been tantamount to their creative expression. Dryden is credited with much of the city's recent urban development including residential, commercial, and mixed-use properties. It has been said by his clients that he finds the small details that will truly elevate a project's impact. For a third generation architect, who almost became a seamster, he has successfully sewn his own style into the community. Atlanta, Georgia native Allison earned her MFA in photography at The School of the Art Institute of Chicago. She honed her skills in New York City before settling in Nashville where she captures images that are exhibited internationally. One of her proudest moments was representing Tennessee in the 50 States Project, which aligned with the photographer's anthropological approach to shooting. Allison may rely upon her large format camera and Dryden his drafting table, yet their objective runs parallel: to add their own spin to what is already there.

Nick, you opened your own firm, DAAD Group, in 2002 while you were still in your late twenties. That's relatively bold and ambitious.

Nick: Or stupid depending on which way you look at it. I always battled with architecture and if I wanted to pursue it or not. My father is an architect, and my grandfather studied under Louis Sullivan and Frank Lloyd Wright and all of those gurus at the time. They discouraged me from getting into it myself because it's a very tough field. But, I just couldn't shake the interest and passion for it. Architecture is a very broad academic discipline, and I loved being able to study fine art, architecture, product design, and urban planning.

DAAD is known for incorporating architecture, sociology and anthropology into its designs.

Nick: After I graduated from the University of Tennessee in the early nineties, I started spending more and more time in Nashville and realized there was major opportunity here. The city was starting to point in the direction of resurgence and rebuilding, and that's where the sociology component stems from: learning development patterns, examining patterns throughout a city's history, and taking into consideration what the neighborhood's interests are. I'm not interested in being stuck behind a desk and drafting board but rather being actively involved in the community and stimulating con-

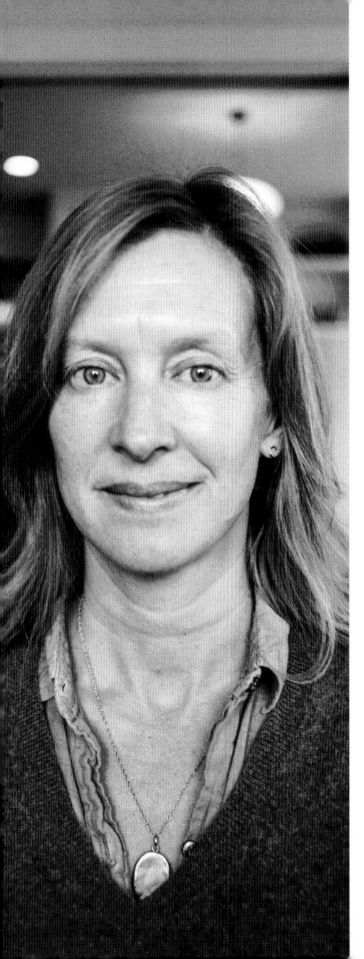

versations. Before my own firm, I worked on big, corporate projects that most people would never be able to see or experience. That was a bummer, and I started to realize that what I wanted to be doing was have a positive effect on my community, rather than doing something that's removed and has a limited impact on an insulated number of people. Nashville also has a great collection of neighborhoods, and I saw the potential for them to rebuild themselves and become more animated. A light bulb went off one day, and I realized the power of design and how it can really influence people's experiences on many scales, whether it's a small object or a bigger space like a city block or neighborhood.

I'm so interested in how you two met and continue to influence one another's aesthetics. Caroline, you primarily photograph landscapes, spaces and interior design, while Nick diagrams entire neighborhoods.
Caroline: We were set up on a blind date. Although there's a lot of overlap, I've always concentrated on interior spaces because that's what interests me. Oddly enough, I like things to be symmetrical and ordered, while Nick is more willing to get off kilter and throw a dart while creating a space.

That's funny because I would think the architect would be more Type A.
Nick: The process demands that to some degree, but I tend to be opposite to most architects in a lot of ways. I like to deconstruct things, and I think that's why I'm very drawn to adapting and reusing spaces. I like tearing things down and putting them back together, which is how you start to reveal the story of a building or neighborhood.

In a way you both build stuff that lasts forever whether it's a building or immortalizing a single moment in time.
CA: We design very similarly, which is by distilling something down to its basic elements. It's way more interesting to start with something that already has a footprint as opposed to a blank canvas. Even if there's nothing visually interesting about a place there's always a story behind it. I like having that framework where I know I have to work with this place and find something beautiful about it. Even if the challenge is that it isn't totally apparent at first.

It's similar to interviewing: I ask curveball questions without being invasive.
Nick: A lot of the stuff that I'm interested in is the in-between-territory. A lot of architects are after the strong, statement buildings with a lot of bravado like

the Convention Center, or whatever the next big property is. I'm much more interested in the tissue and cartilage between those bigger things. Stuff that generally gets lost in the shadows because that's what really makes the most difference in a community.

Caroline, how do you balance commercial work and fine art without losing your own voice?

Caroline: It's like putting on different hats when I shoot for myself, an architect or designer, or a publication. Before moving to Nashville I always kept photography on the side as an art form and hobby. When I moved here I started doing it in editorial, art, and teaching facets, and sometimes it does feel like three different branches. There's more intentionality when I shoot my fine art photography, which is on 4 x 5 sheets of film. It's a lot of looking and being before I even think about taking a shot. And no one wants to pay you to do that. But of course, I would like more synchronicity between how I shoot for myself and other people.

How do you both remain inspired throughout the years?

Nick: On a sociological level, it's seeing the greater impact of the small things that we've done. How DAAD is helping to shape Nashville and evolve as a city. The other element is my clients who I am continually inspired by. I appreciate working with someone who gets it and wants to contribute to the city's dialogue. For me, the process of walking someone through the process is as inspiring to me as the actual design. I love finding an interesting picture and digging deeper to find the story beneath it.

Caroline: For me it's Nashville, which I see as a truly exciting place to uncover. During my excursions in Chicago and NYC, I always shot most of my stuff around Tennessee and Kentucky and then exhibited up there. This has always been my source of inspiration because there is something about this city. There is an interesting patina and endless stuff to dig into. All of the old layers haven't been scrubbed away.

NASHVILLE IS A TRULY EXCITING PLACE TO UNCOVER.

MIKE GRIMES

{*Owner,* Grimey's, The Basement, & Grimey's Too}

If Mike Grimes stamps his approval on something, it sets the bar between mediocrity and excellence. The co-owner of Grimey's New & Preloved Music, and satellite store, Grimey's Too, can't help but get little kid excited when he feels the energy of something special. Since the 11-year old saw KISS play in 1975, he has kept his vow to always work in the music industry. In 1989, he moved to Nashville from Bowling Green, Kentucky. The intention was to get the rock star fantasy out of his system. When deciding how he wanted to make a living, Grimes relied upon the process of elimination. For a decade, he alternated between retail and bands until in 1999 he launched the record shop out of a friend's house. He had nothing to lose besides his 17,000-deep collection, which coerced a community of fellow vinyl lovers to rally around the cause. They admired his willingness to take chances, and stand behind the music that he loves. Currently, Grimes is most passionate about giving the little guys his blessing. His second music club, The Basement, provides a starting point for the bright-eyed and bushy-tailed. By thinking on his feet and tweaking his business where necessary, the local legend has become an evergreen force in a fickle industry.

Did you ever have any non-related music jobs?
Everything you're looking at right now comes from weeding out jobs that I wasn't right for. I worked at a liquor store for six months, built a deck in Brentwood right before Grimey's opened, and worked as a tour manager, which was a joke because I have no sense of direction, am blind as a bat, and a shitty driver.

I always think of records stores as a "hang." Did your customers immediately gravitate towards that community feel?
Yeah! Word of mouth was a big part of it, because I didn't advertise at all. I just knew a lot of people and maybe they just wanted to help me out. While the store crawled at the beginning with mostly $200 days, my overhead was so low that I could afford to keep it open. I had a couple of guardian angels that donated their collections to the shop and several record labels asked to

throw parties for their new releases. Very gradually and organically Grimey's grew into its current state.

Next came Slow Bar, which really solidified your role as a top-notch talent picker.
My business partner and I had talked about opening a place and wound up sitting in this little, old beer bar called Shirley's right in the middle of Five Points one day. We both decided, "What an awesome space to start a little hang!" and met with the owner the following day. She explained, that after 17 years she was ready to get out. I wrote her a check for $10,000 on the spot and a month later, we had our grand opening. The first night it was packed.

Initially, we hadn't planned on having live music but we did a show one night and 70-80 people came. It was electric! Ryan Adams was recording "Heartbreaker" across the street and played that Sunday night in

I'M NOT A FAN OF THE SHY, MODEST AND SELF-DEPRECATING. I'D MUCH PREFER SOMEONE WITH SWAGGER TO GRAB THE AUDIENCE BY THE BALLS.

front of 40 people. My Morning Jacket, The Shins, The Postal Service, Kings of Leons, and The Black Keys all played there. While they're huge now, those bands were in their infancy at the time.

This was also a time when the rock 'n roll community was much smaller then it is now.

The only venues, at the time, that were doing independent rock 'n roll shows were The End, Springwater, and 12th & Porter. We really brought a lot of people over to the Eastside and carved out our niche. When we didn't have live music it was dead, so I started booking every single night, which is how I learned that role.

When you saw a band like The Black Keys was there magic in the moment?

Yes! Their agent called me one day and asked if they could play there for $100. I said, "Man there's tons of great local bands and they all play for door deals. I don't even know this band so offering up that kind of money is crazy." They sent me their CD *The Big Come Up* and I thought never mind, these guys are great! Eighty-five people showed up that night when I tried to get them back the next day they had just gotten the Beck tour. Thankfully we forged a great relationship with them, which is why they've played at Grimey's since.

Why did Slow Bar eventually close and did that failure knock your confidence at all?

Tons of people who have track records of failure after failure keep going. All the elements conspired in a way where the fact that it actually ran almost a three-year course was lucky. I had the wrong business partner, inexpertise to run a bar business, and a bad landlord. While it stung, it was a catalyst to turn around that side of town. Even though I lost something I'd worked really hard for, we were part of the fabric that helped East Nashville to be looked at in a different light.

How does the music scene in present day Nashville compare to when you first moved to town?

The level of musicianship in Nashville is almost second to nothing. I'm not sure if it's at its apex but it's hurtling quickly towards a summit of some sort. The real deal acts know how to put on a party. Being a great front person is so underrated, because to make any-sized venue feel small is a rare talent. The real stars play 5000-seat rooms and make the audience feel as though they're only playing to 100 people. I'm not a fan of the shy, modest, and self-deprecating. I'd much prefer someone with swagger to grab the audience by the balls.

What has kept you so passionate about music after all of these years?

Music is constant variety. Over 100 acts play at the Basement every month, and new bands form every day. It's not like working on an assembly line where you're putting widgets together on a 9-5 schedule. My favorite part is helping the little guys who just want to get their feet wet and draw 25-30 people. Having a tiny place allows me to get them to the next level.

What are some words of wisdom for other aspiring record store and club owners?

Maybe it's an extension of Southern hospitality, but I find it difficult to keep the secrets I've discovered about making a business successful. That being said, Nashville is more competitive than ever right now because the people who were doing positive things inspired others to do the same. You can't stop progress and have to constantly reinvent yourself in some way, shape, or form. I'm sure cart and buggy drivers figured out what to do when the car came along.

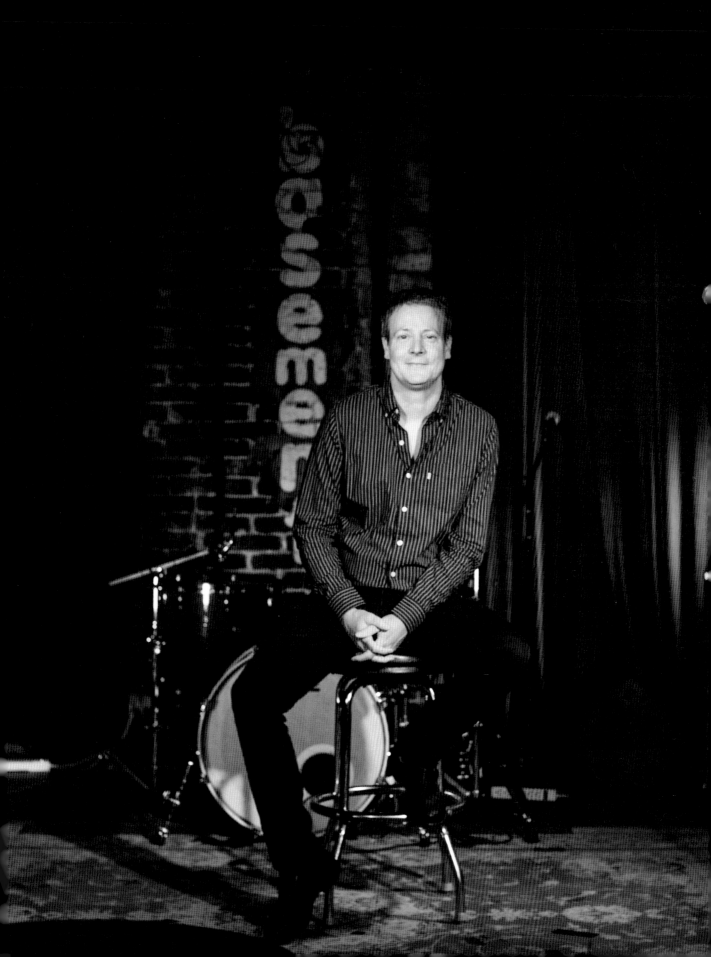

SARAH GAVIGAN

{*Owner*, Otaku South & POP}

Sarah Gavigan's claim to fame is serving steaming bowls of ramen in the South. The chef couldn't have picked a more perfect name for her Japanese comfort food restaurant. *Otaku,* meaning *the obsessed*, mirrors Gavigan's tendency to latch onto whatever piques her interest at the moment. Since moving back to her native Tennessee, the long-time Californian and former music industry agent, went on a mission for her next creative endeavor. She was drawn to the camaraderie of working in a kitchen, and decided to recreate the Japanese gastro pubs she had left on the West Coast. Since hosting her first pop-up dinner in 2012, Gavigan has steamrolled her way to success by going heart first and keeping her blinders on. She leads a new wave of chefs who are experts at marketing themselves to the masses. By drawing parallels between Southern and Japanese cuisine, Otaku capitalized on the culinary history craze. Most recently, Gavigan and her husband, Brad, opened dining and event space POP. It is yet another stab to diversify Nashville as an international city, and lend talent the opportunity to test-drive concepts on a small scale. Momentarily, Gavigan wants to live her life to the fullest. The bigger picture is about providing food, variety, and a full-bodied experience.

From where did the concept for POP originate?
POP was the mother of necessity. My own pop-up was looking for a permanent home, and the kitchen that we were using as a commissary presented itself to us. Since then, we've been dreaming up new ideas for others and ourselves. While the concept is risky, pushing the boundaries has worked for us.

What has been the most meaningful experience since starting Otaku South?
September 29, 2012 was my very first pop-up event at the 12 South Tap Room. I prepped for 250 people in my home kitchen and, to be honest, had no clue what I was doing. There was an older gentleman there who I had exchanged emails with. Fifty years ago he was stationed in Okinawa and while he loved ramen, he hadn't eaten it since. After I served he and his wife, I ran to the other side of the room to watch them eat. The man smelled his bowl, picked up his chopsticks and spoon, and took four bites. He sighed as the biggest smile crossed his face, and tears welled up in my eyes. There's no review, accolade, or pat on the back that could ever top ringing that memory bell for someone.

What has the learning curve been like embarking on a culinary career with no prior experience?
The fact that no one has hurt themselves, been arrested, or broken a bone is pretty miraculous. Everything is about timing and if you hit something at exactly the right moment. When I started this Nashville was so *ready* in every sense of the word.

Ultimately, I wanted to bring to Nashville what I missed about California. I'm from a tiny town outside of Nashville and have just in the last year really embraced the South. I spent the majority of my career representing creative people and pushing a boulder up a hill with a smile on my face. But, when you're struggling you're exerting more

energy and can only sustain that pace for so long. You have one life to live, and do something that fulfills your heart and soul. The best things come with risk. Nothing is easy.

Do you see the ramen crave as simply a trend?
I don't know. I'm a big picture person and as long as I'm doing this I'm okay. If I wasn't I'd be digging in the dirt like a crazy person. I'm in the season of my life where I want things to unfold naturally because I'm tired of fighting. I've never felt a community embrace me like Nashville has, which is ironic and incredible because in many ways I ran away from here. I'm so proud to be a part of the new South.

You're making the city more international.
It's interesting when you look at a Japanese Izakaya cookbook how many similarities, even recipes, there are to the South. One of the things I love most about food right now is how interested a lot of chefs are in taking a historical approach to it. In the same vein as the Southern Foodways Alliance, I love drawing connections.

There's this book I read years ago called *The Highest Goal*, which was a magical connection to getting to the heart of who I am. I had just gone through a business divorce and went out to the desert to clear my head. The book encourages the reader to distill one word that defines you because once you arrive on that path you'll be successful. I realized that I am a connector and ended up emailing, and eventually, chatting on the phone with the author the next morning. It was this crystallization of restructuring my personal goals. Otaku is the first thing that I have ever done for myself.

The connection between Southern and Japanese food is the genesis for me. I feel like I haven't even begun to scratch the surface because I've been in learning and survival mode. Japanese food is a journey and whole new world for me to discover. My business fuels that curiosity and brings other talent into the fold of it.

When you initially started Otaku South you had never even been to Japan. How did you stop that from halting your confidence?
Let's be honest, if there had been other ramen makers at the time this whole conversation would be different. When you're the first one to the game you're given a tremendous amount of rope and luckily I didn't hang myself. I've always tried to approach my business humbly and let my customers know that I am learning as I go along. Sometimes you have to shut yourself off to outside feedback and not get caught up in what other people think. I try to remain open and connected while still being the storyteller of my own brand. I definitely stick to my guns and if the public doesn't want to pay $12 for my ramen, then that's their choice.

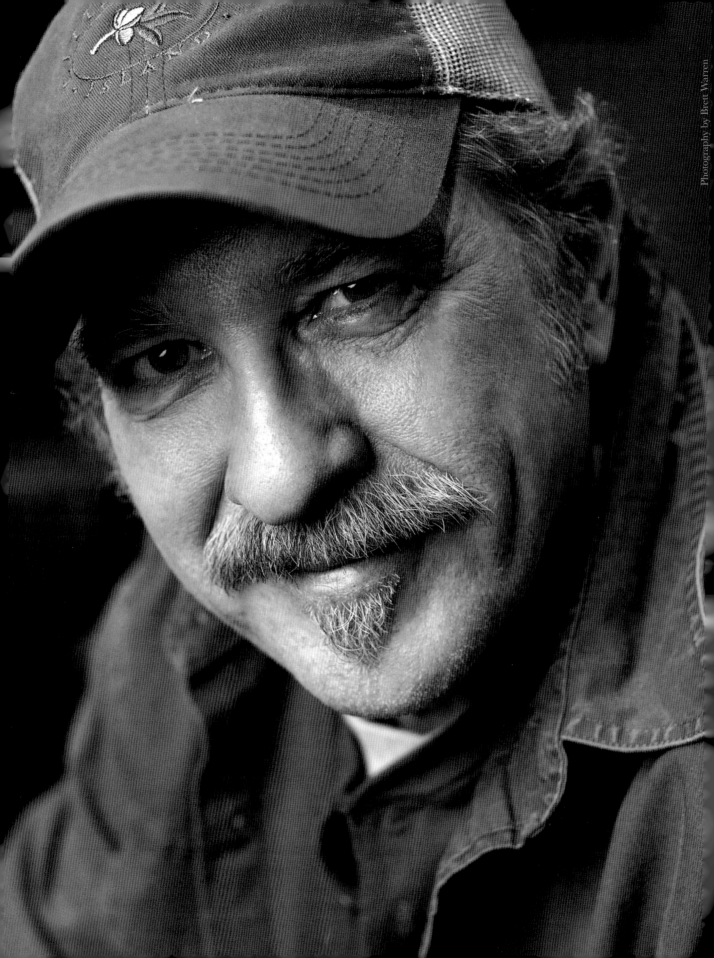

KIX BROOKS

{*Singer/Songwriter* Brooks & Dunn, *Entrepreneur, Actor*}

Anything big or small, Kix Brooks views as equally important. After a twenty-year career as the "energetic half" of Brooks & Dunn, the vocalist and songwriter fearlessly added actor, radio show personality, philanthropist, and serial entrepreneur to his roster. He finds it impossible to say "no" to attractive opportunities and is always confident that he will figure it out. Brooks attributes his enterprising abilities to the influence of his businessman father who instilled in him the importance of hard work and financial smarts. Since his childhood in Shreveport, Louisiana, commerce and creativity have always been of mutual interest. After Brooks earned a degree in Theatre Arts he hustled as a performer in New Orleans beer bars, where he once gigged a grueling seventy-two nights in a row. He worked on the oil pipeline in Alaska and wrote radio advertising in Maine before pursuing a fulltime music career. Upon landing in Nashville in 1979, he signed as a staff writer to Tree Publishing Company, where he has since written religiously. It is Brooks' "only-live-once" philosophy that prompts his tireless investment in new ventures. He exercises his entrepreneurial muscles as cofounder of winery Arrington Vineyards and film production company Team Two Entertainment. Remaining active in the community is a non-negotiable priority and he sits on the boards of multiple hospitals, universities, and civic organizations. It is his readiness for unexpected opportunity that has afforded him more careers than most experience in a lifetime.

Were you always business savvy or was that something you learned by osmosis?

My father was a brilliant engineer and business savvy, as well. When I went to college, he asked what I wanted to do, and at the time I was really into photography, music, and the outdoors. He was sitting there listening to me and said, "If I'm paying, you're going to business school for the first year." Learning basic bookkeeping, accounting, and principles of economics was invaluable to me. I've always been intrigued by music business. When Ronny [Dunn] and I had the kind of success we did, to see how the big wheel turned in the middle of it all was fascinating.

A common thread between successful musicians is they've either worked in publishing or on the A&R side of the industry.

Songwriters as a rule are really smart. I've got a handful of good buddies who only care about the art, and it's kind of refreshing, but for me, the business side is something I don't want to miss out on and is just as exciting as the creative part. It's about the give and take in distributing your art, and working with all of those personalities who help it come together like a puzzle.

How did you know that it was worth going full force into a music career?

I didn't know I was going to be successful. When I was

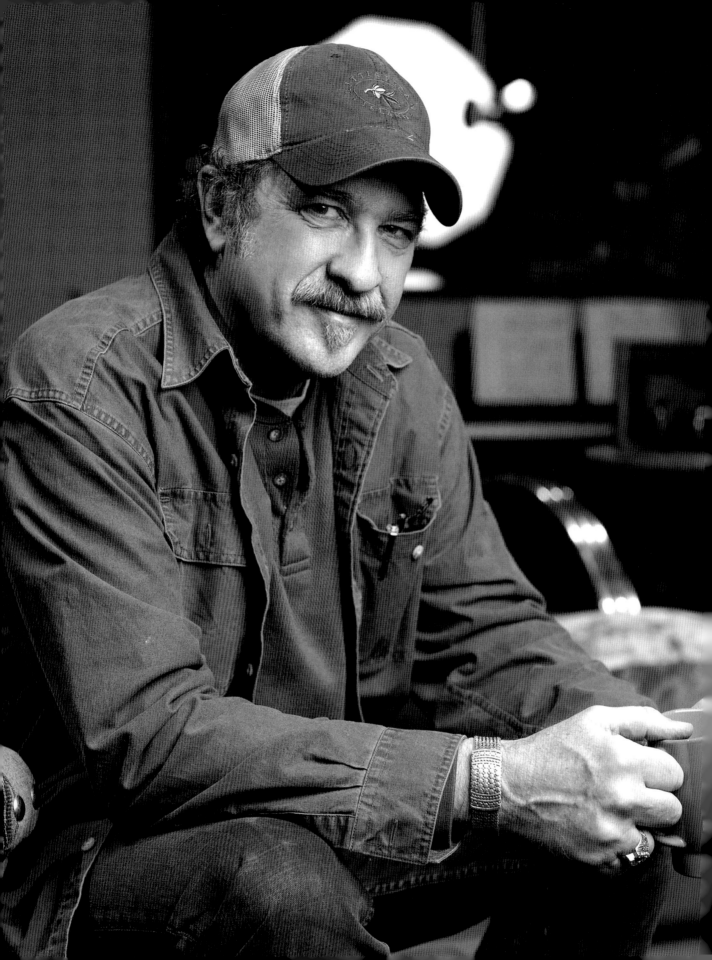

in college, I was making decent money playing gigs, and back then, rent was a couple of hundred dollars a month. You look around at those old guys down there who are still kicking it and living the life and think, "as long as I can play, sing a little bit and make rent, it's all good." It was when I started thinking about having a wife and kids that I decided to pursue songwriting. I built a catalogue, similar to a pension plan, if you have a hit a year, which I fortunately did. Like any songwriter, it's very rare that you find security and long-term success, and there were nights I laid there like most writers do, thinking maybe I should apply for a real job that's a little more secure.

What was it like transitioning from songwriting to performing?

I was thirty-six years old when I met Ronny. I'd had a couple of record deals, been on Capitol, and was writing songs for Tree Publishing. When Tim Dubois asked Ronny and I if we wanted to form a duo the answer was, "No way." For us to get stuck together by a label guy was one of those things that should never have blown up like it did. It went from both of us banging our heads against the wall, playing cheap bars, and writing songs that nobody gave a shit about to everything working. It wasn't any different or better than anything we'd done before, but for some reason, everything mysteriously connected in a really huge way. The good news was we'd both been banging up and down the block for so many years that we had a really good understanding of how crazy, weird, and lucky the situation was.

If someone asked you what it took to make it as a songwriter, what would you say?

I think it is about the hang. A lot of people took me under their wing early on, and I was fortunate enough to come from a really fun and social background. The other thing is perseverance. If you're a good guy, have the talent and hang around long enough, something good is going to happen. Whether you can capitalize on that or not is the big mystery. Who knows why this person has that level of success? There are just so many freakishly talented people in this town.

I think it's also being open to endless possibilities, seeing the bigger picture, and rolling with the punches.

I totally agree. Everyday, opportunities come along that you have to recognize and take advantage of. If you say, "That doesn't pertain to what I'm doing," you may be missing out on a bigger opportunity than the one that you're chasing after. I love all of my businesses, and they continue to spring into other things. I'm at that point in my life and career where you only live once, and I'm not going to miss anything.

NASHVILLE WAS THE FIRST CITY WHERE I COULDN'T MAKE A LIVING PLAYING MUSIC. . . . IT WAS FRIGHTENING HOW MUCH PEOPLE DIDN'T GIVE A SHIT.

How do you know that you want to undertake a new business?

Regarding the vineyard business, I just love wine, have a great winemaker partner, and there was nothing like it in Middle Tennessee. For me, the film business is a challenge similar to being a car mechanic. If I talk to my mechanic and hang out with him long enough, it's similar to meeting with the industry people in Los Angeles. Somehow I sincerely feel that my team and I are creative enough to make successful movies, and I don't expect to do it overnight anymore than I did in the music business. Sometimes you have to look around and go, "How does this work?" And realize you can figure it out. I challenge myself to find things that are exciting and creative that I haven't done before but think I can do.

People tend to limit themselves with these silly, self-imposed regulations. But usually it comes down to just figuring it out.

Everyday I open my eyes and think, what have I got to do today? None of this shit stresses me out because it's all really fun stuff. But I'm not flippantly arrogant about the financial stuff and know you have to pay the bills. I swept floors and worked security in the barricades for every concert that came through Nashville for $25 a night until my rent was paid. You have to roll up your sleeves and keep being creative until you're old like me and can have some fun.

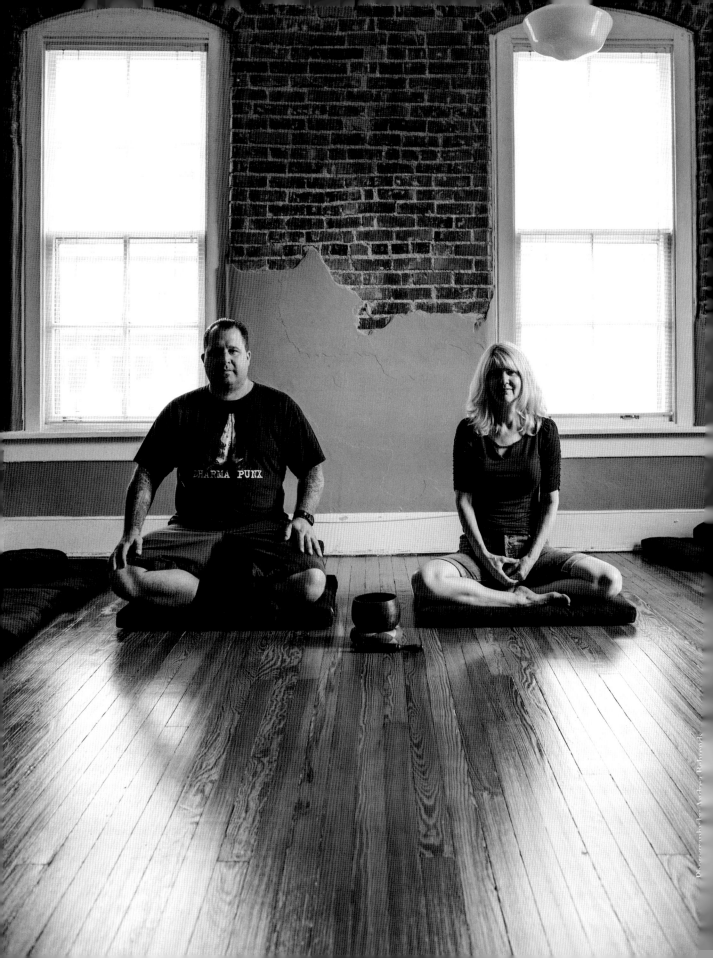

DAVE SMITH + LISA ERNST

{*Meditation Instructors & Founders,* Against the Stream Nashville & One Dharma Nashville}

Mindfulness isn't just New Age lexicon to Dave Smith and Lisa Ernst. The meditation teachers make the practice applicable to the third millennium. They both came to the dharma for different reasons: Smith for drug and alcohol addiction and Ernst because of family tragedy. The teachers speak from their own stories to present historical Buddhist texts on a street level. Even if the focus is similar, their delivery and class formats couldn't be more diverse. Advanced sitters gravitate towards Ernst's 12 South Dharma Center; Smith gets novices on the cushion at west coast offshoot, Against the Stream Nashville. Their policy is doors wide open to all who seek. The goal is to let go of plans, memories, and thoughts long enough to look within. After finding freedom in silence they have committed themselves to opening up the path to those brave enough to listen.

What brought you both to Buddhist meditation?
Lisa: I discovered Buddhism at Hillsboro High School. While it wasn't around as a practice yet, they addressed it from a conceptual standpoint. I had a lot of tragedy in my life early on and the teachings really helped put things into context for me. My mom died when I was 13 and my dad at 16. Once my grandmother passed away, I went into a deep depression. My family was gone and I went into a really dark space. I went to a psychiatrist who tried to prescribe anti-depressants and I decided that I wanted to try meditation instead. After attending several classes, I knew that I had found my home and something I could rely upon.

What impact did it have on your life?
Lisa: I felt lighter, more at peace and it just gave me a sense that good things were possible. The practice gave me the ability to deal with my grief.

When did you know that you were ready to teach?
Lisa: When I was practicing in the Zen tradition my teacher kept hinting that it was time to buckle down and train as a teacher. However, I needed a few years to self-investigate and reorient my path. Finally, it became clear that I wanted to teach and prepared myself by going on retreats, studying, and developing a really strong sitting practice. My teacher Trudy Goodman [founder of InsightLA] knew me well enough to sense when I had arrived. Several years later, she gave me a formal ceremony and authorization to teach.

How did the two of you join forces?
Dave Smith: After I did my training with {Against the Stream founder} Noah Levine, I was assigned to teach a meditation class. Lisa's center came up in my Google search and I never, in a million years, thought they would let me lead a group there.

Lisa: Ironically, I was looking for someone like Dave to fill in our class schedule.
Dave: My first class was an Introduction to Dharma course, and if more than four people showed up I was *very* excited. Next I adopted the name, Against the Stream, because I was committed to Noah's practice and wanted to create a Nashville offshoot. Shortly after, people began spilling out of the room.

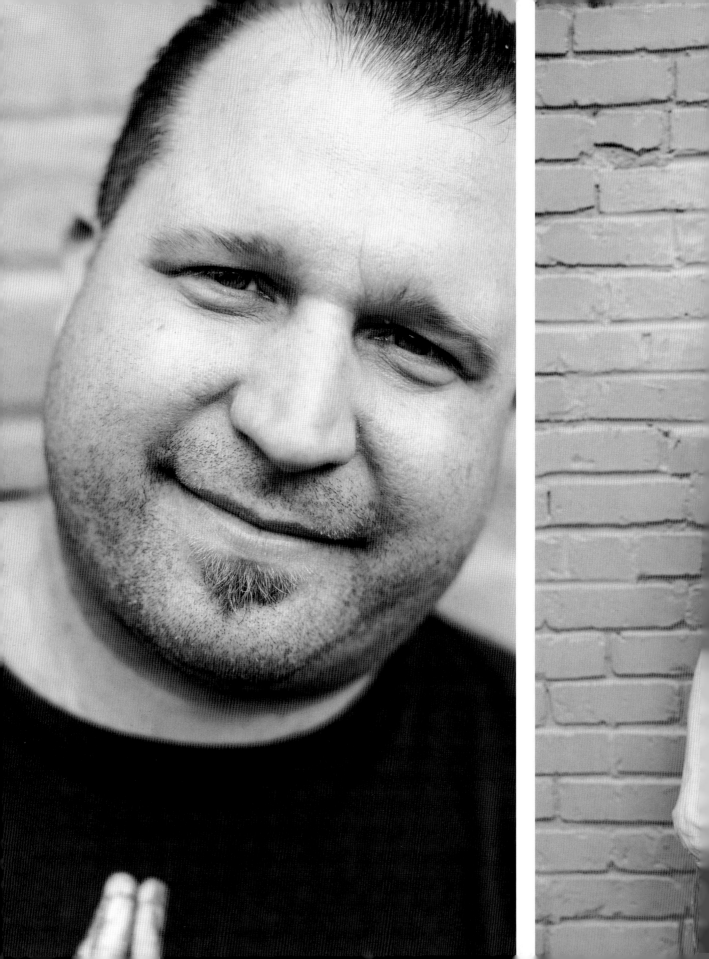

What do you think draws people to one teacher or the other?

Lisa: I think it's just what speaks to your heart and life. There isn't much cross-pollination because people find something that feels like home and stick with it.

Dave: My whole game plan has always been getting people in the door and on the cushion. Once I've done my job there's a million places they can go.

Many people don't realize this, but Nashville is currently a mediation hotspot.

Dave: When I moved Against the Stream from the 12 South Dharma Center into its current location it was simply because we were over capacity every night. While it was risky I was advised, "Do it. But be willing to fail." Nashville is becoming an international city with a lot of diversity.

What has kept you two so invested in teaching the practice?

Dave: It's the last house on the street for me. I had a successful music career and then got caught up in drugs and alcohol. After I got clean, I started a construction company and made lots of money, which didn't make me happy. My last attempt at a "real job" was working in addiction treatment centers. I love teaching Dharma because it keeps me practicing, reading, and studying. My addictive behavior now works to my advantage because I sit all of the time.

Lisa: The practice has, in a very short period, transformed my life. Teaching is my way of opening the door to something that I know can really make a difference.

How would you explain the practice to a complete newbie?

Dave: Go sit in a room full of people and breath and I promise you will feel more at ease. Practicing mindfulness feels familiar, is what a lot of people say. It's about having compassion for your difficulties rather than averting them. A lot of the unnecessary grief in life comes from us wishing things were different than they are. We start at suffering because, by confronting it, we can actually deal.

Lisa: Buddhism often addresses how life is equivalent to suffering, which is why I speak on how much joy the practice has brought me. Without humor life can get really out of balance. While there are times we have to face our darkest demons, you can't work on yourself all of the time or you'll go crazy. That's why I'm a dessert addict and read really trashy stuff at home.

Dave: My teachings are about bridging the gap. How can we use this stuff in our lives now? There has to be a period at the end of the sentence otherwise, it's just fun, intellectual chatter.

DEREK HOKE

{*Musician & Founder, $2 Tuesdays at the 5 Spot*}

Musician Derek Hoke is largely known as the King of East Nashville. Locals laud him for his refreshing doses of honesty, candor, and his exploration of complex ideas within his catchy lyrics. Weekly he hosts, entertains and curates "$2 Tuesdays," a five-act showcase at The 5 Spot, an Eastside venue. The weekly tradition is a cultural representation of the underground rock 'n' roll, country, and soul scenes. Artists test-drive their best material to impress a crowd of mostly professional musicians. Hoke created the event as a way of waking up the wide-eyed to Nashville's endless competition. No one better understands the strain of trying to stand out in a sea of talent than the mild-mannered South Carolina native. He has worked relentlessly to reinvent himself and cultivate an original style. The payoff led to a deal with Electric Western Records after he honed his skills playing barbecue joints and sports bars. Hoke's personal philosophy is to be objective and never make the same record twice. He coins his style "quietbilly," which pays homage to a spectrum of country, gospel, bluegrass, and soul.

If you're hot shit in whatever town you moved here from you're *gonna* start over. Everyone has a band, and this is a town where you don't make a lot of money playing music. You better have something to say or move along. There's a lot of people out there, myself included, who had to relearn playing guitar or writing songs because of how discerning everyone is here. You have to get to the heart of what you're trying to do. It always gets back to what do *you* sound like? A lot of people give up really fast because they didn't get it fast enough.

It's suicide when people play exclusively on one side of the river. Go open for a bigger band. Throw a show in your backyard with free beer for five bucks. I think that's why "$2 Tuesdays" works so well because it's a mini show inside of a big show. It holds people's limited attention spans because of the variety.

I try to hopefully be upfront with everybody about the fact that you're going to make no money, play five songs, and walk around the room with your merch—so be prepared to work it. Everybody will be hanging at the bar, and you're the entertainment. If you're good, they'll listen; if you're not, it's kind of obvious. It's incidental brutal honesty.

As I'm sitting here talking to you right now I'm wondering if anybody is going to show up tonight. Maybe that's why I keep doing it, for the sheer excitement. When I look around at 10:30 or 11:00 p.m., and there's a lot of people in the room it's a good feeling, but when I start expecting that, I get lazy and go on autopilot.

As far as my own music goes, I try different things artistically; otherwise you just make the same records over and over. I like turning familiar things on their head. Al-

I WANTED TO PUT ON A CONSISTENTLY GOOD SHOW, HAVE A GOOD TIME, TREAT PEOPLE WITH RESPECT AND KEEP AN OPEN MIND.

though, at the end of the day it needs to sound like me, otherwise I have failed miserably. I try to make it a difficult task for the listener or critic to compare me to Jeff Buckley or Jeff Tweedy.

You have to keep striving for your own identity in this pool of everybody doing the exact same thing. If you sound like you and you're doing something interesting it might attract some new listeners. Then you can explore your own path. Some musicians sound like they're playing other people's music, even if it's their own songs. Now I'm getting negative again. (Laughs)

I can listen to my music in the car and completely take myself out of it. Not that I sit around and listen to my own records, but you have to in order to make sure you like the way they sound. You can't be so precious, because it has to be ready for total strangers to fall in love or shit all over it.

It all comes down to the question of, "what are you doing that makes you so special?" We all write songs, so why yours? Someone will say, "Well I played 200 dates last year" and the next person says, "I did, too!" You have to be savvy, wake up early, and get at it before the others do. Be persistent and ask a lot of questions. People ask me, "How did you get on NPR?" I don't know. The good stuff happens when you're busy and trying to do the right thing enough. You won't even know how you got there because there's no checkbook in this game.

At this point, I feel like I've established myself musically and personally. And for me, that's all I've ever really wanted since I moved here. Just to be apart of it all.

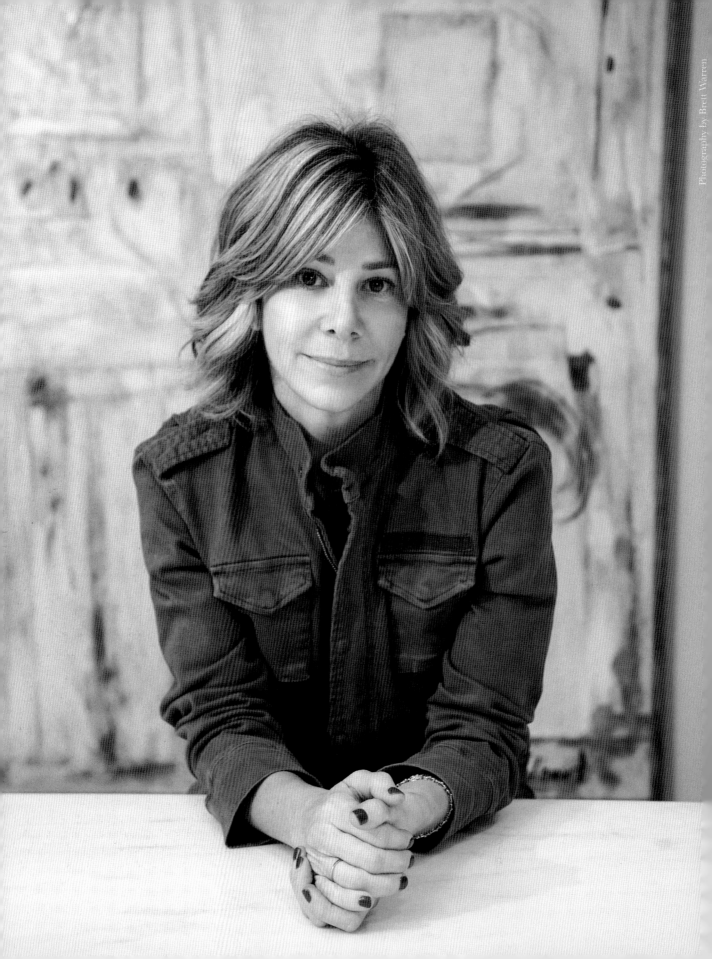

MIRANDA WHITCOMB PONTES

{Restauranteur/Founder, The Frothy Monkey *& Burger Up}*

The heart and head may not agree, but they should always be on the same page. Miranda Whitcomb Pontes, restaurateur and visionary behind Burger Up, Josephine, and Prima, is a prime example of the new entrepreneurial breed. Since launching the Frothy Monkey franchise in 2002, with virtually no hospitality experience under her belt, Pontes has relied upon her instincts. Her ideas come from traveling and recognizing what the city lacks. She has never signed a lease knowing where the money would come from as faith has guided the restaurateur every step of the way. Pontes was raised on soul food in northwest Louisiana, and played "café" as her favored childhood game. While she comes from a long line of teachers, and taught elementary education herself, life was a process of elimination until her passion revealed itself. When she opened the Frothy Monkey in the 12th Avenue South neighborhood, all walks of life gravitated towards the café's lived-in look and friendly-faced staff. It established her "loving people through food" mission statement, and unconventional, trial-and-error way of approaching business. Being the best always takes a backseat to building camaraderie among her customers, staff, and community. Her altruism has made her a vital component of the community as an active supporter of local agriculture, artisans, and nonprofits.

You've always referenced food as something to bring people together. Was that a part of your childhood growing up?

Sitting down at the table existed in one part of my life before my parents got divorced when I was eight years old. After that, it was grab something, eat at the counter and go about your business. Perhaps, being in the restaurant business is recreating what I only saw for a small part of my life.

You spent time in San Francisco, then Boulder, and Nashville. Can you tell me the story of why Frothy Monkey came to life?

A few years prior to moving to Nashville, I ran the marathon and remember running through the city thinking, *what a sweet town, but I will never live here.* I thought I would never move back to the South again. The Frothy Monkey was born out of the idea that I wasn't going to be a stay-at-home mom, and wanted to make a statement about being independent and doing something grandiose.

Owning your own business is one way to declare that.

Yes! This kind of lifestyle is so uncertain and makes people ask, "Why don't you just get a real job where you get a paycheck every week?"

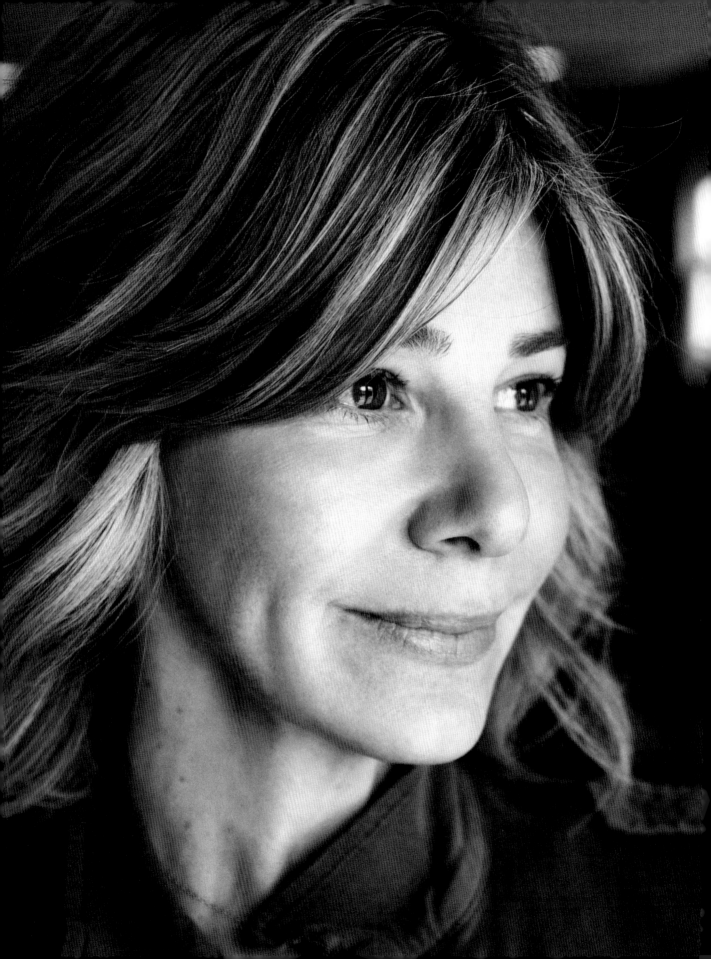

WHY FORCE SOMEONE INTO A JOB THAT DOESN'T COME NATURALLY OR BRING THEM JOY?

I don't like working for other people, either.

Sometimes you have to do something because it's a means to an end. I did not realize that I needed to work for myself until it happened. No way in hell was I going to fail as a business owner. That was the last option and scenario. Why force somebody into a job that doesn't come naturally or bring them joy just because society told them to do it?

When you first entered the hospitality industry, what was the most exciting element?

I loved watching people have their own experience. I was selling a feeling of belonging to something, which everyone needs in his or her lives. As an introvert myself, I wanted to offer a space where people could work, take ownership of, and share with other human beings. It made me so happy to see my spot was a place where people felt comfortable to have a meeting or blind date. I just watched all of these beautiful human transactions take place, and that has been the coolest part.

Even with my interview process I feel as though I'm inviting people into my world.

You just nailed it. That's where it's safe for you. I was always comfortable behind the counter of Frothy Monkey, Burger Up, and Josephine. If I saw the same person at an outside place, I'd be a different person because that confidence and safety net would be gone.

It's the energy you've created. Your restaurants make people feel confident, safe and happy.

Imagine writing a business plan and trying to sell a space based on a feeling. I'm so much about valuing the intangible, and you just validated the importance of feelings and energy. Especially when you're at a restaurant because how many have you been to that are flat and have no soul? I will fight to the end to have the soul remain, at all costs.

How did you learn to be a businesswoman?

I am still learning. It's all by trial and error, learning the hard way, and making some pretty significant wrong decisions. I joined the Entrepreneur's Organization, and that's made a huge difference. My Nashville group meets once a month, and even though it's all different walks of life, we share so many similarities with the issues we face. It's a huge help to talk to other entrepreneurs about how we deal with it all.

You learn by doing, and there is no guidebook that can articulate how the real world rolls. It's always baptism by fire.

Exactly. I want to scream out to the world that there are other ways of learning. You don't learn everything from a book or college. You have to travel, take classes, challenge yourself mentally and physically, and put yourself in uncomfortable situations where you fake it until you make it. It's just a huge, bubbling soup with many different ways of going about things. I am proud of how unconventional my road has been, and truly trusting my heart. If a decision didn't feel right, I wouldn't do it.

What do you think about Nashville is attractive to visionary types?

I think if you have an idea, people listen. The barriers were and still are minimal compared to any other cool, metropolitan city. It's still very genteel where you ask a question, and someone will either have an answer or show you how to get it.

Your restaurants have become famous for employing people who often afterwards achieve great success.

I'm always curious to discover what it is that people truly love. I make it known throughout the company that I'm a person who supports your independent passions and this is just a vehicle to get you there. Don't ever be afraid to take time off to pursue your dreams. It's about treating people like human beings and accepting that life also happens. Of course they're going to enjoy themselves at work because they have freedom alongside of that.

What's most gratifying about all of this for you?

A band I've employed is truly making it right now. A woman in her fifties who's never had her own apartment before now was finally able to do it. Most importantly, being able to serve beautiful, quality food that is innocent like a child because there is nothing tainted about it. People can't help but feel loved by that.

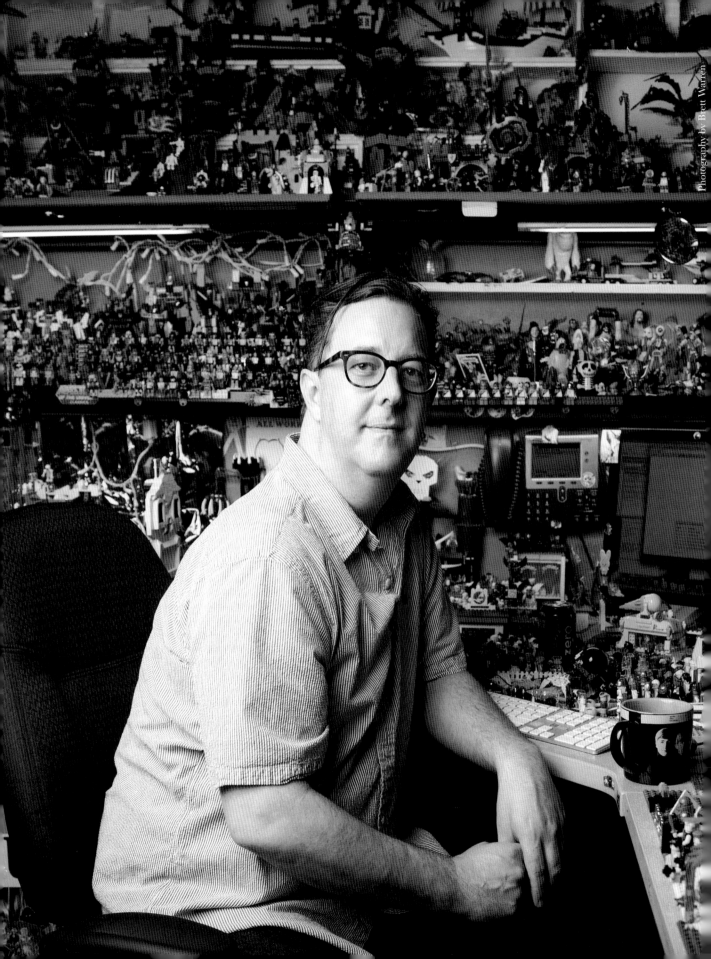

MARK ROWAN

{*President*, Griffin Technology}

Griffin Technology is a high profile, global company that creates cutting edge accessories and electronics for brands like Apple, Google, Samsung, and Motorola. Since joining the team in 2003, President Mark Rowan has been on his toes in attempts to predict trends for an industry that is constantly in motion. Rowan is proof that the odd path works. Discovering his passion for computer networks and database programming prompted the psychology student to drop out of a graduate program. He then backpacked around the world in search of a breakthrough that would allow him to pair his primary interests of technology and music. Upon his return to Nashville, Rowan bootstrapped his way into an engineering role and cut his teeth in the audio equipment industry. In 2003, Rowan began working for visionary Paul Griffin who shared his love for home, mobile, and personal devices. Six years ago, Griffin stepped away from the day-to-day responsibilities and promoted Rowan to fill his shoes. As the face of the worldwide company, Rowan has guided the one-time cottage industry through an era of exponential growth. It is Rowan's love for inventions which keeps the technology fanatic a proud spokesperson for his industry.

What was it like learning the ropes of running a huge company like Griffin Technology?

When I first met Paul Griffin he showed me one of the original iPods and asked if I owned one yet. "Apple is onto something," he said "and I don't think anyone appreciates how big this is going to be." Paul is always onto the next big thing and his mentality had a profound impact on what I believe is possible. As Griffin grew, our original iPod accessories started the mobile accessories trend. The launch of the iPhone and iPad opened up our market from tens of millions to billions of mobile phone users.

Rather than a company being driven by one guy's cool product vision, I'm now turning a battleship. Certainly, every time things don't go as planned I wonder, "what does the rest of the world think?" We've gone through a lot of growing pains. There's success and then the flipside. I've only been able to take on this role because I don't internalize it too much.

How do you see your role within the company?

I see myself steering Griffin into areas of success, rather than simply running the company. I'm not a self-promoter and am definitely more comfortable patting other people on the back than I am taking credit. I've been President for almost six years and only recently have I started to realize and accept what that means. It's a strange situation because I am such a hands-on guy coming from an engineering background and the higher up you get in a company the less interaction you have. Being the president of the company is a high level of abstraction and doesn't come naturally to me. I've had to learn how to be a leader.

Another leader told me recently that the secret to running a company is empowering others and adapting to change on the fly.

That's a fundamental part of our company DNA. As

an accessory company we have to rebuild our business plan, by definition, every six months. Griffin is a different company every year because our market evolves so quickly that we never have the luxury of sitting back and becoming stagnant. We're constantly experimenting and reinventing so that fluid change is a benefit as well. At the end of the day, we don't have a choice because we have to turn over our entire product line every 12 to 18 months.

The people who do well here are the ones who thrive in the learning curve. I've been here almost 12 years, which is, by far, the longest I've ever been in one place. I would have burned out or gotten bored if it wasn't an environment where I'm constantly having to catch my breath. That is the life force that pushes me forward.

This company is a testament to the way the business world is going: malleability, openness to change, and having the ability to wing it.

To some people that lack of predictability isn't a positive but for myself, it's what I need. There's a quote that says, "Planning is everything, but the plan is nothing." You have to be in motion, but not hemmed in by a specific goal. A few years ago through research we discovered that children ages three and four were using iPads. We explained that we wanted a portion of our retail to be dedicated to this demographic and the initial reaction was, "you guys are ridiculous!" Six months later, it was obvious we were right on point. If we had waited for the trend to arrive someone else would have taken that business.

I'm curious about the company's relationship to music and local designers because you're very connected to the city's maker community.

We've always had audio equipment in our product line and while it's not a huge part of our business in terms of dollars, it's a large part of our identity. Shortly after we moved into this building, one of the tech guys for Music City Roots and Bluegrass Underground approached us as a possible sponsor. When [founder] Todd Mayo came to me with all of their statistics I said, "Listen, I trust you because this story came together for a reason and Griffin should be a part of it."

Is your brain wired to constantly think of new ways to reinvent accessories?

Am I constantly everyday coming up with fantastic product ideas? No way. I don't have that kind of magic. All of our ideas start at the top of a very open funnel with a group of us kicking around an idea. We sit around with the new Apple products, poke at them, and ask each other, "What do you think about this? How could this be better?" When people share their insights openly and cobble all of those ideas together, most of the time, you get something that works. Those conversations are the lifeblood of the company and origin of most great ideas.

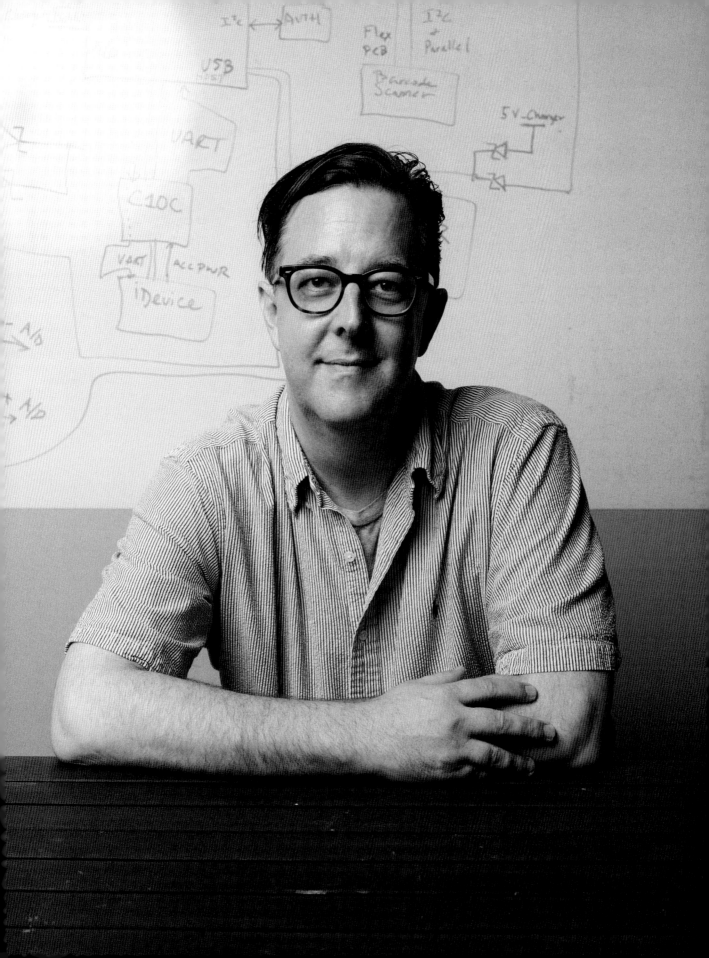

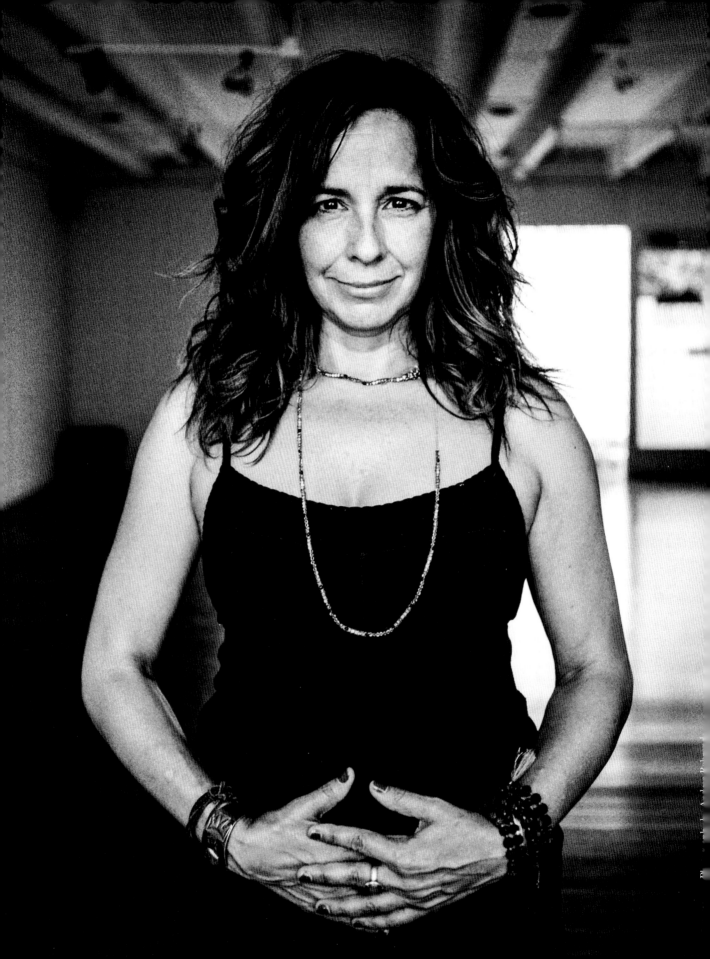

RAQUEL BUENO

{*Yoga Instructor and Founder,* Liberation Nashville}

Be rather than do yoga is how Raquel Bueno's world functions. Ever since the owner of Liberation Yoga stepped into her first pose, the practice has permeated her life. Nearly two decades ago, Bueno attended her first classes in Nashville. Immediately, she became smitten with how the discipline merged body, mind, and spirit. It was evident that she had tapped into her purpose. After devoting herself to the Iyengar practice, she moved back to her native Los Angeles, where she shifted to the Atma style. On the west coast, she dabbled in a variety of teachers and approaches before choosing asana: an amalgamation of holistic and healing. The instructor's classes focus on repairing the body from the inside out by making the connection between emotional and physical ailments. Bueno hopes for her studio to be a sanctuary where practitioners can leave their camouflage at the door. After years of juggling her former corporate job with freelance teaching, she knows better than anyone the importance of being your authentic self. Now she wears yoga clothes everywhere she goes and applies its principles far beyond the mat.

What is your favorite part about being a yoga instructor?

It doesn't feel like work. I've always been passionate about living a physical lifestyle. Yoga allows me to release tension in my body that is tied to my emotions. This is how I process what needs to be felt, heard, and loved in me. If I can help someone else have *that* experience through teaching, then what better thing in this world is there to do?

What in your opinion makes for a good yoga instructor?

When you're teaching you are an instructor to your students. Then you have your own practice on the side.

When did you decide to take the leap and teach full-time?

Until the last couple of years, my 9-5 salary media job supported my yoga. I didn't believe I could teach yoga and pay my bills, which is why I hung onto my salary for so long. Finally, the universe forced me to quit and I moved to Martha's Vineyard for four months where I healed and practiced all day long. When I returned, I decided this is my new life.

I had a deep faith that I would be taken care of. While I went from a six-figure job to making significantly less money, my world has expanded, rather than contracted, since I chose this adventure. My studio, Liberation, is a world based on all the things I love. Why wouldn't I do this? There isn't another option.

What is your personal teaching philosophy?

My teacher always says, "Don't do yoga; be yoga." I am a very practical person at heart and want my teaching to work in real life where we have to get stuff done.
The most important part is having the ability to unbury fears, unrealized dreams, and longing. By digging in and opening up you can truly feel more alive than ever. We are all light and dark, and both are beautiful. That side needs

as much love and compassion so it can lose some of its power over you. After all, you wouldn't recognize the sun if you didn't know the moon.

Is it difficult to have students look to you for guidance if you're battling your own demons?

I'm very clear with my students that not everything in my life is perfect. If you're on a spiritual path people tend to think that you get off scot-free or never make mistakes. I make tons and I'm probably going to make a million more before next week. What I can do is learn from them and hopefully understand myself and other people a little better.

What is one challenge you've been faced with since opening your studio?

From corporate America to the yoga community, there is sometimes cutthroat behavior and envy that stops us from celebrating our individual strengths. Ideally we evolve, honor one another and support each other's personal growth. Together women can be powerful, rather than letting some silly moment in time define their feelings about one another.

What effect have your own teachers had on your life?

I started practicing with my yoga teacher in my late twenties. For the past five years he's been my mentor who I also assist on retreats. My Zen teacher was also a man who I began studying with in my early 30s. I took my Buddhist precepts in 2002, which again all felt very organic. Those teachers have been *extremely* important to me because I never had many positive male role models. I've never even found that equanimity in male/female romantic relationships.

Why the name *Liberation* for your first yoga studio?

The tagline of my studio is "free yourself," which relates to the past three years of my life. It's been a lot of forgiveness and giving myself permission to stand in who I am. We liberate ourselves from the inside out, and outside in, from a variety of painful situations.

What does yoga mean to you?

Yoga is a form of self-expression that teaches us we have a choice in how we live our lives. Sometimes when we go out into the world we protect our inner space a little too tightly. We lose that freedom to really be ourselves and rather, become concerned with the right thing to do, wear, and say. It's about breaking through the layers to accept who we already are. I believe all teachers are the best for *someone*. I'm not going to be everyone's cup of tea, but I try to be honest, show my heart, and offer a glimmer of hope for someone else.

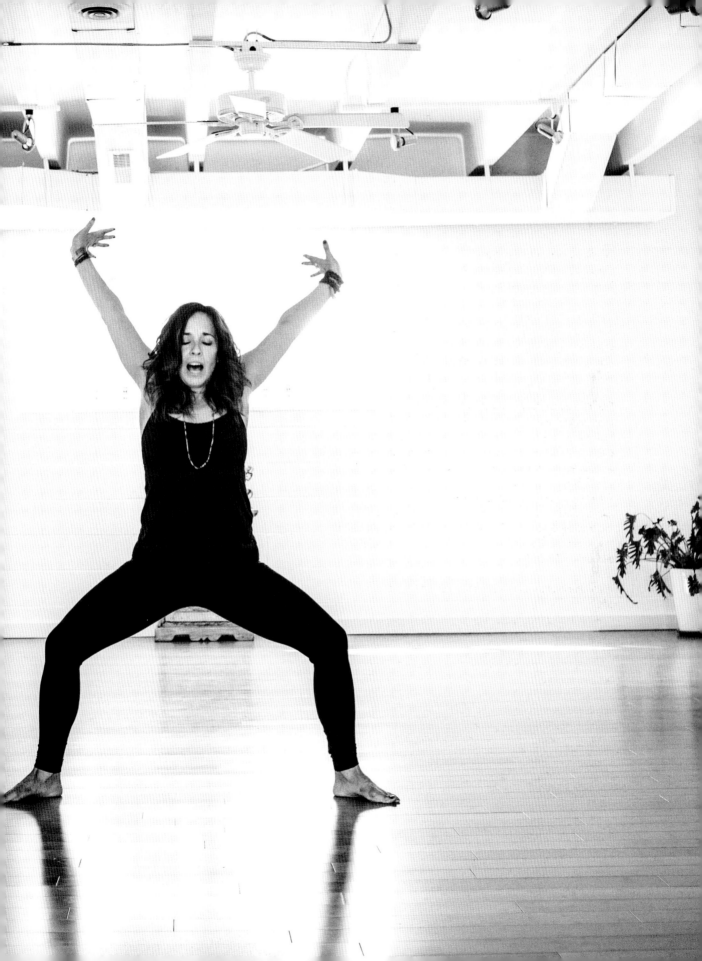

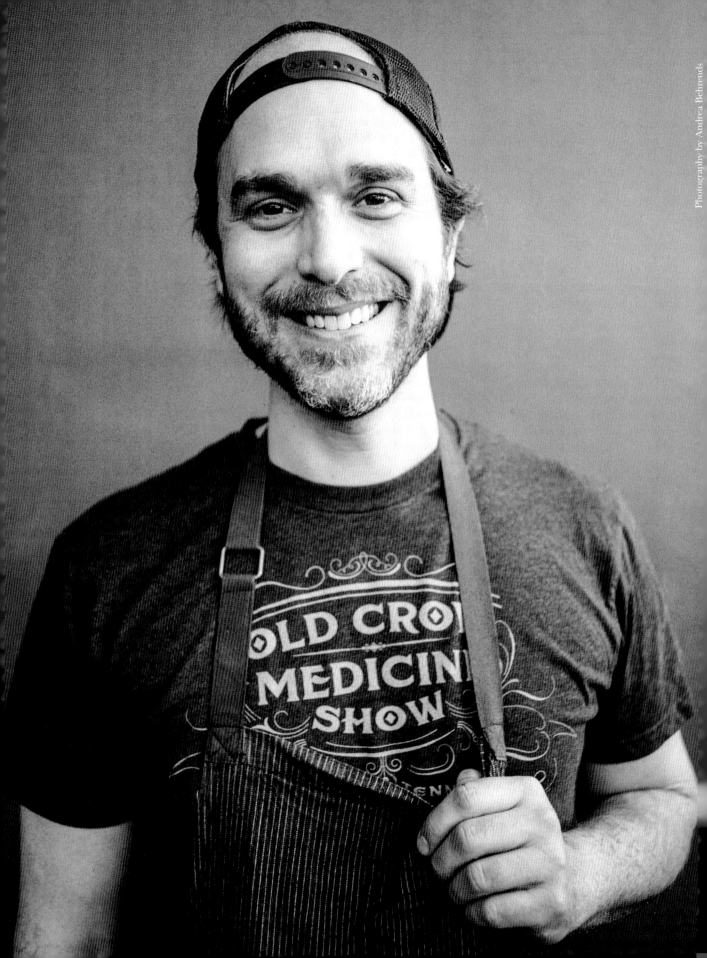

TANDY WILSON

{*Chef/Owner,* City House}

Cooking won't ever quit Tandy Wilson. Since opening City House in late 2007, the chef has achieved critical acclaim and a consistently full reservation book. After working his way up from dishwasher to James Beard Foundation semifinalist, Wilson affirms anything is possible if you just stay focused. Growing up in a traditionally Southern family, meals were at the center of Wilson's social life. It was the matriarchs who first relayed the importance of quality food. He still pulls inspiration from their original recipe cards, and method cooking techniques today. Wilson cut his teeth at Scottsdale Culinary Institute and worked alongside reputable talent in California wine country. Next he traveled to Italy to research regional cuisine, and returned to his hometown to work as Margot Café & Bar's sous chef. Two years later, he renovated a former sculpture studio to open City House in historic Germantown. Wilson still sees food in the same light as when he first started: a passion as opposed to a form of artistry. While his Southern-Italian cuisine is complex, Wilson's work philosophy is simple: Get up, to it, dirty, and done.

You are a fifth generation Nashvillian and extremely passionate about this city.

I think this city is diverse and age doesn't matter here. The doors are wide open and it's just a matter of walking through them. Nashville has taken my restaurant on with wholehearted bear hugs, and let me do my thing. Family, living somewhere you love, and doing something you're passionate about is the foundation for a happy life.

Your take on happiness is simple, yet soulful.

I think for me, I take a blue-collar attitude towards life because that's how I was raised. I'm not looking for people to have some crazy experience at my restaurant. I want them to leave and say "That was fucking delicious and damn I'm full."

Where does your passion from cooking stem from?

We always had: quintessential Southern meals at family gatherings, holidays, and summers at the lake. My dad is in food sales, so I grew up around the industry and my first job was washing dishes in college. You don't love cooking professionally at first because it's really tough, but you also don't know how to walk away from it. At least that's how it was for me.

How did you progress from running silverware to manning the line?

Back in '97 we were hiring rag tag people from the halfway house and right out of prison. Basically what I'm saying is, my competition wasn't recent culinary school graduates. There was room in the field. At my first restaurant job, an old country guy named Charlie worked the salad station and baked all of the desserts.

When I was done washing dishes I would go help him. If Charlie gave you the thumbs up, they'd promote you and that's what happened.

Something I've always appreciated about the service industry is its willingness to give anyone a chance.
If you work hard in the restaurant business it doesn't matter where you come from or what you look like. The manager is only concerned about you killin' it.

I'm curious about where your interest in Italian food stems from.
There are so many similarities between Southern and Italian food. It all comes down to feeding the family nourishing, delicious sustenance for the day. When I was coming up, the French hat was taken but the Italian cap was still available. I also just really identified with the food and loved it.

Chef Margot McCormack was a mentor to you. Do you now pass on the same wisdom to any of your own staff?
Margot let me write on the menu back in the day and gave me lots of constructive criticism. When you get a dish out of a cook and they're excited about it, it's exciting for you too. You bring something different to the table by trusting your team. I want to do my best to encourage their creativity.

How did you know you were confident enough to open your own restaurant?
While I knew I could do the work and liked it, I always said, "I'll never open a restaurant." I am independent and prefer to make the future rather than talk about it so I quietly started researching costs, location, and streams of revenue.

What was your original vision for City House at the time?
I don't like that "too cool for school" attitude. My ultimate goal is to have people from everywhere in my space, and make it a place for celebrations.

What is it about your restaurant that you think people connect with so much?
There are a few things that I put on our success: One, you can smell the restaurant from a block away. Two, it's the type of place that people can make it what they want. You can have dinner for $25 or do four or five courses and wine pairings. I firmly, passionately believe that good food is for everybody. I realize even what we do is out of grasp for a lot of people and I hope one day we'll fix that.

I DON'T LIKE THAT "TOO COOL FOR SCHOOL" ATTITUDE. MY ULTIMATE GOAL IS TO HAVE PEOPLE FROM EVERYWHERE IN MY SPACE, AND MAKE IT A PLACE FOR CELEBRATIONS.

Since first hearing about City House I've been impressed by your loyal legions of fans.
We see a lot of the same faces again and again and that's the ultimate goal. When you start worrying about what other people are doing is the day you start going downhill. I'm pretty firm on that one.

Do you think you'll always want to cook?
Always. Physically I'm pretty busted up after doing this for 15 years, but I can't think of anything cooler than what I do. Maybe drive NASCAR, but that's not an option at this point. (Laughs)

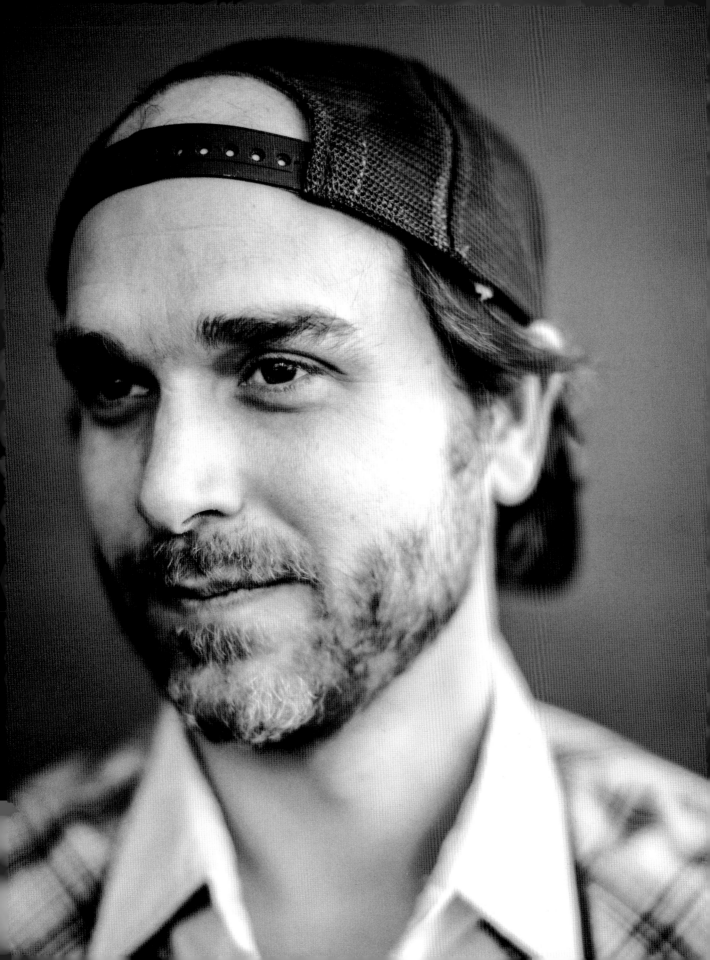

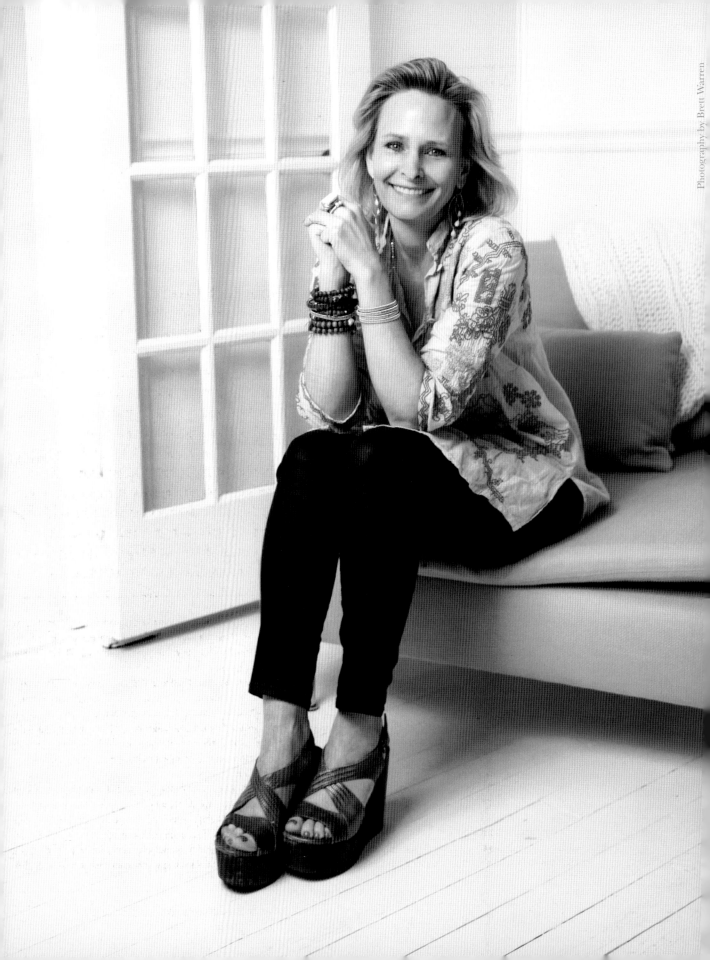

JUDITH BRIGHT

{Jewelry Designer}

"Be mindful of the things that nag for those are the things of destiny" is the mantra that reawakened jewelry designer Judith Bright. Design is a job and lifestyle for Bright who fantasizes about color, shapes, and stones all day long. While jewelry always held an intuitive comfort, Bright opted to study the safety net of nursing at Vanderbilt University. She landed in Los Angeles to work at a non-profit hospital and, ironically, orbited in the opposite direction working for music legend Quincy Jones. As the President and executive producer of his music publishing company, Bright soaked up the legend's work ethic, wisdom, and business savvy for twelve blissful years. However she could never curb the desire to work with her hands and after moving to Nashville, transitioned her hobby into a namesake company in 2005. Through trunk shows and her 12th Avenue South flagship store, Bright's semiprecious gemstone designs became a go-to item within the fashion community. She has since opened boutiques in Atlanta and Birmingham and seen her artisanal designs featured in film and television. Watching her loyal clientele spend their hard-earned money on her heirloom quality pieces is the confirmation that Bright embarked on the right career-path. The indie designer makes the jewelry that she desires and lets her creative brain dictate the appropriate time to release new collections. She runs parallel to other artisans on her own little track.

Who has been the greatest mentor of your life?
Quincy Jones, no doubt about it. I first came on board as his President's right hand person. After I noticed that requests were coming in for his music catalogue, I brought it to Quincy's attention and asked if I could take care of it. I catalogued a humongous box of tapes and plugged it into TV, film, and big band licensing. The theme song for Austin Powers was one of my big wins. I also watched over the business side and copyrights, and co-wrote liner notes.

I was with Quincy for almost 12 years because he and I were very much in sync. We saw the world in the same way, which is important when you're working with someone so closely. "If a task is once begun, never leave it until it's done. Be the labor great or small, do it well or not at all" is a line I always remember him saying. That's my soundtrack and the way I approach everything that I do.

He exemplified quality over quantity, hard work, and a sense of confidence that I could do anything I wanted to. We're all looking for someone to believe in us.

Validation isn't a weakness but rather a gift.
Everyone has so much potential and sometimes it just takes a look, touch, or sentence to instill that in someone. Quincy wasn't a micro-manager because, like myself, he put good people in place and let them do their thing. The integrity is in what you do when no one is watching.

How did you initially gain confidence in your jewelry making abilities?
Jewelry design is the only business I've ever felt completely confident in. Affirmations came from stylists asking to use my jewelry for movies and TV shows, and people offering me trunk shows all over the country. It got to the

point where I didn't care if everyone liked it because I knew I was on the right track.

Do you think the support of Nashville also bolstered your confidence?

In L.A. you throw a rock and hit another jewelry designer. In Nashville I felt like the market was more open. If you put something thoughtful out into the world, people will typically embrace it and help you. This is a grassroots business created through sisterhood: women telling other women about my products. Moving to Nashville was calculated because I knew it was an ideal city for entrepreneurs. There's an energy here that doesn't exist anywhere else. I feel like we're all in this together and we all know it.

A lot of success is right time, place, and being receptive to it.

At the end of the day entrepreneurship is a solitary lifestyle and all about staying the course. You can surround yourself with a support system but in the end, you're responsible.

How do you streamline your ideas?

I spent a lot of time being all over the place. Going from your head to the wrist takes patience because the process can take five minutes up to five months. I find it very challenging to introduce new pieces and concepts. Sometimes it just flows together and other times it's a process. It's important to make your craft easily interpreted by the public. They need to have a clear representation of your vision. Rather than throwing it all out there, I try to introduce a cohesive collection.

Most artists don't know how to distill down their ideas into a concept that is easily digestible to the public. How did you learn this very important skill?

My marketing and business heads were established while working for Quincy. Before I even made a single piece of jewelry, I came up with my logo, letterhead, and business cards. While I had tons of ideas in my head, if I didn't have a formal way of presenting it then people might not take a look at it. That's what I did and I'm at peace with that. At the end of the day, I want my customers to know my work is a Judith Bright piece.

Many artists have a hard time seeing the artistry of the business side.

There's so much creativity in business it's astounding. I love using both parts of my brain. Business is a necessary component to getting your work out there. You have to do it and do it right. At the end of the day life is really short and we all want to share what is the biggest turn on for ourselves.

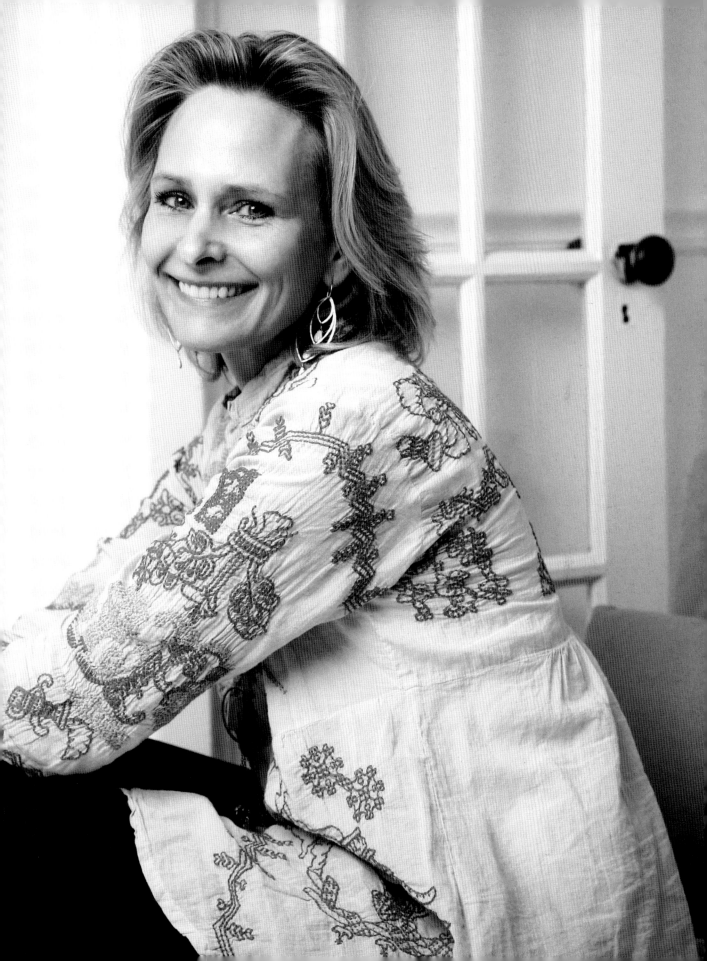

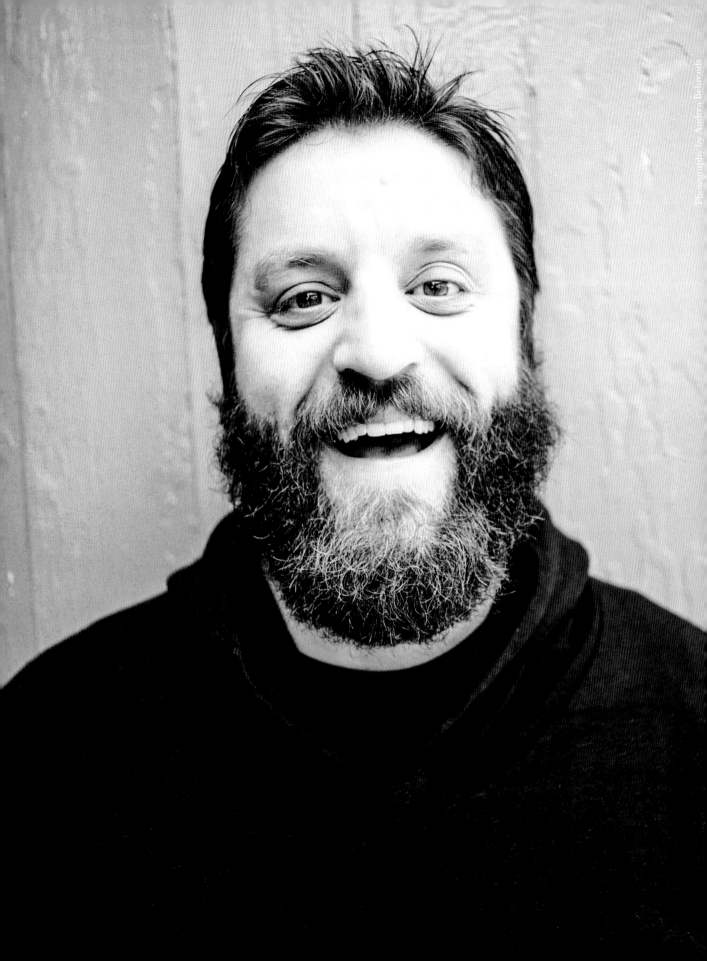

ERIC MASSE

{*Producer/Engineer,* The Casino}

Eric Masse fades into the background to flaunt other people's talents. The owner, engineer and producer of East Nashville studio The Casino adds his own flavor to finesse other's artistry. While the studio's name is in homage to the gamble that is the entertainment industry, Masse's success has proven he knows how to roll the dice. He is from Grand Rapids, Michigan, where he grew up on choral and R&B music. Post high school, he played guitar in Colorado's "hippie jam band" scene. After realizing his passion for recording, Masse quickly moved to Boston, to attend Berklee College of Music. He then relocated to Nashville where he gained industry experience at Blackbird and Idiot Dog Studios. When the time came to declare independence, he wagered on the biggest bet of all by launching The Casino in his own backyard. Fortunately, the odds were in his favor as artists began flocking to the studio. They were attracted to the cerebral, collaborative approach he applies to the creative process. His method is the approach that works best for each artist and to create a moment in time that will last forever. For Masse's personal definition of success is quite simple and something he has already achieved: existing in the crap shoot that is the music industry and experiencing the surreal, kinetic energy of the recording process.

Your background is in "hippie jam bands," yet you're now in production and engineering. What originally piqued your interest in music?
My mom sang in church, and my dad was a huge R&B fan, so music was always around while growing up. The real spark was when I was ten and got a guitar, because it was the first thing that was truly mine. From there, I knew I was going to at least try my hardest to do music in some way or another.

What's your advice to someone who is looking to get into music production?
What's hard in this industry is being able to get up from a lot of "No's" versus just going in and punching the clock. If you can get past the "No's" and failures, suc-ceeding in the music industry is about hard work, just like any other. Success is your own definition, and for me, it's paying my mortgage and still being here.

The hardest part is continuously maintaining confidence. When that's in line, you're generally on cruise control.
Amen! To me, failures are lessons to not make the same mistakes again. It's hard to succeed in this industry *fast*. But if you just want to do what you love exclusively, then it can be done.

What does a music producer do exactly?
Helps the artist realize their vision. You have this artist who has things to say and it's my job to bring that into

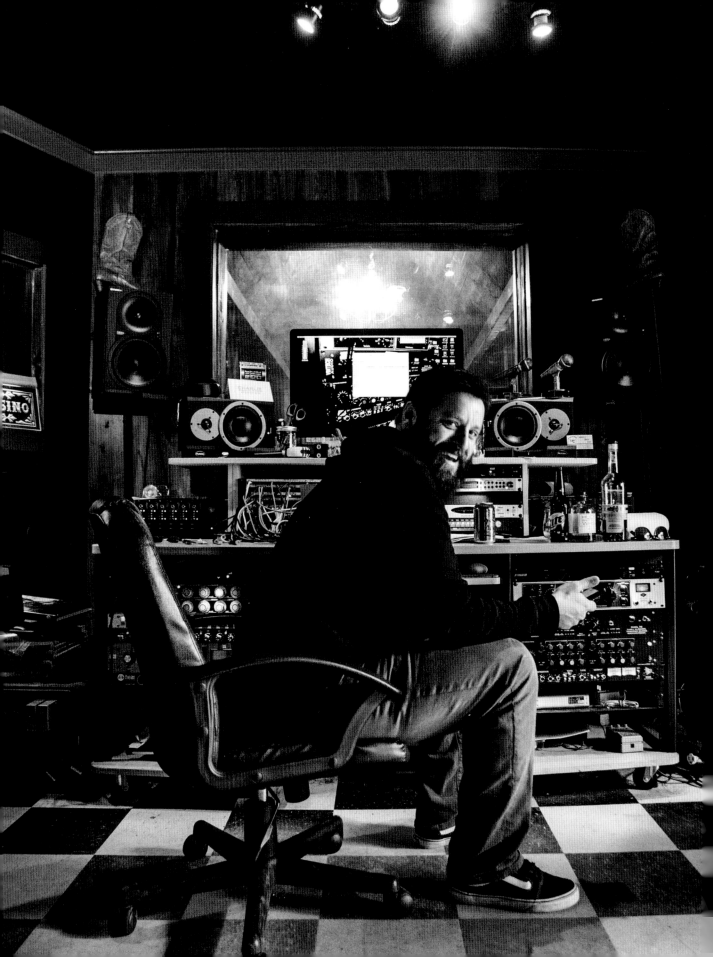

existence. Some artists genuinely need you to instruct which chords to play, and with others, it's keeping the train on the tracks when the band is bickering about tempo. Production is the trenches. You don't know what you're getting yourself into, but it's not about you. It's about friendship, sharing something special and killing it in a way they didn't know existed.

How do you know an album is really going to be something special?

If the songs are really great, that's always a good starting point. If it feels right to us and there aren't a lot of questions, then I can usually do those songs justice.

Why would an artist want to work with you?

They know I'll try my hardest to make their record a believable experience. I make stuff sound real and an accurate representation of the artist. Plus, I think I'm easy to work with.

I can imagine recording an album is a really intimate experience.

The vibe and making an artist feel comfortable is crucial. The level of vulnerability to make a believable product is high. My artists can make as many mistakes as they want, and I'll never make them feel bad. Because it's not about me but rather about disappearing and letting their vision come to life.

There's a lot of gratification that comes from giving someone else the chance to shine.

Exactly. And sometimes it's hard to not put yourself all over the recording. I would like to be known for my work, but I don't want to impress my ideas onto someone else. The stylistic approach is always on a case-by-case basis, and I care enough to realize that. I can't just be a template producer and find a strategy that works every time.

What qualities make you want to work with an artist?

Believability and good songs. Or at least a great vision for the song. I run the gamut with the people I work with, and all I care about is authenticity and honesty. I don't strive well in phony situations.

Do you ever listen to the stuff you've recorded once it hits the shelves?

I can't remember the last record I've made that I put in my CD player beyond approving the masters. This is whacko: Thirty to forty songs I've recorded have received major airplay, and I've never heard one on the radio. One of these days, it's gonna happen—although I'm usually listening to NPR.

You've been a part of Nashville's underground music scene for a long time, and now it's exploding. Why do you think that is?

Nashville is blowing up because of the community. It's just so wild how many normal people there are killing it, and you'd never know until you talk to them.

There's also a modesty here that's really attractive—unlike in other cities where it can sometimes be all showboating and bravado.

It's because everyone is a bunch of self-deprecating, insecure artists. I mean, I think I suck, and you're amazing.

I was going to say the same thing about you!

The best thing about Nashville is it's still affordable. People aren't scattered all over the city in shoebox apartments and splitting bedrooms with people they found on Craigslist. It's a community.

The energy here is unreal. I felt like I moved here and my brain exploded with creativity.

The reason people are talking, writing, and caring about Nashville is because the artists don't really need businesspeople anymore. We can do most of it ourselves, and that, to me, is the future. Yes, you need a label to put out your record and a publishing house to put out a book, but we don't need all those other people telling us what to do. That is power.

It's the declaration of independence. We've cut off contact with the real world.

My excitement level is focused on artists doing it themselves. With that territory comes having to be talented, smart, and learn the business side. You learn the business side of this industry by getting burned a couple of times, and failing at it. I've made so many mistakes, but I try my hardest to learn from all of them. Because of that attitude, I'm still here. Imagine if you failed one hundred thousand times and were still given the opportunity to be in the game. You'd rule the world. If you see something you love, go headlong into the storm, because if you survive that, you'll be unstoppable. Everyone fails a million times over before they succeed.

What is the biggest mistake you've seen others make in the music industry?

Making fifteen mistakes and them moving back to their hometown. To those people I always say, "no shit you failed a bunch of times." Everyone stumbles over and over before things suddenly click. That's just the way it is and always has been.

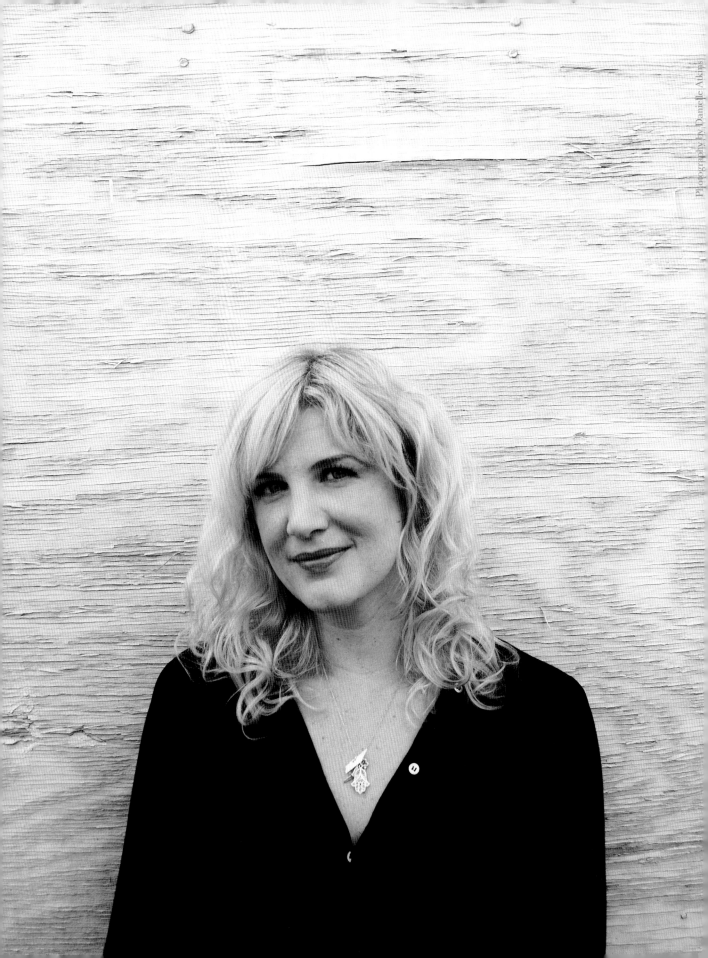

ABBY WHITE

{Journalist/Author}

All Abby White ever wanted was to find the muse and satisfy her case of ADD. The writer knew a job at the bottom of the food chain wasn't for her. After relocating to Nashville in 2011, White relinquished her advertising background in favor of a ticket to the circus: the rollercoaster ride that is the modern world of journalism. It led her to SouthComm, Inc. where she currently works as a staff editor and has outlived several publications. The storyteller is more determined than ever to keep longform journalism alive. White is glutton for any experience that will be grist for her mill, and has developed her voice on the page through practice, and pushing her editorial range. As a child she made her own magazines and Top 100 musical charts, foretelling indicators to her future career in the entertainment industry. Her first editorial position was at *Performing Songwriter* magazine where the professional listener lived out her dream job of music journalism. After five years she jumped ship to join the SouthComm team where she served as editor of women's magazine *Her* and weekly news rag *City Paper*. Most recently, the author penned her first book, *100 Things to Do in Nashville Before You Die*, and stands at the helm of *The Nashville Scene's* award-winning, feminist opinion column *Vodka Yonic*. As someone who looks for the lessons in everyday situations, White is more than willing to make her own private life public. However, she is sensitive to the weight storytelling bears and wants to do her subjects justice and keep her readers engaged. If she can do this then the overachiever's work is done—at least for the day.

You majored in advertising during college so how did you learn to write professionally? I know my own path was mentorships, internships and just by doing.

Agreed and that's kind of how it worked for me too. Working at magazines forced me to learn quickly because we put out a lot of content monthly and now weekly. I watched what everyone else did and soaked it all up.

What was the most difficult part of learning on the ground?

Learning how to interview was harder than writing and is, truthfully, still something I'm working on. One of my oldest friends, Bill Domain, is a brilliant writer whose subjects never wanted to stop hanging out with him. I was fortunate to have some mentors like that whose brains I could pick.

What was the best advice he ever gave to you?

Not to ask the conventional questions and really come in prepared. I think sometimes you can research everything because we have the luxury of the Internet but it's also great to have a very organic conversation. It's great

to have your talking points and then let go. You're going to get the real stuff at that point when the subject lets their guard down.

What is one of your favorite interviews?

I really, really loved talking with Constance Gee. That was right after *Her* had closed down, and I was handed her book on a Thursday and had to turn in my piece Monday. I stayed up all night reading the book, prepping and then Saturday morning went over and talked to her. She was someone who had been mistreated by the press, so why on Earth would she trust me to write her story? That was the first long-form journalism story I did for SouthComm. It challenged me as a writer to absorb as much as I could about a topic and then piece it all together. It definitely helped to be working with incredible editors.

Sometimes it's frustrating to even be restrained to a 2,000-word count.

I'm with you on that. I feel like a lot of people, organizations or stories you learn about can't be done justice in 2,000 words. I always overwrite because I feel such a sense of responsibility when telling somebody's story. As a writer you want your touch on the piece but not so much that it subtracts from the subject's voice. I constantly have that internal struggle seesawing from a participatory story where you're the character to something more objective.

What was the transition like going from music journalism to newsy storytelling?

Around the time I left *Performing Songwriter* in 2008, all of the music magazines were closing. I saw how our pages were consistently dwindling, which was terrifying and depressing because of how much I believed in the magazine and wanted to be a part of it. However, music journalism can wear you out. At first receiving a stack of CDs in the mail was like Christmas and then it turned into, "I have to listen to all that?!" I see how people get cynical and turn into old curmudgeons.

You made an offhanded comment earlier about, "being in this crazy industry yet never being able to get enough of it" and have lived through several publications. I'm curious what you love so much about the newspaper industry.

Maybe I'm killing them off, I'm not sure! (Laughs) I'm like the cockroach that never leaves. I've had those jobs where you turn your brain off from 9-5 and then go live your life. For me, I never had enough energy at the end of the day to pursue my passion because it was sucked out by corporate America. That's why I cling so tightly to my position here and every time they get rid of a paper I scream, "I'm not leaving! Please don't make me go, what can I do?" If it does happen again my hope is I walk away learning as much as I possibly can.

What is it about writing that is so meaningful to you?

I just love meeting someone who tells me an interesting story and then relaying it to someone else. Not to get all 'kids these days' on it but I feel like everything in our culture is so immediate and succinct from 140 characters in Twitter to status updates. I like and utilize all those things, but I don't want to see a younger generation get disinterested in longer-form journalism that might not fit into a 90-second YouTube clip. I don't want to see that art form go away, and if I can participate in it and contribute something of substance then I'm the luckiest person on Earth. There isn't a greater feeling in the world then when Constance Gee says to you, "You are the first person who didn't coddle my story and told it with a fair eye." This is someone's life we're talking about and if someone is taking the time out of their day to talk to me then I owe them the best version of their story whether it's 300 words online or 2,000 words in *The Scene*. I feel a lot of responsibility in that respect and don't want to fuck it up.

I NEVER HAD ENOUGH ENERGY AT THE END OF THE DAY TO PURSUE MY PASSION BECAUSE IT WAS SUCKED OUT BY CORPORATE AMERICA.

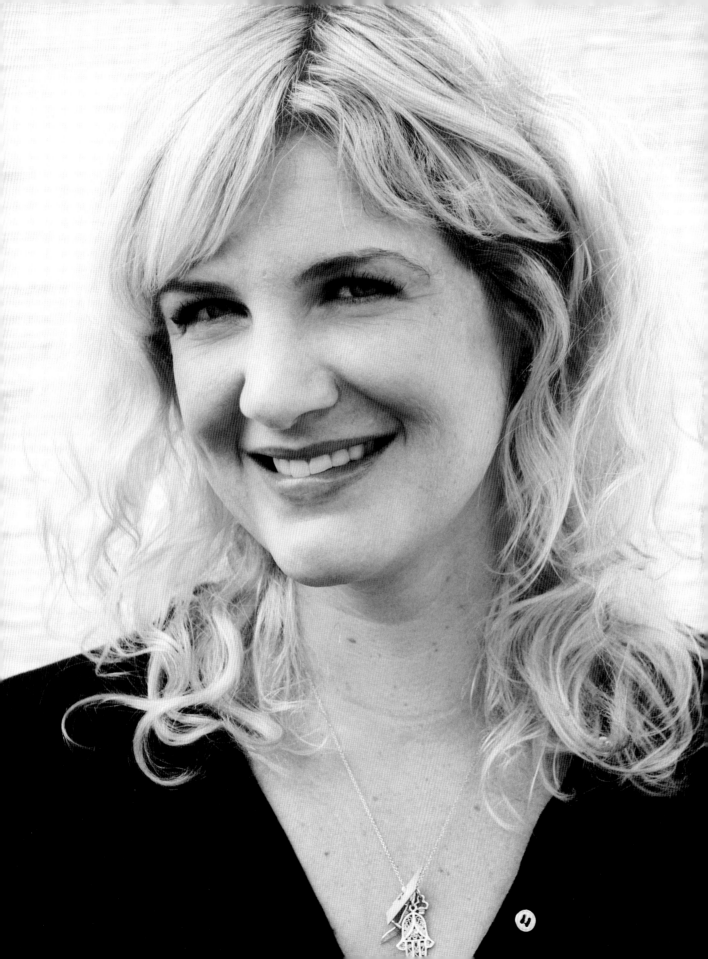

STEPHANIE PRUITT

{Poet/Arts Activist}

An elevator pitch cannot encapsulate Stephanie Pruitt's career. The resumé of the prize-winning poet, marketing guru, and Vanderbilt professor reads like a human juggling act. In one week Pruitt may participate in an art exhibition, give a Ted-X talk, or lend a small business structure by means of her No Starving Artist Consultation Services. The success of her own products, such as poetry vending machines, have proven even the most obscure ideas can result in a sustainable income. The Nashville native is energized by opportunity and realized as a child she wasn't cut out for a linear path. However, she chose marketing as her college major after it became clear her success was contingent on personal branding. There she learned how to combine art and analytics to pursue her random "aha moments." Next she launched quarterly series, *Poems & Pancakes*, and began partnering with restaurants, event planners and organizations to bring literary arts to unconventional spaces. Pruitt abides by the theory that even the most obscure ideas deserve an audience. Through her executive coaching and upcoming virtual platform she intends to empower artists in their entrepreneurial efforts. While she works strategically, Pruitt is also willing to dive into her dreams eyelashes first. The ARTrepreneur has turned a myriad of interests into multiple moneymakers.

Millions of ideas fly through your brain on a daily basis, so how do you decide which ones are worth pursuing?

I wish I had a consistent system. I tend to do a lot of visualizing, and run through dozens of scenarios with the best and worst possible outcomes. Sometimes I think strategically in terms of the idea aligning with my personal brand, but ultimately if it's passed my imagination filter, I'm at least going to dip a toe in and possibly jump. I go into every project knowing it's an experiment, so I won't be disappointed if it flubs or flops.

How do you approach the planning stage of an unconventional project?

Reverse engineering helps. With the poetry vending machines, I thought of all the places I would like to see them: banks, steakhouses, hotels, and shoe stores. Next, I think about what the people running those spaces value. Once I figure out where our parallels and intersections are I shape my plans to make those valuable connections. Talking to people and listening is the key to it all. While I believe strongly in letting my internal compass guide me, I also recognize that a concept, service, or product needs a recipient. My planning has to be empathetic enough to embrace my audience if I want my creations to operate in the world.

Has there been a particular project that has really forced you to grow as an artist, businesswoman, and/or individual?

I grow through every project, because they're all living laboratories. While it sounds cliché my failures and suc-

cesses have been equally valuable. The biggest lesson I've learned is not to rely on the "right" moment. Perfect timing is similar to the Easter Bunny. I try to maintain high standards, make great work, and just jump in rather than hoard my ideas.

How would you define artrepreneur?

An artrepreneur focuses on their craft yet also minds their creative business. They know how to position themselves to make a fulfilling life and income through their art. I have a strong desire to teach young people about the partnering of creativity and business. My goal is to prepare creative minds for the realities they will most likely weather as a working artist. Or, on the opposite end of the spectrums, help them implement their artistic leanings in the business realm.

What is an example of a project that you are currently working on?

Mind Your Creative Business is a coaching service that will operate through social media, podcasts, and online classes. It will empower artists in their entrepreneurial efforts, and hopefully save them from the pitfalls I've experienced. It's for those who don't embrace the starving artist mentality, yet know better than to take on the silly banner of "sellout."

What is your most rewarding accomplishment thus far?

Whatever my most recent project is. I do allow myself to sit back and give myself a high five from time to time, which I think is healthy.

Constantly chasing the next dream will wear you out eventually. I think of my activities as a portfolio, which is made up of the new, old, challenging, easy, unexpected, and consistent.

Where do you get the momentum to pursue so many different projects?

I was born with a strong drive and a reserve of energy that keeps me going. However, it is definitely scary to walk along the edge and constantly pursue three or four projects simultaneously that you hope will all make sense together.

Did your parents instill that courage in you?

My parents did a lot of firsts together: left home, attended college, and had jobs with benefits. They had that push and imparted that on me. My mom always said, "Stephanie is going to do her thing and even if she doesn't land on her feet, she'll keep going."

I FINALLY THOUGHT, NO MATTER WHAT I DO SOMEBODY IS GOING TO BE BOTHERED BUT AS LONG AS I'M CONSTANTLY SAYING YES TO MYSELF I'M GOING TO BE OKAY.

What was it about the poetry genre that initially grabbed you?

I am drawn to opening doors, spaces, and ideas through the fewest number of words possible. The condensation of language is efficient and challenging at the same time. Those parameters make me question, how can I rail against the rules in my own little way?

How would you describe your particular style?

On the weekends, I love to shop at yard sales and junk shops. The first few may have nothing, but at the eighth stop I usually find exactly what I'm looking for. That diamond makes the day absolutely perfect. Anything I create is very much the same. There's always an epiphany, which brings everything else to life. It encapsulates, rather than overshadows.

Do you create for a specific audience?

Of course, otherwise, why would I be doing it? There's nothing powerful about creating something that only 3 percent of the population will understand. I want to be less self-protective and rather, engage with the world around me.

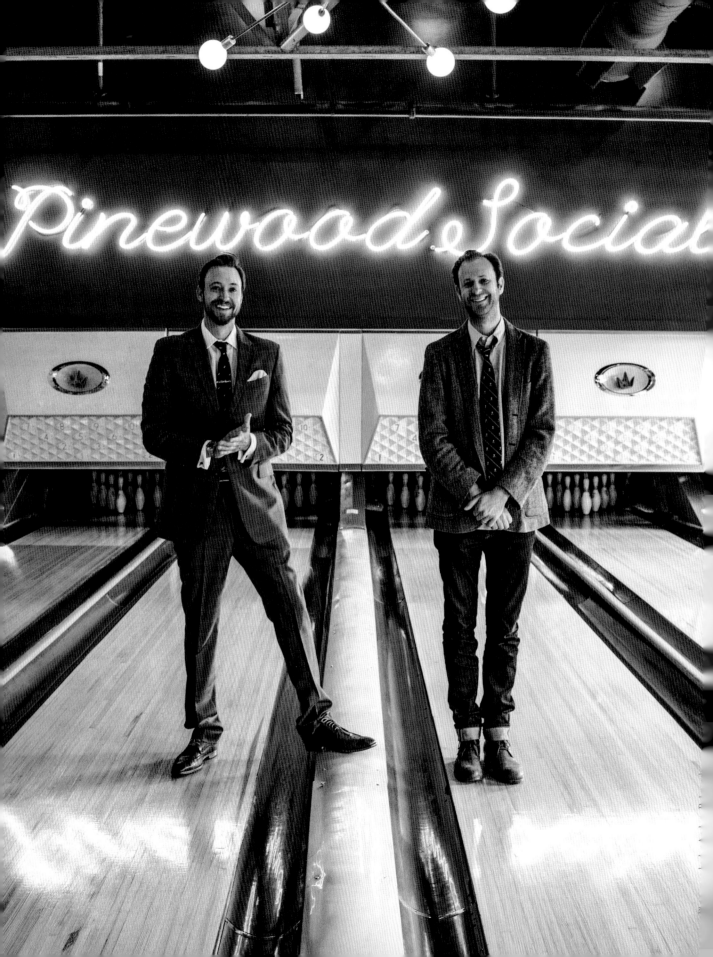

THE GOLDBERG BROTHERS

{*Restaurateurs*, Pinewood Social, The Catbird Seat}

A business by the Goldberg Brothers starts with one question: would they be the first customers in line and number one users of this space? Benjamin and Max Goldberg are sold once they fall in love with an idea, building, or location, and simply bank on others appreciating their vision. The co-owners of Strategic Hospitality are responsible for nationally praised gems Pinewood Social, Patterson House, and the Catbird Seat. The risk takers first introduced their hometown to craft cocktails, and an adult playground complete with bowling, karaoke, and wading pools. Each concept indicates where the Nashville "kids" are at a certain phase of their life and will hopefully be treated by their customers as an extension of their home. After attending college in Miami, Benjamin resolved to elevate his hometown beyond sports bars and steakhouses. He began with Bar Twenty-Three, opened in 2003, which earned him international recognition right out of college. Three ventures later, he recruited Max from a New York City marketing position to join as a partner in his company. By merging minds, they have transformed the city's culinary landscape, forecasted trends, and salvaged underdeveloped neighborhoods. At the core, the Goldbergs are best friends, family, and business partners who trust one another more than anyone in the world. Hospitality is in their blood and business is the way they see the world. Great ideas evolve from bantering back and forth about which project they mutually gravitate towards. They strive to make their grandiose visions tangible and add a Nashville spin to every project. The core of their mission is to create living, breathing art pieces, which will exceed everyone's expectations as well as their own.

Has anyone ever told you one of your concepts was a bad idea?
Benjamin: No one has ever said that I had a great idea! A lot of times people think we're trying to bite off more than we can chew or setting expectations for ourselves that are not always achievable. Leading up to a project we don't get a lot of sleep. It's constant worry that we're going to be able to execute what we've dreamed up in our heads.

How did you get people to take you seriously when you set out to open a bar in your early 20s?
Benjamin: My business partner Austin and I begged and groveled. In order to get the money we needed for Bar Twenty-Three we created a list of people that we thought might believe in us. We pitched one person and after they said yes we thought, "wow this is the easiest thing in the world." Then we went through a hundred "nos." Every time someone rejected our proposal we

asked for three to six names of people they thought might be interested. We crossed out hundreds of names on this dry erase board until we got seven people to say yes.

What keeps you going in that interim period where you're getting rejected constantly?
Benjamin: I didn't have a backup plan because it never occurred to me that I wouldn't get the money. Like most things in life, it just proved to be more difficult than I originally thought. I was naïve and went full steam ahead on the mission at hand.

How did you develop a lifelong interest in business?
Benjamin: We've always been around people who viewed the world in a business environment. Our dad designed women's shoes on a freelance basis, and our grandfather worked at Werthem Factory where they made burlap sacks and packaging for huge companies. Growing up in the Depression Era framed his point of reference for life so he built a farm out in Centerville, Tennessee where he could always feed his family and put a roof over their heads.

You create the ambiance and aesthetic of your restaurants from a blank slate. I'm interested in your view of art and business and how the two tie together.

Benjamin: I love using both the creative and business sides of my brain because each drives the other. Even if we start out with a dirt floor, it's exciting to make a space comfortable, visually stimulating, and spacious enough so people have the opportunity to engage one another.

What is it like working with another family member so closely?
Max: We were very realistic when we first got into this that the brother relationship was way more important than any business we were ever going to do together. Our relationship worked because I was able to craft to Benjamin's style, yet challenge him because of our different strengths and weaknesses. Benjamin's been a great leader for our company and I can't imagine working with anyone else.

Is it challenging to maintain the integrity of old school Nashville while introducing all of these new ideas that were inspired by your travels and time away from home?
Benjamin: I've never thought about old versus new Nashville but rather using our travels and time living outside of the city, Max in Denver and New York and me in Miami, as our number one reference point.
Max: Nashville is our favorite city in the world because of its rich history, quality of life, and ingenuity. People want to support small business owners and see them succeed. It's

the coolest thing in a world to have a customer say, "We have a friend in town and just *had* to show them this place."

What project have you guys learned the most from?

Max: I've learned a lot from all of them. I'd always had a passion for the hospitality industry but the first time I understood the inner-workings was the first 18 months I worked at Paradise Park.

Benjamin: I learn something new from every single project but the first one I did, Bar Twenty-Three, was an immense learning curve. My business partner Austin and I had to learn the base level knowledge like doing payroll, paying taxes, and getting a beer license. Every single thing was fresh, whereas now the scope of our project is more ambitious in size and offerings. As two 23-year old kids opening up a bar for the first time in their lives we just plowed through it together.

What keeps you two motivated and inspired to tackle new projects?

Max: We really try to open places that we believe in and don't necessarily exist in Nashville at the time. Pinewood Social isn't the first retro bowling alley with a food and drink program, but we added our own touch with the living room, karaoke, and outdoor space. Traveling, seeking out inspiration, and reading about what restaurateurs are doing is a big part of conceptualizing projects.

Benjamin: We want people to come in, enjoy themselves, and learn something from us just like we learn from them. Guest interactions are what inspire us to keep improving. If people eat or drink something at one of our restaurants for the first time, then we've opened up a path of their life they didn't know existed before. That inspires us on the most simplistic level.

What is the process like of choosing talent to be the face of your restaurants?

Benjamin: We view our chefs and mixologists more as partners in projects than employees. Hopefully we allow them the freedom to create, learn, experience, and work together to create their own vision. We want to create an environment that is beneficial for everyone and we can 100 percent stand behind.

Max: We genuinely care about people and it means the world to us that they want to be a part of our vision. We're not the cool guys at the bar and don't treat this as a playground. We treat it as a business and family. We love the people that we work with and want to do everything we can to help advance their careers.

Benjamin: It's definitely not a one-way road but rather, we're all in the same ship together trying to make something as great as we possibly can. At the end of the day we want to know our team is going to go to bat for us and us for them regardless of where they fall within the company.

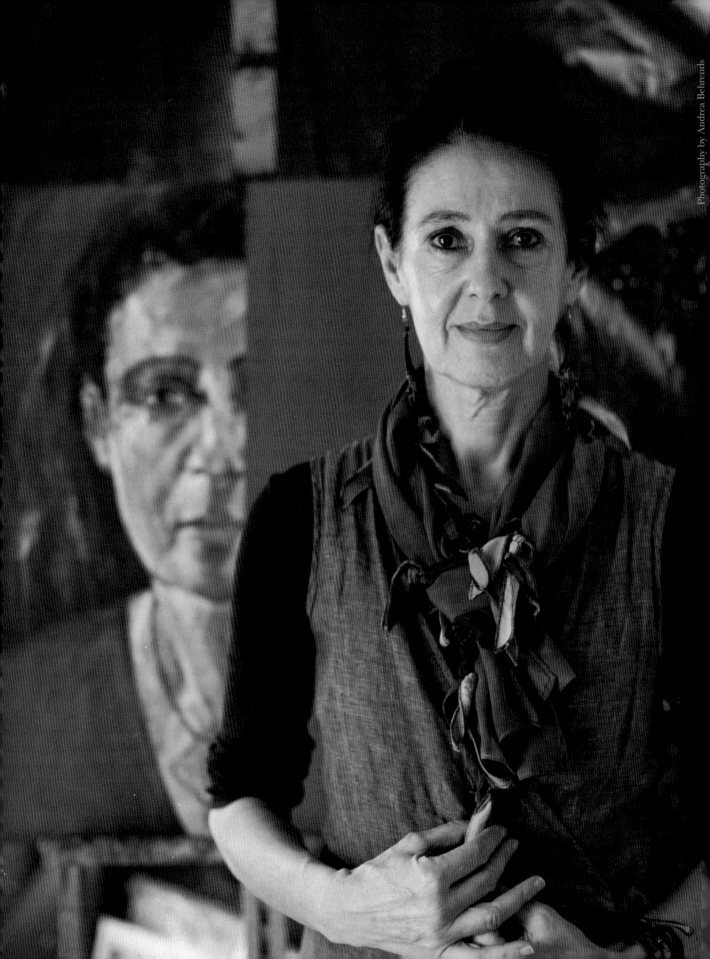

MARLEEN DE WAELE-DE BOCK

{Painter/Visual Artist}

In her native Belgium, Marleen De Waele-De Bock attended a prestigious art school where she earned a degree in printmaking. This rigorous education became the foundation for her future endeavors in painting, illustration, graphic design, and fashion design. While De Waele-De Bock sees art as a free form of expression, classical principles have always underscored her work. The painter has lived and exhibited all over the world and knows better than anyone that inspiration is everywhere. She gravitates towards what speaks to her at the moment, and lets the experience of life dictate her work. Even culture shock has never slowed her down. Shortly after graduation, the newly wed and her husband moved to Mozambique. After surviving a three-year volunteer contract and civil war, they settled in South Africa for over a decade. There, De Waele-De Bock developed a following for her compositions of African marketplaces, crafts, and sculptures. Then her geologist husband was transferred to Tennessee. Shortly after their arrival De Waele-De Bock received her first exhibition at the Parthenon. Immediately, the painter dug into her surroundings to create a new series inspired by the South. She has since exhibited locally and regionally, and runs Bel Art, her own gallery located in the downtown Arcade. Painting is De Waele-De Bock's personal form of storytelling, and each piece unfolds in the same elusive manner as the initial idea arrived. For when the artist gets into groove nothing else seems to matter.

Having graduated from a formal arts program back in Belgium, do you approach your teaching in the same way at O'More College of Design?

Visual art is the only creative form where the lines can become really blurred. My position in the classroom is if you want a degree, my students need to show that they are worth one. It's a difficult balance between giving them a real world perspective on the art world without discouraging them.

They say the majority of art school students don't end up pursuing it as a profession. You're a rarity in that.

It's the life that revolves around creating something. It's like being high all of the time. For the record, I've never taken drugs but I'm sure it's a similar feeling to the one I get when you love your work, and other people do as well. If a collector buys it, well then that is the ultimate compliment.

Some paintings are a real struggle and ask for a lot of concentration and patience. When you're able to get over that hurdle it's the most wonderful feeling in the world. Still, I crave that recognition from other people. It takes the process a step further and that cyclical process is what drives me.

What gave you the confidence to show the world your work for the first time?

It was the support system that came from art school. All of my teachers were exhibiting artists and that environment was so inspiring. While it taught me the technical elements it was the discussions and camaraderie between the professors and students that really made

me grow. The art world is much different now in the digital age but back then we created our portfolios, had them critiqued, and started small. I worked my way up from coffee shops to gallery exhibitions.

After art school you moved to Mozambique where the materials were so limited that you only had paper bags and linoleum to draw on.
Mozambique at the time was one of the poorest countries on Earth and so different from my previous life in Belgium. I was teaching at the university and just trying to survive and not become too depressed by the environment around me. I learned a lot about myself from that experience, and how to create when you're completely disconnected from the art world.

It was a socialistic country, so the only radio was the president talking in Portuguese and some African music. I was completely cut off from the outside world and there was no other way to get through it than to just immerse myself in the culture. It was a really tough two-and-a-half years.

After we moved back to Belgium to have our daughter, I was so grateful to go shopping, have coffee and crepes, and enjoy the good life. Next, I went back to art school for graphic design and in 1990, we left for South Africa.

After studying printmaking and graphic design in school, when did you transition into painting full-time?
I've always loved painting, and having a printmaking background is the basis for any artistic medium. In Belgium I did small commission jobs and then I really dove into it when we moved to South Africa. I found the people there very inspiring as well as the marketplaces, craft makers, and wildlife.

Next I started a children's clothing line, which I pursued for a couple of years. I've always had a great love for fabric and my love for design came from having my kids. When I couldn't find beautiful, unusual patterns I decided to create my own. Right before I was supposed to design the winter collection, my husband and I found out that we were moving to Nashville. I closed the business and began focusing on large-scale paintings with South African sculptures as my subject. That was my first exhibition, at the Parthenon, after we moved to Nashville.

How do you choose a particular theme for an exhibit?
People will ask if I still paint the African culture and I say, "No! I'm in America and inspiration comes from where you are." Today I'm inspired by the seasons, nature, and landscapes like the horse pastures I used to see

WHEN I PAINT TIME IS FLYING. THAT'S WHY I'M ALWAYS LATE AND HAVE TO RUSH EVERYWHERE. IT'S THE BEST FEELING IN THE WORLD.

while driving my kids to school. Whether it's winter or spring, where everything is in blossom, the forest behind my home allows me to really experience the trees, flowers, and greenery.

You tend to stick with a theme for several years. Is it because your perception deepens over time?
Even if you stick with the same subject for years, you get a different result every time. Professional artists tend to really explore one subject matter before moving onto the next one. Students, on the other hand, are encouraged to try out different subject matters because they're still finding their way. It's about growing to your style and developing a cohesive collection.

I think it's about experimenting and being flexible until you find your niche.
It's all very personal. Art is about studying, living, practicing, and traveling. My work is a mixture of good times, bad times, sad times, happy times, which all sum up my own experience of life. It's about being willing to continuously grow.

What do you love most about creating?
While I'm flexible on when and how often I paint, creating gives me an incredible amount of happiness. When you do what you love it's the best feeling. I get into the flow when I paint and the hours fly by. It's why I'm always late and rushing everywhere I go. Obviously I love it, because when you're in the waiting room at the dentist's office time seems to take forever, doesn't it?

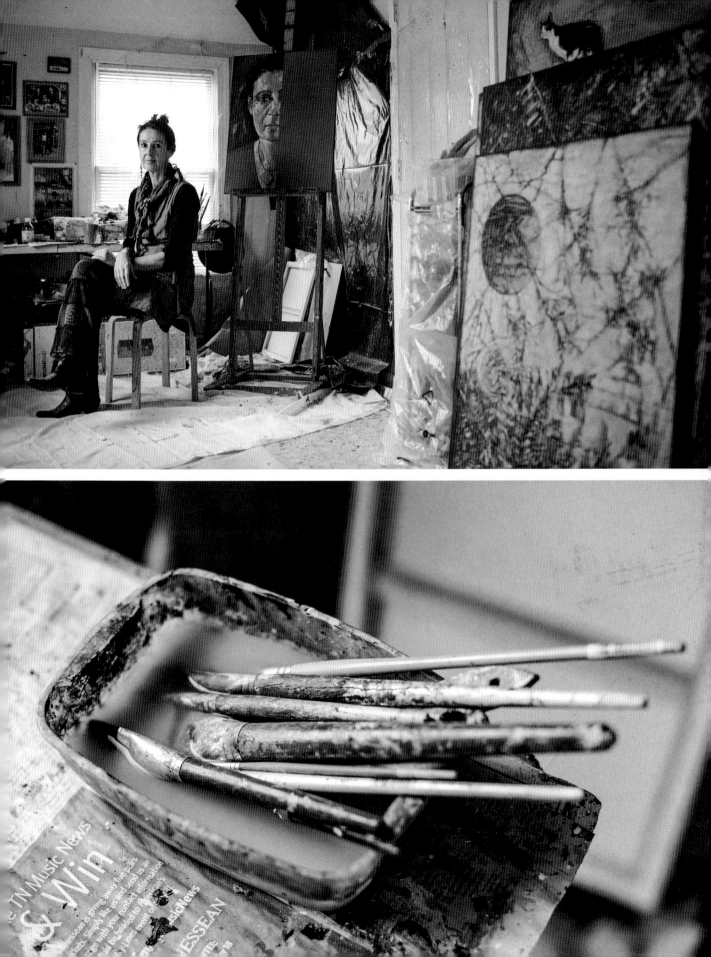

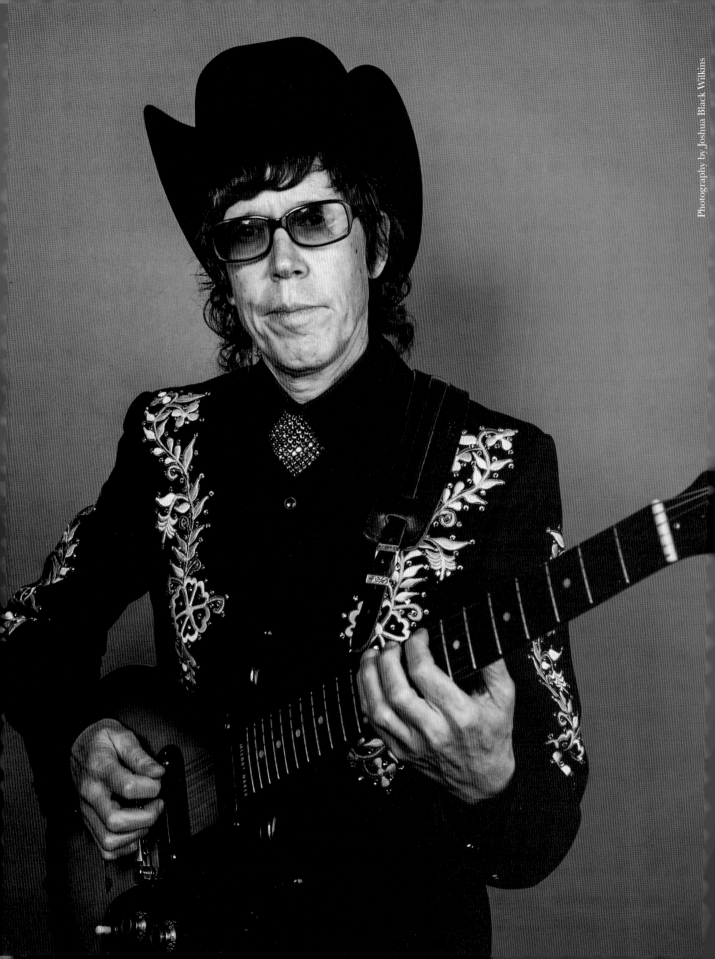

Photography by Joshua Black Wilkins

KENNY VAUGHAN

{*Guitarist/Session Player*}

Kenny Vaughan works hard to play gigs and ignore reality. Since landing in Music City in 1987 the performing musician, session player, and songwriter has become something of a local legend. Vaughan was first introduced to Johnny Cash, Buck Owens, and Merle Haggard by a childhood neighbor in Denver, Colorado. At age thirteen, he had the epiphany that the nine-to-five world wasn't for him. While still in his teens, Vaughan started gigging at local honky tonks, and establishing a career as a classic country musician. Punk and rock 'n' roll eventually led him to Chicago and New York. On a whim, he uprooted to Nashville where he has worked with countless legends like Lucinda Williams, Marty Stuart, and Rodney Crowell. Vaughan relates his success to the decision to never hold a real job a day in his life. Throughout his career, he has questioned his sanity and contrastingly, absorbed invaluable musical theory, history, and skills from his contemporaries. He is proof that positive thinking and persistence ensure a musician a lasting career. Or at the very least, an eternal spot on the hottest recording studio call lists. That's pretty good for a self-proclaimed derelict without a college degree.

I've never had a job, not even one day. My parents moved away when I was eighteen, and I just kept on playing gigs. After I was kicked out of high school, I didn't have anything else to do. I was so lazy, and, to me, having a real job was like going to prison. I couldn't imagine or fathom the horror of going to work. It was not an option. Nope, I wasn't going to do it. No way. This lifestyle is fairly ridiculous because I never know how much money I'm going to make. There is some willingness to ignore reality. Who cares about reality? That's probably not the best way to live your life, but it worked out for me. I'm paying tuition for my kid to go to school at NYU, and I don't know when my next gig is going to be. It's crazy but then again, you just keep doing it. I was never going to do anything else because there was nothing else for me to do.

I've had the good fortune to work with some of the real mavericks that built this business in Nashville. They made their own rules and were creative. It was a small, cottage industry back then that the larger corporations just turned a blind eye to. Great talent made great product, and there was a small market for it. When I moved here in 1987, I got lucky and met the right people at the right time. I came here because of a phone call and an offer to play a gig for three weeks. When I came down here, I started going out every night and met all these people the first week I was in town. I kept meeting more people, playing more gigs and getting a steady stream of work. There were no plans, including for staying here. I just was able to make a living, and I'm glad to still be here. The last two years have easily been the best of my life. Everywhere you turn there's people who are blowing your mind. It's ridiculous how many talented people live here.

THIS IS A PRETTY RIDICULOUS LIFESTYLE.

I really have my father and his fabulous record collection to thank for it all. He was a jazz guy and took me to see all of these great artists. My guitar lessons were always taken with the jazz players, because those were the ones who had the knowledge, music theory, and would show you all the cool stuff. Nobody was exclusively into anything when I was growing up, so I never cared to concentrate on one particular style of music. I was just in the business of being myself, and I figured that's how it would be until I died.

I never tour more than I'm here but traveling is one of the biggest perks of the job. I like going to museums and famous landmarks in all of these great places. We're going to Washington, D.C., and have five hours to kill, let's go to the Smithsonian! When I lived in Chicago I never went to the Sears Tower either, but now it's like what the hell, why not?

Everybody is operating at such a high talent level here, but it's not really all that competitive. It's very supportive. Being a guitar player, I can go take lessons from some of the greatest guitar players I've ever seen in my life. I know them because they're my friends. Within two miles of where we are right now, there's about one hundred world-class studios. It's truly motivating to be here because you're around other people who are doing creative things all the time. Anytime you're around people like that, you absorb that energy, and, it in turn, makes you think creatively. It makes a lot of sense for me to live here because when you're around like-minded people, it rubs off on you. You absorb some of that power and feed off of it. I find that energy inspiring on a daily basis. I'm not so sure that I would be thinking that way if I lived in another city. I mean, look at all those French Impressionists who lived in Paris at the turn of the century. They all kind of knew one another and were hanging out in the same cafes. I believe the reason those paintings look so fresh and vibrant today is because they had an intellectual life amongst themselves, you know? It wasn't just one guy. They were certainly inspired by one another or at least the energy at that point in time.

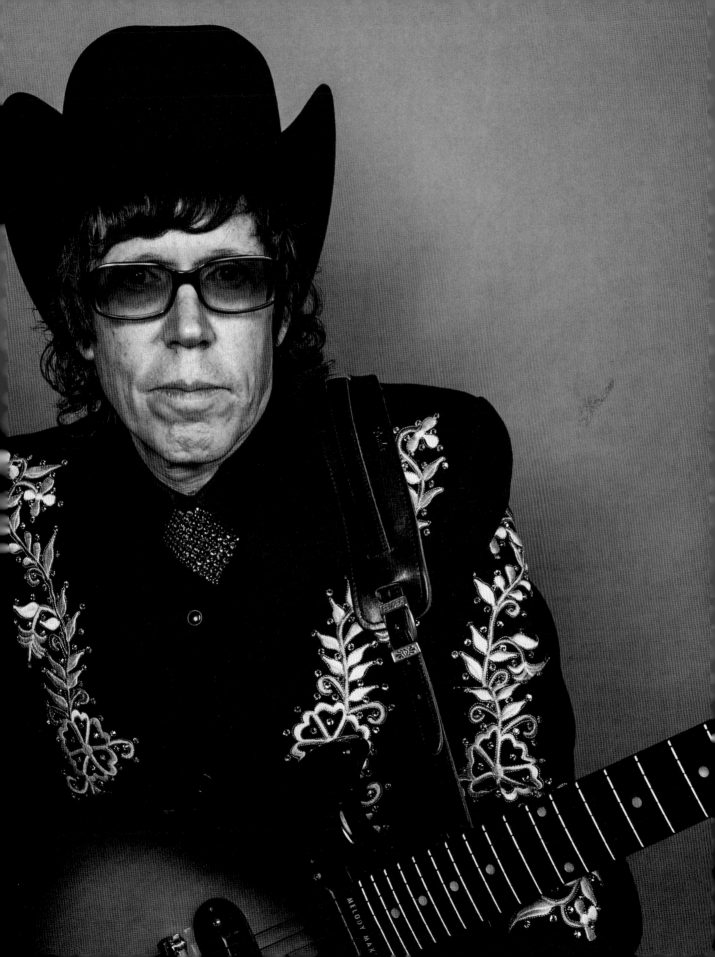

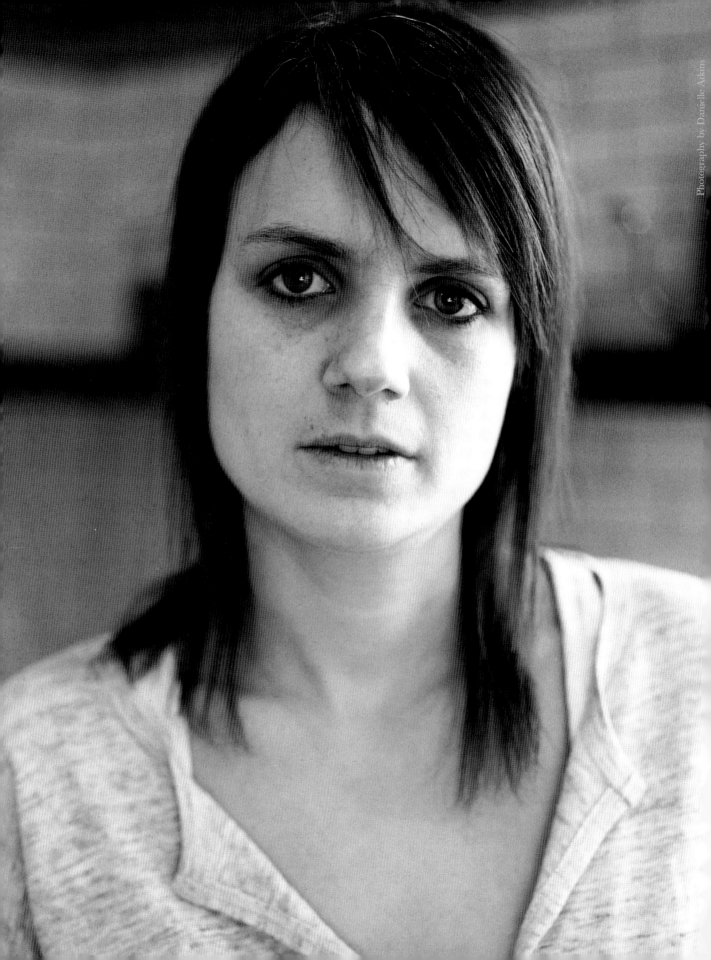

RACHEL LEHMAN

{*Owner*, Crema Coffee}

"Fully developed, clean and balanced" are the adjectives Rachel Lehman uses to describe her coffee. The same approach translates to CREMA's business philosophy, the coffeehouse and roaster she co-founded with her husband, Ben, in 2008. Relationships, rather than transactions, are the most important thing in Lehman's life. She strives to be face-to-face in all facets of the business from hand-pouring morning cups to buying direct and relationally from producers around the world. The Midwesterner grew up in an agricultural community, which inspired her social activism spin on small batch buying. She has worked in coffee for half her life, and first saw it as more of an art form while attending college in Denver. There she learned about latte art and barista competitions, and became determined to elevate Nashville's coffee scene after finishing up her degree. For five years, she worked as General Manager at Berry Hill's Sam & Zooey and, towards the tail end, began writing her own business plan. She and Ben recognized the odds were stacked against them and opted to fund the venture on their own dime. Buzz built slowly, much like CREMA's physical growth, as the early pioneers established their presence in their Rutledge Hill neighborhood. When they began roasting in 2011, lines dramatically increased. At their own pace, the pair expanded into a web store, second outpost, and wholesale accounts at restaurants around town. While the owner-operator's role has become inevitably more complex, at the core, her priorities remain simple: to create a memorable coffee experience by connecting customers to the source of their daily ritual.

What was your original business plan like?

We are stubborn and wanted full control of our business, so Ben and I took the long, but good, road. Through much sweat equity and the help of awesome employees we've grown the business by being quality driven, and farmer/customer focused. We didn't want any outside investors so it became our financial responsibility to take care of that risk. We were also comfortable with it just being the two of us because there's so much more tug-of-war when you bring lots of people into the mix.

Being the first in a neighborhood is advantageous, yet also trying. Where did that fire in your belly come from?

I am a fighter who doesn't give up easily, and goes into things for the long haul. Once I'm committed to something, I'm okay with it taking me awhile to realize my vision. For example, my husband and I did most of the build-out of CREMA, along with the help of family and friends, due to a shoestring budget. I am not wishy-washy and try to keep at whatever business I've chosen to do. My parents instilled that work ethic in me by example as two people who worked hard without complaint.

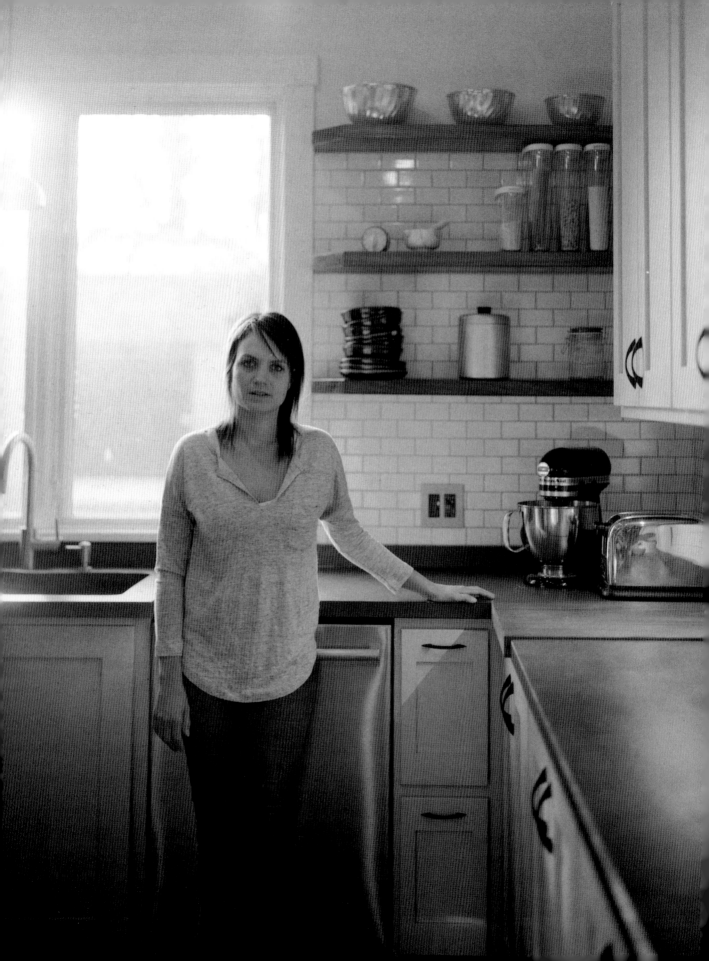

What was the turning point that created the Crema craze?

We started roasting coffee three years in, which really connected with our customers. It was a gradual educational process after I chose to price our 12 ounce bag at $17. People told me that I was out of my mind because when we started every single cup in town was the same price.

Now when I put coffee at different price points, I really had to stand on the front lines. I was constantly explaining that the varietal, rareness, or size of the lot justified what we were charging. Competition was welcomed because together we validated what's happening in the marketplace and the industry.

Roasting allowed us to carefully curate our menu through developing relationships with farmers. Even when we initially started and were sourcing from out-of-state roasters, we tried to incorporate as many local products as possible. I come from an agricultural background, so I'm hyper-aware that buying coffee off the commodities exchange does more harm than good to our vendors.

While learning how to roast was a rocky process, we took about four months to get our product right. The most fun part has been getting to meet farmers in places such as Central America where we've been able to directly purchase specialty grade coffees. I love collaborating with them to enhance growing conditions that will better meet consumer's needs and wants. It's so important for me to share these stories with our customers in hopes that they can taste the difference. Many of our customers want to grab and go, and that's ok, but we want them to know that's the core of our company.

What is it like seeing your business grow from zero to ten, and also having offshoots and having to relinquish that control? Also what have you learned?

I didn't get into this business to be an owner, so having a second location has been a big stretch for me. I tend to focus my energy intensely on one project. We've built our business on the premise of "doing one thing and doing it well." Often I feel a lot of pressure to keep up with the industry, but then I remember what's really important: our staff, customers, and farmers, which is what keeps me motivated. What the industry says is cool often is not in line with reality.

The hardest part is not hearing all of the external pressures to open more locations or expand. That is such the popular way: if you're not growing, you're dying. However, it's just not us. We care about crafting one, small amazing experience.

I REALLY CARE ABOUT PEOPLE, COFFEE, EXPERIENCES AND BEING ABLE TO PROMOTE OTHER BUSINESS OWNER'S PRODUCTS.

I am a mom, wife, and business owner. I've learned the extent of what I can and can't manage without feeling strung out. I never want to feel like a removed, non-participatory owner.

I've learned to structure things in a way so I can still do the things I love. I say no more times than yes and rely on people I trust. Otherwise, the work could be endless.

My goal is to plug in my employees and watch them progress through life. I want my staff to be growing and learning. Plus, it relieves me of the areas that I'm not as passionate about. My favorite elements of the job are the hospitality, wholesale, and educational sides.

Finding the balance in this tug-and-pull has been interesting because I feel like my role is always in a cyclical change. When you're a small business owner you have to be cool with flexibility, wearing different hats throughout a single day, and putting out constant fires. Doing everything is the biggest challenge that I face.

I want to make the coffee industry less pretentious and more relatable. It's a long process from the farm to the cup, and I'm passionate about demystifying coffee, and creating experiences that develops one's understanding and appreciation for the world's most amazing beverage.

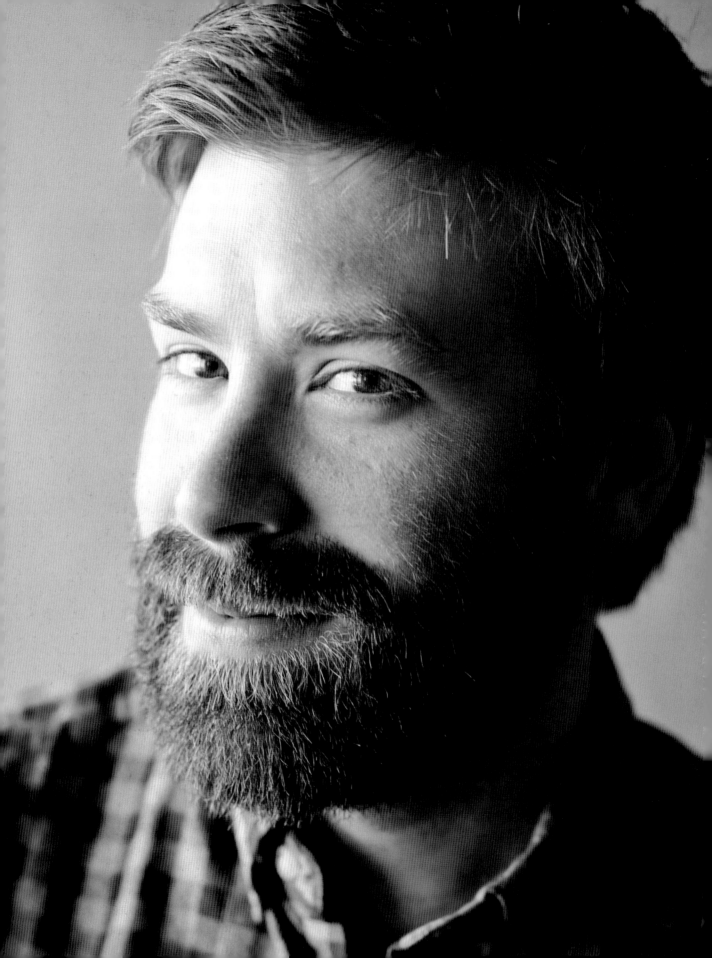

LARRY KLOESS

{*Promoter/Curator & Founder,* Cause a Scene}

Music is the mechanism Larry Kloess uses to motivate others. His concert series and independent booking agency, Cause a Scene, levels the playing field between musical acts and fans. Since 2012, the booking agent and promoter has hosted hundreds of live music events ranging in location from living rooms to traditional venues. In the household settings that CAS made its name, artists and audiences mingle on the same makeshift stage. The lack of bright stage lights to hide behind represent Kloess' greater mission of weaving together diverse social circles. His company was, after all, birthed from the desire to no longer be the odd duck out. Upon returning to Nashville after school, Kloess felt disconnected from the city he has called home for nearly two decades. While the 2010 flood is what brought him back, it is the citizens that have kept Kloess close. Music is the bedrock he's always had an insatiable appetite and ear for. He launched the CAS brand to cultivate a community around quality. Still, with a psychology background and no entertainment industry pedigree the promoter relied 100 percent upon faith and external affirmation. Once the shows began selling out, fans aptly coined him the city's tastemaker. They appreciated how he sifted through the clutter to deem what bands were worthy of their dimes. Kloess hopes the movement will be an axis point around which others can pivot to follow their passions. Cause a Scene and following dreams aren't mutually exclusive in his eyes.

How did Cause a Scene initially start?

Larry Kloess: I was really inspired by a band out of Texas called Seryn and approached the guitarist one day after their set. "If you guys ever want to come back to Nashville, I'd love to do it at my house, and can guarantee a lot of people will come." The next month, they play in front of 13,000 people in Atlanta and then, the following night, 75, in my living room. A lot of people saw me in a light they had never seen before and suggested, "You need to dive deeper because your passion for music is evident." That was the first house show I had ever attended or hosted. It gave me the itch to be around musicians, concerts, and creative people.

What was the initial idea behind throwing shows in such intimate settings?

I've always been interested in people watching, personalities, and seeing how we all relate to one another. Although I was a huge music fan, I found it difficult to connect with others at shows. Living rooms are warm, inviting and easily bring the walls down between people. The setting adds extra layers and gives fans the ability to rub elbows with a musician they admire.

When did Cause a Scene really have its first breakthrough?

The first year I had no clue what I was doing and hosted most of the shows at my house, and my parent's farm.

IF YOU'RE AROUND GREAT ARTISTS YOU STEP UP YOUR GAME. BOUNCING IDEAS OFF YOURSELF ONLY GETS YOU SO FAR.

The first time I ever did a show outside of my house was with a married couple that lived in the Nations neighborhood. There was a lot of buzz around that area and 250 people showed to watch three bands in their backyard that night.

How did you court that many attendees especially for a city like Nashville where there is music playing every night?

Word spread between my fellow concertgoers and friends, as well as artists who would lead me to one another. In May 2012, I threw a show on my birthday at my parent's farm with this band Foreign Fields whose next show was with the Counting Crows. Every kid wants to make their parents proud so it was really special to have them see what I do. I oftentimes give a ra-ra speech after shows about community, making the city smaller and how everyone's story matters. I do believe everyone has a dream inside that is worth going after, no matter how fearful they are.

Why are stories and a sense of community so important to you?

If you're around great artists you step up your game. Bouncing ideas off yourself only gets you so far. I wanted to be around others who were chasing their dreams and help push them down the line a little further.

Why are you so passionate about music personally?

The spotlight on Cause a Scene is so much brighter because I've been able to book well known acts. They create buzz and allow the baby bands to grow, which makes that funnel increasingly bigger. Music has given my life a level of significance. It's my platform for building a rapport whether it's by giving mix tapes, band recommendations, or advice about which shows people should go to.

What is the ideal light you would like your audience to see you in?

From a business perspective, I want to work with professional artists who will keep up the caliber of the brand. From a passion standpoint, I would love to build a level of trust with my audience to vet which music is worth checking out.

How did you build the confidence to call yourself a tastemaker?

After people referred to me as one over and over again. You have to believe in yourself before anybody else will take you seriously. The encouragement I received gave me the ability to stand on my own two feet and embrace that title. To have success and get to levels that I never dreamed of just validated what I was doing.

You said to me once, "Even if someone stole my idea, I'd out-work them until I crossed the finish line." Where does that momentum come from?

I've never been this passionate about anything before. I want to spend my life doing this and not just in the margins of my week. That's when it clicked that something that started out fun and as a way for people to hear great music had turned into a business. Cause a Scene has turned my life upside down in the best way possible. Now I don't believe anything is impossible, and want to use it to inspire others to chase after their own purpose in life. In trying to reach my own, I've aimed way too high, reached outside of my grasp and thought outside of the box. If you're around others who are chasing their passions, it forces you to step up your game.

Dream big: ultimately, where would you like to see Cause a Scene go and how do you plan to build the business side?

Great question! As CAS has grown over the past three years, there has been an increasing demand from people in other cities to bring the brand there. That's likely a direction I'll pursue over the coming years. Building communities around a shared love of music is a dream and a passion of mine, and I would love to see CAS be able to bring people together and introduce them to new music in cities outside of Nashville. Recently, I curated and booked the popular Musicians Corner 2015 lineup and would love to dive deeper into working with community-driven festivals around the country. The rest you will have to wait and see what happens.

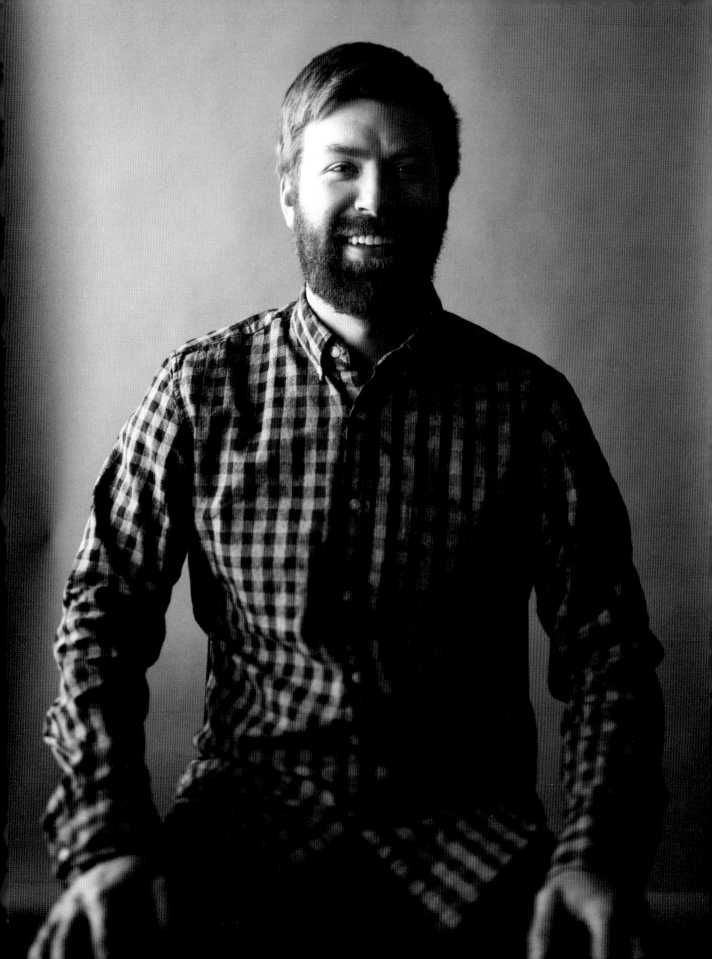

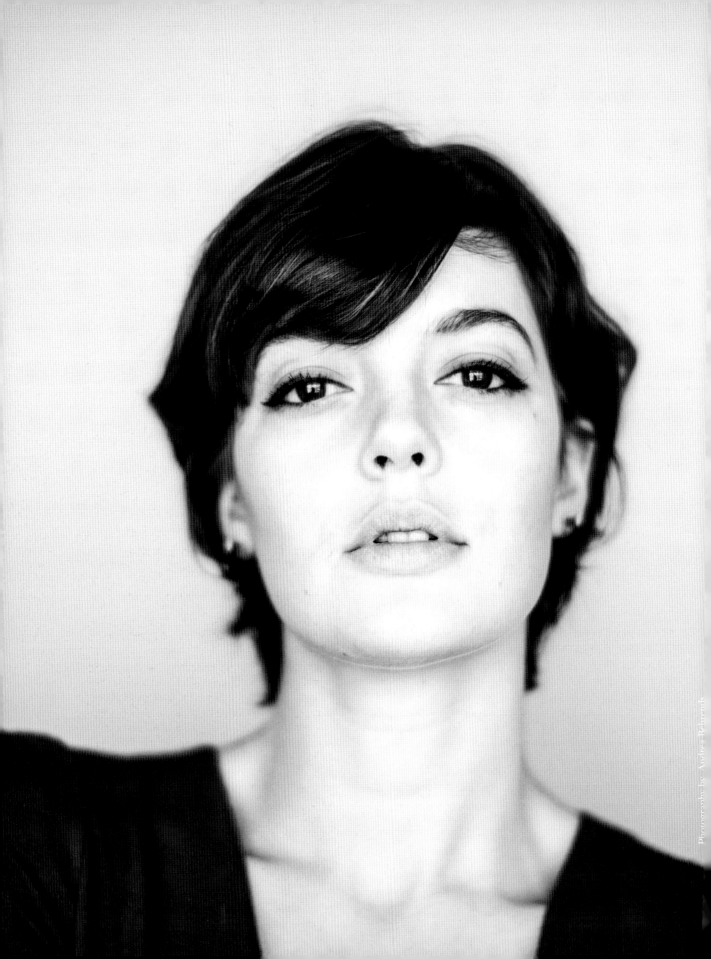

SALOME STEINMANN

{*Model*}

Salome Steinmann is most comfortable being a character in another's artistic process. While the model hit the genetic jackpot, she grew up in a culture where inner beauty is valued over external appearances. The fantasy world in which the model works is a far cry from Altamont, Tennessee, where she spent her formative years. At 18, Steinmann left the Mennonites. She moved to Virginia, alone, before settling in Nashville, where she worked day and night simply to survive. The world we know as normalcy was a culture Steinmann neither recognized nor understood. To fly under the radar, she became a chameleon changing out her masks depending on the situation. However, Steinmann's efforts were in vain as her striking looks and statuesque frame caught the eyes of local photographers. She became a muse to the artistic crowd, and was quickly signed to a modeling agency. In 2009, the girl who grew up without technology was asked to hone her craft on the reality TV show, *Make Me a Supermodel*. The experience made Steinmann grow into her skin and led to a slew of reputable jobs. Today, she is delighted as ever to be a projection of someone else's vision, and part of a moment in time. At the core, she loves the collaborative process and ability to bring out different sides of herself.

What was it like leaving the Mennonites and transitioning into the real world?

I left the Mennonites with $400 in my pocket, and was without a car, work record or understanding of the modern world. I was terrified because everyone I knew told me that I was making the worst decision of my life. However, I knew the culture wasn't right for me and I had to try something else.

Was it like going to another planet?

Yes! I didn't understand the lingo, jokes, or people's expressions. After being raised to trust everyone around me, I had the shocking realization that's not how the real world works.

How did you learn to adapt to that new environment?

I worked all of the time because that was the only thing I was comfortable with. I learned that from the Mennonites where if you're not a good cook, cleaner or hard worker then you're not going to attract a husband. Everyday, when I got home from work, I felt exhausted from trying to soak up the world around me. I learned to hold my cards close to my chest to survive. Thank goodness I balanced out a bit.

How did you originally get into modeling?

After I moved to Nashville, I was waiting tables one day when a photographer approached me and said, "You have good angles." He photographed me, sent the photos to his agent, and I got signed right away. The same

month another photographer asked if I would test for him, and I got my first real job, which was a cover for a bridal magazine. It just went from there. Honestly, I've always loved traveling and was willing to model for free as long as I was able to go somewhere.

You get into character like an actress would. Where does that skill come from?

In the Mennonites, everyone wears the same clothing and there isn't a lot of verbal communication. Through this, I became able to read people really well, notice underlying expressions and small details. Similarly, growing up in a family of nine taught me to be flexible, slightly detached, and perceptive of what other people are going through. All of these qualities help me understand what a photographer needs from me as we're shooting.

What's it like to be revered as a muse by photographers that you admire?

It's an honor because two talents are coming together to make magic. A job is about the money whereas being included in someone's personal work is a compliment. I think I've been able to form this connection with multiple photographers because I'm unassuming, don't expect much, and I'm willing to take direction.

What was the process like learning to be comfortable in front of the camera?

Modeling has always been easy for me. It's something I fell into and experience trained me. I also was never that emotionally invested in it, so I had nothing to lose. It's been a learning process. One specific job or photographer didn't make me who I am. It's like being a server in a restaurant and remembering the customer that stiffed you or the few who were extraordinarily generous. Some photographers are in love with what they do and others are there for superficial reasons. All of that comes across in the shoot and brings a different mood out of me.

Each photographer has a rhythm, which I usually can intuitively read within five or ten minutes. It's similar to kissing someone. You pick up on non-verbal cues through body language to know what to give the camera.

What is your favorite thing about the job?

I worked all throughout my youth so having the chance to be glamorous, wear amazing clothes and meet interesting people is fascinating. Modeling is a form of play and like entering an entirely different world, which I love.

PEOPLE ARE THE MOST IMPORTANT THING IN MY LIFE AND MODELING IS JUST AN EXTENSION OF THAT.

Is it difficult to have a job that is tied to how you look?

It's embarrassing and hard because you can't change the way you look. It sucks being told that your skin is terrible, stomach too pudgy, or that your ass doesn't fit into those jeans. But at the end of the day, it's every girl's dream. You're getting paid to look beautiful so how can you complain? The universe has been really good to me.

What do you think the real secret to success is?

Sometimes you have to become a little obsessed with what you do to really become good at it. If you don't *get into it*, there isn't that willingness to learn all the little details that make a difference.

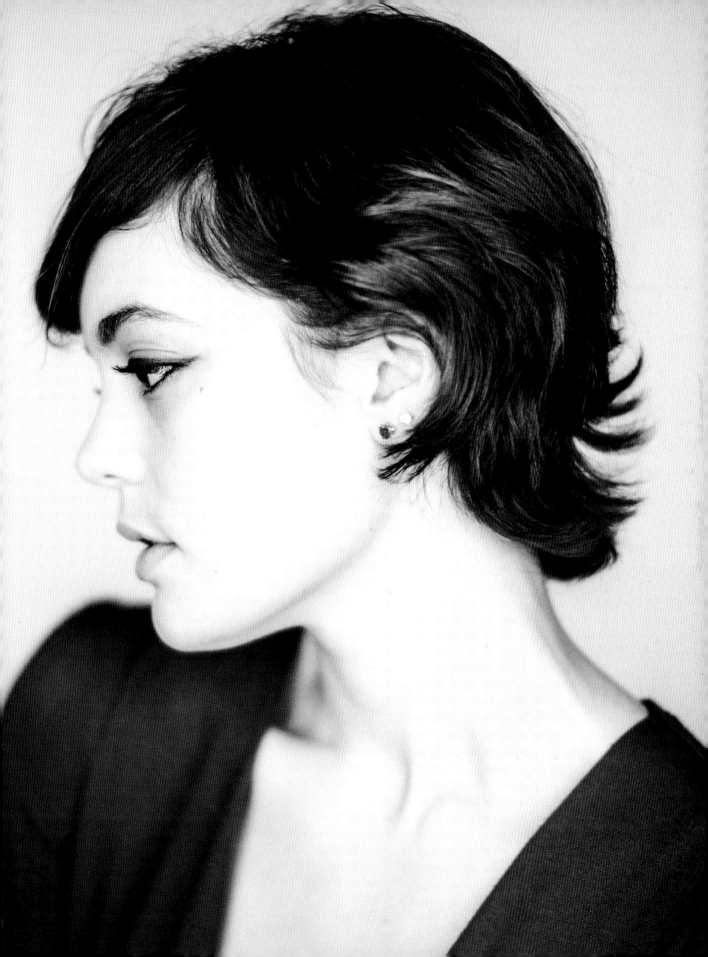

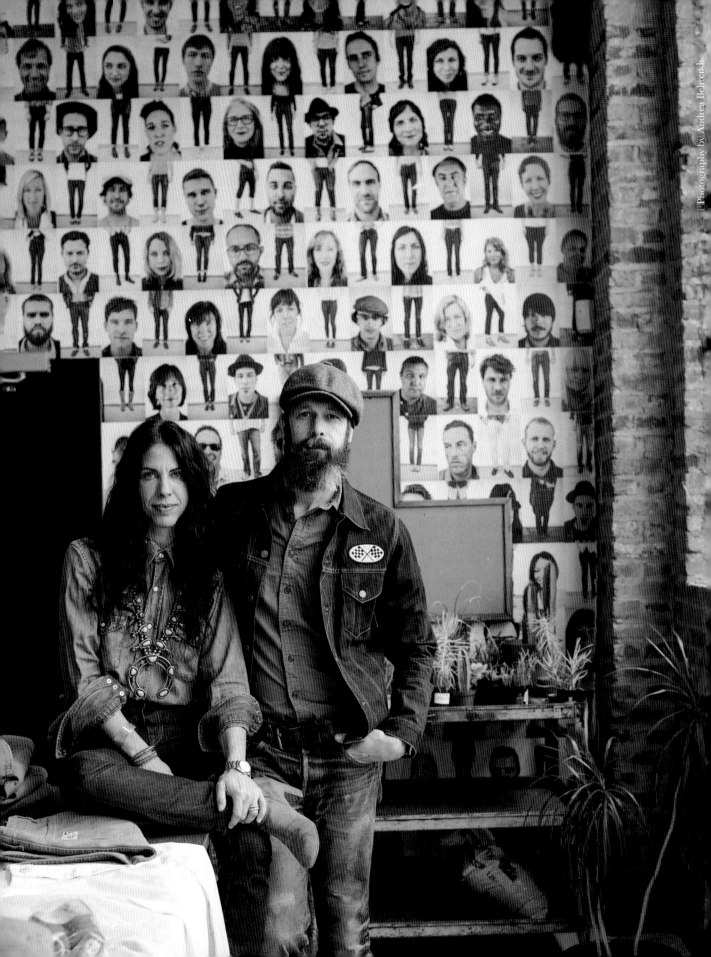

MATT + CARRIE EDDMENSON

{*Founders,* Imogene + Willie}

Matt and Carrie Eddmensons have their story down pat and are sticking to it. Family, friendship, and fate make up the genes of their denim and heritage brand, Imogene + Willie. Since introducing their line in 2009, the cofounders have become cultural icons for Southern style. Throughout their evolution, they have remained true to their love for salvaging the past. Since meeting as preteens in their utopian Henderson, Kentucky, hometown, they both realized they had met their match. The Eddmensons have faced the world in friendship, romance, and business. They are partners in every sense of the word, the secret to seamlessly spearheading a mini-empire. Prior to Nashville, they gained over a decade of fashion industry experience working for the family business, Sights Denim. At the go-to source for processed, distressed denim, the Eddmensons honed their craft and established priceless connections. After the business folded, they moved to Nashville to make handmade denim on American soil. The gas station-turned-flagship store has since become an idiosyncratic tourist destination, staple for locals, and springboard for expansion. Even with their second retail location in Portland, Oregon, they've stayed true to the mom-and-pop model that brought them to the forefront of the maker movement. Imogene + Willie will always keep classic designs contemporary, and provide a platform for promising artisans.

Why did you initially choose Nashville as a place to start your mini-empire?

Matt: Nashville is two hours away from our hometown, so we knew if the business tanked we could just pack our bags and leave. We worked in the fashion business prior to moving here in the smallest of small American towns. I joke that I lived on Main Street and worked in New York because all of our customers and clientele flew in from all over the world. While they were staying in Henderson, Carrie and I were appointed to be their caretakers and entertain them in the evenings. Through that we developed invaluable relationships that were beneficial when the business folded after 26 years, and we started writing the business plan for I+W.

Carrie: There was nothing fashion-related going on here at the time. We ultimately moved here for the gas station. We came here, hated it and were almost ready to go home when we randomly passed by the gas sta-tion. Even though we begged, the building was only for sale. Four months later, I told our real estate agent, "If we can't have that gas station we're looking at other cit-ies." Even though he was doubtful, he called the woman and after he hung up said, "You're never going to be-lieve this. They were on their way to the gas station to take the sale sign off and put a 'for lease' sign up. If you make her a pair of jeans, you can have the building."

What was it about the gas station that grabbed you?

Matt: Our only other choice was brand new develop-ments that had zero character. Also, the gas station was a built-in showroom for what we wanted to create.

Carrie: We were financially strapped and fell in love with the raw beauty of the building. The space has grown with us and is what it is.

Matt: It was meant to be ours and here we are. That space is most representative of our business.

What does it feel like to have catalyzed Nashville's fashion scene?

Carrie: There was no strategy whatsoever. It was just being in the right place at the right time. We talked about the business, shared all of our dirty laundry and, somehow, it evolved. The foundation was secured within the first six months because that was when people really latched onto it. We've never claimed to be pioneers but rather, provided some proof or security that other makers could do it. While we played a part in the movement, by no means did we start it. At the end of the day, it's just about upping the game.

What do you think the secret to your success as collaborators is?

Carrie: That question is loaded.

Matt: Our perception of success has ultimately changed because what started out as this dreamy, creative project quickly became a business. Anytime money is involved we all know that things become peculiar and less carefree. We feel as though we've gotten our MBA in business simply through running Imogene + Willie. Our biggest struggle is to stay creative and passionate, while running a full-fledged company.

Carrie: While sometimes it can feel like a curse truly, our hyper compatible relationship is the greatest gift that either one of us will ever have. We've been doing a lot of soul searching lately because there are major struggles that come with that dynamic. I think that our life journey is about dealing with it and recognizing even the greatest relationships aren't always going to be roses. Everyday we get better at figuring out how to come to a conclusion and solution when we're not in line, which, inevitably, strengthens the business.

Do you think you two have been able to stay the course because you keep one another grounded?

Carrie: We are two incredibly stubborn and rebellious people, and while there have been many times to abandon our original vision we're never going to do it. I think that ties into the fact that we're both very raw, and have this need for transparency. When we started it, we didn't have millions of dollars like our predecessor companies. It was basically suicide to start the kind of business that we did. Now we feel compelled to pay homage to all that we've been give.

This is a family business, which a lot of folks find very endearing. Why is that so important to you?

Matt: My parents had me when they were 19, got a divorce shortly after, and afterwards I spent most of my life at my grandparents' house. My brother went to my maternal grandparents and I went to my dad's parent's house. On the weekends we merged families because my grandparents were best friends. When I fell in love with Carrie I remember my dad telling me, "Don't forget that you're marrying the family too. They don't go away." I absolutely fell in love with her tightly knit family and they have been a huge influence on my life and our business. I see value in the long-term as opposed to the fly-by-night mentality where you run and jump into something, and then it's over. There is a strong possibility our business could be here in another ten years, which is really exciting to me.

Carrie: There's so much commitment in our town to family and friendships. There's this radius with family in the middle, which is a force great enough to keep us together through anything. Imogene + Willie happens to be the name of one set of my grandparents, but it represents Matt's as well. Family goes beyond blood and is rather this deep-rooted commitment and loyalty to the people in your life. But it's not all roses. If we're going to create, instill and promote that as our brand we're going to talk about the real stuff too.

What has been the most gratifying thing about your business? And also the biggest challenge that perhaps you didn't anticipate?

Matt: When you start your own business you are making up the rules to a certain extent. The challenges in our business have come from poor decision making, misjudging other people's character or being taken advantage of from this very romanticized view of what I+W is. In business, you're either coming out of a storm or going into one. It's similar to driving underneath a bridge in the rain. For ten seconds, when your car is covered, everything stops and then it's right back into it. Those challenges have really whipped us into shape a little bit. The most gratifying thing has been rising to the top by making the products we envisioned.

Carrie: I'm grateful for the world being open to us doing business in an unconventional way. And that it stuck. Are our jeans good? Yeah. Are they the best in the world? Probably not, but for some reason people have latched onto, adopted, and appreciated our brand. While it's not a traditional business model because of the acceptance from others it works. Lastly, I'm so happy we've been able to affect other people's lives, and provide them with jobs, when the economy went to shit. Having the freedom to be our own boss negates any difficulties we've faced in the past.

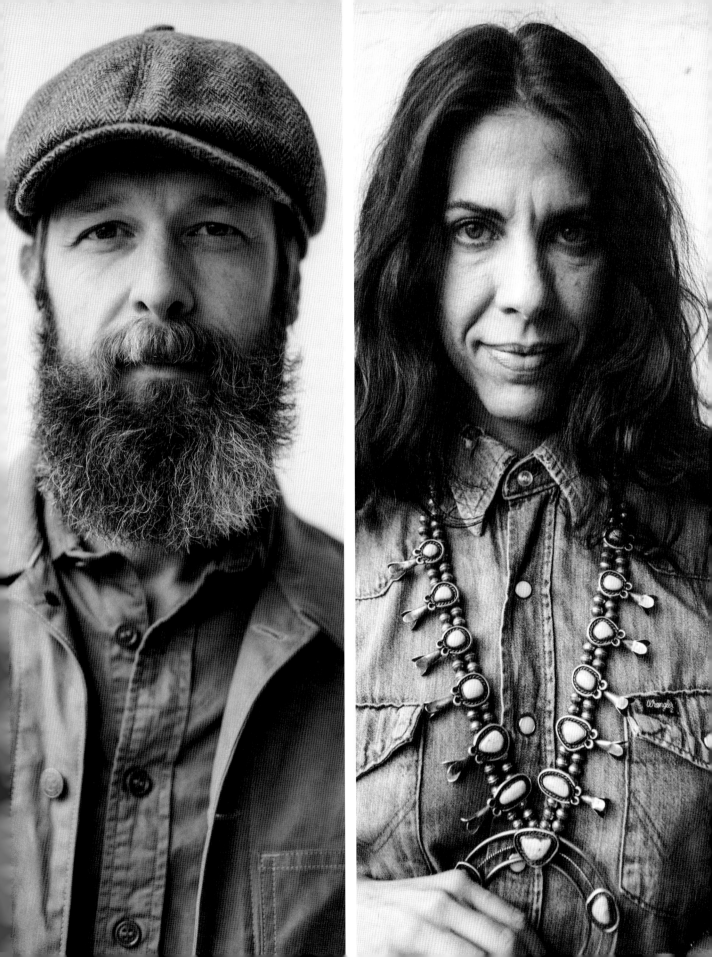

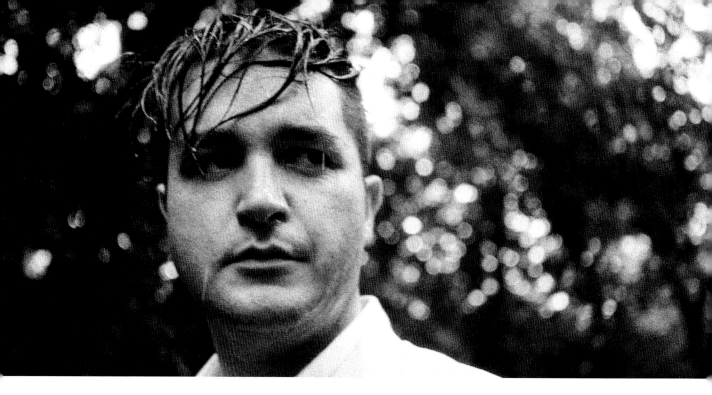

BRETT WARREN

Baiting bees with honey is similar to dropping Brett Warren in the couture wing of a department store. The fashion photographer from McMinnville, Tennessee, is a multifaceted artist who storyboards, styles, and designs sets for his shoots. He plays make believe while weaving his own reality into the fantasy.

How did you hone your storytelling photography style?

My internship with Annie Liebovitz was pivotal. From her I learned that if you have a point of view, then do whatever you can to get it across. After I returned home, I painted houses for months to pay for my first elaborate shoot: Pinocchio.

What do bring to the photography set?

I try to empower others by giving them the freedom to express and challenge themselves. I love being able to facilitate those opportunities.

What about editorial photography so appeals to you?

I am big on escapism and wholeheartedly believing that I am in another reality. While there's always a linear story in my head for every shoot, I love giving my models the opportunity to make it their own. It's a very similar relationship to an actor and director.

How do you conceptualize an idea for an editorial spread?

I try to imagine other worlds that my models could comfortably exist in, and then storyboard and sketch it out. Although my look is really over-the-top every story is about channeling my emotions into the characters. By calling them out, I'm able to put them to bed and gain a little bit of power.

What is the bigger inspiration: film or fashion?

I love fashion as an art form. Designers pour stories into clothing and my goal is to tell a different tale in my own medium. The biggest inspiration is this other world where anything is possible. One of my favorite films is *The Great Gatsby*, which is a visual spectacle in a world of minimalism. It's lovely to partake in that sometimes.

Why the fight to pursue fashion photography in Nashville, which doesn't have a legitimate industry?

I feel like Nashville and I are both on the horizon of something major. I am naturally drawn to creating stories about transformation because of the journey I've been on. If I can use my career ups and downs to grow as an artist and individual then I'm exactly where I'm supposed to be.

CONTRIBUTORS

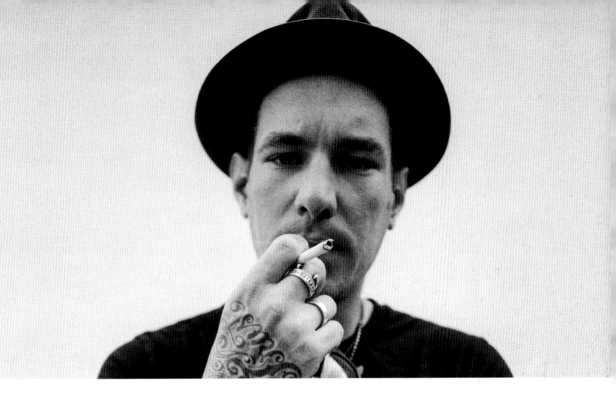

JOSHUA BLACK WILKINS

Joshua Black Wilkins makes pictures of those who behave badly. The photographer and musician, bears no care if his personal work has commercial appeal. The images often explore the realm outside of "ordinary" beauty. After years of making hyper-manufactured holograms, he now strives to make the most honest images possible.

How did your photography career begin?
I started purely as a hobby in the mid 1990s—around the same time that I got into playing music. Professionally, I learned as an assistant in the commercial country music world. That experience perpetuated the path I've taken since.

What is your personal artistic philosophy?
Internally and subconsciously, I am always pushing to the left. My website and social media outlets make it easy for me to be selective about the jobs that I take on. If you don't like slightly scandalous photos, then we're probably not going to work together. By putting too many possibilities out there, you give out the wrong impression and get hired for projects you have no business doing.

The commonality between your subjects is always that no one is faking it.

I don't waste a frame or megabyte if someone looks like they've practiced in front of the mirror. It's nearly impossible for me to make a great looking photograph unless there is energy behind the expression. Whether it's just a subject and myself or a whole glam squad there has to be a connection.

What are your words of wisdom to aspiring photographers?
Consider your subject a peer meaning, ask them to do things you would be comfortable doing. I learned this as an assistant by watching, working really hard, and keeping my mouth shut. While everything doesn't have to go on your website it's best to only say, yes to the jobs you care about. Also just dig in, find the shots that you like and do the best you can. Whether it's a personal or commercial job, I always get the same nerves and concerns right before I start shooting.

ANDREA BEHRENDS

Imagery is the way Andrea Behrends explores the world. It is how the portrait photographer seeks out the answers to her questions. She breaks down barriers to make them feel as though no one is watching.

In the mid '90s the Red Hot Chili Peppers graced the cover of *Rolling Stone*. I was in high school and questioning which subculture I fit into. After discovering the darkroom at my high school, I thought, "maybe I'll be a photographer." It was there that I learned chemical processing, exposure, and film development.

I began shooting self-portraits because I had no intentions of fumbling around with someone else's face while in the process of learning. In the only photo I own from that time, I look pissed off and punk rock with a Blow Pop sticking out of my cheek.

I had several college professors who nurtured photography in two facets: as a fine art medium and as straight portraiture. One professor documented his wife's breast cancer process from double mastectomy until death. That's when my interests in photography shifted from shooting cool bands to documentary.

I took a class called "Small Town Documentary" where I, this Chicago city girl, went into a town with a population of less than 500. It was my first exposure to the immersion it takes to document a subject. It made me realize that ev-

eryone has a story and is a potential portrait. All you have to do is ask for the opportunity. It's the extroverted side of my personality that allows me to connect with my subjects.

Post college, I worked as an assistant and shot products and people. I worked on editorial spreads, national ad campaigns, and hundreds of weddings. One commercial photographer and his wife took me under their wing and taught me the ins-and-outs of production. Another educated me about life while shooting cigars, booze, and high-end watches for *Playboy's* Christmas gift guide. During that period, I discovered my own aesthetic: it's simple, clean, and captures the essence of my subject.

Any success I've had I relate to being a member of the artist tribe, my childhood, yoga poses, energy, vibration, education, *The Artist's Way*, and morning pages. I cannot wait to be 70-years old and have a retrospective of portraits I've taken over the years.

Photography is the most important, long-term, intense relationship I've ever had. It's who I am, what I'm supposed to do, and something I will sacrifice everything for. But there's more to it than that because it's never that simple.

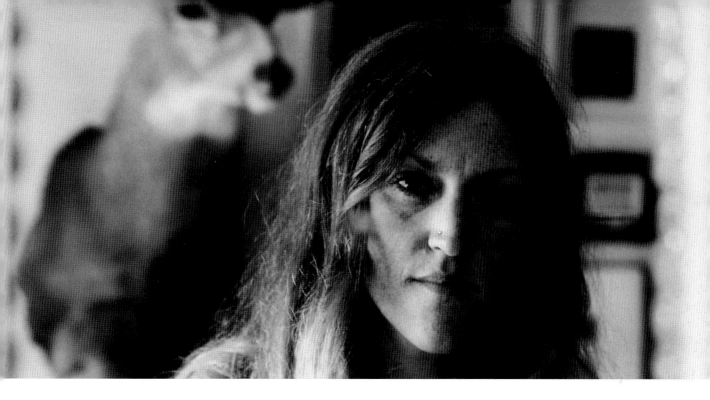

DANIELLE ATKINS

What began as a means for Danielle Atkins to bond with her father, advanced into a full-fledged career. After following in his footsteps she continued to define her aesthetic by shooting as often as possible. Subjects cannot hide from her large-format camera. A higher-than-average resolution ensures Atkins always gets the real deal. These frozen moments exhibit the diverse external beauty and emotional depth that make up mankind.

What is your favorite portrait?
My dad meant everything in the world to me so when I bought my 4x5 camera, I couldn't wait to show him. Like myself, he wasn't keen on having his picture taken, however, I convinced him to hold still for one sheet of film. That image is priceless, perfect, and something I cherish now that he's gone.

How did you gravitate towards your current subjects: food and portraiture?
While I was living in California I mostly photographed bands. However, every time I edited my images the portraits are what I gravitated towards. Food photography literally fell into my lap after I moved to Nashville. Once I started, it became impossible to stop because I find it as beautiful as anything else.

What is the best compliment a subject or client has ever given you?
"Wow that was easy." It has been said by people who have never been professionally photographed to those who've had their picture taken a million times. To make someone feel at ease is hugely satisfying.

What is your trick to getting subjects to appear so natural on film?
"Take a breath, relax your body, and shake it out" is my usual go-to phrase. It reminds people to breath rather than stiffen up. I want them to feel as though we're having a great conversation. They are telling me who they truly are through my camera lenses.

What is your secret to making a successful career?
Feeling slightly uncomfortable keeps me driven. I am always pursuing potential projects, clients and subjects.

What is your favorite part of the job?
Almost every day is different. I would never be able to go to the same job everyday because boredom creeps up on me very easily.